THE
HUMANITIES

FIFTH EDITION
THE HUMANITIES

Louise Dudley and Austin Faricy

Revised and expanded by the editorial staff of McGraw-Hill

McGRAW-HILL BOOK COMPANY

NEW YORK ST. LOUIS SAN FRANCISCO DÜSSELDORF JOHANNESBURG
KUALA LUMPUR LONDON MEXICO MONTREAL NEW DELHI PANAMA
RIO DE JANEIRO SINGAPORE SYDNEY TORONTO

Library of Congress Cataloging in Publication Data

Dudley, Louise, 1884—
 The humanities.

 Bibliography: p.
 1. The arts. I. Faricy, Austin. II. Title.
NX440.D82 1973 700'.1 72-12766
ISBN 0-07-017970-0

McGraw-Hill, Incorporated, New York

Printed and bound in Italy.

This book was set in News Gothic. The editors were Robert
P. Rainier, Robert Weber, and Susan Gamer; the designer
was J. E. O'Connor; and the production supervisor was
Adam Jacobs. The printer and binder was Officine Grafiche Arnoldo
Mondadori, Verona.

CONTENTS

PART FOUR STYLE

LIST OF ILLUSTRATIONS

* This illustration appears in color.

* This illustration appears in color.

* This illustration appears in color.

* This illustration appears in color.

* This illustration appears in color.

* This illustration appears in color.

PREFACE

Before the first edition of this text was published, two experimental versions had been printed for class use; I wrote the first, Mr. Faricy and I the second. For the first and second editions Mr. Faricy contributed the chapters on music. For the third edition I alone was responsible. I made, however, extensive use of the illustrations selected and edited by Mr. Faricy.

For the fourth edition, new areas of subject matter were introduced: the film, dance, opera, Japanese lyrics. Mr. James Shirky, a member of the Humanities staff of Stephens College, rewrote entirely the chapters on music. Other important additions were the essays by Dr. James Rice, one of which made up Chapter 20 of this edition. Mrs. Beverly Sterling and Mrs. Barbara Toalson almost persuaded me that typing may be an art. Last, but by no means least, I am indebted to all the teachers of Humanities at Stephens College, both present and past, especially to Dr. Alfred Sterling. Everyone has given me something of inspiration and of challenge.

Louise Dudley

A Note on the Fifth Edition

For this edition, the entire text was reviewed by the editors and consultants of the McGraw-Hill Book Company. Wherever necessary, it was updated with references to recent examples in all the arts. Similarly the illustrations have been enlarged both in size and number, and many color pictures are included for the first time. Basically, however, this book remains the original work of Professor Dudley and Mr. Faricy.

THE HUMANITIES

Today we think of the humanities as a loosely defined group of cultural subject areas rather than as scientific, technical, or even socially oriented subjects. Thus, by the term *humanities* we generally mean art, literature, music, and the theater—areas in which human subjectivity is emphasized and individual expressiveness is celebrated. A melancholic Chopin nocturne, Euripides' magnificent tragedy of Medea, the empathy we feel with the forces of nature in a Turner painting are all powerfully human and personal expressions. The importance of the human being and his feelings (and how he expresses those feelings) is the concern of the humanities today as much as yesterday. To each man's search for identity and significance perhaps only the humanities can bring enlightenment—from Euripides' plays in ancient Greece to Beckett's and Ionesco's today, from Rembrandt's paintings in the seventeenth century to Picasso's in the twentieth century. In our time science and technology have overwhelmed many facets of our lives, and, indeed, even our possibilities of survival are affected. With a certain amount of relief and hope we turn to the humanities, where the world of man's spirit is documented in human, rather than technical, values.

Modern man perhaps will gain more from the humanities than from his most recent weapons or, assuredly, from his technological destruction of the environment and from the economic failures that leave him feeling, at times, so helpless. The potential good to be derived from the social sciences (sociology, history, psychology, political science) or from the physical sciences (biology, chemistry, physics) is somehow vitiated by human failings of greed, prejudice, and power interests; and though our science gives solutions to many contemporary problems, weaknesses prevent us from taking full advantage. One can imagine the humanities offering

a more human view of man's existence and function. The heightened appreciation of human dignity (and weakness) felt so powerfully in man's art, music, and literature can elevate our feelings and actions to positive forces in a world increasingly aware of its failures.

Apart from the possibilities for reform, the humanities can offer virtues and benefits of immediate significance for the average human being. In simplest terms, the arts provide enjoyment and stimulation, particularly when we try to understand them. But because we often can derive enjoyment with little or no preparation, most of us are satisfied with rather elementary forms of comprehension and appreciation. In this book, therefore, we will make a systematic attempt to evaluate our experiences with the humanities, to develop and refine our initial responses, and to arrive at a mature and meaningful understanding of the arts. Exposure alone may accomplish this end—in continuing to look, listen, or read, we will see, hear, and experience more than at first. This act of discovery is itself rewarding for its sense of accomplishment; but its more important benefit is that we begin to perceive what the artist intended to put into a particular work. Some of this additional benefit can be obtained, as we said, by continuing to expose ourselves to the work in question; the rest can come only through our effort to understand what the artist had in mind during the process of creation.

To attain such an understanding, it may not be necessary for us to know everything about the artist's life or the period in which he worked, but it will surely help us to know something about how the work of art was created. What story (if any) is the artist trying to tell? What materials was he using (stone, paint, words, musical notation, etc.)? How did he use his materials (what is his style and organization)? Finally, how does his work relate to other works of art, both past and present? Without asking questions like these we risk losing, through ignorance, much of past art and, through carelessness, a good deal of contemporary art. (How else can we approach, say, John Cage's music, Jackson Pollack's paintings, or the theater of the absurd?) If we depend solely on intuitive response to evaluate a work of art, music, or literature, we are refusing to recognize the artist's long period of training and his vastly superior experience and authority in the matter. The result is that we lose the enjoyment and stimulation we sought in the work in the first place.

Thus, although we will not present a history of the arts in this book, some historical information will come to the reader almost automatically as he studies the humanities. And that information will bring a new understanding and enjoyment of the various facets of artistic creativity. Moreover, when we recognize a universal human problem—the abandoned mother, the unjustly accused prisoner, the man in search of identity, the pain of unrequited love—we will identify with the artist and his work in a thoroughly satisfactory and rewarding way. Each time we return to it, we will understand it better and come to realize how much the artist put in it—and how little we have yet found.

All the arts, as we shall see, have a purpose. All have a medium, be it stone, words, film, or something still undiscovered. The medium is then organized into a meaningful pattern or design. Finally, all the arts occupy some place in our judgment. These are the basic characteristics of all the arts, the characteristics that give them their particular flavor and meaning. Yet the fact that the arts have all these qualities in common does not mean that the purpose of a painter is like that of a composer or writer. Indeed, if their purposes were identical, we would not need different arts. So each of the arts has its particular purpose as well as expression. This was made clear by the Mexican painter José Clemente Orozco when a visitor to the Museum of Modern Art asked what he was trying to express in his mural *The Dive Bomber* (inspired by the Nazi invasion of France in 1940). Orozco replied, "If I were able to put it into words, I would not have had to paint it." Thus, while we maintain that the three basic humanities have in common the use of mediums, elements of organization, and evaluation of effectiveness, we hasten to show that architecture is not "frozen music" (as John Ruskin maintained in *The Stones of Venice*), nor should a "poem be like a picture" (in spite of the Roman poets). Similarly, what a musician expresses appropriately on the piano will have an altogether different effect—and meaning—when transcribed for the violin. Should an idea about nature be expressed in an epic poem or in a madrigal?

To prepare the reader to assess the humanities is our purpose, and our approach is conceptual rather than historical. It is our hope that by introducing new names in the humanities (or new works by old names) we will increase the range of enjoyment and stimulation that the reader derives from the history of world civilization. To the degree that the examples of the humanities discussed here represent not merely typical but in many instances outstanding works of art, music, and literature, we hope to have given the reader the means to enrich the rest of his days.

THE
HUMANITIES

1. INTRODUCTION THREE BASIC ASSUMPTIONS

THE PURPOSE AND PLAN OF THE BOOK

This book has to do with the appreciation of the humanities—a subject which concerns everyone, for every day everyone consciously and unconsciously makes decisions and judgments that are determined by his knowledge and appreciation of the various arts. A child watches for his favorite television program; a teacher waits for a certain musical program on the radio; a young married couple debate long and seriously about the materials for their living room. Even a hardheaded businessman who would deny emphatically any interest in art will trade in his automobile for one with better lines or will pay an extra hundred dollars for a special paint job. These are not examples of great art, it is true, but they show concern for artistic values.

Most such people know that they are not getting all the pleasure they could from art. They know others who are getting greater pleasure than they from concerts, paintings, plays, and poetry; and whether or not they realize it, they would like to share these pleasures themselves. In the realm of art they feel like the inhabitants of the world before Prometheus brought them the divine fire:

Though they had eyes to see, they saw to no avail; they had ears, but understood not; but, like to shapes in dreams, throughout their length of days, without purpose they wrought all things in confusion.
—Aeschylus (fifth century B.C., Greek dramatist),
 Prometheus Bound, 447–451, trans. Herbert Weir Smyth[1]

[1] The Loeb Classical Library, published by Harvard University Press.

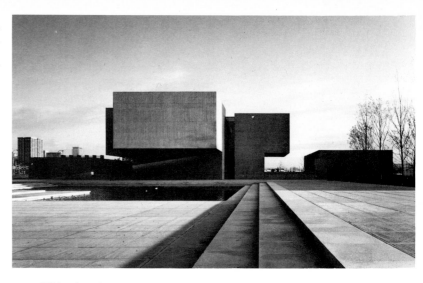

Figure 1-1. I. M. Pei (1917–), American architect. Everson Museum of Art, Syracuse, N.Y. (1961–1968). (Bush-hammered concrete; 60,000 square feet, 120 by 255 feet below grade, 130 by 140 feet above grade.)

Figure 1-2. Morris Louis (1912–1962), American painter. Pillar of Fire (1961). (Plastic paint on canvas, 92 by 47½ inches. New York, Harry N. Abrams Family Collection. Photograph by Eric Pollitzer.)

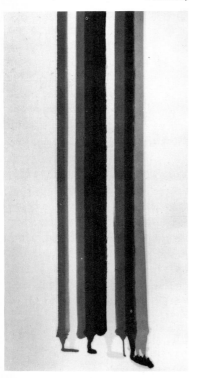

With the development of mass communications and travel, people are no longer as isolated from the arts and culture generally as they used to be. In the course of reading, traveling, and conversing with friends and acquaintances, people come into contact with many different artistic stimuli that provoke questions they are not always able to handle or feelings they do not necessarily understand.

The mass media, particularly magazines and television, have for some time been stressing the importance, even the newsworthiness, of what is going on in the arts. Thus the inauguration of a new museum by I. M. Pei in Syracuse, New York, becomes the occasion for an article (Figure 1-1); a new school of artists—the color-field painters—is worth a feature article in *Life* (Figure 1-2); the BBC in England cooperates with American television (with help from the Xerox Corporation) to produce an outstanding cultural program, "Civilisation" (1971–1972), featuring the distinguished art critic Kenneth Clark. Undoubtedly, such events are of great cultural and artistic importance, for they indicate that there is already a huge interest in the humanities, and that the mass media are eager to take advantage of it. But for many people, young and old, these very occasions raise as many questions as they answer. Kenneth Clark and his views do not interest everybody, and with the best will in the world his erudition cannot reach the so-called "average man," in spite of its enormous value. Similarly, color-field painting will not mean the same thing to every person who sees the article in *Life*, and to many readers it will mean scarcely anything at all; Pei's "brutalist" museum in Syracuse will have a different impact on different people, and on many people it will have very little impact. What this suggests is that there are many people still to be gathered into the humanistic net.

This book is written for those people. It cannot teach appreciation, and it does not pretend to. Appreciation cannot be taught. Appreciation, like any other pleasure, is an experience; and experience can only be had.

A book like this can, however, show some of the bases of appreciation, some of the qualities of art that others have enjoyed, and some of the basic principles that underlie all the arts. In short, this book tries to open the eyes and ears to art in order that, seeing and hearing, we may understand and enjoy.

The plan of the book is to start with the more nearly obvious principles of art and proceed to the more abstruse. The first two questions asked of any work are usually: What is it about? and What is it for? The first question concerns the *subject*, the second the *function* of a work of art. Accordingly, subject and function will be discussed first. Subject and function, however, are not essential to all art, for there are works without subject and works without function; for this reason subject and function are grouped together as background.

The next question asked of a work of art is: What is it made of? The answer indicates its *medium*. Medium, of course, is essential to all art, since any work of art must be presented in some medium.

The fourth question is: How is it put together? This question is important because it has to do with *organization*. The elements of an art, whether shapes, tones, colors, or words, must be arranged according to some pattern to express meaning; in brief, they must be organized before we can have a work of art.

The two remaining questions are in the nature of a comment on the finished creation. One asks: What is the personality, the individuality, of this work? This brings up the matter of *style*. The other asks: How good is it? This is *judgment*.

If these items are put in order, we have the outline of this book:

1. Background.
 a. Subject. What is it about?
 b. Function. What is it for?
2. Medium. What is it made of?
3. Organization. How is it put together?
4. Style. What is its temper? Its mood? Its personality?
5. Judgment. How good is it?

Before we begin the formal presentation of these points, however, there are three assumptions about the nature of art which we need to clarify. They will determine our attitudes and our basic premises.

THE AGE AND IMPORTANCE OF ART

The arts constitute one of the oldest and most important means of expression developed by man. Even if we go back to those eras called "prehistoric" because they are older than any periods of which we have written records, we find works to which we give an important place in the roster of the humanities. In 1879 a Spaniard, accompanied by his little daughter,

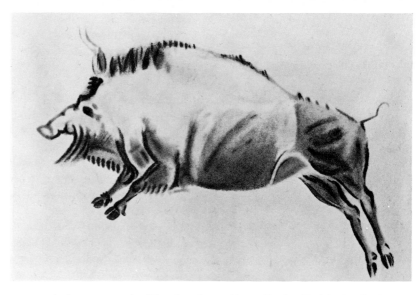

Figure 1-3. Galloping Wild Boar. *(Found in the cave of Altamira, Spain. Photograph, American Museum of Natural History.)*

Figure 1-4. Apollo with Kithara, Greek *lekythos from the middle of the fifth century* B.C. *(Red-figured lekythos. Terracotta. Height: 15 inches. New York, Metropolitan Museum of Art; gift of Mr. and Mrs. Leon Pomerance, 1953.)*

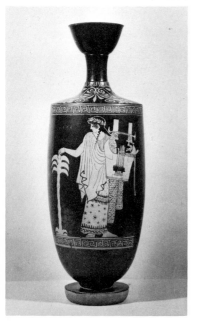

was exploring a cave in Altamira, in northern Spain. Suddenly she began to cry, "Bulls! Bulls!" He turned his lantern so that the light fell on the ceiling of the cave, and there he saw the pictures of wild boar, hind, and bison which we now know as the Altamira cave paintings (Figure 1-3). Since that time, some similar paintings have been found in other caves, and the experts have given their judgment that these belong to the Upper Paleolithic Age, ten to twenty thousand years before Christ.

In almost every country the earliest art goes back to prehistory. The Greek Homeric epics, the *Iliad* and the *Odyssey*, probably date back to a time before the beginning of recorded history. These poems may have been put together between the twelfth and the ninth centuries B.C., but it is generally believed that they are collections of earlier tales which had been known and sung for many years before that time.

We do not have any examples of music and dancing at such early dates, because for a long time there were no adequate means of notation for these arts; but we do know that music was important very early in human history. In 586 B.C., for example, the Greeks held a festival or competition at which one man played a composition for the aulos—a double-pipe reed instrument. There are also pictures of instruments on early Greek vases; on a lekythos (oil container) from the middle of the fifth century B.C. there is a painting of Apollo holding a kithara (Figure 1-4) —the most important of the Greek instruments and the precursor of the modern harp.[2]

The Old Testament refers often to musical instruments. In II Samuel 6:5 we are told that when the ark was brought home, "David and all the house of Israel were dancing lustily before the Eternal and singing with lutes, with lyres, with drums, with rattles, and with cymbals" (Moffatt translation). Moreover, the Hebrews had a song book, the Psalms, which in its present form probably dates from the second century B.C., though

[2] Donald J. Grout, *A History of Western Music*, pp. 5–7.

many of the songs are older. It is divided into five books, each closing with a doxology. Often there are definite directions as to how the song is to be sung. Psalm 9 is to be sung by a choir of soprano boys. Psalm 12 is for bass voices. Psalms 54, 55, and 67 are with stringed intruments. Psalm 5 is to have a flute accompaniment. At times the tune is given; and a favorite tune may be used for several poems, as at the present time. Psalms 57, 58, 59, and 75 are to be sung to the tune "Destroy it not" (Moffatt translation).

Not only is art found in all ages; it is found also in all the countries of the world. Stonehenge (Figure 4-2, page 74) is in England; the beautiful head of Nefertiti (Figure 1-5, page 6) is from Egypt; Aesop's *Fables* are Greek, as is the little song of Sappho, a poetess of the fifth century B.C.:

Mother, I cannot mind my web today
All for a lad who has stolen my heart away.[3]

The *Arabian Nights* tales, which came to us from Persia or one or the other of the Arabic-speaking countries, eventually go back to ancient India. The *Rubaiyat* of Omar Khayyam, from the eleventh century after Christ, is Persian, though it is best known to us in the quatrains of Fitzgerald:

A Book of Verses underneath the Bough,
A Jug of Wine, a loaf of Bread—and Thou
 Beside me singing in the Wilderness—
Ah, Wilderness were Paradise enow!

It seems very modern, as does this later short poem from the Chinese:

What life can compare with this? Sitting quietly by the window,
I watch the leaves fall and the flowers bloom, as the seasons
come and go.[4]

No matter what age or country we consider, there is always art. And this art is not good because it is universal, but universal because it is good. Old songs and stories, old pictures and statues, have been preserved because they are alive, because they meet the needs of people, because they are liked. There is a timelessness about art which makes us feel it is not old; that is, it does not grow old. The girl who says

Mother, I cannot mind my web today
All for a lad who has stolen my heart away

[3] Translated by Marjorie Carpenter.
[4] Quoted from the Chinese of Seccho by Aldous Huxley, *Perennial Philosophy*, p. 63.

Figure 1-5. Nefertiti, Queen of Egypt, Eighteenth Dynasty (*ca. 1375* B.C.). *(Plaster cast of a painted limestone original now in Berlin, New Museum. Life-size. New York, Metropolitan Museum of Art; Rogers Fund, 1925.)*

is not thinking that she ought to brush up on Sappho and the other Greek lyric poets. The chances are that she is having trouble doing her own work, for the same reason. When we recite the Psalms—"The Lord is my shepherd I shall not want," or "By the rivers of Babylon, there we sat down, yea, we wept, when we remembered Zion"—we do so because we find in them something that fits our needs.

A favorite tune is the one to which we sing both "We won't go home until morning" and "For he's a jolly good fellow." Early French lyrics of the song began: *"Malbrouk s'en va-t-en guerre"* ("Marlborough is off to

the wars''); these lyrics date from about 1709, when the Duke of Marlborough was fighting in Flanders. The song is said to have been a favorite of Marie Antoinette about 1780. It was introduced into Beaumarchais' comedy *Le Mariage de Figaro* in 1784. The tune itself, however, is much older. It was well known in Egypt and the East, and is said to have been sung by the Crusaders. But none of us who sing it today are thinking of these aspects of the song. We sing it because we like the song, because it fits our mood when we want a jolly, rollicking air.

Suppose it is a more modern poem we are thinking about.

Márgarét, are you gríeving
Over Goldengrove unleaving?
Leáves, líke the things of man, you
With your fresh thoughts care for, can you?
Ah! ás the heart grows older
It will come to such sights colder
By and by, nor spare a sigh
Though worlds of wanwood leafmeal lie;
And yet you will weep and know why.
Now no matter, child, the name:
Sórrow's spríngs aré the same.
Nor mouth had, no nor mind, expressed
What heart heard of, ghost guessed:
It ís the blight man was born for,
It is Margaret you mourn for.
 —Gerard Manley Hopkins (1844–1889, British poet),
 ''Spring and Fall: To a Young Child'' (between 1876 and 1889)[5]

In reading poetry of this kind, dealing as it does with universal feelings, one doesn't care much when it was written or by whom.

In the final evaluation of any work of art, age and nationality as such are matters of comparative indifference. Bach, Beethoven, and Brahms lived in different centuries and all composed great music; the final evaluation depends on the music alone. Epstein's *Portrait of Oriel Ross* (Figure 1-6) was made in 1931, more than three thousand years after the head of Queen Nefertiti of Egypt. There are elements that indicate the country and the date of each work, but our judgment is determined by the works themselves.

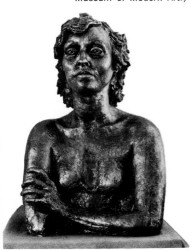

Figure 1-6. Jacob Epstein (1880–1959), British sculptor. Portrait of Oriel Ross (1931). (Bronze. Height: 26½ inches. New York, Museum of Modern Art; gift of Edward M. M. Warburg. Photograph, Museum of Modern Art.)

The first point, then, about the humanities is that art has been created by all people, at all times, in all countries, and it lives because it is liked and enjoyed. A great work of art is never out of date. This point has been stated in many different ways by different people. Some speak of the intrinsic worth of art: its value is in itself. Bernard Berenson, the art critic and historian, talks of the ''life-enhancing'' value of art. Whatever words are used, the fact remains that we like art for itself, and the value of art, like all spiritual values, is not exhausted. It is used, but it is not used up. It does not grow old. A good expression of this is found in this quotation from President John F. Kennedy's speech of November, 1962, on behalf of the National Cultural Center in Washington:

[5] From *Collected Poems* by Gerard Manley Hopkins, Oxford University Press.

Aeschylus and Plato are remembered today long after the triumphs of imperial Athens are gone. Dante outlived the ambitions of thirteenth century Florence. Goethe stands serenely above the politics of Germany; and I am certain that after the dust of centuries has passed over our cities, we, too, will be remembered not for victories or defeats in battle or in politics, but for our contribution to the human spirit.

By the same token, a painting by Rembrandt of a seventeenth-century dignitary is great even though we may know little or nothing of the man portrayed. It is not the social or political importance of the sitter that makes the portrait significant but rather the artistic effort, which has outlasted the contemporary significance of its subject.

ART AND EXPERIENCE

The second assumption essential to our study has to do with experience. It has been said that art is experience, because all art demands experience; but probably it is clearer to say that all art involves experience, that there can be no appreciation of art without experience.

When we say that art involves experience, we mean by experience just what we always mean by the word: the actual doing of something. If you have talked on television you know that experience. If you have never ridden a horse or fallen in love you do not know those experiences. You may have always wanted to see the home of Washington at Mount Vernon; you may have read much about it and have seen pictures of it; but you do not have the experience of the place until you see it for yourself. It is one experience to sing a song and a different experience to hear it. It is an experience to read a story or see a play, just as it is an experience to write the story or act in the play. But it is not an experience of the story, the song, or the play just to hear *about* it.

Olga Samaroff Stokowski (1882–1948), a well-known pianist and music educator (and the wife of Leopold Stokowski), expressed this idea when she said:

Someone else can compose music for you.
Someone else can perform music for you.
No one on earth can listen to music for you.[6]

Of course that statement is true in principle of all the arts. Each person must know a work for himself. The dramatist may write a good play, which may be presented by skillful actors, but it is lost to the critic unless he sees it for himself. The poet and the painter may write their poems and paint their pictures, but you cannot know or judge them unless you have heard and seen them for yourself, not as fact or information but as experience. On the lowest level, this means that since a work of art is always something to be seen or heard, we must see it or hear it, or see *and* hear it, if we are to know what it is. We must hear the music and see the painting if we are to know them. Years ago, Gertrude Stein was asked why she

[6] Olga Samaroff Stokowski, *The Layman's Music Book*, p. 36.

bought the pictures of the then unknown artist Picasso. "I like to look at them," said Miss Stein. After all, what can you do with a picture except to look at it? A painting is something to be looked at; a poem or a piece of music is to be heard. Many of the people who say they do not like poetry have never heard it; they read a poem as they would a stock market report or a telephone directory.

It is interesting and valuable to learn about any work, to know what the critics have said or what were the conditions under which it was produced. But unless one knows the work itself, has experience of it, he knows little. The first and last demand of art is *experience*.

It is because of this physical appeal of art that we like to dwell on individual works. We look at a painting or a statue though we have seen it a thousand times. We drive a block out of the way every morning to see a building we admire. We continue to get pleasure from looking at Queen Nefertiti even though we have known this statue for years. We wear out a record playing a favorite piece of music over and over, and if we are alone or among friends we hum bits of it. When we have heard a poignant melody, even casually, as we may hear the love theme from Franco Zeffirelli's film *Romeo and Juliet* or the theme from Mozart's *Twenty-first Concerto* used in Bo Widerberg's film *Elvira Madigan,* we may be humming it not only all the next day but for a long time after that. Many people quote poetry to themselves and to others, although this custom of a slower and gentler time has tended to fall into disuse. And it is not at all uncommon, even today, to quote lines from, say, Shakespeare to make a point:

All the world's a stage
And all the men and women merely players . . .

Some people will automatically convert a real-life situation into an occasion for quoting something "appropriate." A personal setback may evoke Shakespeare's sonnet beginning "When in disgrace with fortune and men's eyes . . ." And of course poetry is still, as ever, a source for expressions of love. For several generations lovers have cherished Elizabeth Barrett Browning's sonnet beginning

How do I love thee?
Let me count the ways . . .

Young people of today are more apt to use songs as quotations or as love references; everyone is familiar with the old cliché "They're playing our song."

The scientist has no such love for the manner in which a scientific idea is expressed. He does not walk down the street repeating happily to

himself, "The square of the hypotenuse is equal to the sum of the squares of the other two sides," or "The distance of the sun from the earth is some ninety millions of miles." Such ideas may be and are just as exciting as those of poetry, but the idea and the words are not the same; to the scientist the physical presentation of an idea is not important. To the poet the idea and the words are the same. Change a word and you have changed the poem. It is this quality of experience that the American poet Archibald MacLeish must have had in mind when he said:

A poem should not mean
But be.[7]

All of the arts *are* more truly than they *mean.*

Before leaving this discussion we may note two characteristics of experience. First, the experience of art is personal and individual; it depends on what you are, what you have inside you. In the last analysis your experience will not be exactly the same as that of any other person. Do not expect to agree with everyone; all you can do is to be honest and straightforward.

Second, every artistic experience is accompanied by some emotion, or emotional reaction. You like it or you do not like it. As you react, you think it is "wonderful," "frustrating," "fine"; or you say, "Lord, what fools these mortals be!" Your feeling may be changed markedly when you have closer acquaintance with that work or artist, but there is always some feeling that is a part of the experience.

One of the most instructive aspects of experiencing works of art has to do with new types of art, which genuinely baffle many observers, even those who really want to appreciate them. A recent, and very telling, instance was the abstract expressionist movement of the late 1940s and the 1950s (for example, see Figures 1-7 and 2-23). The early exhibitions by Jackson Pollock, Willem de Kooning, Franz Kline, Robert Motherwell, and others were a disconcerting experience to many people. They simply did not understand the art and were generally told something like "You have to *feel* it'—a notion that many took to be an evasion or intellectual snobbery. The fact is, however, that repetition of exposure to such art, together with a receptive attitude, *has* resulted for many in greater understanding and enjoyment.

ART AND NATURE

Many books have been written about art, and many learned theories have attempted to explain it. Some of these are good, some are poor; sometimes they agree, often they disagree. But on one point there is universal

[7] Concluding lines of "Ars Poetica," from *Poems 1924–1935* by Archibald MacLeish. Used by permission of Houghton Mifflin Company.

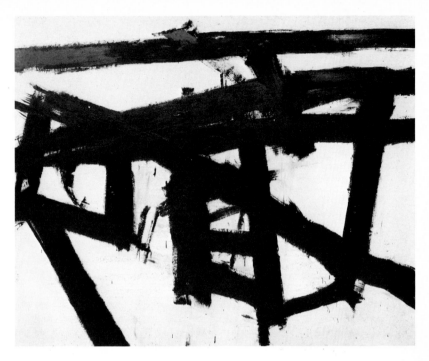

Figure 1-7. *Franz Kline (1910–), American painter. Mahoning (1956). (Oil on canvas, 80 by 100 inches. Gift of the Friends of the Whitney Museum of American Art. Photograph by Geoffrey Clements.)*

agreement. Art is *not* nature. Art is made by man. Art and nature are opposites. What is art is not nature; what is nature is not art.

There is a story that a woman looking at a painting by Matisse said, "I never saw a woman look like that!" and Matisse replied, "Madam, that is not a woman; that is a painting." A woman must be looked at as a woman, and a painting as a painting. In the final scene of *Hamlet* the dying hero enjoins his friend Horatio:

If thou didst ever hold me in thy heart,
Absent thee from felicity a while
And in this harsh world draw thy breath in pain
To tell my story.

No dying man ever said such a thing.

Art is made by man, and no matter how close it is to nature, it always shows that it was made by man. Therefore we have a right to ask of any work of art: Why did the artist make it? What did he want to show? What experience was he trying to make clear? What had intrigued him so much that he wanted to share it with others?

As children, probably most of us thought an artist learned how to paint very much as other people learned to sew on buttons, to drive a car, or to write on a typewriter. We supposed that when the artist found a scene he wanted to paint, he sat down and painted it. In this view the artist was a kind of human camera to reproduce a scene. Poetry and music seemed as easy, if one "knew how" to write them. The artist needed only

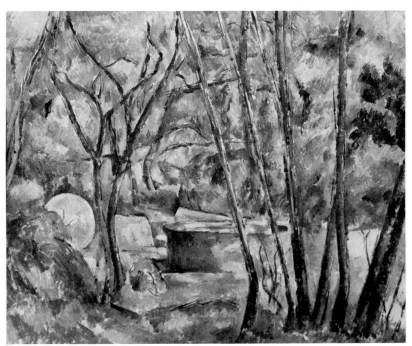

Figure 1-8. Paul Cézanne (1839–1906), French painter. Well and Grinding Wheel in the Forest of the Château Noir (1895–1900). (Oil. Size: 25½ by 31½ inches. Merion, Pa., Barnes Foundation.)

Figure 1-9. Photograph of location of Well and Grinding Wheel, Figure 1-8. (Courtesy of Erle Loran, Cézanne's Composition, University of California Press.)

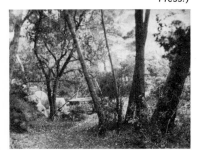

to find words to rhyme or notes to form melodies, and that was all. Such a view is, of course, nonsense.

The artist sees or learns something that impresses him, he wants to put it into some form so that others may understand it too, and he starts to make a picture, a poem, or a piece of music according to his present inspiration and his previous training. He does not worry much about beauty, but he wants desperately to get it "right," to have it express just the point he has in mind.

Suppose, for instance, a poet is feeling the intoxication and freshness of spring, the very first day of spring, "just spring." The children are all on fire with the new life of the day. They are so eager they can't take time to say Betty and Isabel or Eddie and Bill; instead, the words come rushing out all run together, *bettyandisbel, eddieandbill.* And all this is tied up in the poet's mind with the little old balloon man who is lame, "goat-footed" like a satyr, and whose whistle can be heard "far and wee." To express all that, the poet has only words on paper; he cannot even use voice or hands! No wonder he can't write as people do ordinarily. No wonder his words spill here and there over the page. No wonder he makes up new words—*puddle-wonderful, mud-luscious*—and spaces the words *far and wee* to try to make clear the faint sound of the whistle when it is first heard, and then the way the sound dies away in the distance. And when E. E. Cummings has finished, we feel he has captured the right flavor of the day.

in Just-
spring when the world is mud-
luscious the little
lame balloonman

whistles far and wee

and eddieandbill come
running from marbles and
piracies and it's
spring

when the world is puddle-wonderful

the queer
old balloonman whistles
far and wee
and bettyandisbel come dancing

from hop-scotch and jump-rope and

it's
spring
and
 the

 goat-footed

balloonMan whistles
far
and
wee

—E. E. Cummings (1894–1962, American poet),
 "In Just-spring"[8]

Cézanne painted a landscape which he called *Well and Grinding Wheel in the Forest of the Château Noir* (shown in Figure 1-8). It looks very much like scenes we have observed, and we would say Cézanne had copied nature. However, we have a photograph of the exact scene (Figure 1-9), and we are able to compare the actual appearance of the landscape with Cézanne's version. First we notice the amount of detail. Cézanne gains unity by paying no attention to the textures of the trees, the grass, or the stones; he paints them all in similar fashion. Next is the arrangement. In the painting the trees on the right are smaller, and there are more of them. The well and the grinding wheel in the center are made larger and more important. The path to the well is left out. And while he has kept the curling branches of the trees on the left, Cézanne has made them into a curved pattern which draws the eye to the trees on the right,

[8] From *Poems 1923–1954*, Harcourt, Brace and Company, Inc. Copyright 1923, 1926, 1944, 1951, 1954 by E. E. Cummings.

and with them makes a circular movement which encloses the entire design. In the painting, also, the contrasts between light and dark are made much less pronounced than in the photograph. In the painting we see what Cézanne has done with the landscape, or we see Cézanne's reaction to the landscape. He has changed details from the way they were in nature, and by doing so he has made a design that we want to look at and study. By his deliberate changes the painter has created a new artistic reality in which the various elements are more closely related to each other both intellectually and visually, creating at the same time a new kind of tight space as the elements come forward. It is not nature, but art.

OUR PERCEPTION OF THE WORLD

When we say that art is not nature and that we should not expect to find in art exactly what we find in nature, we assume that all of us see the same things in nature and that our vision is accurate. But only a little study proves the opposite. We may look first at the statue of a bull that was found in front of an ancient Assyrian palace (shown in Figure 1-10); it is usually referred to as the "Guardian of the Palace." He is an important animal, large and stately, a very realistic bull. He should be capable of guarding anything that needed to be guarded. But if you look carefully, you can see that this bull is not like nature: he has five legs. There are four on the side, as you would see them if you were looking at him from the side. But come around in front; if you meet a quiet bull head-on, you expect to see two legs; one leg would look queer by itself, and so another leg was added.

Or turn to the Egyptians. We are all familiar with the Egyptian paintings of men and women, with their thin straight bodies, stiff but graceful (Figure 1-11). We like them, but they do not follow nature. We notice first the eyes. If you look straight at a person's face, you see his eyes roughly as oval. If you look at a face in profile, the shape is entirely different. But when drawing a face the Egyptians made the head in profile with the eyes as of a full face. Moreover, the body was presented facing you, but the arms and legs were in profile. In those cases the artists were, of course, as were the makers of the Assyrian bull, portraying what they knew, what they thought of as the total appearance instead of the actual look of things.

We have come to accept such distortion when we are familiar with it through tradition, as with Egyptian figures. But when a new artist distorts, then he is likely to arouse ridicule or anger. The early works of Beethoven were thought to be the ravings of an upstart, and the orchestras of Wagner's time protested that his scores could not be played. The twelve-tone works of the composer Alban Berg, dating from the 1920s and 1930s, were greeted with violent protests because the twelve-tone scale was such a startling departure from the traditional seven-tone scale; it produced a music that sounded "unnatural."

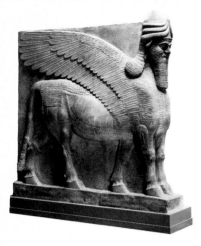

Figure 1-10. Winged Bull with Five Legs (*ninth century* B.C.), *from the Palace of Ashurnasirpal II.* (*Limestone. Height: 11½ feet. New York, Metropolitan Museum of Art; gift of John D. Rockefeller, Jr., 1932.*)

Figure 1-11. Nekaühor and His Namesake Son, *false door (detail) from offering chamber in tomb of Nekaühor. Egyptian, Fifth Dynasty (ca. 2500 B.C.).* (*Limestone, painted relief. New York, Metropolitan Museum of Art, Rogers Fund, 1908.*)

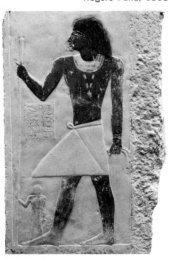

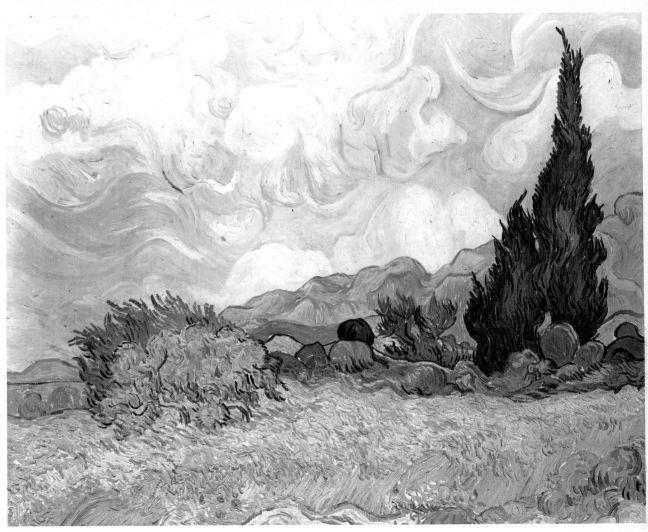

Figure 1-12. Vincent Van Gogh (1853–1890), Dutch painter, etcher, and lithographer. Landscape with Cypresses (1889). (Oil on canvas. Size: 28½ by 35¾ inches. London, The Tate Gallery.)

We are all inclined to see and hear only what we know is there, what we have been taught to see and hear. The artist opens our eyes and ears so that we can see the world more clearly. Through the artist, we open our eyes and ears to new visions of life. And it is amazing how quickly we do learn to see what the artist is trying to show us. A few years ago, students looking at Van Gogh's *Landscape with Cypresses* (Figure 1-12) protested that nature never looked like that; now they sit back with general content: "Ah, Van Gogh's *Landscape with Cypresses!*" The revolutionary experiments of Picasso and Braque, known as "cubism," in which a simultaneous presentation is made of different aspects of a form, have by now become part of the common contemporary vocabulary of art (see Figure 2-13, page 28). Cubism, and its later variants, have found their way

into the industrial arts—advertising and packaging, for example—where we accept them without a second thought. The wide acceptance of even abstract expressionism, a still more radical movement, has already been mentioned. By the time the abstract expressionists were at work, however, the question of how far an artist should move from nature had given way to the question of his right to express himself however he wished. Since World War II the various movements that have evolved—such as hard-edge painting, color-field painting, pop art, op art, minimal art, and impossible art—have seldom been practised with great fidelity to nature.

SUMMARY

The three basic assumptions of this study of the humanities are:

1. Art has been created by all people at all times; it lives because it is liked and enjoyed.
2. Art involves experience.
3. Art is not nature.

PART ONE
BACKGROUND

2. SUBJECT

What is the subject of the following two selections? The first is from the contemporary American poet Elizabeth Bishop; the second is from one of the leading modern American novelists, Saul Bellow.

Think of the storm roaming the sky uneasily
Like a dog looking for a place to sleep in,
listen to it growling.

Think how they must look now, the mangrove keys
lying out there unresponsive to the lightning
in dark coarse-fibred families . . .
> —Elizabeth Bishop (1911– , American poet),
> "Little Exercise"[1]

Hard work? No, it wasn't really so hard. He wasn't used to walking and stair-climbing, but the physical difficulty of his new job was not what George Grebe felt most. He was delivering relief checks in the Negro district, and although he was a native Chicagoan this was not a part of the city he knew much about—it needed a depression to introduce him to it. . . . He could find the streets and numbers, but the clients were not where they were supposed to be. . . .
> —Saul Bellow (1915– , American novelist),
> "Looking for Mr. Green"[2]

[1] From *Poems: North and South: A Cold Spring* (1955) in *Complete Poems* by *Elizabeth Bishop,* Farrar, Straus & Giroux, N.Y., 1955.
[2] From *Seize the Day,* by Saul Bellow, The Viking Press, Inc., 1951, "Looking for Mr. Green" (1968).

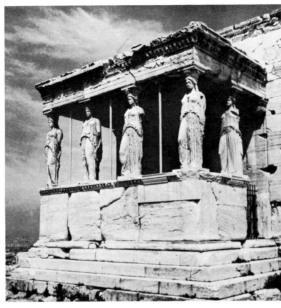

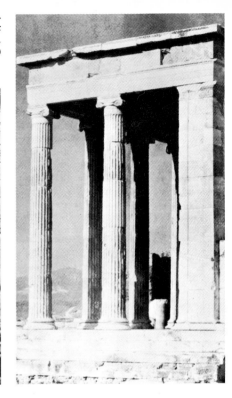

Figure 2-1. Erectheum, Porch of the Maidens *(420–393 B.C.). (Pentelic marble. Height of each carytid: 7 feet, 9 inches. Athens, Acropolis. Photograph, Royal Greek Embassy.)*

WHAT IS SUBJECT?

Subject is the term used for whatever is represented in a work of art. In Cézanne's *Well and Grinding Wheel* (page 12) the subject is the landscape. In the poem quoted above the subject is a storm; in the prose selection the subject is a welfare investigator looking for his clients. Each of the caryatids (columns sculptured in human shape) on the famous Porch of the Maidens on the Erechtheum (Figure 2-1) represents a young woman. The short piano composition by Ravel called *The Fountain* shows the rise and fall of the water in a fountain. In brief, the subject of a work of art answers the question: What is it about?

Not all arts have subjects. Those arts without subject are called "non-objective"; they do not represent anything. They are what they are without reference to anything in the natural world. The caryatids of the Erechtheum represent maidens, but the other columns of the building do not represent anything at all. The columns of the North Porch (shown in Figure 2-2) are tall, graceful, and very beautiful, but they do not imitate or represent anything. Bach's cantata *Christ Lag in Todesbanden* has a subject, as the title indicates—"Christ Lay in the Bonds of Death"—but his "Brandenburg" Concertos do not have a subject. Subject is not essential to art.

SUBJECT IN THE ARTS

Not only do some works of art have subject while others do not, but in the matter of subject we find characteristic differences between one art and another. Architecture, for example, is essentially an art which is not representational. Occasionally we will see buildings made to look like ice cream freezers or coffeepots, if they are used for selling ice cream or coffee, but they are recognized as freakish examples, and fortunately they are rare. A building is constructed for a certain purpose (a home, a factory, an office); and it may be in a definite style (classical, Gothic, Romanesque); but usually it has no subject. A building may, however, show details that are representational, as we saw in the Erechtheum, although as a whole it has no subject.

If architecture is the art where subject is least common, literature is the one where it is most common. When we read words we expect them to be *about* something. There are so-called poems and bits of prose which have no subject, but they are rare. So important is subject in literature that we usually name any piece of writing by its content: "a novel of adventure," "a psychological novel," "a literary essay," "a poem about nature."

Traditional sculpture and painting usually have subject. In looking at a painting or a statue, we expect to recognize the subject, to know what it is about: a man, a horse, a landscape. And as in literature, painting and sculpture are classified according to subject. Paintings are identified as, for example, landscapes, seascapes, portraits, figure paintings, paintings of animals. Statues are classified as portraits, single or group figures, animals, etc.

There is, however, a great deal of sculpture and painting without subject. The sculptor or the painter, like the architect, may make a design which is interesting in itself and which expresses his idea though it has no subject. Examples of this type of art are Henry Moore's *Two Forms* (Figure 2-3) and Pieter Mondrian's *Composition with Blue and White* (Figure 2-4). In works such as these the artists do not expect the critic to imagine any specific subject. Yet the Moore sculpture does suggest the ideas of birth and growth, of two nonspecific forms related to each other.

Figure 2-3. Henry Moore (1898–), British sculptor. Two Forms (1934). (Pynkado wood. Height: 11 inches. New York, Museum of Modern Art; gift of Sir Michael Sadler. Photograph, Soichi Sunami.)

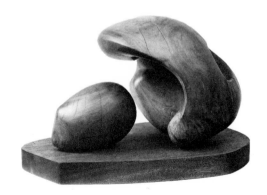

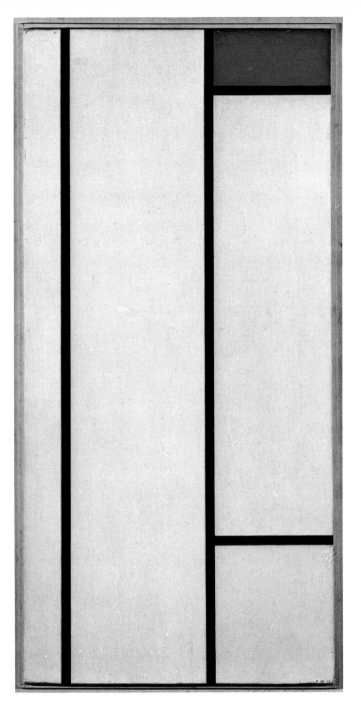

Even the Mondrian can perhaps be related to some stimulus form and color which the artist reduced to the final, completely nonobjective forms we see here. In still more extreme forms of contemporary expression—such as the "minimal art" of Tony Smith, where there is only the slightest relationship to outside reality (Figure 2-5), the artist is trying to express only a sensation of form.

Of the combined arts, theater and opera always have subjects; dance may or may not have subject. The minor arts, such as textiles, metalwork, and pottery, sometimes have subject and sometimes do not; in these arts the subject is often a matter of indifference. One may eat with a spoon for months without ever noticing whether the design on the handle represents grapes or roses, or whether it has any subject. Even in wallpaper and dress materials, where the design is more conspicuous, subject is of little importance. Choice is often made on the basis of design and color rather than subject.

Music occupies a position about halfway between literature and architecture. A great deal of music has no subject: the sonata, the etude, the symphony, etc. On the other hand, much music has subject; we have already mentioned *The Fountain* and *Christ Lag in Todesbanden.* Music without subject is called *"absolute music"*; music with subject is called *"program music."*

Sometimes a distinction is made between program music which actually imitates the subject and that which merely sets the mood and suggests the story or picture the composer had in mind. *The Fountain* obviously belongs to the former group: it imitates the motion of the fountain, its ceaseless flow, its constant change, and its monotony. An example of the latter group is the composition called *Pictures at an Exhibition.* As the title indicates, Moussorgsky represents himself as visiting an art exhibit and looking at one picture after another. There are eleven pictures, with such different subjects as "The Old Castle," "Children in the Tuileries Gardens," and "Two Polish Jews." There is also a theme which represents the artist walking from one picture to the next. In this composition Moussorgsky tries to give the mood of each picture—romantic or gay, comic or quarrelsome—but he does not imitate the subject itself.

Figure 2-5. *Tony Smith (1912–), American sculptor.* Free Ride *(1962). (Steel. Size: 6 feet 8 inches by 6 feet 8 inches. New York, Collection of the artist; Fourcade, Droll, Inc.)*

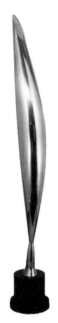

Figure 2-6. Constantin Brancusi (1876–1957), Roumanian sculptor. Bird in Space (1925). (Polished bronze, marble and oak base. Height: 50¼ inches. Philadelphia Museum of Art, The Louise and Walter Arensberg Collection. Photograph, A. J. Wyatt, staff photographer.)

Music is unique among the arts in that it cannot make its subject clear. Even when the music is definitely imitative, as in Rimsky-Korsakov's *Flight of the Bumblebee*, the subject is not always clear. If the music is played with no clue to the subject given, many people will not recognize what it is about. One person, hearing the piece about the bumblebee, realized that the music had subject, but decided that it represented a blizzard.

WAYS OF PRESENTING THE SUBJECT

Realism, Abstraction

REALISM As we have said, no art is ever like nature. Even when the artist chooses a subject from nature, he changes, selects, and arranges details to express the idea he wants to make clear. Often the presentation of details and the organization of them in the work are so nearly obvious, and seem so natural, that we do not notice that the work is not like nature, as in Cézanne's *Well and Grinding Wheel*. When this is the case, we say the work is "realistic." The *Portrait of Oriel Ross*, by Jacob Epstein (Figure 1-6, page 7), is very real in its actual presence, in the way it convinces us of its physical existence. Another level of reality may be seen in the Italian Renaissance painting by Domenico Ghirlandajo, *Old Man and Boy* (Figure 2-24, page 41) or in Jan van Eyck's *Annunciation* (Figure 9-8, page 168), where the artists have utilized very detailed elements from nature, photographic touches that bring us closer to nature itself. Such works we call "naturalistic" rather than realistic.

ABSTRACTION Abstraction is another way of presenting a subject. Sometimes an artist becomes so interested in one phase of a scene or a situation that he does not show the subject at all as an objective reality, but only his idea of it, or his feeling about it. For example, Brancusi is impressed by the grace of a bird in flight, by the sweep of its body as it flies through the air, so he tries to represent those qualities in his statue *Bird in Space* (Figure 2-6). It does not look like a bird, and it is not supposed to look like a bird. It is supposed to convey an impression of a bird's grace and speed.

Mondrian has a painting which he calls *Broadway Boogie-Woogie* (Figure 2-8, page 26). Again, it does not look like Broadway, or boogie-woogie, yet it suggests characteristics of several things we associate with the dance: the perforated roll of the mechanical player piano, monotony of beat, strong accent, improvisation, and the bright lights of the city. Probably no one could recognize the subject by himself, but once it has been suggested, we can see the connection. This painting looks very much like the Mondrian painting we saw earlier, *Composition with Blue and White*. But that had no apparent subject, and this has. Both types are commonly called *abstract*; for the one without subject, however, a more exact term is *nonobjective*.

Between abstraction and realism there are many ways of presenting the subject. Henry Moore's *Reclining Figure* (Figure 2-7) is fairly close to an abstraction; El Greco's *Resurrection* (shown in Figure 2-9), on the other hand, is close to realism. As in many of El Greco's paintings, the bodies are unnaturally long. El Greco was illustrating that part of the Creed which says of Christ that he "was crucified, died, and was buried. He descended into hell. The third day he rose again from the dead." In his picture El Greco wanted the body of Christ to rise, and it does seem to rise from the mass of writhing bodies around it. A body of normal size would have seemed dumpy, stodgy, and still. For works, like the El Greco (or like the Van Gogh shown in Figure 1-12, page 15), which are close to realism, the term *expressionist* has been used, and for works that approach abstraction, like Moore's *Reclining Figure,* the term *organic* is sometimes used. The use of these or other terms, however, is unimportant. It is important to realize that each artist presents his subject in accordance with his idea of that subject. Often one artist will use different ways of presenting a subject. For instance, Picasso's *Old Guitarist* (Figure 2-10) seems more distorted when compared with his realistic *Blue Boy* (Figure 2-11) than when compared with *Fernande* (Figure 2-12). And *Fernande* seems almost realistic when put by the side of *Ma Jolie* (Figure 2-13), in which the woman has disappeared into a series of straight-edged, transparent planes which overlap and penetrate each other in the typical cubist fashion.

Since the subject often would not be known without the title, question is often raised about giving a name to a picture or a musical composition if it in no way bears any likeness to the object named. Would it not be better to consider all such works nonobjective? Probably not. The title usually helps one to understand what the artist had in mind. In some

Figure 2-7. Henry Moore (1898–), British sculptor. Reclining Figure (ca. 1935). (*Elm wood. Dimensions: 19 inches high, 35 inches long, 17¼ inches wide. Buffalo, N.Y., Albright-Knox Art Gallery; room of Contemporary Art Collection.*)

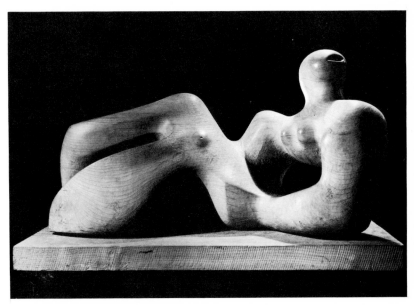

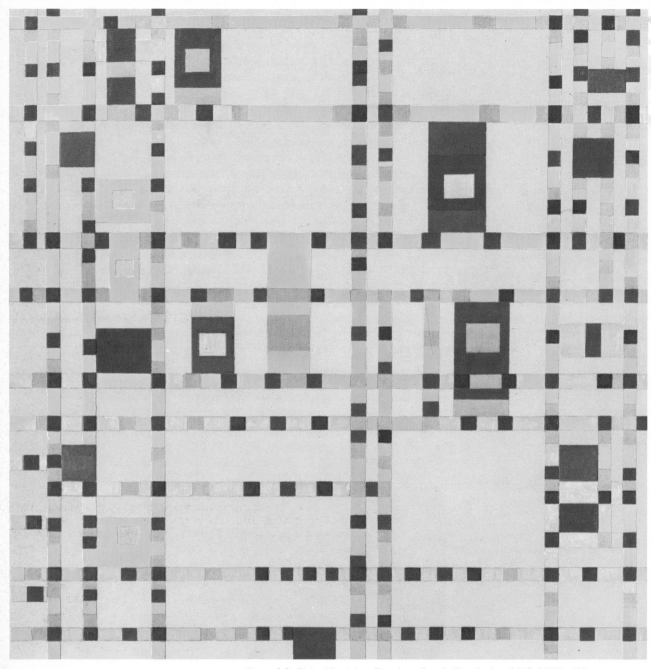

Figure 2-8. Pieter Mondrian. Broadway Boogie-Woogie (ca. 1942–1943). (Oil on canvas. Size: 50 by 50 inches. New York, Museum of Modern Art.)

BACKGROUND

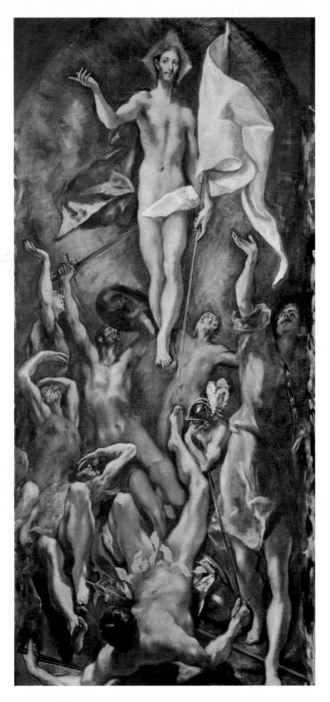

Figure 2-9. El Greco (1541–1614), Spanish painter. Resurrection (ca. 1597–1604). (Oil on canvas. Size: 108¼ by 50 inches. Madrid, Prado. Photograph by Alinari.)

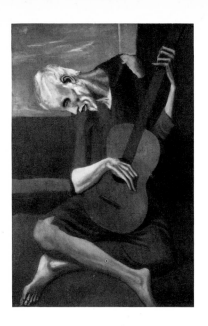

Figure 2-10. Pablo Picasso (1881–). Spanish painter. The Old Guitarist (1903). (Oil on wood. Size: 47¾ by 32½ inches. Chicago, Art Institute of Chicago; Helen Birch Bartlett Memorial Collection.)

Figure 2-11. Pablo Picasso. Blue Boy (1905). (Gouache. Size: 40 by 22½ inches. New York, Museum of Modern Art; collection of Mr. and Mrs. Edward M. M. Warburg.)

Figure 2-12. Pablo Picasso. Fernande (1909). (Oil on canvas. Size: 24¼ by 16¾ inches. New York, collection of Mrs. Henry H. Church. Photograph, Museum of Modern Art.)

Figure 2-13. Pablo Picasso. Ma Jolie (Woman with a Guitar) (1911–1912). (Oil on canvas. Size: 39⅜ by 25¾ inches. New York, Museum of Modern Art; acquired through the Lillie P. Bliss Bequest.)

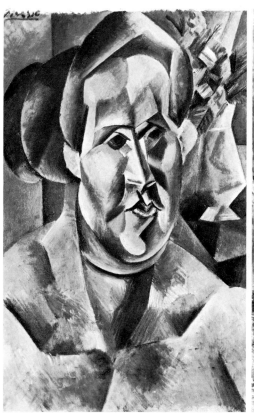

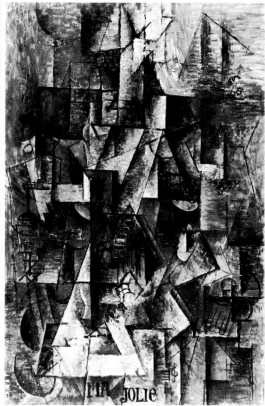

cases, as in Brancusi's *Bird in Space,* Honegger's *Pacific 231,* or Ravel's *Fountain,* the name offers a real explanation of the artist's purpose and idea. In others, as in Picasso's *Ma Jolie* or Moussorgsky's *Pictures at an Exhibition,* the title gives the source for the original inspiration.

The Symbol

A symbol may be roughly defined as something that stands for or suggests something else. It is a kind of shorthand whereby long or complicated facts or ideas may be expressed in a short time or space. At its simplest it is only a sign which by common agreement has a definite meaning. On the highway, red means "stop" and green means "go." The bands on the sleeve of a railway conductor indicate how long he has been in the service of the company. Stars, bars, and eagles indicate rank in the army. Words and notes on the printed page are symbols. All such symbols are in reality only signs and can be changed at will. Red could be made to mean "go" and green "stop." We have in recent years made attempts to change spelling and have succeeded in a few cases.

On the stage, signs are often given to convey some detail or some element of the story. In Ibsen's play *A Doll's House,* we learn that it is Christmas when men come in with a Christmas tree, and one of the characters announces his coming death by presenting a calling card with a black cross on it.

Time, "Father Time," is usually represented as an old man carrying a sickle. In sonnet 116 Shakespeare uses this symbol to emphasize the triumph of love over time:

Love's not Time's fool, though rosy lips and cheeks
Within his bending sickle's compass come.

Mercury (shown in Figure 2-14), messenger of the gods, may usually be identified by his winged sandals, his staff entwined with snakes (caduceus), and his winged hat (petasos). The caduceus had magical powers over sleeping, waking, and dreaming, and so became identified with healing. It is now the symbol of the medical profession and of the Army Medical Corps. Bacchus, the god of wine, is usually portrayed with grapes or grape leaves. In the vase painting by Execias, *Dionysus Sailing the Sea* (shown in Figure 2-15), we recognize Bacchus (Dionysus) by the grapes and grape leaves which fill the upper part of the picture. The story is that one day while he was asleep, Bacchus was taken aboard a ship by some sailors who wished to sell him into slavery. Waking, the god asked them to take him to Naxos. When they refused, vines laden with grapes grew up around the mast, and the mariners were changed into dolphins.

There are many symbols of the Christian church: Peter is represented with a key because of Christ's saying that he gave Peter the keys of the kingdom of heaven (Matthew 16:19). Paul is often represented as a bald

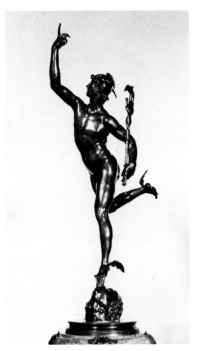

Figure 2-14. Adriaen De Vries (attributed to). Mercury (ca. 1574). (Bronze. Height: 5 feet, 9 inches. Washington, D.C., National Gallery of Art; Mellon Collection.)

old man carrying a sword. The symbols of the four Evangelists Matthew, Mark, Luke, and John were commonly used in the Middle Ages and are frequently found today: Matthew is symbolized as a winged man, Mark a winged lion, Luke a winged ox, and John an eagle. We see these in a characteristic setting in the tympanum—the curved space above the door —of the cathedral at Chartres (Figure 14-24, page 298).

There are also private symbols in art; often only the artist knows what a private symbol represents. The parables of the New Testament are such symbols; the disciples often had to ask Jesus to explain them, as in this case:

Behold, a sower went forth to sow. And when he sowed, some seeds fell by the wayside, and the fowls came and devoured them up: Some fell upon stony places, where they had not much earth: and forthwith they sprung up, because they had no deepness of earth: And when the sun was up, they were scorched; and because they had no root, they withered away. And some fell among thorns; and the thorns sprung up, and choked them. But other fell into good ground, and brought forth fruit, some an hundredfold, some sixtyfold, some thirtyfold.
　　　　—Matthew 13:3–8

Sometimes one is not certain whether a symbol is intended, as in Frost's poem:

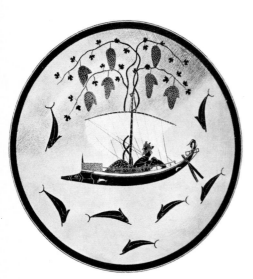

Figure 2-15. Execias (6th cent.), Greek vase painter. Dionysus Sailing the Sea (550–525 B.C.). (Black on red pottery. Diameter: 14½ inches. Munich, Antikensammlungen.)

Whose woods these are I think I know.
His house is in the village though;
He will not see me stopping here
To watch his woods fill up with snow.

My little horse must think it queer
To stop without a farmhouse near
Between the woods and frozen lake
The darkest evening of the year.

He gives his harness bells a shake
To ask if there is some mistake.
The only other sound's the sweep
Of easy wind and downy flake.

The woods are lovely, dark and deep,
But I have promises to keep,
And miles to go before I sleep,
And miles to go before I sleep.
　　　—Robert Frost (1875–1963, American poet),
　　　　　"Stopping by Woods on a Snowy Evening" (1923)[3]

This poem offers no obvious difficulties; the images are clear-cut, and the sense is clear. The poet stops to admire the scene in the snow, but he does

[3] From *Complete Poems of Robert Frost*, 1949. Copyright 1923, 1949, by Henry Holt and Company, Inc.

not pause very long because he has made promises he must keep, and he has still a long way to go. But is this all? One wonders if that is all the poem has to say, if there is not a meaning hidden in the seemingly simple lines. When Frost says:

But I have promises to keep,
And miles to go before I sleep,

does he have in mind just the trip home? Or does that seemingly simple statement stand for something else? When he says "before I sleep," does he really mean "before I die"? When he speaks of "promises to keep," is he thinking of work that he has set out to do? Does he refer to responsibilities that he must meet before he dies? There is nothing in the poem that says there is such a meaning, but most of us find this kind of meaning nevertheless. And if we do, we decide that the poem is symbolic.

In Sandburg's "Grass," the grass that covers all is clearly a symbol; the poem means more than that grass grows on battlefields:

Pile the bodies high at Austerlitz and Waterloo.
Shovel them under and let me work—
I am the grass; I cover all.

And pile them high at Gettysburg
And pile them high at Ypres and Verdun.
Shovel them under and let me work.
Two years, ten years, and passengers ask the conductor:
What place is this?
Where are we now?

I am the grass,
Let me work.

> —Carl Sandburg (1878–1967, American poet),
> "Grass" (1918)[4]

The grass in this poem symbolizes time, oblivion, men's forgetfulness of the sacrifices of soldiers. A somewhat similar symbolism is used by the contemporary American Robert Lowell, in *For the Union Dead* (1964). The symbolism here is much more complicated, however, and the theme is how values for which people die may be ignored by others:

". . . One morning last March
I pressed against the new barbed and galvanized

fence on the Boston Common. Behind their cage,
yellow dinosaur steamshovels were grunting
as they dropped up tons of mush and grass
to gouge their underworld garage . . .

[4] Reprinted from *Cornhuskers* by Carl Sandburg. Henry Holt and Company, Inc.

shaking over the excavations, as it faces Colonel Shaw
and his bell-cheeked Negro infantry
on St. Gaudens' shaking Civil War relief,
propped by a plank splint against the garage's earthquake. . .

Shaw's father wanted no monument
except the ditch,
where his son's body was thrown
and lost with his "niggers."

The Aquarium is gone. Everywhere,
giant-finned cars nose forward like fish;
a savage servility
slides by on grease."

—From *For the Union Dead* by Robert Lowell, © 1964, Farrar,
Straus & Giroux, N.Y.

Lowell's poem is somewhat more sharply focused than Sandburg's, which refers to the world and all time. Lowell, a Bostoner himself, is interested in the disrespect offered to the monument of an Abolitionist who led the first Negro regiment in the Civil War. Two months after they marched through Boston, this regiment had been cut in half; not only do people forget this, says Lowell, but they offer us a parking lot instead of the memory.

The great dramatists of the ancient Greeks, like Euripides, often go far beyond the tale itself to give their audience an interpretation of man's struggle against life, the gods, and his environment. Thus Medea, in the play of that name by Euripedes, becomes a symbol of womankind outraged, of jealousy so great (it drives her to the murder of her own children) that it transcends the emotion of any one woman.

In visual art we may see relatively clear symbols, as in Munch's expressionist painting *The Shriek* (Figure 2-21, page 37)—a comment on psychological dislocation—or Kandinsky's *Improvisation # 30*, which symbolizes a foreboding of World War I (Figure 2-20, page 36). We also may find more abstruse symbols, in such work as Beckmann's *Departure* (Figure 2-16). Here the much more private nature of the painter's expression necessitates some sort of translation by the critic. We may guess—and it is no more than a guess—that the side panels symbolize the tyranny of Nazism and the central panel the artist's liberation from it.

Dreams and the Subconscious

During the 1920s artists developed ways of presenting the subject that have to do with dreams and the subconscious. Under the influence of Freudian psychology, the subconscious has come to be recognized as important in human conduct, and naturally it has found expression in art.

Subjects of this sort attempt to show the inside of man's mind as well as the appearance of his outside world. They try to show thoughts and

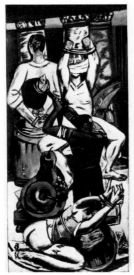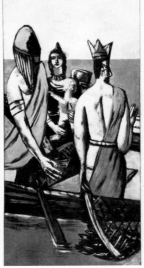

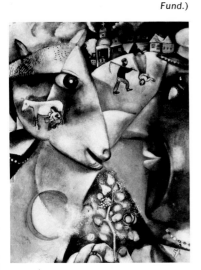

dreams that are not controlled by reason or any conscious order. The work which results is like its subject; it may be clear and vivid, but it is not necessarily logical. Events and people are put together in unrelated and therefore irrational combinations. The reality of such scenes can best be understood if one remembers his own thoughts and dreams; he finds himself taking part in actions under circumstances which probably have to do with his ordinary life, but which are combined in forms that are strange and irrational. Paintings of this kind belong to the type called "surrealism" —that is, "super" realism. Indeed, it seems that they have to be photographically "real" if their apparent illogicality is to be convincing.

Chagall's painting *I and My Village* (Figure 2-17) presents a rural scene. The two important characters are the man and the cow. Their faces are bound together in a circle and they look at each other with sympathy. The man holds a spray for the cow to eat. The cow is thinking of being milked, as we can tell from the small figures painted on her jaw. In the background are the other objects of the village—a workman with a scythe, a woman, and a row of the village houses—some of them right side up and some upside down. The cross at the top of the picture and the ring on the man's hand are symbols we recognize which help us to understand the man and the entire situation. Probably the most famous surrealist picture is *The Persistence of Memory*, by Salvador Dali (Figure 2-18). The four limp watches symbolize the relativity, flexibility, and destructibility of time.

In addition to this figurative and relatively naturalistic surrealism, there is another type known as "abstract" surrealism and represented by Joan Miró, Max Ernst, and Roberto Matta (Figure 2-19, page 34). The works of these artists have a less photographic character. Their playfulness —even absurdity—and deliberate lack of logic again suggest the dream world.

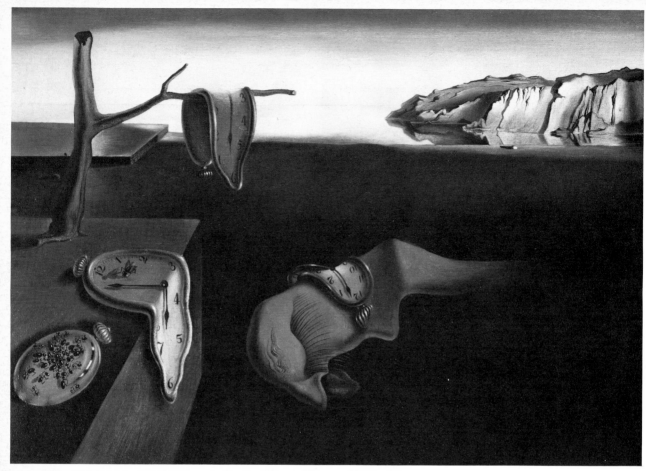

Figure 2-18. Salvador Dali (1904–). The Persistence of Memory (1931). (Oil on canvas. Size: 9½ by 13 inches. New York, Museum of Modern Art.)

Figure 2-19. Roberto Matta (1912–), Chilean painter. Fresco for UNESCO Building (Paris).

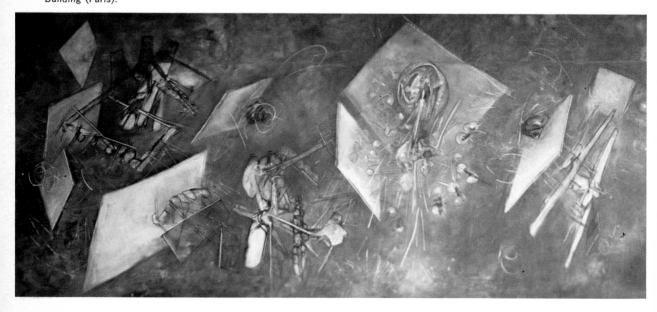

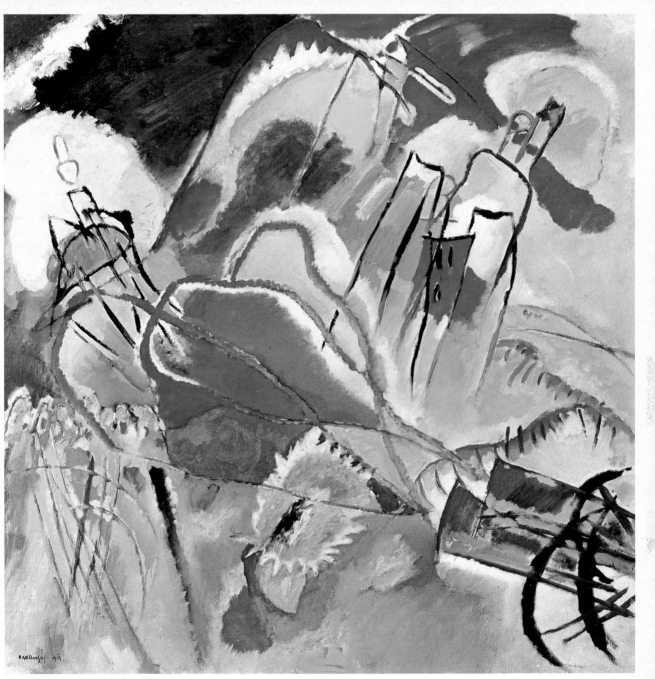

Figure 2-20. Vasily Kandinsky (1866–1944), Russian painter. *Improvisation #30 (Warlike Theme) (1913). (Oil on canvas. Size: 43¼ by 43¾ inches. Chicago, Art Institute of Chicago; Arthur Jerome Eddy Memorial Collection.)*

In literature, the desire to locate and hold the subconscious is found in the stream-of-consciousness novel, in which the author attempts to trap every thought or feeling that passes through the mind of a character. Time, naturally, becomes confused in the process. Joyce's *Ulysses* is one of the well-known examples; Proust's *Remembrance of Things Past* is perhaps even more celebrated. In poetry, surrealism can be felt in such a poem as Karl Shapiro's "Love for a Hand." Here the dream world is explicit, and every stanza contains some symbol of the relationship of the man to the woman. The figure of speech and the implications in the last words, "his hand eats hers," are a culmination of the mysterious atmosphere created by the light moving in the room, the ominous references to "little animals that prowl," and the image of drowning.

Two hands lie still, the hairy and the white,
And soon down ladders of reflected light
The sleepers climb in silence. Gradually
They separate on paths of long ago,
Each winding on his arm the unpleasant clew
That leads, live as a nerve, to memory.

But often, when too steep her dream descends,
Perhaps to the grotto where her father bends
To pick her up, the husband wakes as though
He had forgotten something in the house.
Motionless he eyes the room that glows
With the little animals of light that prowl

This way and that. Soft are the beasts of light
But softer still her hand that drifts so white
Upon the whiteness. How like a water plant
It floats upon the black canal of sleep,
Suspended upward from the distant deep
In pure achievement of its lovely want!

Quietly then he plucks it and it folds
And is again a hand, small as a child's.
He would revive it, but it barely stirs,
And so he carries it off a little way
And breaks it open gently. Now he can see
The sweetness of the fruit, his hand eats hers.
 —Karl Shapiro (1913– , American poet)[5]

In Visconti's film version (1971) of Mann's novel *Death in Venice,* the scene is sometimes the present and sometimes the past. When the main figure, a conductor, begins thinking about the past, it is acted out before him; then, just as in actual thought, time shifts back to the present. The conductor himself is seen both as a young man and an older one; his

[5] Copyright 1952 by Karl Shapiro. Reprinted from *Poems 1940–1953* by Karl Shapiro by permission of Random House, Inc. Originally appeared in *The New Yorker.*

BACKGROUND

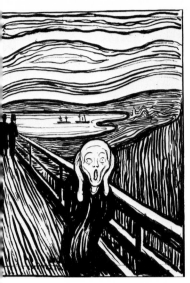

Figure 2-21. Edvard Munch (1863–1944), Norwegian painter and printmaker. The Shriek (1896). (Lithograph, 20⅝ by 16¹³⁄₁₆ inches. Collection, The Museum of Modern Art, New York. Matthew T. Mellon Fund.)

relationships with his wife and friends are not shown in terms of the "now" of the story but as they developed over the years and as part of the explanation for his illogical behavior of the fictional present. Narratives like this and like Joyce's and Proust's resemble surrealism because they break from the "normal" by jumping back and forth in time, and in their preoccupation with the workings of thought they naturally become involved with the role of the subconscious. But they should be distinguished from "surrealism" in the sense in which the term is applied to something like Dali's *Persistence of Memory*, which uses visual symbols, naturalistically portrayed, to indicate the reality hidden in the subconscious.

Analogous to the surrealist's attempt to discover "truth" in this way is the attempt of the expressionists to change the physical appearance of external reality. To this end they made violent use of color, form, and space. This is also an attempt to get at the essential truth which one sees inwardly and feels. The Norwegian Edvard Munch, who came to Germany at the end of the nineteenth century, became the spiritual and artistic inspiration of the expressionist movement. His lithograph *The Shriek* (shown in Figure 2-21) conveys a sense of terror through its omission of naturalistic details and its distortion and twisting of what it shows. Munch and the other expressionists change form, space, and color for the sake of expressiveness and emotionality.

A contemporary type of expressionism is known as *abstract expressionism*. In paintings of this school, the colors are slapped, dribbled, or sometimes thrown onto the canvas. The effects are at times accidental, but the artist feels that the creative act itself is a work of art. Kandinsky has many of the characteristics of this school (Figure 2-20), even in his earlier works, which already have a certain explosive force. The mature paintings of Kandinsky (see Figure 2-22, for example) clearly prefigure the endless motion of the abstract expressionist movement since the late 1940s, as seen in the works of Jackson Pollock (Figure 2-23) and others. The typical expressionist artist throws himself into the work, losing himself in its ceaseless motion and expressiveness.

BEAUTIFUL AND UGLY SUBJECTS OF ART

The last consideration in this chapter on subject has to do with the artist's choice of subject. What are fit subjects for art? Are there certain subjects that are not allowed in art? Almost instinctively, some will answer these questions by saying that the noble, the lovely, the beautiful, the distinguished, and the unusual are the proper subjects for art. *The Fountain* and the caryatids of the Erechtheum seem to have appropriate subjects for works of art, and usually one has something of this kind in mind when he calls a subject "artistic." By this same impulse, subjects that are ugly, undignified, or commonplace would not seem proper subjects for art.

Figure 2-22. Vasily Kandinsky. Light Picture, #188 (1913). (Oil on canvas, 30¾ by 39½ inches. The Solomon R. Guggenheim Museum.)

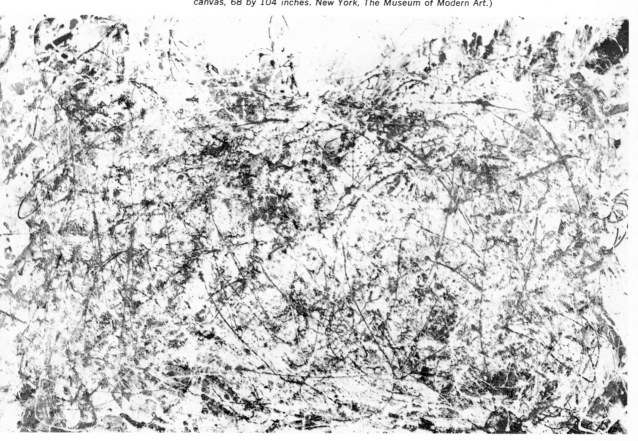

Figure 2-23. Jackson Pollock (1912–1956), American painter. No. 1, 1948. (Oil on canvas, 68 by 104 inches. New York, The Museum of Modern Art.)

But when one turns from theory to practice, this idea is not borne out. Some of us might turn away in disgust if we actually met the old man with a diseased nose painted by Ghirlandajo (*Old Man and Boy*, Figure 2-24). But the old man's concern for the boy and the boy's adoration of the man are so great that we forget the man is old and ugly.

Even far more specifically and violently "ugly" subjects—like Orozco's mural painting in the Governor's Palace at Guadalajara in Mexico (shown in Figure 2-25), where the great liberator of Mexico, Hidalgo y Costilla, sets the nation aflame with revolt and violence—may move us to pity, enthusiasm, and admiration as well as horror. Whatever reaction—or combination of reactions—we have, the result is a great experience. We can have such an experience from any violent confrontation artistically and dramatically presented. Actually, with works like this, the question of ugliness fades into the background. Only those who are committed to the cult of beauty for its own sake will object to what Orozco has shown.

Shakespeare has painted a very clear picture of winter in a short lyric in *Love's Labour's Lost*. The muddy roads, the greasy, sweaty cook, the nose "red and raw," are not beautiful details; yet this is one of the most charming moments in all of Shakespeare's writings, and very few moments in all literature leave us with an equal sense of winter's beauty.

When icicles hang by the wall
 And Dick the shepherd blows his nail
And Tom bears logs into the hall
 And milk comes frozen home in pail,
When blood is nipp'd and ways be foul,
Then nightly sings the staring owl,
 "Tu-whit; tu-who!"
 A merry note,
While greasy Joan doth keel the pot.

When all aloud the wind doth blow
 And coughing drowns the parson's saw
And birds sit brooding in the snow
 And Marian's nose looks red and raw,
When roasted crabs hiss in the bowl,
Then nightly sings the staring owl,
 "Tu-whit; tu-who!"
 A merry note,
While greasy Joan doth keel the pot.
 —William Shakespeare (1564–1616, British poet and dramatist),
 Love's Labour's Lost, V, ii, 922–938 (ca. 1590)

Emphatically, art is not limited to subjects that in themselves are beautiful or agreeable. The beautiful and the agreeable are subjects of art, but they are not the only ones. Any subject may be a subject of art. We may like in art what we do not like in nature, because we see the subject as it has been interpreted for us by the artist.

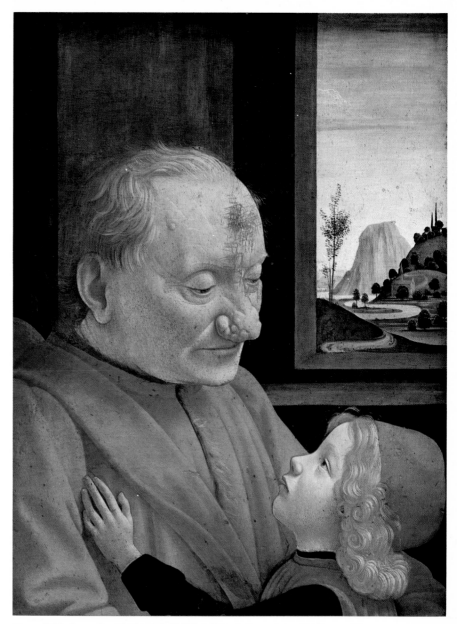

Figure 2-24. Domenico Ghirlandajo (1449–1494), Italian painter. Old Man and Boy (ca. 1480). (Oil on wood. Height: 2 feet, 3/8 inches. Paris, Louvre. Photograph by Alinari.)

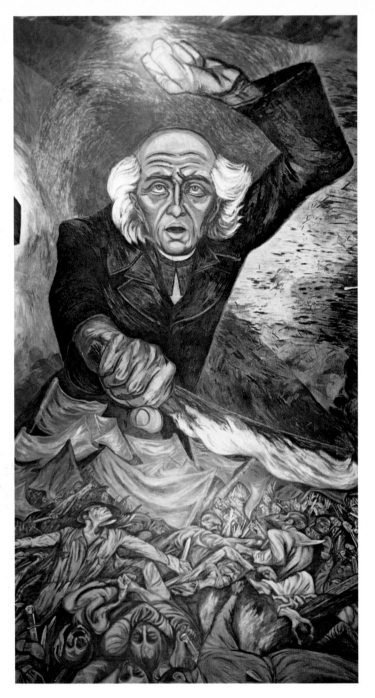

BACKGROUND

This last sentence answers the question of the relation of subject to *value* in a work of art. Does the choice of subject help to determine the final judgment as to whether a work may be counted good or bad, great or mediocre? Can we say that a work of art is good if it has a certain subject, and poor if it has another? A "beautiful" subject does not necessarily produce a good work of art, nor an "ugly" subject a poor one; a noble subject does not mean a noble work of art, nor an ignoble subject an ignoble work. The value of art does not lie in the subject but in what the artist does with his subject. The greatness of art comes not from the subject but from the artist. Thus a beautiful woman will not necessarily give us a great portrait nor a portrayal of God a noble result.

The Beckmann triptych (three-part painting) discussed above, *The Departure* (Figure 2-16, page 33), is in itself far from a beautiful or pleasant subject. But the result of the contrast between horror and release from horror, the serenity of the central panel as a symbol of man's overcoming the forces of fate, provides the spectator with a purging of the emotions. Daumier's *Rue Transnonain* is as shocking a subject as one could wish to find, but the subject has here become a source of great tragedy. The same is true of Picasso's *Guernica* (Figure 3-5, page 50).

In literature also there are moments of supreme brutality and horror which nevertheless constitute great art. Euripides' *Medea,* which we have already mentioned, is an example: a spiteful, brutal, and terrifying act is the occasion for supreme tragedy. Shakespeare's plays are filled with violence of various kinds, from the multiple deaths marking the end of *Hamlet* to the murders in *Macbeth* and the suicides in *Romeo and Juliet.* Yet each of these plays in its own way is a milestone in the history of the humanities, filled with noble sentiments and great imagery. In the works of contemporary dramatists like Beckett and Ionesco, the so-called "theater of the absurd," the interest is not in delineating noble sentiments but rather in demonstrating futility. What is shown may not be uplifting in the manner of older plays, but plays like *The Chairs* and *The Bald Soprano* by Ionesco or Beckett's *Waiting for Godot* have a great deal to say concerning the modern world and its problems, and they say it well.

3. SOURCES OF ART SUBJECTS

When I consider how my light is spent
Ere half my days in this dark world and wide,
And that one Talent which is death to hide
Lodged with me useless, though my soul more bent
To serve therewith my Maker, and present
My true account, lest He returning chide,
"Doth God exact day-labour, light denied?"
I fondly ask. But Patience, to prevent
That murmur, soon replies, "God doth not need
Either man's work or his own gifts. Who best
Bear his mild yoke, they serve him best. His state
Is kingly: thousands at his bidding speed,
And post o'er land and ocean without rest;
They also serve who only stand and wait."

 —John Milton (1608–1674, British poet and essayist),
 "On His Blindness" (ca. 1655)

The subjects used in art are usually clear and obvious. They need no explanation other than the work itself. Rimsky-Korsakov's bumblebee and Elizabeth Bishop's storm are self-explanatory. Cézanne gives the name of the forest in which he found the well and grinding wheel that attracted his attention, but it is of no real importance in our understanding of the picture. On the other hand, there are many works of art which depend for their understanding upon some knowledge of the subject. When Tchaikovsky

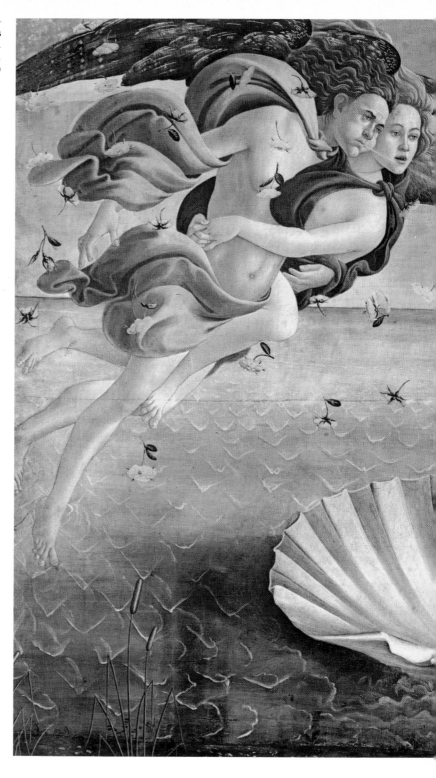

Figure 3-1. *Sandro Botticelli (1444– 1501), Italian painter.* Birth of Venus *(ca. 1485). (Tempera on canvas. Height: 5 feet, 3¼ inches. Florence, Uffizi. Photograph by Alinari.)*

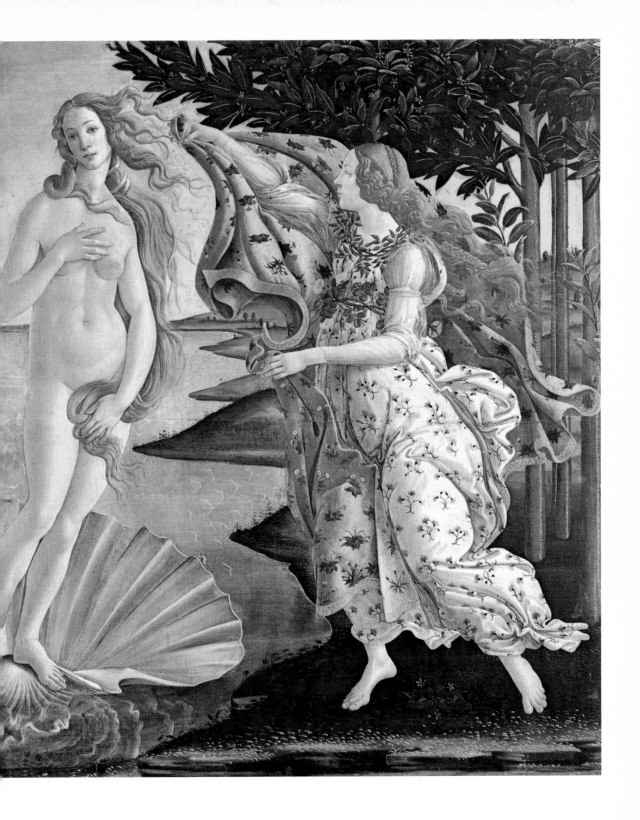

Figure 3-2. Michelangelo (1475–1564), Italian painter, sculptor, architect, and poet. David (1501–1503). (Marble. Height: 18 feet. Florence, Academy. Photograph by Alinari.)

calls his suite *"Romeo and Juliet,"* he takes it for granted that we know the story of Shakespeare's young lovers.

Milton's sonnet "On His Blindness" tells the facts essential for an understanding of the poem: that the poet lost his eyesight when he felt his greatest work lay before him, and that through this experience he learned patience and submission to the will of God. However, one understands the poem better and enjoys it more if he knows, even vaguely, the story of the poet's life. Milton lost his sight in the service of his country before he had written the great poem which he had always wanted to write and which he knew he could write, the poem he did write later in spite of his blindness, *Paradise Lost.*

Similarly, anyone can see that Michelangelo's *David* (shown in Figure 3-2) is a statue of a young man, a very beautiful young man with a serious, determined expression on his face. He is standing with his left arm raised and his right arm by his side. Anyone can identify the subject to this extent, and he can get a great deal of pleasure from the statue with no other information. But the sculptor has named the young man *David,* and we understand the statue better if we know the story Michelangelo expected us to know. It is told in I Samuel 17 how David, a mere boy, killed the giant Goliath with a pebble from his slingshot.

The examples given so far can all be enjoyed without any knowledge of the subject. But Botticelli's *Birth of Venus* (shown in Figure 3-1) is very obscure if one accepts it at its face value. The young woman is very beautiful, but why should she be standing naked on the edge of a shell? Why does not the shell topple over? Who are the people on each side of her? What are they doing? Botticelli assumed that those who looked at his picture would know that Venus, the goddess of love and beauty, was born from the foam of the sea, and his patrons did know. In the picture, she is being blown to the shore by the winds, while one of the Horae (seasons) is waiting on the bank to receive her.

When we talk about the sources of art subjects, we are thinking primarily of subjects like those just mentioned, those which demand some knowledge on the part of the critic if he is to get the idea the artist had in mind.

The number of subjects used in this way is limitless. Any artist may use any subject from any source, and it is impossible ever to know all the subjects of art. Even the scholar who has devoted his life to their study never expects to know all of them. There are, however, a few sources which are part of the background of every cultivated person. For convenience they may be grouped under these five headings.

1. History; including legend and folklore
2. Greek and Roman mythology
3. The Judaeo-Christian tradition
4. Oriental sacred texts
5. Other works of art

HISTORY

In one sense, all art is conditioned by the historical period in which it is created. The dress, the houses, the manner of living, the thoughts of a period are necessarily reflected in the work of the artist. Such general references, however, may be taken for granted, and we do not call a subject historical unless it refers to specific places, persons, or events.

Such subjects are numerous. One obvious reason is that rulers like to have themselves and the great deeds of their time perpetuated; consequently, statues and paintings of the great are found in each civilization. In these the artist often has a double duty in that he is supposed to give a flattering likeness of his subject and at the same time display his skill. An exception to this general rule is found in the portraits of the Spanish court painted by Goya. A first look at the portrait of Maria Luisa of Parma (Figure 3-3, page 50) shows her as a royal person in all her royal finery; a second look, however, gives a telling commentary on her character and disposition. Goya seems to mock her pretentious elegance. The painting tells us that she is ugly and vain.

Another reason for the use of historical subjects is that artists are sensitive to the events taking place in the world around them. In *Rue Transnonain* (Figure 3-4) Daumier was voicing protest against social injustice. In a street skirmish a shot from one of the windows of number 12, rue Transnonain, wounded an officer; the soldiers thereupon rushed into the building and killed all its inhabitants. Daumier's lithograph depicts the scene when they had left. A similar protest is found in Picasso's painting *Guernica* (shown in Figure 3-5), which was inspired when an unarmed Basque city was bombed by the Fascists in the Spanish Civil War (1936–1939). Today many artists are more exclusively concerned with aesthetics, but similar examples may still be found. The pop artist Robert Rauschenberg, among others, has produced some art of social protest directed against the war in Vietnam (Figure 3-7, page 52).

Historical subjects as such can be identified and recognized with little trouble; records are kept, histories are written, and references are usually clear and easy to find. In quite a different class is legend, the progenitor of history. Legend may be defined as history that is not or cannot be authenticated: the facts are not verifiable. We can be sure of few, if any, facts about King Arthur or King Lear, and those facts do not correspond with the legends about them. Often a legend gets attached to a historical person; for example, Charlemagne is a historical king of France, but the exploits of his nephew Roland are legendary. Many artists, writers, and composers have made use of legend. Till Eulenspiegel, the legendary bad boy of medieval Germany, is the hero of Richard Strauss's tone poem *Till Eulenspiegel's Merry Pranks.* Wagner used legend for the subject of his great cycle of four operas, *The Ring of the Nibelung.* In it he tells the saga of the Nibelung gold from the time it was stolen until it was restored to the Rhine maidens. Wagner based the *Ring* cycle on a twelfth-century

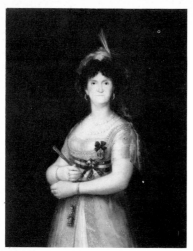

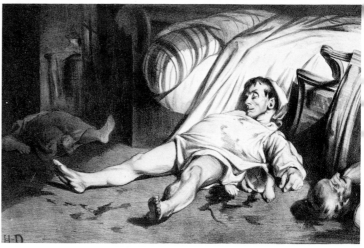

Figure 3-3. Francisco Goya (1746–1828), Spanish painter, etcher, and lithographer. Maria Luisa of Parma (ca. 1790–1792). (Oil on canvas. Size: 43⅝ by 33⅝ inches. New York, Metropolitan Museum of Art; bequest of Mrs. H. O. Havemeyer, 1929. H. O. Havemeyer Collection.)

Figure 3-4. Honoré Daumier (1808–1879), French lithographer and caricaturist. Rue Transnonain (1834). (Lithograph. Size: about 11½ by 17½ inches. New York, Metropolitan Museum of Art; Rogers Fund, 1920.)

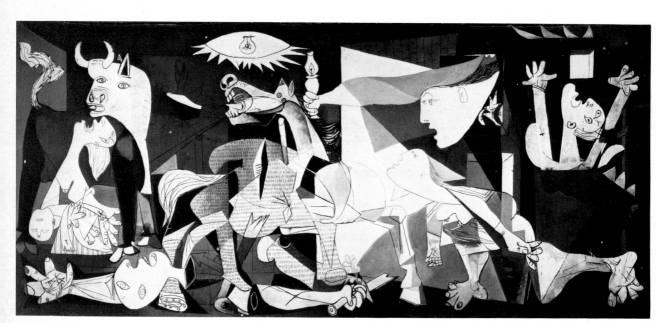

Figure 3-5. Pablo Picasso. Guernica (1937). (Oil on canvas. Mural 11 feet, 6 inches by 25 feet, 3 inches. Collection of the artist, on extended loan to the Museum of Modern Art.)

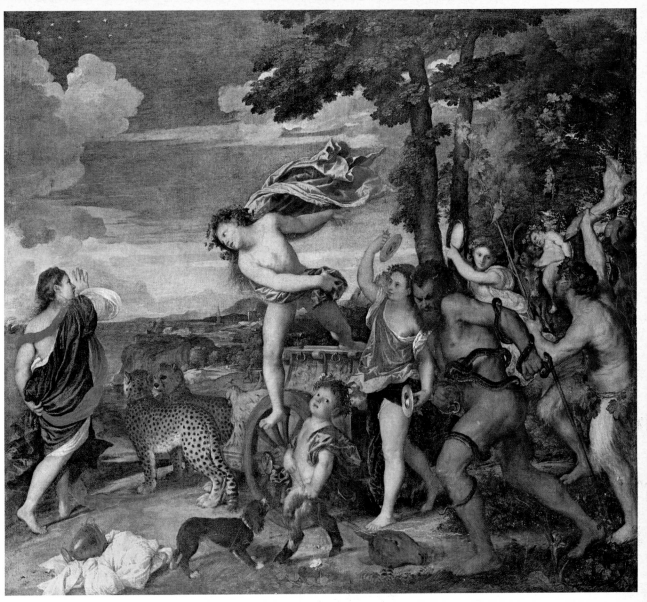

Figure 3-6. Titian (1477–1576), Italian painter. Bacchus and Ariadne (ca. 1520). (Oil on canvas. Size: 69 by 75 inches. London, National Gallery. Reproduced by courtesy of the Trustees.)

poem, The Song of the Nibelung, which was a reflection of the historical struggles between Huns and Burgundians during the Dark Ages.

GREEK AND ROMAN MYTHOLOGY

Greek and Roman mythology has been a very important source for subjects in art. The stream of its influence on Western civilization may be traced primarily to two sources. First are the works of Greece and Rome during

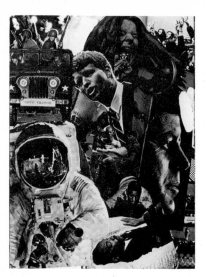

Figure 3-7. Robert Rauschenberg (1925–), American painter. Signs (1970). (Silkscreen. Size: 43 by 34 inches. New York, Leo Castelli Gallery. Photograph by Rudolph Burckhardt.)

Figure 3-8. Laocoön (ca. 40 B.C.), School of Rhodes. (White marble. Height to right hand of Laocoön: 8 feet. Rome, Vatican Museum. Photograph by Alinari.)

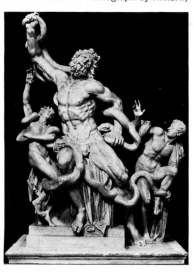

the period of Greek and Roman civilization, from the sixth century before Christ to the fifth century after Christ. Those arts are so well known that they count as a definite part of our inheritance: architecture, drama, poetry, sculpture, and painting. Second are the arts of Europe during the Renaissance, the period of revived interest in things Greek and Latin between the fourteenth and sixteenth centuries. During this period, poets, painters, and sculptors drew largely from Greek and Roman sources for subjects. Of the examples already mentioned, the poems of Homer and Sappho, the Erechtheum, and the vase painting *Dionysus Sailing the Sea* belong to the first period; Botticelli's *Birth of Venus* belongs to the second.

Stories from Greek and Roman mythology center on the gods and the heroes. Each of the gods had his own province and was known by some symbol. Jupiter, for example, the king of the gods, was known by his thunderbolt. Bacchus, god of wine, was shown with grapes and grape leaves.

About each of the gods there clustered many stories. We have already noted a story about the birth of Venus. Another goddess, Proserpine, the daughter of Ceres (Demeter) was carried off by Pluto to be queen of the underworld. Ceres implored Jupiter to restore her daughter to her, and at last a compromise was made whereby Proserpine would forever spend half her time with her mother and half with her husband. It is summer when Ceres has her daughter with her.

In addition to the stories of the gods, there are many tales of the heroes, who were mortal men in close touch with the gods, and in whose exploits the gods themselves assisted. Each of these heroes became the nucleus for a series of stories to which any author might add additional tales as the fancy struck him. Among the heroes are Perseus, who killed the Gorgon (monster) Medusa and saved the life of Andromeda; Oedipus, who was doomed to kill his father and marry his mother; and Theseus, who killed the Minotaur with the aid of Ariadne and then, tiring of her, deserted her on the island of Naxos, where she was met and loved by Bacchus. Titian's painting *Bacchus and Adriadne* (Figure 3-6, page 51) shows Bacchus leaping from his chariot to console Ariadne, who has just been forsaken by Theseus; she has gathered up her skirts, preparing to flee, when she looks back at the god—and stays.

The greatest of all Greek stories, however, are about the Trojan War, which was fought over Helen, whose face "launched a thousand ships, and burnt the topless towers of Ilium." We find many references in art to one or another story connected with Troy—such as the judgment of Paris, when a shepherd boy had to choose which of three goddesses was the most beautiful, or the use of a wooden horse by the Greeks to obtain entrance to Troy. The Laocoön (Figure 3-8) represents the punishment inflicted by the gods on the Trojan priest who urged the Trojans not to take the Greeks' wooden horse into the city.

The three great classical epics are concerned with the Trojan War. Homer's *Iliad* tells of the war itself, beginning with the anger of Achilles and narrating the events through the death of Hector; Homer's *Odyssey* describes the wanderings of Ulysses after the war; and Vergil's *Aeneid*

describes the adventures of Aeneas and the founding of Rome, also after the war.

THE JUDAEO-CHRISTIAN TRADITION

Religion and Art

Anyone who has taken a trip to Europe has probably seen innumerable museums and churches. Many travelers see so many that they become discouraged. Tourists who are taken about by guides are all given the same set *table d'hote* cultural diet. Catholics and non-Catholics, the religious and the nonbelievers, all see the same monuments of art, and much of this art is religious art. Obviously, religion has played an enormous role in inspiring works of visual art, music, architecture, and literature through the ages. In fact it is no exaggeration to say that in some periods, such as the prehistoric and the medieval, there was really no difference between religion and art. The painters of the caves at Altamira in northern Spain (see Figure 1-3, page 4) probably had no notion of themselves as artists in our sense; they were performing a religious rite that was supposed to help them in hunting. Similarly, the craftsmen of the Middle Ages (we are not using the word "artists" yet) were part of a reverential age of faith in which religion permeated the totality of experience, as something which could not be separated from any other aspect of living. In modern culture religion is separate to an immeasurably greater extent, so much so that it is hard for us to grasp how everything for medieval man was part of religion. It was the Church which was the source of education, entertainment, most social occasions, and, of course, faith. This faith was both expressed in and strengthened by the carvings on church portals and the colorful designs in stained-glass windows. Such carvings and designs told people the things the Church felt they should know. For the illiterate people of that age the portal carvings and window pictures were a kind of text—they have often been called "the poor man's Bible." The craftsmen who had produced them were unimportant, and indeed most often anonymous.

It was during the Renaissance of the fifteenth and early sixteenth centuries that the European craftsman became the "artist" and conscious of his role in a way that had never been true before (in the Far East, artists had arrived at this point somewhat earlier). With this change of attitude by the artist, art itself changed from the spontaneous expression of a universal feeling—whose visible symbol was the cathedral of the Middle Ages—to a more studied, artificial, and individual expression: the art of the Renaissance.

As religious art became self-conscious and individual, it also became more intellectual and philosophical; the Sistine Chapel frescoes, which are discussed below, are an excellent example. It also took on a new set of values and dimensions. In the first place, it became, far more than ever before, a kind of private status symbol. The individual sponsor, or patron, became hugely important. For example, Giotto's Arena Chapel frescoes (fourteenth century; Figure 3-26, page 67) were done for a wealthy

Figure 3-9. Leone Battista Alberti (1404–1472), Italian architect. Church of S. Maria Novella. (Florence. Photograph by Alinari.)

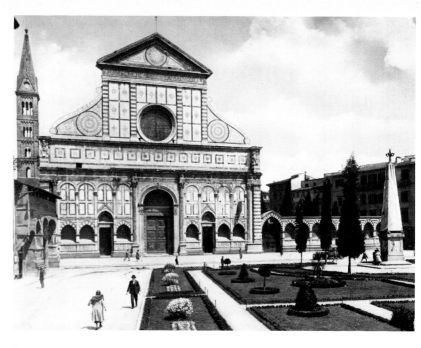

Figure 3-10. Romanesque Madonna and Child. (Oak, polychromed. Height: 31 inches. New York, The Metropolitan Museum of Art; gift of J. Pierpont Morgan, 1916.)

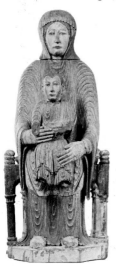

Paduan who sponsored them in memory of his father. The church of S. Maria Novella, designed by Alberti in the fifteenth century (shown in Figure 3-9), was sponsored by a wealthy Florentine family. More important, however, religious art during the Renaissance reflected the new intellectual currents of the time. Thus Michelangelo's frescoes in the Sistine Chapel sum up the combination of pagan neo-Platonic philosophy with Christian belief that is typical of the sixteenth-century Renaissance. Finally, and perhaps most important, with the greater individualism and intellectuality exercised by this new breed of artists, religious art took on broader meaning. Now individual artists wandered somewhat from biblical texts to produce increasingly humanistic interpretations. The scene in the Sistine Chapel where God is shown creating Adam (Figure 3-19, page 62) is a long, but interesting, distance from the biblical text: "And the Lord God formed man of the dust of the ground, and breathed into his nostrils the breath of life; and man became a living soul." (Genesis 2:7). Both the Old Testament text and Michelangelo's interpretation have their own poetic quality. The simple indirection of the former statement leaves the painter a great deal of room, which he readily takes. Ghiberti has interpreted this moment differently (Figure 4-4, page 77) in his bronze doors for the Baptistery in Florence: in a very simple fashion he shows God raising Adam to his feet (this is also a departure from the text). Michelangelo's depiction is much more dramatic. The figure of God is rushing through the air as it approaches the figure of Adam, who is lying on the ground with one arm raised languidly and supported by the knee. God does not quite touch Adam; he merely extends his "strong hand and outstretched arm," willing the languid figure into life, as the life-giving energy seems to flow from the divine figure to the human one. Where Ghiberti has given us a calm

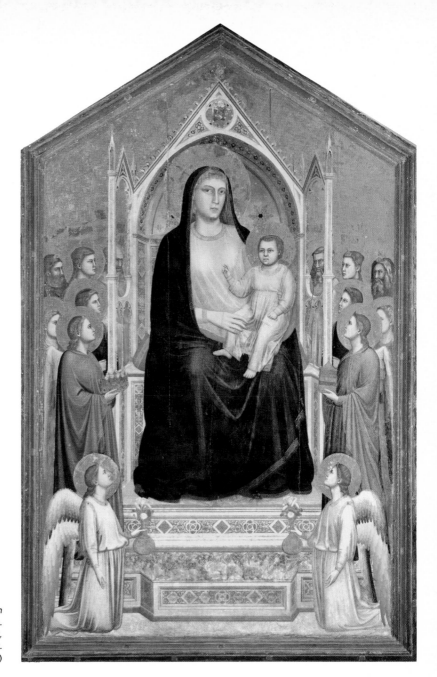

Figure 3-11. Giotto (1266–1336), Italian painter. Madonna Enthroned (ca. 1310). (Tempera on wood. Height: 10 feet, 8½ inches. Florence, Uffizi Gallery. Photograph by Alinari.)

lyrical scene, Michelangelo gives an interpretation that produces a sense of mystical yearning; man, who longs to be born, is gazing toward his Creator, the symbol of irresistible force and creativity.

As we study the development of art in the Renaissance period, we are able to see how each generation or century interprets biblical texts differently, and how in each case the interpretation reveals the basic attitude of the period. Let us take, for example, the way in which successive

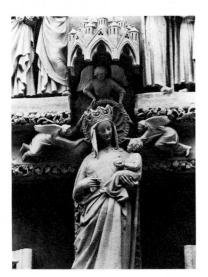

Figure 3-12. La Vièrge Dorée (ca. 1280). (Amiens Cathedral. Height: 120 inches.)

generations have treated the Virgin Mary, either as a devotional object or as a work of art—or as something in between.

The French *Madonna and Child* of the twelfth century—the Romanesque period—at the Metropolitan Museum of Art (shown in Figure 3-10) is a highly stylized, formal, and unemotional representation. It seems to convey the quality of a feudal society and a religion whose dominant form was monasticism. There is nothing warm or "human" about this portrayal. Human reality has been omitted altogether, or at least completely subordinated to the concentric lines that flow over the entire surface of the sculpture. The result is a highly abstract, impersonal image or ikon.

The *Vièrge Dorée* ("gilded Virgin") of the cathedral of Amiens (shown in Figure 3-12) is a product of the thirteenth century (the Gothic period) and the growth of town life during that time. This is a humanized and warm representation. Here the mother looks tenderly at her child, a more real infant than the rather large figure sitting on the Madonna's lap in the Romanesque example we have just discussed. The Virgin is now all sweetness and smiles, unlike the somber, even severe, expression of the earlier figure.

Giotto's *Madonna Enthroned*, a work of the early fourteenth century (Figure 3-11, page 55) is conceived monumentally and is almost classically Roman. Giotto, who is famous for his convincingly sculpturesque forms, here projects a new and heroic ideal of humanity. This is an ideal that may be related in general terms to the classical background of Italy, which was being consciously revived at this point, particularly by the middle class: we are now in the Renaissance ("revival") period.

Botticelli's *Madonna of the Magnificat* (shown in Figure 3-13) is an example of the more developed and intellectual classicism that was widely practiced during the fifteenth-century Renaissance. Botticelli's *Birth of Venus* (Figure 3-1, page 46), which uses elaborate literary allegories and references from classical literature, is one side of the coin; the warm-blooded, sensuous portrayal of a holy figure such as the Virgin is the other side. As has already been noted, the Renaissance tried constantly to reconcile the values of paganism with those of Christianity.

During the last phase of the Renaissance, in the early sixteenth century, we find the heroic conception of humanity and the idealization of all figures carried to its logical conclusions. The *Madonna of the Book*, by Michelangelo, from the Bargello National Museum in Florence (shown in Figure 3-14), exemplifies the heroic idealization of the human form. This was also typical of Raphael and Leonardo da Vinci—Michelangelo's contemporaries. All are characterized by a sense of contained power, and by placement of the figures within a geometrical framework.

The Madonna and Child continues as a subject down to our own time. Each period which has treated this subject has given it the stamp of a particular age. With the Protestant Reformation of the sixteenth century, the number of countries in which religious art was supreme decreased. The new Protestant countries included a large part of Germany, the Netherlands, the Scandinavian countries, Great Britain, and Switzerland. In the United States, which has always been predominantly Protestant,

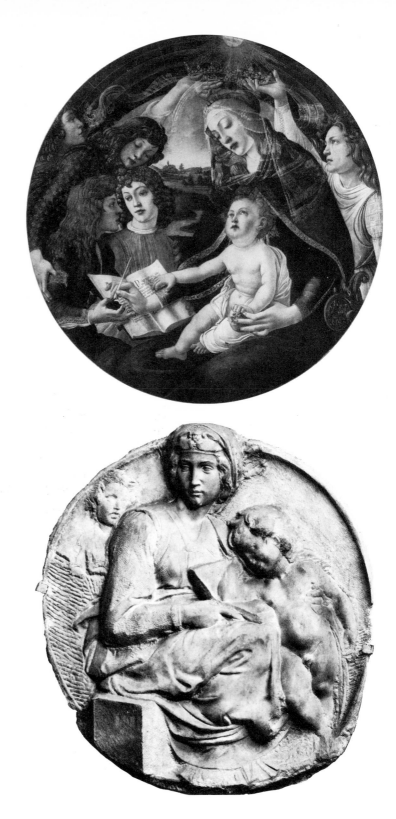

Figure 3-13. Sandro Botticelli (1447–1510), Madonna of the Magnificat. (Florence, Uffizi Gallery. Photograph by Alinari.)

Figure 3-14. Michelangelo, Madonna of the Book. (Marble. Florence, Bargello Museum. Photograph by Alinari.)

there has been little religious art of importance. Indeed, as the general influence of religion has diminished in modern times, its influence on art has also diminished. One obvious exception should be noted: religious folk art, for example in France, Germany and Spain, in which untrained artists express themselves in emotionally effective terms. But although religious themes in art have diminished in importance, it is not to be supposed that they have disappeared. In the visual arts, in literature, and in music examples are still to be found today.

T. S. Eliot, for example, in his poem "Journey of the Magi," writes a monologue in which an old man tells of his journey as a young man to find the star, the difficulties and disappointments of his long trip, and at last his finding of the child. Now as an old man he ponders on the meaning.

JOURNEY OF THE MAGI

'A cold coming we had of it,
Just the worst time of the year
For a journey, and such a long journey:
The ways deep and the weather sharp,
The very dead of winter.'
And the camels galled, sore-footed, refractory,
Lying down in the melting snow.
There were times we regretted
The summer palace on slopes, the terraces,
And the silken girls bringing sherbet.
Then the camel men cursing and grumbling
And running away, and wanting their liquor and women,
And the night-fires going out, and the lack of shelters,
And the cities hostile and the towns unfriendly
And the villages dirty and charging high prices:
A hard time we had of it.
At the end we preferred to travel all night,
Sleeping in snatches,
With the voices singing in our ears, saying
That this was all folly.

Then at dawn we came down to a temperate valley,
Wet, below the snow line, smelling of vegetation;
With a running stream and a water-mill beating the darkness,
And three trees on the low sky,
And an old white horse galloped away in the meadow.
Then we came to a tavern with vine-leaves over the lintel,
Six hands at an open door dicing for pieces of silver,
And feet kicking the empty wine-skins.
But there was no information, and so we continued
And arrived at evening, not a moment too soon
Finding the place; it was (you may say) satisfactory.

All this was a long time ago, I remember,
And I would do it again, but set down
This set down
This: were we led all that way for
Birth or Death? There was a Birth, certainly,

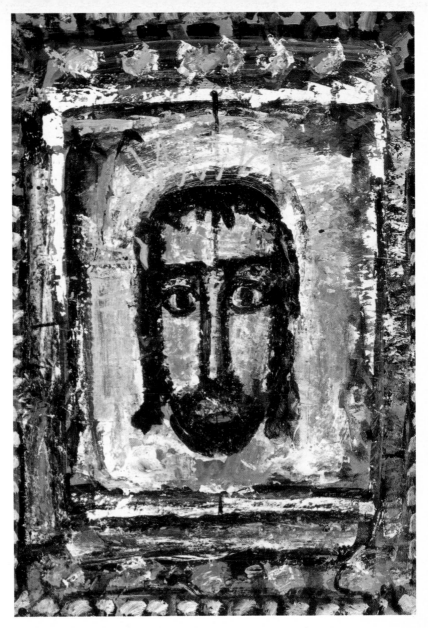

Figure 3-15. Georges Rouault (1871–1958), French painter. La Sainte Face (1933). (Oil on paper. Size: 36 by 26 inches. Musée National d'Art Moderne, Paris.)

We had evidence and no doubt. I had seen birth and death,
But had thought they were different; this Birth was
Hard and bitter agony for us, like Death, our death.
We returned to our places, these Kingdoms,
But no longer at ease here, in the old dispensation,
With an alien people clutching their gods.
I should be glad of another death.

 —T. S. Eliot (1888–1965, American poet), "Journey of the Magi."[1]

[1] From *Collected Poems 1909–1962*. Copyright 1936 by Harcourt, Brace & World, Inc.; copyright © 1963, 1964, by T. S. Eliot. Reprinted by permission of the publishers.

Another modern artist, the painter Rouault, has painted a head of Christ in which he shows clearly the physical suffering and at the same time the calm of spirit which not only overcomes the suffering but is compassionate (Figure 3-15, page 59).

In these two examples, as in *Christ Destroying His Cross*, by the Mexican painter Orozco (Figure 6-13, page 116), it is noteworthy that we are no longer dealing with the glorifications or direct religious references of earlier art. In these works, and indeed in most modern Western treatments of religious themes, the writer, artist, or composer uses the subject as an occasion for the expression of his own feelings and philosophy of life. Eliot's *Journey of the Magi* is a very personal treatment of the theme: the old man's ruminations are on his own experiences and reactions; the motif is "we" rather than "He." Rouault's art is definitely that of a Christain socialist at the beginning of our century; but the artist is using the sufferings of Christ to express his own personal melancholy as he considers the sufferings of mankind in general. Orozco goes even further, using the story of Christ to accuse humanity of unthinkingly destroying itself; Christ seems to act as an avenger, to wrest back his cross from those who have used it for their own ends. What strikes Orozco as a humanitarian is the fact that Christ's name has been so constantly invoked to defend and support acts of war and destruction—as the weapons in the background of the picture quite clearly show.

The fact that modern pictorial art has become increasingly abstract has been another reason for the decline of traditional religious subject matter. But a few examples of very nearly traditional religious subjects can be found. Salvador Dali's *Last Supper* (1955), in the National Gallery in Washington, is one—but even this work is filled with the painter's own symbolism (Figure 3-16).

In music there has been a revival of religious subjects. Rock hymns, such as "Put your hand in the hand of the Man who calms the sea," are one example; another example is Leonard Bernstein's *Mass* (1971), a serious work attempting to present the traditional Roman Catholic Mass in modern terms. Although there are conflicting opinions about the effectiveness of *Mass*, it is nevertheless significant that an important contemporary musician has utilized this ancient material to express a new viewpoint.

Judaeo-Christian Sources of Art

THE BIBLE The Christian Bible, as is commonly recognized, is not a single book but a library. The books of the Bible may be grouped as follows:

 I. Old Testament (39 books)
 A. History (Genesis through Esther). The historical books give the story of the Jews from the creation to the Babylonian exile.
 B. Poetry (Job through the Song of Songs). Job is a poetic drama; Proverbs is a collection of wise sayings and epigrams. The

Song of Songs and Ecclesiastes are, respectively, a group of marriage songs and a statement of gently cynical philosophy.

 C. Prophecy (Isaiah through Malachi). The Prophets were not soothsayers, but practical men who judged and interpreted the affairs of their own times. They were patriots, reformers, preachers, and teachers.

II. New Testament (27 books)
 A. History. The four Gospels: Matthew, Mark, Luke, and John; the Acts of the Apostles.
 B. Letters. The epistles written by Paul and others to the Christian churches that were just starting in the various parts of the world.
 C. Apocalypse. The Revelation of St. John.

Any consideration of the Bible in relation to art must take into account the fact that the Bible itself is great art. For the English-speaking peoples, the Bible has the additional advantage of being available in the King James version, probably the greatest translation ever made. So the Bible not only is a source of art, but is itself art.

The most frequently used subjects from the Bible are taken from the life of Jesus. And in the life of Jesus the accounts of his birth and death are most often used; the Madonna with the baby Jesus, the Annunciation, the visit of the Magi and the shepherds, from the stories of his birth; and from his death, the betrayal by Judas, the scourging, the Crucifixion, deposition, and entombment. In the Old Testament, the stories of the creation are probably more important than any others, though reference is frequent to the heroes of the Old Testament: Abraham, Jacob, Moses, Samson, David, Elijah, and others.

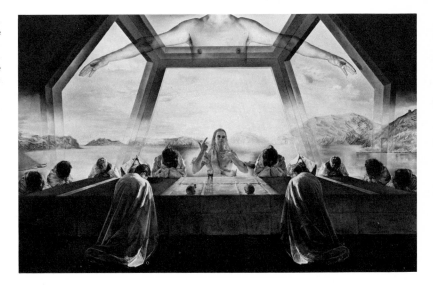

Figure 3-16. Salvador Dali (1904–), Spanish painter. The Sacrament of the Last Supper. (Oil on canvas. Size: 65⅝ by 105⅛ inches. Washington, D.C., National Gallery of Art, Chester Dale Collection.)

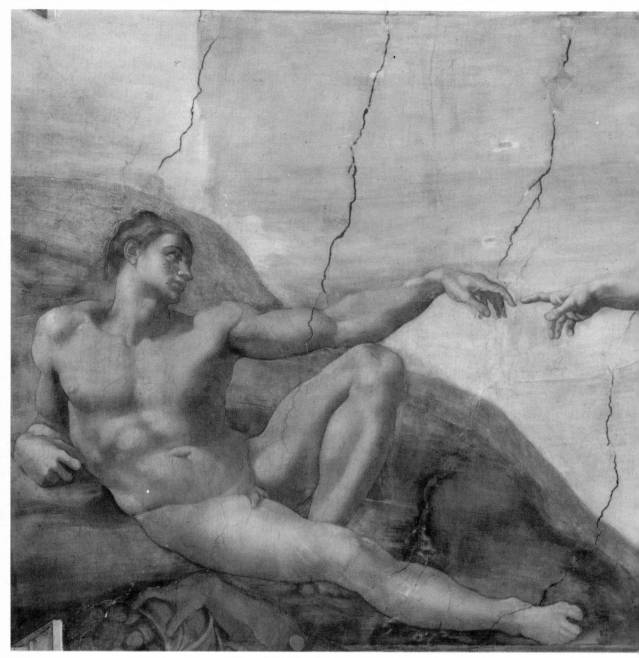

Figure 3-17. Michelangelo. Creation of Adam, *detail of Sistine Chapel Ceiling.* (Length of Adam: 10 feet. Photograph by Alinari.)

BACKGROUND

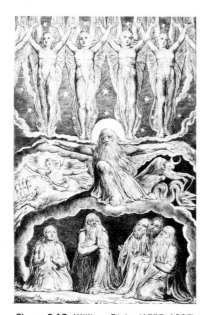

The influence of the poetry and prophecy of the Old Testament is found chiefly in music. *The Messiah* by Handel takes its text in part from the Prophets. The opening tenor recitative uses the words of Isaiah, Chapter 40, "Comfort ye, comfort ye, my people." An oratorio on King David was written by Honegger. Blake's engraving *When the Morning Stars Sang Together* (shown in Figure 3-18) is taken from the book of Job. When the Lord answers Job out of the whirlwind, he asks:

Where wast thou when I laid the foundations of the earth?
Declare, if thou hast understanding.
Who hath laid the measures thereof, if thou knowest?
Or who hath stretched the line upon it?
Whereupon are the foundations thereof fastened?
Or who laid the corner stone thereof;
When the morning stars sang together,
And all the sons of God shouted for joy?
 —Job 38:4–7

Figure 3-18. William Blake (1757–1827), English poet, painter, and engraver. When the Morning Stars Sang Together (ca. 1825). (Engraving. Size: 6 by 7½ inches. New York, The Metropolitan Museum of Art.)

The Sistine Ceiling. It has been a not uncommon practice to tell stories from the Bible in a series of pictures. One of the greatest of these was made by Michelangelo to decorate the ceiling of the Sistine Chapel (Figure 3-19). The chapel is a long, narrow room, about 155 by 45 feet. In painting this space, Michelangelo chose to divide it into a number of small areas.

Down the center of the ceiling is a series of nine rectangles telling the story of the creation through the time of Noah (Figures 3-17 and 3-19 through 3-25).

Figure 3-19. Michelangelo. Ceiling of Sistine Chapel (1508–1512). (Fresco. Length: 132 feet; width: 45 feet. Rome, Vatican. Photograph by Alinari.)

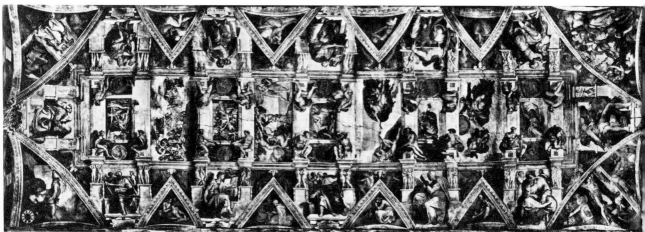

1. Separation of Light and Darkness
2. Creation of Sun and Moon
3. Creation of Land and Water
4. Creation of Adam
5. Creation of Eve
6. Temptation and Expulsion
7. Sacrifice of Noah
8. The Deluge
9. The Drunkenness of Noah

Michelangelo began to paint this vast room with its 40-foot-high ceiling at the far end (at the right of our picture here) so as to leave the altar free as long as possible. Thus the pictures were actually done from number 9 to number 1, reversing the biblical sequence and ending with the monumental and mystical *Separation of Light from Darkness* (Figure 3-21). This is a huge and almost frightening single figure far different from the complex and detailed narratives at the left of the picture.

Each of these panels shows sculpturally decorative and classically conceived nude male figures (this is Michelangelo the sculptor expressing himself) who project in a general way the mood of the panel (Figure 3-22).

The subject of the series is the fall of man and his redemption through the coming of Christ. For that reason the artist shows in the corners scenes representing God saving the chosen people; for example, the one at the upper left, *The Hanging of Haman,* is from the story of a beautiful Hebrew girl who was made queen by the Persian king Artaxerxes. When the king's evil minister, Haman, plotted against the Hebrews, Queen Esther and her uncle Mordecai managed to defeat him and save their people (Figure 3-23).

Forming a border around the entire ceiling is a row of figures representing the prophets of the Old Testament and the sibyls (prophetesses) of classical mythology (Figure 3-24 shows one), who foretold the birth of Christ. The Old Testament prophets who foretold the coming of a redeemer or savior are also included. Figure 3-25 shows the prophet Isaiah: "Behold, a virgin shall conceive, and bear a son, and shall call his name Emmanuel" (the Hebrew *Emmanuel* means "God is with us").

THE APOCRYPHA The Apocrypha are those books of the Bible which were not accepted in the official Old and New Testaments: for example, the three Hebrew narratives Judith, Susanna, and Tobit. Judith is the story of a beautiful young woman who saved her country when it was besieged by Holofernes. She induced Holofernes to enter her tent and persuaded him to go to sleep. Then she cut off his head and carried it back to her home. Inspired by her feat, the Israelites fought and drove away their enemies. Botticelli has a picture of her as she goes home, her servant carrying the head of Holofernes in a bag.

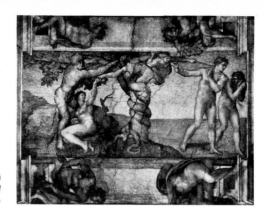

Figure 3-20. Michelangelo. Temptation and Expulsion, *detail of Sistine Chapel Ceiling. (Photograph by Alinari.)*

Figure 3-21. Michelangelo. Separation of Light from Darkness, *detail of Sistine Chapel Ceiling. (Photograph by Alinari.)*

Figure 3-22. Michelangelo. Decorative Nude, *detail of Sistine Chapel Ceiling. (Photograph by Alinari.)*

Figure 3-23. Michelangelo. Hanging of Haman, *detail of Sistine Chapel Ceiling. (Photograph by Alinari.)*

Figure 3-24. Michelangelo. Libyan Sibyl, *detail of Sistine Chapel Ceiling. (Photograph by Alinari.)*

Figure 3-25. Michelangelo. Isaiah, *detail of Sistine Chapel Ceiling. (Photograph by Alinari.)*

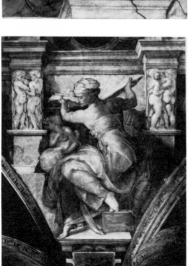

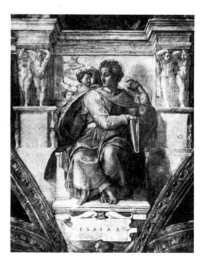

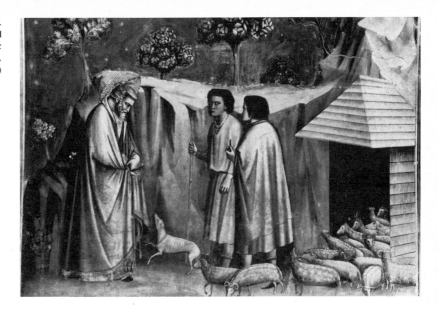

The New Testament Apocrypha comprise early stories of the lives of Jesus and Mary. Those that have had the greatest influence on art are the ones that have to do with the birth and death of the Virgin.

In the Arena Chapel at Padua, Giotto has painted a cycle of frescoes depicting the life of the Virgin. *Joachim Returning to the Sheepfold* (Figure 3-26) shows the dejection of Joachim, who was later to be the father of Mary, after his offering had been refused because he was still childless. In his sadness, he does not even realize that he has reached the sheepfold. The shepherds hold back in doubt and in fear of intruding, but the little dog recognizes his master and runs to meet him.

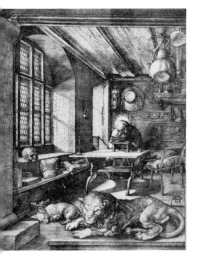

LEGENDS AND LIVES OF THE SAINTS The saints are those people formally recognized by the Christian church because of the exceptional holiness and piety of their lives. About them many stories have been told which have found their way into the arts. There is, for instance, the story that one day when S. Jerome was teaching, a lion walked into the room and lifted up its paw. All the students fled, but S. Jerome, noticing that the lion was wounded, pulled a thorn from its paw. After that the lion was Jerome's constant companion. In Dürer's engraving S. *Jerome in His Cell* (shown in Figure 3-27), the saint is pictured working in his study; the scene is one of scholarly quiet and order, and in front is a large lion, sleeping peacefully.

RITUAL The ritual of the church has been of great importance in art. The prayers and the words of the responses are beautiful. Through constant repetition they have become familiar to everyone, and they have had great influence on language and speech patterns. Just as important has been the influence on music; the various rituals were early set to music,

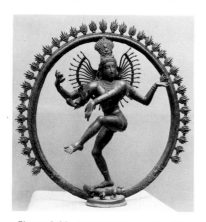

Figure 3-28. Siva as Nataraja. *Southern India (ca. 1800). (Copper. Boston, Museum of Fine Arts, Marianne Brimmer Fund.)*

and the composers of each generation wrote new music for the services. The most important of all the rituals of the church is the Mass, which is the celebration of the Holy Communion. It is regularly in five parts (only the opening words are given):

> Kyrie: "Lord, have mercy upon us."
> Gloria: "Glory be to God on high."
> Credo (Creed): "I believe in one God."
> Sanctus: "Holy, holy, holy."
> Agnus Dei: "O Lamb of God, that takest away the sins of the world."

We have already mentioned Leonard Bernstein's *Mass,* a modern version of this traditional ritual.

Oriental Sacred Texts

As we have become more and more familiar with Eastern art through travel and modern reproductions of art, the importance of Oriental sacred texts has become apparent. The countries of the Orient, especially China, Japan, and India, have all produced sacred texts of one kind or another, and these have inspired various kinds of art. Most fruitful have been the texts and traditions of Hinduism and Buddhism.

Among the principal deities of the Hindu system are Vishnu, Siva, and the goddess Devi. Vishnu is one of the oldest of Hindu gods; worship of Vishnu, which goes back into the earliest recorded periods, is inspired by the sacred books known as Veda, where he appears as a kind of solar god. The later book known as the Mahābhārata is an epic in which Vishnu is identified as the divine hero-teacher. In the famous Bhagavad-Gita ("Song of the Blessed"), a section of the Mahābhārata and perhaps the most widely read religious book of India, Vishnu is identified with Drishna, the god of caste duty who is only one of the many incarnations of Vishnu. During the earliest Vedic times the god Siva was worshipped as part of—or identical with—Rudra, the storm god. Unlike the beneficent Vishnu, Siva is associated with the darker powers of nature. He is the divine dancer who creates and destroys. His eternal movement is the rhythm of the universe itself. The example from the Museum of Fine Arts in Boston shown in Figure 3-28 depicts him with his complement of four hands, each of which represents one of the aspects of his being and his importance.

The Buddhist religion, which is perhaps the most widespread and influential in the Oriental world, began in India and spread from there into most of the other countries of the East. Its artistic representations are almost without number and many of them have their inspiration in the "Jataka" tales, which tell stories from the early life of the Buddha. The Lohan or disciple of Buddha from the T'ang period of ancient China (Figure 6-6, page 110) is one of many thousands of examples of the spread of Buddhist ideas from India into the various other countries of the Far East.

Not only do all the great religions of the East have their particular texts to furnish narrative religious material, but there are also historical

books and handbooks which tell the artist how to work. An example of narrative text is the well-known Persian Shah-Nama ("Book of Kings") of the fourteenth century, a narrative of the Moslem Persian monarchs frequently illustrated in Persia (Figure 9-30, page 186). An example of the handbooks for artists is the book known as the "Six Canons" (that is, laws) of the painter and critic Hsieh-Ho, from around A.D. 500. In this book the author prescribes as the necessary qualities of the successful painting such things as "rhythmic vitality," "the law of bones and brushwork" (composition and lines), "harmonious coloring," and "finish." In India we find a text on the technique of the drama, the *Natryasudra*; and texts on the plastic arts, known as the *Silpa Sastras*, which prescribe rules for sculpture and architecture. These very specific injunctions about how one acts, dances, paints, and carves all date from the Gupta dynasty of A.D. 320 to about 535—about the same time as the early Christian period in the West.

SUBJECTS DERIVED FROM OTHER WORKS OF ART

A last category of subjects may be found in those works that take their subject directly from other works of art.

It is worth observing what the poet adds over and above the description when a painting is the source of information. Anne Sexton gives us vivid images of the power in the revolving constellations in Van Gogh's *Starry Night*. The strong verbs, the powerful comparison of the cypress tree to the hair of a drowning woman, the many images of heat and movement all prepare us for the dramatic short lines conveying her personal identification with the powers of nature and her urge to lose herself in those powers and die. In a way she has gone beyond the painter.

The town does not exist
except where one black-haired tree slips
up like a drowned woman into the hot sky.
The town is silent. The night boils with eleven stars.
Oh starry night! This is how
I want to die.

It moves. They are all alive.
Even the moon bulges in its orange irons
To push children, like a god, from its eye.
The old unseen serpent swallows up the stars.
Oh starry, starry night! This is how
I want to die:

Into that rushing beast of the night,
sucked up by that great dragon, to split
from my life with no flag,
no belly,
no cry.
 —Anne Sexton, (1928– , American poet),
 "The Starry Night," from *All My Pretty Ones*[2]

[2] From *All My Pretty Ones*. Reprinted by permission of Houghton Mifflin Co., 1963.

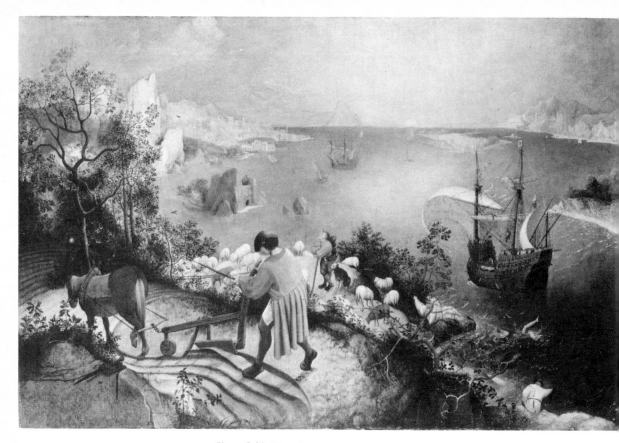

Figure 3-29. Pieter Brueghel the Elder (ca. 1525–1569), Dutch painter. The Fall of Icarus (ca. 1554–1555). (Tempera on canvas. Height: ca. 2 feet, 4 inches. Copyright A. C. L. Bruxelles.)

Brueghel used the subject of Icarus for one painting, and Auden and Madden have been inspired by the painting to write poems. The Greek myth tells that Icarus, the son of Daedalus, the great artisan, was given wings by his father. Since the wings were fastened on by wax, Daedalus warned the boy not to fly too near the sun. But the boy, exulting in his new power, could not restrain himself; soon the wax melted, he fell into the sea, and he was drowned.

In Brueghel's painting *The Fall of Icarus* (see Figure 3-29) the boy is almost submerged; only one of his legs is seen as it disappears into the water. Nearby is a luxurious ship, and on a slight rise a farmer is plowing with a horse; below is a shepherd who is looking up at the sky, his sheep all around him.

Auden gives his poem the name of the museum in which the painting is found.

MUSÉE DES BEAUX ARTS

About suffering they were never wrong,
The Old Masters: how well they understood
Its human position; how it takes place
While someone else is eating or opening a window or just walking dully
<div align="right">along;</div>
How, when the aged are reverently, passionately waiting
For the miraculous birth, there always must be
Children who did not specially want it to happen, skating
On a pond at the edge of the wood:
They never forgot
That even the dreadful martyrdom must run its course
Anyhow in a corner, some untidy spot
Where the dogs go on with their doggy life and the torturer's horse
Scratches its innocent behind on a tree.

In Brueghel's *Icarus*, for instance: how everything turns away
Quite leisurely from the disaster; the ploughman may
Have heard the splash, the forsaken cry,
But for him it was not an important failure; the sun shone
As it had to on the white legs disappearing into the green
Water; and the expensive delicate ship that must have seen
Something amazing, a boy falling out of the sky,
Had somewhere to get to and sailed calmly on.

> —W. H. Auden (1907– , British poet),
> "Musée des Beaux Arts"[3]

Charles Madden finds a very different emphasis; he is less philosophic about the theme, using it rather as a means of evoking a poetic mood.

THE FALL OF ICARUS
(From Brueghel's painting)

The bulging sails by a riotous wind caught
pull the ships and their rigging nets toward shore
to be emptied. The sailors quickly will calm their floors
and their houses in the evening light will melt into the mountains.

And on the hill with one foot planted in the earth
his plowing almost done, his eyes cast down and fully shielded
from the sun which now is growing shadow, the farmer
turns in soil and toil the final circles of the day.

Below him a quiet pastoral: on lichen-bearing rocks
the feeding sheep, the quiet watching dog, the silent shepherd
so stalking with his eyes the homing flights of birds
that neither he nor the intent fisherman closer to the shore,

[3] From *The Collected Poetry of W. H. Auden.* Copyright 1940 by W. H. Auden; reprinted by permission of Random House, Inc.

Figure 3-30. *Pablo Picasso. Polyxena, daughter of Priam, killed in the tomb of Achilles. From Ovid, Les Metamorphoses (1930). (Etching. New York, Museum of Modern Art; gift of James Thrall Soby.)*

none has seen the silent fall of Icarus
through the riotous wind and the shadows of the coming evening light,
nor do they hear his sigh, both of pity and delight
of his remembered waxed and winged flight.

> —Charles F. Madden (1921– , American poet, teacher),
> "The Fall of Icarus"[4]

We have mentioned Tchaikovsky's suite based on Shakespeare's play *Romeo and Juliet.* Debussy's *Afternoon of a Faun* is based on a poem by Mallarmé, and the ballet is based on both. Rimsky-Korsakov's *Scheherazade* finds its source in the *Arabian Nights.* Browning's poem "Fra Lippo Lippi" was inspired by the painting *The Coronation of the Virgin* by Fra Filippo Lippi. Strauss takes his subject *Don Quixote* from the novel by Cervantes. Maeterlinck's play *Pelléas et Mélisande* was used by Debussy for his opera of the same name.

There are many instances of paintings or graphics inspired by poetry. Generally, however, these works of graphic art are illustrative in character, although they may very well give an added dimension to the poem itself. In principle, a painter is not likely to devote a serious work of art to illustrating or embellishing a single poem, if for no other reason than that it is both difficult and unrewarding. On the other hand, longer works of literature have engaged a great many artists from the Renaissance forward; the plays and poetry of Dante, Milton, Shakespeare, Molière, and Byron are examples. Among the outstanding works of visual art derived from literature are the series of lithographs done by the French painter Eugène Delacroix (1798–1863) for the great verse drama *Faust* by the German poet Johann Wolfgang von Goethe, who was quite ready to admit that the artist had contributed something to the poetry. Much more recently (1931) Picasso did a series of illustrations for an edition of the *Metamorphoses* of Ovid (a collection of poems of the first century after Christ). The thirty etchings which illustrate this great collection of love poetry (Figure 3-30) are marvelously expressive of its sensuous paganism, although they are far removed in character from any plastic art produced by the ancients themselves. By attaching his own interpretation of the pagan to these poems, Picasso has given them an added dimension, as Delacroix did for Goethe's *Faust.* The painting derived from literature must not merely illustrate if it is to be successful—just as the poem derived from a painting must not merely describe. The source must be a point of departure for the artist's own creativity.

Dramas are often based on novels, and operas on plays; many cinema plots are taken from dramas or novels. Works that derive from other works of art are always individual and can never be classified or grouped together. Therefore, it is sufficient for our purpose merely to note that works of art often are so derived.

[4] From *Northwest Review*, University of Oregon.

4. FUNCTION

DEFINITION

Benvenuto Cellini, the famous goldsmith, made an elaborate little bowl for Francis I, King of France (see Figure 4-1). It is made of gold on a black ebony base; on it are two figures: a woman representing the land and a man representing the sea. We identify the man by his trident (a three-pronged spear), which is the symbol of Neptune, the god of the sea. As we look at the bowl and marvel at its exquisite workmanship, we ask: What is it for? The answer to this question gives the *function* of an article. Cellini made his bowl as a container for salt, and from its function it is called a saltcellar. As used in this book, the word *function* will be reserved for those arts whose medium is itself directly practical and useful.

Many of the works cited in the last chapter were made primarily for their function. The lekythos on which was represented Apollo with his kithara is primarily a vessel for holding oil. It has a long neck to make it possible to pour the oil slowly. The painting by Execias called *Dionysus Sailing the Sea* is in the bottom of a cylix, a shallow drinking cup. These paintings, like the figures on the saltcellar, are decorative and without any actual function, but it should be noted that with the Greeks, as with Cellini and other later artists, the decorations are related to the function of the vessel. Bacchus, the god of wine, is clearly related to the function of the cylix; Cellini uses Neptune, the god of the sea, to symbolize salt.

These are clear examples of functional art; but sometimes we do not know, or are not sure of, the original function of an object. Since the Altamira cave paintings predate the use of writing, we have to make assumptions about their function, which undoubtedly had something to do with hunting. By analogy with magical practices among primitive people

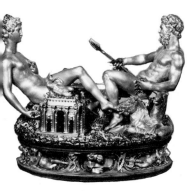

Figure 4-1. *Benvenuto Cellini (1500–1572), Italian sculptor and goldsmith. Saltcellar of Francis I (ca. 1545). (Gold and enamel. Height: about 8 inches. Vienna, Kunsthistorisches Museum.)*

today, we conclude that the pictures were designed to ensure a successful hunt—what we now call "sympathetic magic." Apparently the caves were in more or less constant use as sanctuaries or holy places, since successive generations of painters have superposed their paintings on each other. It is therefore fairly safe to say that these paintings had a practical function.

Stonehenge (shown in Figure 4-2) is also prehistoric, but of it we have more definite knowledge. Its characteristic feature is a series of circles of huge stones set upright in the ground and capped with lintels. Toward the center are two broken rings of stones and at the center a large slab which may have served as an altar. One long-established fact has seemed most significant. Stonehenge is oriented so that its axis passes through a 35-ton marker stone and points directly to the spot on the northeast horizon where the sun rises at the summer solstice, the longest day of the year. The place may have had some ceremonial or other religious purpose. Certainly it was built with one eye on the calendar. Astronomical calculations prove that Stonehenge was in use about 1500 B.C.

Many works are cherished for themselves after their functions have ceased, and these have the right to be considered as artistic. The Altamira paintings are a case in point. The war speeches of Churchill are now being widely printed and read as works of literature. The lithographs by Daumier which appeared for forty years in the periodical *Charivari* as cartoons making social comment are now collected and reproduced for their own sake.

FUNCTIONAL AND NONFUNCTIONAL ARTS

Figure 4-2. Stonehenge (ca. 1800–1400 B.C.) (Diameter of circle: 97 feet; height of stones above ground: 13½ feet. Salisbury Plain, Wiltshire, England. Photograph, British Information Service.)

Obviously, function plays a larger part in some arts than in others. Architecture is directly and almost entirely functional: buildings are always built for some special use. The applied arts also are almost entirely functional.

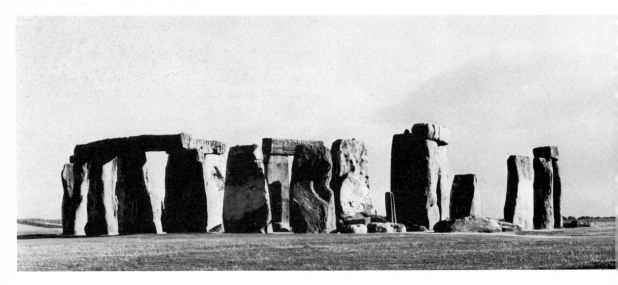

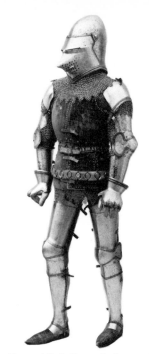

In fact, they are called "applied" arts because they have function. Metalwork such as gates, lamps, grilles, Chinese ritual bronzes, Christian religious objects, armor, weapons, tools, and coins; ceramics; glassware; stained glass; mosaic and tilework; textiles; enamelwork; furniture; and books are among the many types of applied arts, or crafts. Each of these examples is made for some definite and specific use. Moreover, in the applied arts, as in architecture, function is so important that it, rather than the name of the art, is used to identify individual works. Examples of those arts are ordinarily known by their direct function; although we speak of a painting, a poem, or a statue, we do not usually speak of a building or a piece of ceramics or metalwork; we say instead "a school," "a church," "a plate," "a saucer," "a suit of armor" (Figure 4-3).

If architecture and the applied arts are most directly functional, literature and painting are probably least functional, though there are many examples of writing and painting with a definite purpose. Picasso's *Guernica* and Daumier's *Rue Transnonain* were protests against abuses of their time. *Uncle Tom's Cabin* was written for the definite purpose of fighting slavery, and it did much to arouse antislavery sentiment before the Civil War. Oliver Wendell Holmes's short poem "Old Ironsides" was written to protest a naval order that the frigate *Constitution* be destroyed. This ship, known as "Old Ironsides," was famous for its exploits during the War of 1812. Holmes's poem—which begins with the familiar line, "Aye, tear her tattered ensign down!"—aroused so much response that the order to scrap the old ship was countermanded; her tattered flag was not torn down.

Expository and argumentative writing is indirectly functional insofar as it is designed to accomplish some definite end. Newspaper stories and pictures are also indirectly functional; they want to make clear the news. All advertisements, whether in words or in line and color, are functional in that they are designed to influence people.

Figure 4-3. Italian suit of armor (ca. 1400). (*Armor for man. New York, The Metropolitan Museum of Art, The Bashford Dean Memorial Collection, gift of Helen Fahnestock Hubbard, 1929, in memory of her father Harris C. Fahnestock.*)

FUNCTION IN MUSIC

Music in its origins was primarily functional, its two sources being dance and religion. The earliest peoples seem to have invoked their gods by beating the drum and singing, and from that time to the present music has been of primary importance in worship.

Dancing is also very ancient. As it has evolved, modern dance music includes the ballet and tunes for social and folk dances, such as the jig, waltz, minuet, fox trot, polonaise, mazurka, rumba, tango, and cha-cha. Rock is the most recent development. In dance, music is essential to mark the rhythm and so to keep the dancers together. It also sets the mood of the dance—lively, warlike, gay, courtly, graceful.

Closely akin to dance music are marches, work songs, and game songs. A march serves the same purpose as a dance in that it marks the time for people walking in a procession, whether it be a military occasion,

a wedding, or a funeral. Work songs mark the rhythm of work. Chanteys are sung by sailors when lifting anchor or loading cargo. The popular Russian folk song "The Volga Boatman" helped the tow-men in their struggle against the current of the river. Game songs are about halfway between dance and work songs. In "The Farmer in the Dell" or "London Bridge Is Falling Down," the song is sung as the game is played, and the song is an essential part of the game.

Certain compositions become identified with certain specific occasions. One march, "Hail to the Chief," is used for the President of the United States. Another, Handel's "Dead March" from *Saul,* is used for the funerals of the royal family in England. The Wagner and the Mendelssohn marches are so universally used in America for weddings that the wits have wondered if weddings are legal without them.

With the development of musical instruments, music outgrew its narrow dependence on dancing and ritual, and we now have much music that has no connection whatever with either dance or religion, such as symphonies, sonatas, and operas. On the other hand, many musical compositions retain a connection with their functional origin though they are no longer functional. Few of the polonaises and mazurkas of Chopin, for example, could be used as accompaniment for a dance, but they are still given the names of dances and resemble these dances in certain ways. Bach's great Mass in B minor is too long to be used for church services, but it retains the form of the Mass designed for church ritual. Lullabies and serenades may also be dissociated from their original use, yet they retain certain characteristics: the lullaby has a sweet melody and swaying rhythms; the serenade connotes night and love.

FUNCTION IN SCULPTURE

Sculpture is much more functional than painting or literature. Religion has for ages made great functional use of sculpture. The bronze doors which Ghiberti made for the Baptistery at Florence (Figures 4-4 and 4-5) are a magnificent example. They are so faultless that when Michelangelo saw them he exclaimed, "They are so beautiful that they might fittingly stand at the gates of paradise"—and they have been called the "Gates of Paradise" ever since.

In the medieval and Renaissance church, sculpture was frequently used for instructional purposes. The panels of the "Gates of Paradise," for example, record scenes from the Old Testament. In the first panel, as has been mentioned, the subject is the Creation. Several different scenes are presented; in the lower left-hand corner God is bringing Adam to life while the angels rejoice; in the center of the panel is the creation of Eve, with a circle of angels surrounding the figures. On the left, behind the creation of Adam, is the Temptation: Adam and Eve stand under a tree with the serpent coiled around it. On the right is shown the Expulsion.

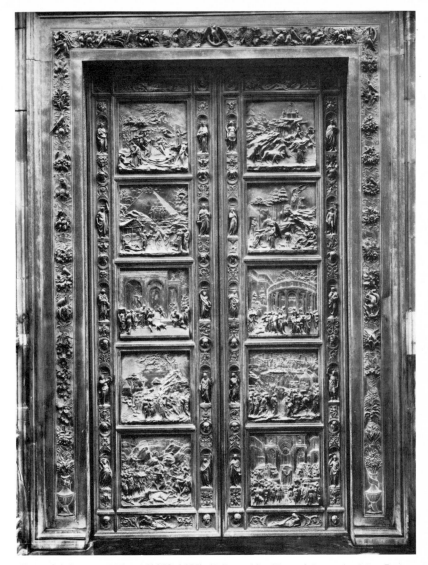

Figure 4-4. *Lorenzo Ghiberti (1378–1455), Italian goldsmith, sculptor, and painter. East Door, "Gates of Paradise" (1425–1452). (Bronze. Height of door: 16½ feet. Florence, Baptistery. Photograph by Alinari.)*

Adam and Eve have been driven from the garden by an angel, while God is seen far back in the heavens.

On one wall of the Gothic cathedral at Amiens is a calendar showing the signs of the zodiac. Each of the signs is represented by its symbol, and under it is a relief, of the same size and shape, which shows a

Figure 4-5. Lorenzo Ghiberti. The Creation, *detail of "Gates of Paradise." Height of detail: 3 feet, 10 inches. Photograph by Alinari.)*

Figure 4-6. Signs of the Zodiac, *with corresponding occupations (first half of thirteenth century). Details, basement of west facade. (Stone. Height of each quatrefoil: 2½ feet. Amiens, Cathedral. Photograph, Monuments Historiques.)*

typical occupation for that sign or month. The first of the three signs in our photograph (see Figure 4-6) pictures a goat, the sign of Capricorn, which corresponds roughly to the month of December. Shown under it is a man putting up meat for the winter. The middle relief shows a man pouring water—Aquarius—who stands for January. Under his is a table at which is seated a man with two heads who, like the month of January (from Latin *Janus,* the name of this two-headed personage), looks to both the new and the old years. February, the last of three signs, is represented by two fish, the sign being Pisces, "fish." Under them is a monk trying to keep warm. He has taken off his shoes and is warming his hands and feet before the blazing fire.

Another important function of sculpture is the commemoration of individuals, as in the Lincoln Memorial in Washington. Often a statue records an event of importance; the *Charioteer* probably commemorates a victory. Among sculptures that are not connected with architecture, fountains take an important place. The fountain is frequently used as a medium for telling a mythological or allegorical story; for example, the fountain by Carl Milles opposite the Union Station in St. Louis represents the union of the Missouri and the Mississippi rivers. A more recent monument of this type is the *Rotterdam Memorial* by Ossip Zadkine, commemorating those

who died in the bombing of Rotterdam at the beginning of World War II (Figure 4-8).

The tombstone is one of the opportunities for sculpture that is too frequently disregarded. But tombstones can and should be beautiful. Figure 4-7 shows an American tombstone of the colonial period, from New England. In Figure 4-9 and Figure 4-10 we have two examples from different ages: one is Greek of the fifth century B.C.; the other is recent American, the work of Augustus Saint-Gaudens.

Figure 4-7. Tombstone of Samuel Green (1759). (Detail. Lexington, Mass.)

Another functional use of sculpture is the coin. Every coin shows a relief: the Lincoln penny, the Jefferson nickel, the Franklin Roosevelt dime, and the Washington quarter. In the United States we are now paying more attention to the designs on coins than we did fifty years ago. It is interesting to note how the spirit of a country is reflected in the designs on its coins. Ancient Greek coins are as important artistically as ancient Greek monumental sculpture and as typical of their times (Figure 4-11.)

FUNCTION IN ARCHITECTURE

Architecture is the only one of the major arts that is directly functional. It is also the art in which the proper performance of function is most important. Buildings are large and expensive, and they cannot easily be replaced. If a chair is not comfortable, we can buy another and use the uncomfortable one only when we have company. But we cannot treat architecture in any such way. If a building does not function, we have to put up with an inconvenient and inefficient structure. Therefore it is in architecture that we see most clearly the influence of functional demands.

Figure 4-8. Ossip Zadkine (1890–1967), *Dutch sculptor. Monument for a Devastated City (1953). (Netherlands National Travel Office, New York.)*

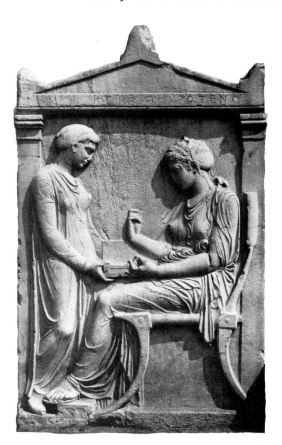

Figure 4-9. Hegeso Stele (*late fifth century* B.C.). (*Pentelic marble. Height: 4 feet, 10½ inches. Athens, National Museum. Photograph by Alinari.*)

Figure 4-10. Augustus Saint-Gaudens 1848–1907), American sculptor. Adams Memorial (ca. 1891). (Bronze figure, granite setting. Height: 4 feet, 1 inch. Washington, D.C., Rock Creek Cemetery.)

Figure 4-11. Greek coin (fifth century B.C.). (Silver. New York, Metropolitan Museum of Art; gift of J. Pierpont Morgan, 1905.)

These can be traced to demands that arise from climate and those that come from social conditions.

Factors Influencing Function in Architecture

CLIMATE With central heating, structural steel, and air conditioning, it is possible to build any kind of house in any climate; nevertheless, climate is still a factor of which everyone is acutely conscious. Is the climate wet or dry, hot or cold, sunny or dark, even or variable, windy or calm? In countries where there is strong wind, the house is planned with windbreaks and the living rooms are put in protected areas away from the wind, whereas in warm climates with temperate winds, the house is planned to take advantage of the prevailing breeze. In a cold climate, emphasis is placed on building for warmth; in a warm climate, it is placed on the attempt to keep cool. When the climate is mild, the primary function of the wall is to ensure privacy and to keep out the sun and rain; hence, it may be of very light material. In China and Japan, for instance, the walls are merely sliding screens.

The size and number of the doors and windows are likewise determined largely by climate. In hot southern countries, where the sun is blinding, the object is to shut out the light; accordingly, in Spain and in Egypt the windows are small and few. In the northern countries, where there is much rain and the winters are long and dark, the demand is for more light, and the windows are large and numerous. The shape of the roof depends primarily on the amount of rain and snow. A flat roof is found in warm, dry countries, as in Egypt and Greece, where the roof can be used as an extra sitting room or as a bedroom on warm nights. But a flat roof is practical only in a dry climate. Where there is rain it is usually found best to tilt the roof to make it easier for the water to run off. The degree of slope is determined partly by the amount of rain. In countries where there is much rain the roofs are more steeply pitched than in countries that have only a little rain. The amount of snow is an important factor also. Snow is very heavy; a large quantity will break through a roof; hence, in mountainous countries where there is a great deal of snow, the roofs are very steeply pitched and are left unbroken by windows so that the snow will slide off. The steeply pitched, broken roofs that are found on the châteaux are useful in France, where there is much rain and little snow, but they would not be practical in the Alps. In China there are very heavy rains during the monsoons. Accordingly, the roofs are steeply pitched and project over the house; at the eaves they are turned up to admit light.

Here in the United States both the northern and the southern states have beautiful examples of the colonial type of architecture. But there are interesting differences due primarily to differences in climate. In the South there are many more verandas than in the North. And in the South the columns of the porch often extend to the roof in order to shade the windows of the second story. There is a difference, too, in the arrangement of the

buildings. In New England, because of the cold and the snow, the barn and the other outbuildings were often attached to the main residence so that the men of the house could do the chores without going out in the cold. In the South, with its mild winters, the outbuildings were scattered all around the yard as separate structures. Even a rather modest house would have a smokehouse (for meat), a hen house, a carriage house, probably an ice house (for storing ice), and a cellar (for keeping food cool), as well as the barns.

SOCIAL FACTORS The term *social factors* is used here to mean all those elements in architecture that are determined by man, in contrast to those that are governed by nature. A first consideration in any building is the use to which it is to be put, its function in the narrower sense of the term. A building is designed for a special purpose: it may be an office building, a church, a residence, a garage, and so on. These primary functions are influenced by the physical conditions—climate, as we have just seen, and terrain—but they are even more dependent on social forces. In olden times there was always need for protection. Castles and fortifications were made with very thick, strong walls, as defense against the enemy. Palaces had to be strong enough to ward off possible attack. The palace which Michelozzo built for Cosimo de' Medici served both as palace and fortress (Figure 4-12).

Another example of social influences on architecture can be found by comparing buildings designed as places of worship (Figure 4-13). To Christians a church or a cathedral is primarily a place where large numbers of people can assemble, because corporate worship is an integral part of the Christian faith. Hence the cathedral at Amiens is large, the construction is open, and it will hold many people. The Greeks, on the other hand, had no service in the same sense; their gatherings for religious purposes were infrequent and were held out-of-doors. For them the temple was primarily a shrine for the statue of the god, and in consequence their temples were small, accommodating only a few people at a time. The Parthenon, though large for a temple, is only about one-fourth the size of the cathedral at Amiens. And small as is the Parthenon, it was divided into two rooms: a large room in which the statue of Athena was kept, and a smaller one for the treasures. The Erechtheum, another Greek temple, is even smaller. The Egyptian temple had a different arrangement because the ritual was different. In Egypt the temple was primarily a sanctuary which could be visited only by the Pharaoh and the priest. In front of the sanctuary was a series of rooms to which other people were admitted according to their rank. An Egyptian temple such as that at Edfu consisted of four parts: first, the pylon, a huge gateway covering the entire front of the building; second, a large open court accessible to everyone; third, a hall, or hypostyle, made up of columns. This hall, which was dimly lighted because the columns covered the entire floor, was reserved for dignitaries who occupied a position midway between the people and the Pharaoh. And finally, there was a small inner sanctuary for only the priest and the king.

Figure 4-12. Michelozzi (1396–1472),
Italian architect. Medici-Riccardi Palace.
(Stone. Length: 300 feet; height: 90 feet.
Florence. Photograph by Alinari.)

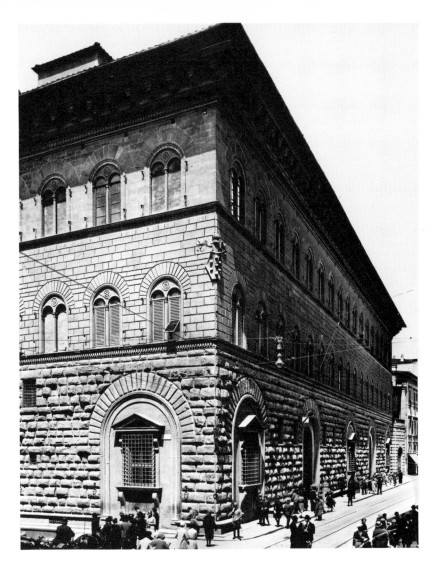

Figure 4-13. Floor plans showing relative
size of Erechtheum, Parthenon, temple
at Edfu, and Amiens Cathedral.

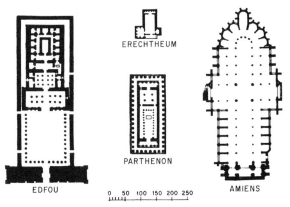

Figure 4-14. RCA Building (1929–1939). Reinhard, Hofmeister, Corbett, Harrison, MacMurray, Hood, and Fuoilhoux, architects. (New York, Rockefeller Center, Inc.)

Sometimes the government steps in with laws which affect architecture, though these may not be directly concerned with building as such. A tax on the number of windows, for instance, will result in houses with fewer windows. It is supposed that a tax on the number of stories of a house had much to do with the development of the mansard roof, which gave all the space of an extra story though technically it was only an attic. One interesting example of this type is to be found in the zoning law of New York City. This law was made necessary by the skyscrapers, for if very tall buildings are placed on each side of a street, the street between will be dark, like a very narrow canyon. The purpose of the law is to ensure that a street should always have the proper amount of air and sunshine, and it accomplishes this end by regulating the height of a building in proportion to the width of the street and the size of the lot. An imaginary triangle is drawn with the lot as its base, and the law requires that the building should not project beyond that triangle, except for a tower not to exceed one-fourth the area of the plot. In order to utilize their plots to the best advantage, builders have designed structures in which the upper floors are set back from the lower floors. In the RCA building (shown in Figure 4-14) there are a number of such setbacks before we reach the central tower, the height of which is not restricted by law.

FORM FOLLOWS FUNCTION

Whenever art has function, the function influences and often determines the form. This is just another way of stating the obvious fact that if an object is made for a certain function it should be made in such a way that it can perform that function. As the function changes, the form changes, and if there are many functions there will be many forms. Take an object of everyday use such as a spoon. There are spoons for babies and spoons for adults, spoons for cooking, spoons for eating, spoons for serving, deep spoons and shallow spoons, spoons with long handles, and spoons with short handles. Even a rather small household will have a variety of spoons because there are a variety of functions to be served by them. Door keys offer another interesting example. Keys are now carried by many people, and one person often has to carry more than one key; accordingly, keys are small. But when gates and doors were in the charge of special porters who were always in attendance, keys were large and massive; they were in fact a visible symbol of the power and importance of the place to be locked.

These examples have been taken from the industrial arts, but instances may be cited from any art that is functional. A lullaby must have a rocking rhythm to soothe the baby. A march or a jig must keep the time exactly so that one may march or dance in time to it. A coin must be small and flat, and any decoration on it must also be flat.

FUNCTION AND BEAUTY

Some arts are functional and some are not. Is there any relation between function and value as art? Can we say that functional arts are greater or less great than arts that are not functional? The value of any work of art depends on the work itself, not on its being functional or nonfunctional. Architecture, which is always functional, is not superior or inferior to painting or poetry, which are usually nonfunctional. In the evaluation of two works of art, the presence or absence of function, just like the presence or absence of subject, is a matter of no consequence. If one were asked to name the world's greatest works of art he could certainly include the plays of Aeschylus and Shakespeare, the cathedrals at Chartes and Amiens, and the symphonies of Brahms. The plays have subject but no function; the cathedrals have function but no subject; the symphonies have neither subject nor function.

In the evaluation of functional art, however, the problem is different. Obviously the function should be known if the work is to be understood; if it is a birdbath or a saltcellar, it should be known as a bath for birds or as a container for salt when it is judged. It cannot be adequately judged just as a shape.

But when the function is understood, is there any relation between the function of a work and its value as art? Yes; in a general way there is. There has been a great deal of discussion on this point, and any statement may be contradicted by excellent examples to the contrary, but it will usually be granted that a functional object is not beautiful unless it can perform its function adequately and acceptably. If it is desirable for people to see and hear in church, a church should be constructed so that they can see and hear in it. A chair that is uncomfortable is not so good as one that is comfortable. A residence should be so planned that the business of housekeeping may be carried on in it with the maximum of ease and efficiency. A beautiful teapot that is useless is like a beautiful bridge one cannot cross or a beautiful car that will not run.

In this respect we must admit that the saltcellar of Cellini fails if considered as a saltcellar. The figures are well conceived and executed, but the whole is too elaborate for its function. On the other hand, it was a custom at this time to have on the table a large and elaborate saltcellar known as "the salt." The salt was placed before the master of the house, between him and the guest of honor, serving to indicate rank: for this social use the Cellini saltcellar was admirably adapted.

In fact, adequate performance of function usually tends to produce beauty of design. Why this should be true we do not know, but it is true. The shapes in nature that are the most beautiful are also the most efficient, as the wings of a bird. Practical design offers many examples; everything is eliminated except what is essential, and the result is beautiful. Examples of such shapes are found in the canoe, the canoe paddle, the handle of an ax or a scythe, the blades of an electric fan.

Nevertheless, it is true that, although efficiency does make for beauty, efficiency and beauty are not the same. An article that adequately performs a function is not necessarily beautiful. Art demands something beyond function, something in addition to efficiency and proper performance of function. The shape of a spoon may be the best possible for its particular function, but the spoon is not for that reason a work of art. In the economy of nature the best shape for an object's use *tends* to be the most beautiful, but it is our pleasure in the shape and not its usefulness that makes us consider it as akin to art.

PART TWO
MEDIUM

5. MEDIUM— GENERAL CONSIDER- ATIONS

DEFINITION

Many widely diverse objects go under the name of art. A song, a sonata, a symphony, a statue, a skyscraper, a tapestry, a tragedy, a teapot, a poem, a painting, a palace, an oratorio, a cathedral, a chest, an etching, an engraving, an epic, a dance, a novel, a lyric—all these and more are classed as art. A single reading of this list, however, is sufficient for certain obvious classifications. The song, the symphony, the sonata, and the oratorio belong to the art of music; the cathedral, the palace, and the skyscraper are examples of architecture; the poem, the tragedy, the epic, the lyric, and the novel are literature. The basis for these classifications is primarily the way the artist has communicated his idea to us—his medium. The word *medium*, which comes from the Latin word *medium*, signifying "means," denotes the means by which an artist communicates his idea; it is the stuff out of which he creates a work of art. Architecture makes use of wood, stone, brick, concrete; sculpture makes use of steel, marble, bronze, wood; painting makes use of colored pigments on wood or canvas.

Medium is essential to art. Subject and function, as we have seen, are not essential. There is art without subject and there is art without function, but there is no art without medium. A work can exist only in some medium. And the names we use to designate both the art and the artist are derived from the medium. The poem we have examined by Elizabeth Bishop and Wagner's *Flying Dutchman* were both inspired by the idea of a storm. Bishop, who used words in poetic form to express her idea, is called a poet; Wagner, who used tones, is called a musician or composer.

On the basis of medium, the arts are primarily classified as *visual* and *auditory*. Painting, sculpture, architecture, tapestry, and glassware are

examples of visual arts; they are seen. Music and literature are auditory arts; they are heard. Even when one reads silently a musical score or a page of poetry, he hears the sound in his mind. On the basis of medium also, the arts are classified as *time arts* and *space arts*. The visual arts are space arts. The auditory arts are time arts. Theater, opera, and cinema are known as *combined arts*, being both visual and auditory, existing in both space and time. Though it is largely visual, dance is classed with the combined arts because it exists in both time and space.

By a third classification on the basis of medium, the arts are divided into *major* and *applied*, or *minor*, arts. The five major arts are music, literature, painting, sculpture, and architecture. The applied, or minor, arts are metalwork, weaving, ceramics, glass, furniture, photography, lettering, bookmaking, and the like. The terms *major* and *minor*, however, are of no importance in determining the value of any single work of art. A good piece of glass or porcelain is better than a poor painting; a beautiful Oriental rug is greater than a poor statue; a good saltcellar is greater than a poor building. The five great arts deserve the name *major* not because there is anything necessarily great about them as such, but because more very great works have been made in those mediums than in the arts that are designated "minor." Another distinction between the major and minor arts is that the major arts generally express an emotion or idea—or both— while the applied arts generally do not. It is important to note that any work of art is great or not great in and of itself and should be judged thus, without consideration of its classification.

THE ARTIST AND HIS MEDIUM

An artist chooses the medium that can best express what he wants to convey. Often an artist will use more than one medium. William Blake, for instance, used words in some of his works, as in "The Sick Rose."

O Rose, thou art sick!
The invisible worm
That flies in the night,
In the howling storm,
Has found out thy bed
Of crimson joy,
And his dark secret love
Does thy life destroy.
 —William Blake, British poet and artist (1757–1827),
 from *Songs of Experience* (1794)

He also created visual art, as in his print "When the Morning Stars Sang Together" (Figure 3-18, page 64), where the medium is engraving. He also used a third medium, watercolor. In each case he chose the medium

that seemed right for the idea he was expressing. Thus it is quite safe to say that the idea expressed in "The Sick Rose" is essentially verbal and poetic, that it would be rather difficult to express it visually. In the print, he has admittedly taken a difficult poetic image to illustrate, but the presence of the host of stars and the division of the different types of beings into rows or levels have made it possible for him to express the idea in pictorial terms.

However, the words *choice* and *selection* used in connection with the determination of medium give a false impression, for they imply that the artist makes a deliberate choice. This is not so. The artist does not make a conscious, reasoned choice of his medium; the selection of medium is a part of the artistic inspiration. The idea which Blake put into a poem came to him as an idea for a poem. That for the engraving was for an engraving. He did not have an idea out of which he might make a poem *or* an engraving. When the unknown Greek sculptor of the fifth century before Christ made the bronze statue of Zeus now at the National Museum in Athens (Figure 5-1), he chose sculpture because what he wanted to convey demanded volume. The poet is a poet rather than a painter because he thinks in terms of words. As one poet said, "When I enjoy a scene, I find myself hunting for words that will exactly express the impression it has made on me."

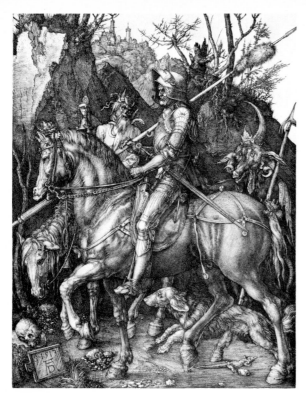

Figure 5-2. Albrecht Dürer (1471–1528), German artist. The Knight, Death, and the Devil (ca. 1513). (*Engraving. Size: 9¾ by 7¼ inches. New York, Metropolitan Museum of Art.*)

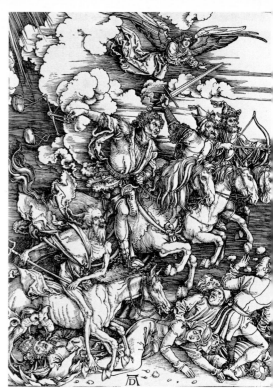

Figure 5-3. Albrecht Dürer. The Four Horsemen of the Apocalypse (ca. 1498). (*Woodcut. Size: 15¹³⁄₁₆ by 11½ inches. Boston, Museum of Fine Arts.*)

Moreover, the artist thinks in terms of a specific medium. Two of Dürer's great prints are of horsemen; for one the artist has used engraving, for the other woodcut. He chose each medium to express the exact idea he wanted to make clear in that print. The engraving (shown in Figure 5-2) is called *The Knight, Death, and the Devil.* The knight probably represents the Christian who is not led astray by temptations. A very serious and praiseworthy person, he rides across the picture apparently bound for the ideal city shown against the sky. He pays no attention to his companions: Death, who holds an hourglass before him, and the Devil, half pig and half wolf. The woodcut is called *The Four Horsemen of the Apocalypse* (Figure 5-3). According to a passage in the New Testament (Revelation 6) the first horse is white, and its rider, who carries a bow, "went forth conquering and to conquer." Some think Christ is this conquering rider. The second horse is red and symbolizes war; its rider, who carries a sword, drives peace from the earth. The third horse, which is black, represents

famine; the scales in the hands of its rider show that food is scarce and must be weighed. Last is a pale horse, "and his name that sat on him was Death."

A sculptor plans his statue not for wood in general but for oak or mahogany. The architect does not plan a house and then decide whether it shall be of brick, wood, or stone; the demands of brick, wood, and stone are different, and he must design his house according to his material. The jeweler does not imagine a design and then say, "Shall I make it in copper or gold?" It is a design for gold or a design for copper. The artist thinks and feels in terms of his medium.

Moreover, the artist loves and respects his medium for itself; he uses it because it has certain qualities, and he tries to bring out and emphasize those qualities. The sculptor gives life to his statue not by denying that it is wood or stone, but by incorporating the qualities of wood or stone into the meaning of the sculptured piece. In the statues of Henry Moore, we are always conscious of the texture of wood as wood, or bronze as bronze. To the poet the words are the poem. They are not one of many ways he has found to express his idea; they *are* the idea. His poem cannot be separated from the words of the poem.

In studying any work of art, therefore, it is always worthwhile to ask why the artist "chose" (in our qualified sense) the medium in question. Why did Wagner give the sword theme to the trumpet? Why did the sculptor of the statue of Zeus want it in bronze? Why did Dürer use engraving for *The Knight, Death, and the Devil* and woodcut for *The Four Horsemen of the Apocalypse?* How do these works suit the inherent qualities of the medium chosen? We can surmise that Dürer used engraving for *The Knight, Death, and The Devil* to show the variety of nature and man; he also wanted to achieve a high degree of light and shadow to give the man and the

Figure 5-4. Ludovisi Throne (*ca. 460* B.C.). (*Marble. Height at center: 3 feet, 4½ inches. Rome, Terme Museum. Photograph by Alinari.*)

Figure 5-5. Alexander Calder (1898–), American sculptor. Lobster Trap and Fish Tail (1939). (Mobile. Steel wire and sheet aluminum. Size: 8½ feet high, 9½ feet in diameter. New York, Museum of Modern Art; gift of the Advisory Committee.)

Figure 5-6. Pablo Picasso. Outdoor Sculpture (1967). (Steel and concrete. Height: 50 feet. Chicago Civic Center. Photograph © Pub. Bldg. Comm., Chicago.)

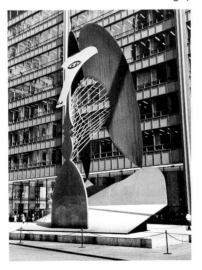

horse a sculptural effect. Both these aims are easier to achieve with engraving than with woodcut. The *Four Horsemen of the Apocalypse* produce an emotional and dynamic effect for which the generalized technique of the woodcut is far more suitable. Wagner's sword theme was probably given to the trumpet because the trumpet symbolizes war. The Greek sculptor may have used bronze because a free-standing marble figure would have been impossible: the weight of the body would have broken the legs.

We must remember, of course, that traditional sculpture was far more influenced by medium than contemporary sculpture is. We can say that sculptors like Michelangelo and the Greeks were influenced by the availability of marble (although they occasionally chose bronze, as in the case of the Greek Zeus). Traditional sculpture was far more tied to the availability of Carrara or Pentelic marble and to the needs of architectural decoration than is the case today. When Picasso does one of his "public sculptures" (Figure 5-6), he is responding more to his own stylistic evolution than to the availability or desirability of sheet metal.

It is interesting, and important, to note that today the hard-and-fast distinctions between certain mediums are breaking down. For example, the distinction between free-standing sculpture, such as Michelangelo's *David* and relief sculpture, such as the *Ludovisi Throne* shown in Figure 5-4 and discussed below, is no longer always valid. How is a mobile by Calder (his *Lobster Trap and Fish Tail*, discussed below, is shown in Figure 5-5) to be classified, for example? Moore's *Two Forms*, which we have already seen, tends to demolish the idea of solid masses as a necessary characteristic of sculpture.

THE DISTINCTIVE CHARACTER OF MEDIUM

If what is said in one medium cannot be said in another, it follows that no work can ever be translated from one medium to another. There is no argument about this point if it is a question of two different arts. A description of a scene and a painting of the same scene do not tell the same story; inevitably what they say is different. And the same is true, though to a lesser degree, when it is a question of two mediums within a single art. If the artist's intuition demands a statue of marble, it follows that a copy of the statue in bronze will miss something which the artist considered essential to the original.

It is in music and literature that the problem of translation arises most often. Music that was written for the orchestra is arranged for piano and music written for piano is arranged for orchestra. Works in foreign languages are translated into English, and English works are translated into foreign languages. In this kind of translation, something of the original is always lost or changed. Every time Stokowski transcribes the music of Bach, the result is Stokowski as well as Bach. Gilbert Murray's translation

of Euripides show us Euripides plus Gilbert Murray. The orchestral score of *The Afternoon of a Faun* transcribed for piano has lost something that was essential to the music. Even when a great artist like Casals plays a Bach prelude on the cello, we have lost something of the original conception.

On this point, however, a caution is necessary. It is better to know a Greek play in translation than not to know the play. It is better to hear Bach arranged by Stokowski than not to hear Bach. It is better to know the famous masterpieces of painting and sculpture in reproductions than not to know them at all. One should strive not to be too much of a purist, on the one hand, or too easily pleased, on the other; one should not refuse to know Bach's music as played by the orchestra, but one should hear it on the harpsichord if he has the opportunity. It is well to study the works of Botticelli in reproductions until one has a chance to see the originals. One should read translations from the Greek but remember that he will understand Sophocles and Euripides best when he reads their plays in the original Greek.

The problem of adapting a work of art from one medium to another is perhaps most familiar to us in the form of literature made into film drama. Examination of a film adaptation of a literary work will also show some of the differences between the art of writing and the art of film. This will serve as an example of what distinguishes one medium from another, and of what sort of artistic and social value an adaptation may have. To a certain extent, the film version of a literary work spoon-feeds the viewer. More demands are made on someone reading a literary work than on someone watching a film, in general; for example, the reader may have to use his imagination to fill in details. Yet a panoramic novel like Tolstoy's *War and Peace* may be brought to new life by means of film, which can use costume, landscape, architecture, and interior design to re-create the portrait of early nineteenth-century Russia. A psychological novel, though, may suffer very much in "translation" to film, as is shown by Luchino Visconti's film treatment of Thomas Mann's *Death in Venice*, which has been mentioned already. (The film was a prize winner at the Cannes film festival.) Those who are familiar with Mann's short, evocative novella of the twentieth century, with its subtle atmosphere of a doomed city, may well find unbearable the panoplied costume movie set in a fashionable watering place and the endless self-recriminations of its hero. The whole idea and purpose of Mann's *Death in Venice* has been changed. Where the original leaves us with a feeling of irremediable regret and nostalgia, the end of the film leaves us with a feeling of pity for the guilt-ridden but still innocent hero who has gotten nowhere near the object of his forbidden love, a beautiful Polish boy. Mann's hero (a writer, not a composer as in the film) is committed to an unending search for ideal beauty rather than beautiful boys. His discussions of this problem with a colleague, typically abstract in the fashion of that time and that intellectual level, make good sense in the novella. In the more factual medium of the film, however, it becomes difficult to take these two quite seriously. In the book, they did

not have to be as "forceful" or even as "interesting" as it seems film cha
acters must be. Another point is that Mann's novella is not as long
elaborate as a feature film. A poetic vignette like *Death in Venice*, perhap
ought to stay in the form in which it was created. This is not meant
imply that literature should not be translated into film. The comments c
the film version of *War and Peace* have suggested that film can add to th
reader's enjoyment. Novels of this kind, which evoke a whole period
history, tend to make good films. Such novels include Hemingway's *F*
Whom the Bell Tolls, a story of the Spanish Civil War of the 1930s, and th
very recent treatment (1971) by Paolo Pasolini of Boccaccio's *Decamero*
a lusty reconstruction of fourteenth-century Florence during an outbre
of the Black Death. Where the original literary work is a play, the film ve
sion may offer to the average viewer the advantage of widening the confine
of the play. In the film versions of *Romeo and Juliet*, we lose the most subt
moments of the play, but the films seem to bring the period and its peop
to life in a way that must prove very valuable to the modern viewe
Lawrence Olivier's film version of Shakespeare's *Henry V* (Olivier also pe
forms the title role) is an excellent evocation of the importance of Agincou
in the conflict between the English and French. Many people who hav
never shown any interest in Shakespeare come away from the film versio
of *Henry V* with their first real idea of what he is all about.

INFLUENCE OF MEDIUM ON CHOICE OF SUBJECT

Sculpture

The nature of the medium inevitably influences the type of subject it ca
portray. Traditionally sculpture in the round has tended to emphasize mas
and weight, and its subjects are objects of definite form and solidity. Tree
and clouds are not common in sculpture. Moreover, the sculpture of th
past has been limited almost entirely to the bodies of animals and, espe
cially, the bodies of men. It has emphasized not only the human body bu
in large measure the nude human body. We do not really suppose tha
David was naked when he fought Goliath, but the body of David is mor
nearly ideal when it is naked, and therefore better suited to the meanin,
and purpose of the statue. When clothes are used, we want them to b
simple and straightforward, as in the figures of the caryatids of th
Erechtheum.

Sculpture in relief, unlike sculpture in the round, has a background t
which figures are attached, and because of this it can show more kinds c
subjects with more varied backgrounds. On the background may be carve
many subjects not so appropriate to sculpture in the round: trees, clouds
birds, fish. In the famous "Gates of Paradise" Ghiberti seems almost a
free as a painter in his choice of subject. In the so-called *Ludovisi Thron*
(shown in Figure 5-4), which is supposed to portray the birth of Venus
the goddess is being lifted from the water by two attendants. The repre

sentation of cloth, especially the delineation of the form seen through the cloth, is exceptionally fine.

With the interest in abstract art there have developed new styles, as we have seen in Moore's *Two Forms*. This new sculpture differs from older forms in treatment of medium as well as in subject. Whereas older sculpture is solid, the new sculpture is often hollow, playing up concave as well as convex surfaces. Thin strips of metal are combined with plastic or glass, even with wood and wires, to make interesting arrangements. Often they are suspended where they can move, and one gets various lights and shadows from them. Such sculptures, called "mobiles," are associated primarily with the name of Alexander Calder. An example is *Lobster Trap and Fish Tail* (shown in Figure 5-5), which hangs in the stairwell of the Museum of Modern Art in New York City. Of his mobiles Calder said in 1951: "The idea of detached bodies floating in space, of different sizes and densities, perhaps of different colors and temperatures, . . . some at rest, while others move in peculiar manners, seems to me the ideal source of form."[1]

Although abstract, *Two Forms* and *Lobster Trap and Fish Tail* are still tied to concrete subject matter, as their titles show. In some works more recent than these, sculptors have produced entirely subjectless art—pure exercises in form and space. Examples are found in the works of Tony Smith and Anthony Caro. Here a minimal amount of traditional subject matter and aesthetic content prompts the sculptor to utilize the barest kind of mechanical materials (Figure 2-5, page 23).

Painting

Traditional painting has a much wider field than sculpture; it may concern itself with anything in space. Whatever can be seen can be painted: lakes, trees, clouds, houses, mountains, fields, anything that has form to the eye either in reality or in the artist's mind.

Traditional painting and sculpture are both limited in time. Each can represent its object only at a single moment of time. In life the running horse or the smiling girl does not stay the same for ten consecutive seconds; the sculptor or the painter chooses, and preserves the object at, one instant. He may create a feeling or an illusion of movement so that we are conscious of the action that is taking place or is about to take place. In El Greco's *Resurrection*, Christ seems to be really rising out of a mass of bodies. In Botticelli's *Birth of Venus*, the goddess is being blown to the shore. Even in Ghirlandajo's *Old Man and Boy*, we feel that it is just for a moment that the figures will be in these positions, that one or both will move very soon. In each case the artist is showing the characteristic motion or gesture of the person about to move; we feel that the next second there will be movement; but the scene as presented is still—the action does not change.

[1] Alfred H. Baer, Jr. (ed.), *Masters of Modern Art*, p. 148.

Early in this century there was a great deal of talk about a painting by Duchamp called *Nude Descending a Staircase* (shown in Figure 5-7). The artist was trying to picture just what the title indicates, the appearance of a form in motion. He did this by presenting a succession of pictures of the same thing from slightly different points of view. Some modern artists, notably Picasso, have given a sense of movement to a painting by presenting at one time different aspects of a head or figure. Here, as in everything connected with art, we must admit that all standards are empirical—that is, derived from experience. The artist may do anything he can do. In other words, if Duchamp and Picasso can persuade us that we can see action in a painting and that we like to see action portrayed in that way, then painting becomes a medium for the portrayal of action.

Literature

Painting allows a wider range of subjects than sculpture, but literature allows a wider range than painting; while painting can present anything that might be seen, literature can present anything that can be put into words. Moreover, it is not limited to a second of time as are the visual arts. Literature can describe a situation at any given moment and can tell what happened before and after that time. Literature differs from the other arts in another respect. Since the language of literature is the same as the language of abstract thought, it can express abstract thought as the other arts cannot. Shakespeare can have Hamlet say, "There's a divinity that shapes our ends, rough-hew them how we will" (*Hamlet,* V, ii, 10–11). It is hard to imagine representing this idea pictorially. The sculptor or the painter may portray a thoughtful face; the musician may make one think; but none of the three can express a thought as clearly as the writer.

On the other hand, imitation through literature is less exact than imitation through either painting or sculpture. A statue of a dog may conceivably be mistaken for the living dog, but a poem about a dog will never be. And yet the poem may call to mind the characteristics of a dog better than the statue.

Music

As we have seen, music can never portray any subject clearly. And since music can only suggest the subject, it can suggest any subject. Subjects that cannot even be put into words can be expressed in music. Vague ideas, half-formed opinions and emotions, feelings that can never be given tangible form—all these are found in music. To the extent that music permits the imagination its greatest scope, to the extent that it draws in the individual to make his own, almost limitless, interpretation of and contribution to the meaning of the music—to that extent music becomes the most subjective and personal of the arts. Almost everyone has experienced the variety and richness of the response to music; and each time we listen to a composition, we may find something new, something we had not heard before.

Figure 5-7. Marcel Duchamp (1887–), French painter. Nude Descending a Staircase, No. 2 (1912). (Oil on canvas. Size: 58⅜ by 35⅜ inches. Philadelphia, Museum of Art; collection of Louise and Walter Arensberg.)

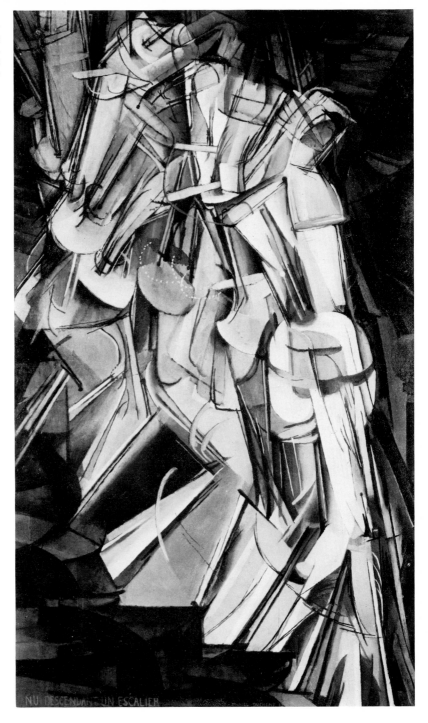

LIMITATIONS AND POSSIBILITIES OF MEDIUM

Although the artist is free to use any medium that seems right to him, he must work within the limitations of his medium. Each medium has its own possibilities and limitations. What Blake says in words in "The Sick Rose" he cannot say in engraving, and what the Greek sculptor of the statue of Zeus says in bronze could not be said in words or in engraving.

The limitations and possibilities of medium can be illustrated clearly if we compare the use of a single subject in several mediums. Take, for instance, the myth of Orpheus, the great musician who went to the world of the dead to demand back his wife Eurydice. His request was granted on condition that he should not look at her until he had reached the upper world. But just before he arrived he looked back, and his wife was lost.

Figure 5-8. Orpheus and Eurydice (ca. 430 B.C.), Roman copy in Pentelic marble of marble original. (Height: 3 feet, 10½ inches. Naples, National Museum. Photograph by Alinari.)

This legend was the subject of a Greek relief of about the fifth century before Christ (shown in Figure 5-8), though the work is known only in a Roman copy. The sculptor had to choose one second and only one from the entire story. He chose the moment just after Orpheus had looked around, when both Orpheus and Eurydice realized that she must return to Hades. In that one instant he has had to show all the love and longing of the lovers. The legend says that when Orpheus turned, Eurydice disappeared. Sculpture could not show a person in the act of disappearing, and therefore Hermes, the messenger of the gods, is shown waiting to take Eurydice back to the realm of Pluto.

This change in the story, however, shows how what seems a limitation of the medium becomes an opportunity, for the sculptor shows the contrast between the mortals and the gods, not in physique but in attitude. The mortals, Orpheus and Eurydice, are pathetic in their fruitless yearning and powerlessness; the god is patient, conscious of the inevitability of the gods' decree, but quite detached from the sufferings of men.

The story is told again by Ovid, a Latin poet who lived about the time of Christ, in his *Metamorphoses*. Since he was using words, Ovid could give minute details of all kinds. He told, for instance, how the wild beasts and even the trees and rocks responded to the playing of Orpheus. He described the bad omen at the wedding when Hymen's torch smoked, and how Eurydice, while running away from the unwelcome advances of a shepherd, was bitten by a snake and died. Orpheus, inconsolable, at last made the desperate resolve to seek her in Hades. Playing on his lyre, he passed all the people being tortured there. Finally, he reached the throne of Pluto and Proserpine, where he declared boldly that if they would not give him back his wife, they would have a new inhabitant of Hades, for he would not leave without Eurydice. They agreed that she might go on condition that he should not look behind to see if she were following. When he had almost reached the entrance, he looked back; and she disappeared. Later, some Thracian maidens tried to captivate him, but when he refused to have anything to do with them, they tore him to bits and threw the pieces into the river.

Gluck, an eighteenth-century German composer, used the story in his opera *Orpheus and Eurydice*. The change in medium again necessarily involved changes in presentation. In the first place, an opera is limited in time, and singing is much slower than speaking. Therefore, the story had to be shortened; the opera begins after the death of Eurydice and ends with the departure from Hades. Moreover, it would be impossible on the stage to show the various punishments of Hades: Ixion is on a fiery wheel, the daughters of Danaüs are carrying water in a sieve, Tantalus is immersed in water up to his lips. Instead, Gluck introduced bands of Furies who assail Orpheus and challenge his approach. The most interesting change comes in the return of Orpheus and Eurydice. Ovid says simply that Eurydice followed Orpheus until they were almost out in the world. Orpheus was, of course, playing on his lyre, but there is no other indication as to what was happening on the journey. Such a scene would be difficult if enacted on the stage—a man singing and a woman following in silence. Hence, Eurydice is made to talk. She asks where they are going. Why does Orpheus not look at her? Has he ceased to love her? At last she says in desperation that she would rather be back in Hades if her husband does not love her anymore. At this Orpheus can stand it no longer: he turns, and she disappears. (It is not important for our study to notice that in this version the god Amor—love—brings her to life again, saying that the lovers have suffered enough, and Orpheus and Eurydice leave Hades happily.)

PRESERVATION OF ART

Since art can be known only as it is expressed in some medium, it is lost if the medium is lost. We cannot study the architecture of Mesopotamia as we can that of Greece, for the houses were made of sun-dried brick and almost all of them have been washed away. The Angles and Saxons, when they settled in England, must have known many stories about the heroes of their native land; but only one of these stories, *Beowulf,* was written down; the others have been forgotten.

About some of the lost works of art a great deal is known. The great statue of Athena called the *Athena Parthenos,* for which the Parthenon was a shrine, was described by the historians. It was about forty feet in height, and it was made of gold and ivory. Standing as it did in the Parthenon, lighted by the beams of the early morning sun, it must have been an object of rare beauty. But the statue itself has not been preserved; there are two known copies that are inadequate, and while we may learn various facts about the statue, we cannot experience its beauty. Other examples might be cited almost indefinitely, but the point is clear. If the medium of a work of art is gone, the art is gone. It is therefore extremely important that the medium be preserved.

In this matter of preservation we find a sharp difference between the

visual and the auditory arts. The visual arts are material realities and as such can be preserved. A painting, a statue, a building, even a bit of embroidery or lace may be kept; and when we want to study it we can see the original work. It may not be in as good condition as when it was made, but we can see the thing itself. In a painting by Rembrandt we see the actual paint which was put on by the artist; the colors may be darkened by time, but the picture we see is the work of the artist himself. The statues of Michelangelo are the figures made by Michelangelo. In the visual arts, therefore, the problems of preservation are all problems of keeping the medium safe and in good condition: of finding paints that will not fade, of seeing that houses and statues are made of materials that will endure and that they are not destroyed.

In the auditory arts the situation is entirely different. Music and literature exist in time, and time once past is gone forever. The only way we can keep the time arts is to reproduce them. We cannot hear the song as it was sung a half-hour ago; we must sing it over again. We cannot listen today to the poem as we heard it yesterday, but we can repeat the poem. The problem of preserving the auditory arts, therefore, is the problem of finding some means of keeping them so that they can be reproduced.

Originally music and literature were kept by memory and by oral transmission. One man taught another; the grandfather told tales to his grandson; the mother sang songs to her child. In most countries, songs and stories were handed down in this way for a long time, often for centuries, before they were put into permanent form. Even today some of our literature and music comes to us by word of mouth. The stories we tell of Santa Claus, the verses and songs we sing in games, and the simple steps to which we dance them are learned from others, not from books. From Maine to California children sing of London bridge and the farmer in the dell, not because the words have any significance for them, but because they have learned the songs from their parents and friends.

The difficulties with this kind of transmission, however, are very great. The song or the story may be forgotten or changed. Moreover, it does not remain the same. When a new singer tells a story or sings a melody, he often changes it, sometimes unconsciously, sometimes consciously. The poet who does not understand one word will substitute another he does know. In the Kentucky mountains songs have been preserved since the time of Shakespeare, but they are not exactly the same: words and music have changed.

A better way to preserve a time art is to convert it into symbols that can be kept. Hence, from the very earliest times, there have been attempts to find such symbols. The symbols for words came first; they are old. In fact, we can almost say that they are as old as history, for we know comparatively little history earlier than the symbols of written language. Moreover, these symbols are accurate and can be accurately interpreted. We know the writings of the Egyptians, the Greeks, and the Hebrews, and we know that we are reading those writings in the main correctly.

The symbols of music were invented much later, and hence we do not know music of as early a date as we do literature. We know that the early peoples had music and musical instruments; the Hebrews talk of the cymbals and the psaltery, and the Egyptians and the Greeks drew pictures of people with musical instruments. We know also that the Greeks had a very elaborate musical system; they have written its laws and principles; much of our present theory derives directly from the Greeks. But none of these people had a precise way of writing the music itself, and very little has been preserved. The earliest music that can be read with any degree of accuracy is that of the Middle Ages. Before that time there were various attempts at musical notation, but either these early examples were not exact or we have not learned how to interpret them accurately. Hence, for us, the history of music is vague until about the year 1000.

More recent devices for preserving the auditory arts are the sound film, the phonograph record, and the tape recorder. These can preserve the exact tone, the exact speed, the intonation, and many other characteristics that are lost in the written symbol. They have not, however, superseded writing; music and literature are still primarily written symbols.

For the combined arts there are even yet no very good methods of preservation. In the drama and the opera we have, of course, symbols for words and for music; and we can take photographs of stage sets and actors, of singers and dancers. But for the combination of various effects that make up the theater or the opera we have now no adequate means of preservation. The film with its sound track would seem to be a perfect means for preserving the combined arts; and it is probably the best we have today. The conditions for the making of a motion picture, however, are so different from the conditions of a stage performance that it is difficult, not to say impossible, to get the same effects. Furthermore, as the film is developing now, it has become a new art rather than a means for reproducing or preserving a stage performance.

It is also quite doubtful how good television will be for the preservation of the combined arts. It seems to have great possibilities, but if we can judge by present indications it is developing like the film into an independent art.

For the preservation of all the arts there will undoubtedly be improvements in the future. Within the past fifty years we have seen so many changes effected by the film, the phonograph, and television, that we cannot say what the future will hold. Several years from now a library may consist almost entirely of phonograph records and sound films, and it may be that we shall listen to a record of a book or magazine as naturally as we now read it. We now have notation for dance, but future generations may look on our previous failure to preserve dance with as great wonderment and lack of comprehension as we have in viewing the period before writing was invented or adequate music notation devised. But whatever may happen in the future, for the present, opera and theater performances are almost entirely lost, and music and literature are preserved primarily through written symbols.

The symbols of music and literature have the disadvantages of all symbols: they are arbitrary, and they must be known to be interpreted correctly. A child or an entirely unlettered person can recognize a picture, but he must know how to read notes or written words before he can get the meaning of written music or literature. Moreover, the symbols themselves are not entirely exact. The printed page gives only the word; one cannot tell how long it is to be held, in what tone it should be uttered, or how much stress it is to be given, and, unless one knows the language, the symbol does not even give the sound. Printed music is in this respect much more exact, for it can give duration and pitch and can indicate accent. Even so, however, it is far from accurate, and it is so cumbersome that comparatively few can read it and even fewer can write it, whereas the simpler symbols for language can now be read and written almost universally.

The disadvantages of the symbol have, however, a corresponding advantage. In the auditory arts, especially in music, there is often a third person coming between the artist and his audience helping to explain to the audience what the artist is trying to say. We hear the music of the composer and the drama of the author as interpreted by the performer. Under the best circumstances the performer is himself an artist. Reading the lines or playing the music is not to him merely a mechanical performance; it is a new interpretation, a re-creation.

This element of re-creation in the auditory arts is so important that we do not even admit the artist's right to decide on a fixed interpretation. A poet may read one of his poems with a certain emphasis, but anyone has the right to change that emphasis if he wants. A pianist will remember how the music was played by the composer if he was fortunate enough to hear him, but he will not hesitate to change the interpretation as he thinks best. In both these respects the auditory arts are in marked contrast to the visual. When a painter draws a line or puts on a color, no one has the right to change it, and there is usually no artist-interpreter to make the meaning clear. Hence it may be said that the visual arts, as we know them, are relatively exact and definite; they tend to be finished, complete, and static. The auditory arts tend to be vague and indefinite; they are always subject to various interpretations, but they are dynamic and creative.

TECHNIQUE

Technique is the ability to do *what* you want to do, *when* you want to do it, *in the way* you want to do it. Technique, in short, is the artist's control of his medium. It has to do with the way the artist uses his medium in expressing an idea, not with the value of the idea itself.

A musician's technique is his ability to make the music sound as he wants it to sound; a sculptor's technique is his way of handling chisel and hammer to produce the effect he wants from them. In the same way there

are techniques of blowing glass, casting bronze, making etchings, laying bricks. The technique is perfect when it enables the artist to do just what he wants with his medium. Browning states this ideal when he makes Andrea del Sarto say,

I can do with my pencil what I know,
What I see, what at bottom of my heart
I wish for. . . .
—Robert Browning, British poet (1812–1889),
"Andrea del Sarto" (1855)

Obviously techniques differ not only in the different arts but in various mediums of a single art; a person's technique in one medium will be quite different from his technique in another. A painter may be a good technician in oil but a poor one in watercolor. A musician may have a fine technique with the bassoon but a poor one with the flute.

Technique is the actual doing of something; it is the handling of material; it does not usually apply to mental labor. We speak of the technique of Botticelli in painting the picture but not of his technique in planning the composition. We notice that Michelangelo has used different techniques in *David* (Figure 3-2, page 48) and in the *Entombment* (Figure 19-8, page 404); in the one the surface is smooth, in the other rough. But the decision that the smooth surface was right in the one case and the rough in the other was not a matter of technique.

On the basis of technique the distinction is made between an art and a craft. For the artist, the technique is not the end but the means; it is the language of which he is master; through his technique he is able to say what he wants to say. For the craftsman, technique is the end. He is concerned only with techniques; he does not go beyond techniques. He may make an excellent copy of a picture; he may make an engraving or an etching from it. But he will follow the design of the artist; the artist must make the design.

At various times, however, technique has been considered of great, if not primary, importance, especially in music. It is as though the best singer were the one who could do the most difficult cadenzas and the most amazing trills, as though it were a virtue that the song is hard to sing, not that it is beautiful music. It is interesting, of course, to observe a difficult feat well done, whether it be a player hitting a tennis ball or an acrobat hanging by his teeth. So, likewise, it is interesting to hear a soprano reach a high note or to see a dancer poised on one toe for an inordinately long time. Nevertheless, the real point is not whether the performer is master of a difficult bit of technique but whether the passage expresses the ideas of the music or the dance. Is the dancer merely giving an exhibition of her ability to stand on her toe, or is it an essential part of the dance? Is the high note appropriate, or is it merely difficult? Probably the best commentary on technique is this story told of a critic: After a

singer's performance, an admirer said, "Was that not difficult?" and the critic replied, "Would to God it had been impossible!" Technique should always be the means, not the end.

Technique impinges on the question of value in art in yet another way in the problem of whether an artist's work may be hampered by poor technique. We hear much talk of this kind: "A good artist but poor technique!" "He has good ideas for a landscape, but he cannot paint them!" "He is Milton, but mute and therefore inglorious!" To this problem, as to all other problems in art, no immediate or summary solution may be given that will fit all cases. In the re-creative or performing phases of art, technique is of great importance. A man who speaks with a monotonous voice cannot make as forceful an actor as one who has learned to control his voice. A pianist must know how to play; a singer must be able to sing. A *performer* then, is truly hampered by poor technique.

When, however, it is a question of creative work such as painting, writing, poetry, or music—as opposed to re-creative or interpretive work—we tend to take technique more for granted. Obviously the trained artist thinks and works like an artist, no matter how, in the end, he may express himself. He works in terms of space, form, texture, color, and other artistic ingredients, but subconsciously rather than consciously, putting together a given combination of these elements spontaneously as he reacts to the reality which he has observed and which has stirred him to create. His "technique" is so deeply ingrained by that point that he no longer thinks about anything but expressing himself. In this sense we may say that the artist's creative ability and his technique go hand in hand.

This point is of importance in the criticism of art. In judging any work of art it is wise to take it for granted that the artist has done what he wanted to do—in other words, that he has not been hampered by lack of technique. It is easy to look at the distortions and abstractions of Rouault and Picasso and say, "If only he would learn how to draw!" or to hear the dissonances of Hindemith and say, "If only he had had a few lessons in harmony!" But such criticisms are almost always false. The artist who distorts a figure does so because he wants the effect gained through distortion; the composer who puts dissonances in his music does so because he wants their effect.

6. MEDIUMS OF THE VISUAL ARTS

ARCHITECTURE

Traditionally the material of which a building is made has been determined by the materials native to the place where the building is erected. In Greece marble was easily available, and many of the buildings were made of marble. In Rome concrete was used because there were great quantities of an earth called *pozzuolana* which, when mixed with lime, made a hard and enduring cement. Throughout Europe limestone was easily available, and the cathedrals were built of limestone. In most sections of the United States there were heavily wooded forests, and the first houses were built by chopping down trees and putting up log cabins. In some parts of the country clay was to be had for the digging; settlers dug the clay and fired the brick where the house was to be put. In the Southwest the Indians had no stone and no way of firing brick, and so they built their houses of brick dried in the sun, *adobe*. The Eskimos built with blocks of hard snow. In most circumstances buildings have been constructed of the materials at hand.

This condition has changed, however, because new building materials are being made and the architect is less dependent on local materials than he used to be. The most important of the new materials are structural steel and reinforced concrete. But many other new materials have gained wide acceptance. Plate glass makes possible huge expanses of uninterrupted windows. Glass bricks have the advantage of being translucent—that is, letting in light—while not being transparent. There are fabricated woods made of thin sheets of wood glued together with grain running in opposite directions to prevent warping and bending as in ordinary wood. Such fabricated woods can take their place with steel and reinforced concrete

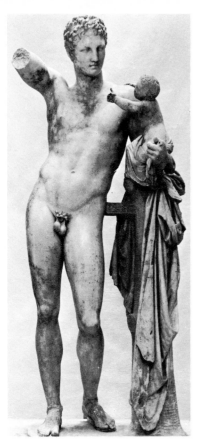

Figure 6-1. Praxiteles, Greek sculptor. Hermes and Dionysus (*ca. 350 B.C.*). *(Parian marble. Height: 6 feet, 11 inches. Olympia Museum. Photograph, Saul Weinberg.)*

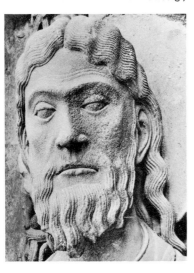

Figure 6-2. King of Judah *(twelfth century).* (*Stone. Above life size. Chartres, Cathedral of Notre Dame. Photograph by Houvet.*)

as scientific materials that lend themselves to exact calculation. Aluminum and enameled surfaces are being tried. Linoleum, rubber, and concrete tiles are used for floors. Plastics are being used increasingly, and we can expect other new materials in the future.

The choice of medium determines, or is determined by, the type of construction used in the building. For buildings in wood, the post-and-lintel type of construction is generally used. For stone, post-and-lintel is used if the slabs are large; if the stones are small, the arch is usually employed. The arch is the typical method for stone construction, as post-and-lintel is for wood. Steel and reinforced concrete, which are very strong and relatively light, can be used in any type of construction; the type that is characteristic of them is known as "skeleton" construction. (See Chapter 14.)

SCULPTURE

Stone and Bronze

The two mediums most commonly used for sculpture are stone and metal. Stone is durable; it resists weather, fire, and all ordinary hazards. On the other hand, it is heavy and expensive and breaks easily. Of the stones, marble is the most beautiful. It takes a high polish and is almost translucent. A noteworthy example of marble sculpture is the *Hermes and Dionysus* of Praxiteles (shown in Figure 6-1). The stone is so smooth that one wants to feel it, to run his hand over the surface. The sculptor has followed the contours of the body so well that one almost believes he would find the surface soft and pliable if he could touch it. In medieval cathedrals the figures were carved of the material of which the church was made, usually limestone. Limestone is soft, and for that reason it does not polish well. Even in photographs one can tell the difference between the surface of a marble statue like the *Hermes and Dionysus* and the surface of a statue made of softer stone, such as the *King of Judah* (shown in Figure 6-2) from Chartres. Granite is coarse but hard and is suited for bold effects. In the *Adams Memorial* (Figure 4-10, page 81), Saint-Gaudens has used granite for the background, its hard uncompromising texture and speckled color being used to contrast with the soft clothing of the bronze figure.

Of the metals, the one most commonly used traditionally was bronze. The processes used in making stone and bronze statues are exactly opposite. Stone statues are made by cutting away the stone until only the figures are left. For metal sculpture, the sculptor builds up the figure he wants in clay and then has it cast in bronze.

In small statues the bronze is solid, but in large ones solid metal

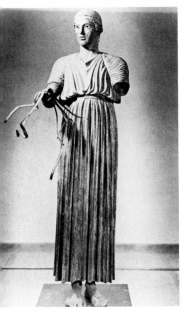

would be too heavy and too expensive; besides, it has a tendency to crack when it is cooled. Most bronze statues, therefore, are hollow. The process of casting bronze is a very difficult and intricate one, so difficult that it constitutes one of the disadvantages of the medium. Another drawback is that bronze is easily melted down for other uses; many a bronze statue has been poured into cannons. Its rich color, however, and the smooth texture, reflecting lights as they can be reflected only in metal, make it one of the most beautiful of all the mediums for sculpture. Moreover, it is relatively light, and the figure can support itself in many positions that would be impossible in stone. The *Charioteer* (shown in Figure 6-3) and the *Hermes and Dionysus* of Praxiteles are original Greek statues. The *Charioteer* is in bronze, the *Hermes* in marble. The *Charioteer* stands on his own feet, and though the figure is large, it needs no other support. In the *Hermes*, however, extra support is given by a tree trunk partially covered with a cloak on which the god is leaning his left elbow. The marble would break if the entire weight of the statue were concentrated on the legs.

After the downfall of Greece a large number of Greek statues in bronze were destroyed, but copies in stone were made by the Romans. Since the stone would not support the figure in the position used in the bronze, stone supports, often poorly disguised, were added. This is the reason that one often sees a trunk of a tree in a copy of a Greek statue where it is not expected.

In modern times a variety of metals, such as forged iron, welded steel, and duraluminum, have replaced bronze, while bronze-casting as an art is disappearing. For many artists, the newer metals symbolize modernity. This is true of Roszak, Lipton, and David Smith, who produce abstract surrealist forms (Figure 6-4, for example); and of Tony Smith and Donald Judd, who create "minimal" effects (see Figure 2-5, page 23).

Because of the differences in method and medium, the effects to be gained in stone and metal are very different. Stone tends to be heavy and massive, but brittle, whereas metal tends to be light, tensile, and graceful.

Wood

Besides stone and metal, wood, terra cotta, and ivory are important mediums for sculpture. Wood has an initial advantage in that it is cheap, easily available, and easy to cut. More important is the fact that it polishes well and has a smooth, shining surface and a beautiful color. Furthermore, it is relatively light and can be made into numerous shapes. Often the grain of the wood can be seen, and if used well, it adds greatly to the effect of the whole, as in Henry Moore's *Reclining Figure* (Figure 2-8, page 25) and *Two Forms* (Figure 2-3, page 21). Wood is also useful for relief sculpture. It is, of course, limited in size; and it burns easily.

Figure 6-4. Theodore Roszak (1907–), American sculptor. Thorn Blossom (1948). (Steel and nickel-silver. Height: 33½ inches. Collection of the Whitney Museum of American Art, New York. Photograph, Geoffrey Clements.)

Ivory

Figure 6-5. Snake Goddess. (*Minoan, ca. 1500 B.C.*). (*Gold and ivory. Height: 6½ inches. Boston, Museum of Fine Arts.*)

Ivory and terra cotta may almost be counted as lost mediums, for they ar used very little today, though they have been important in the past. As w have said, the great statue of Athena in the Parthenon was of gold an ivory. In the Boston Museum is a statuette of ivory called the *Snak Goddess* (shown in Figure 6-5); it dates from the little-known Aegear or Minoan, civilization, which preceded the Greek. When excavations wer being made in Crete, a woman interested in the Boston Museum of Fin Arts bought a mass of earth just as it came from the spade because it cor tained fragments of gold and ivory. When the pieces were put togethei this little figure emerged, and it is now one of the treasures of the Museum The snakes and the bands of her skirt are of gold. There are holes in he tiara, which would indicate that gold was wound through it also. The lad looks very modern with her small waist and full skirts. Probably she was priestess, for she carries snakes in her hands. Certainly she was an aristc crat; her face and bearing both bear witness to a noble lineage.

From the Middle Ages on, ivory has been much used for small piece in which very delicate carving is needed—as, for example, crosses, chess men, and the backs of books. Usually carvings in ivory are small, th reasons being the great expense of ivory and the difficulty of securing it ii large pieces. The color of ivory is a rich, creamy yellow. Like wood, ivor cracks.

Figure 6-6. Lohan. Chinese, Liao Dynasty. (*Pottery, hard reddish-buff clay, green and yellow glazes. Height: 49¾ inches. Toronto, Royal Ontario Museum.*)

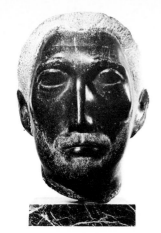

Terra Cotta

The term *terra cotta* means "baked earth." Terra cotta is made by firing clay, as in pottery. It is usually painted and covered with a heavy glaze. The great advantages of terra cotta are that it is very cheap in comparison with stone or bronze, and that brilliant colors are made possible by the glazing. Like all pottery, terra cotta is easily broken and chipped. As a medium for sculpture, terra cotta has been used at all times. Excellent examples are to be found in the work of many early peoples, notably the Greeks, the Chinese, and the Etruscans. A frequent subject in Chinese art is the lohan, a disciple of the Buddha. Usually, as in the example shown in Figure 6-6, we find that emphasis on meditation which is characteristic of Buddhism. In the Renaissance, terra cotta was the favorite medium of successive generations of the della Robbias, a family of artists.

Artists in all arts at all times have experimented in new mediums, and sculptors of the present day are no exception. Henry Moore's little figure *The Bride* is of cast lead and copper wire. Zorach's *Head of Christ* is of black porphyry (Figure 6-7). Cast stone, wrought iron, aluminum, glass, and steel are other mediums used today.

This use of new and technologically derived mediums is seen in the work of such artists as Theodore Roszak, who has already been mentioned, Seymour Lipton, and, above all, the late David Smith. Smith, in many ways the ancestor of the current use of welded iron and steel for sculpture, began as a riveter in the Studebaker plant at South Bend, Indiana. Influenced by Picasso's experiments with metal sculpture, Smith began to do welded iron sculpture (Figure 6-8), using a number of fanciful openwork forms whose symbols and imagery depend on the machine itself.

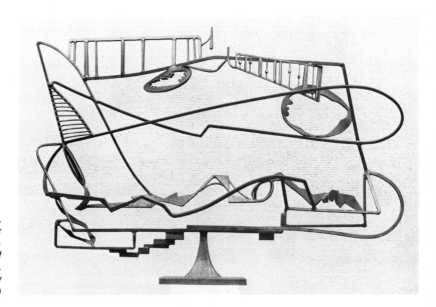

PAINTING

Painting may be defined as the application of colored pigments to a flat surface, usually canvas, paper, wood, or plaster.

Pigments

Pigments used in making colors come from different sources: clay, coal tar, vegetable matter, etc. Some are manufactured; some are found in nature almost as they are used. Some have been newly discovered; some have been known for a long time. Many of the pigments used today are obtained from natural sources. The reds and browns now obtained from clay are the same reds and browns used by men who painted on cave walls in prehistoric times. Vegetables have been the source for many pigments: indigo produces blue and madder red. Ultramarine, which is the *blue* blue, the most expensive of all blues, was made by grinding the stone lapis lazuli. Purple can be extracted from a shellfish, the murex.

Many pigments also have been made by the chemists. It is generally believed that the first chemical pigment was Prussian blue, discovered in 1704. About a century later many new pigments were made, and in 1828 Guimet discovered a way to make ultramarine artificially. Since that time there have been an ever increasing number of pigments made by chemical formulas.

Vehicles

The sources of color have been pretty much the same throughout the generations, but the way the color is applied to the surface has changed. Since the colors as procured either from nature or from artificial sources are dry, they must be mixed with something in order to be spread on a surface. This substance, usually a fluid, is called the "vehicle." In oil paintings the colors are mixed with oil; in other words, oil is the vehicle. In watercolor water is the vehicle. The vehicle determines the surface on which the paint is spread. Canvas is not a good surface for watercolor, nor is paper a good surface for oil. Since the pigments are essentially the same no matter what surface or vehicle is used, a medium is commonly distinguished by the surface and vehicle used. We do not speak of painting in earth colors but of painting in oil on canvas or acrylic. Each medium determines its own brush stroke and produces its own effect.

OIL Probably the most widely used medium for painting at the present time is oil. The vehicle is oil and the surface is usually canvas, though various other surfaces may be used. The special advantage of oil is that it stays moist for a long time. The artist can work over what he is doing, and if he wishes he may change today what he painted yesterday. The paint may be applied in any way that suits the artist, so thinly that the canvas shows through or so thickly as to produce a rough surface. The rough surface of

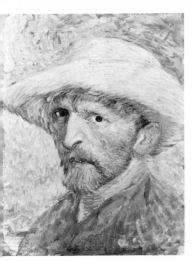

Figure 6-9. Vincent Van Gogh. Self-Portrait in a Straw Hat (1888–1889). (*Oil on canvas, on wood. Size: 13¾ inches. The Detroit Institute of Arts.*)

Van Gogh's *Self-Portrait in a Straw Hat* may be seen even in the photograph (examine Figure 6-9); the paint is so thick that each stroke shows clearly. In contrast, the paint in Gauguin's *By the Sea* (Figure 6-10, page 114) has been applied smoothly, and individual brush strokes do not show at all. Both pictures are on white canvas, which gives them a brilliant quality.

There are two methods of painting in oil, the direct and the indirect. In the direct method the paints are opaque and are applied to the surface just as they are to look in the finished picture. In the indirect method the paint is put on in many thin layers of transparent color; the effect produced in this way is very rich and luminous. Unfortunately, it cannot be distinguished in a photograph. The direct method is the more flexible medium of expression; the artist can use his pigment very freely and express in it any fleeting change in his thought. And, if it has not the richness of the transparent colors, it can obtain great vitality through the use of colors in high intensity. For the expressive purposes of, say, Van Gogh, the direct method was clearly more suitable. For the purposes of Rembrandt or El Greco, where the overlapping layers of paint on a dark canvas control the emergence of the light as it strikes the surface, the indirect method was more suitable.

The disadvantages of oil have to do with the preservation of the picture. Because the paint takes a long time to dry, the oil has a tendency to rise to the surface and form a film over the picture, making the colors dull. Moreover, it tends to become yellow, and in time the paint cracks.

WATERCOLOR In watercolor the pigments are mixed with water and applied to a fine, white paper. The paper shines through the paint and makes the color brilliant. It is difficult to produce warm, rich tones in watercolor. Changes may be made once the paint has been applied, but usually such changes tend to make the color less brilliant. In Marin's painting (Figure 6-11, page 115), the characteristic "watery" look of watercolor can be clearly seen. Watercolor is best for spontaneous, evanescent expression.

Opaque watercolor is called "gouache." It differs from the dominantly brilliant quality of translucent watercolor painting, whose major effects are caused by the white paper itself. The gouache, which is made by mixing zinc white (Chinese white) with the regular watercolor paints to tone them down, is more sober in quality and therefore suitable to more dramatic purposes. This may be illustrated by Picasso's *Blue Boy* (Figure 2-11, page 28), although it retains a certain lightness of expression and a pastel-like surface texture.

FRESCO In fresco painting a wall is prepared with successive coats of plaster. Designs are prepared in advance on large sheets of paper, each sheet accounting for a section of the wall. The artist marks off on the wall the approximate amount he knows he can cover in a day's work and gives it the final coat of fresh (Italian *fresco*) plaster to which that section of the

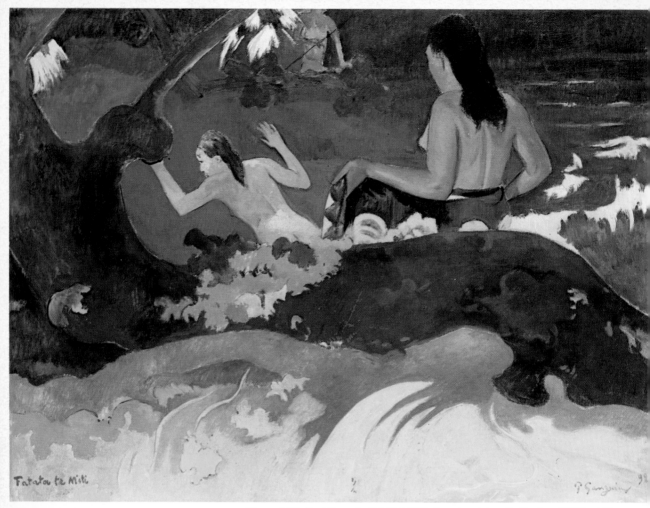

Fatata te Miti

Figure 6-10. *Paul Gauguin (1848–1903), French painter.* By the Sea *(1813). (Oil on canvas. Size: 26¾ by 36 inches. Washington, D.C., National Gallery of Art, Chester Dale Collection.)*

drawing is transferred. He is then ready to paint. The pigment is mixed with water and applied to the wet plaster. The color dries into the plaster, and the picture thus becomes a part of the wall. Since fresco must be done quickly, it is a very exacting medium; there is no rubbing out and no changing once the design is begun. It is accordingly a medium of broad, bold outlines, usually with great simplification of form. Because of the chemical action of the plaster on the paint, only earth pigments may be used, and these colors lack intensity; there is, however, uniformity of tone with no glaring contrasts. The disadvantages of fresco are two: first, it is almost impossible to move a fresco; second, the painting, being permanently fixed to the wall, is subject to any of the disasters that may happen to the wall. If the plaster cracks or has a hole punched in it, the picture is hurt to that extent. The Sistine Chapel ceiling is in fresco; numerous cracks are clearly seen in the decorative nude shown in Figure 6-12, page 116. For many years fresco was used very little, but in recent times there has been a return to fresco painting, notably by the Mexican artists Diego

Rivera and José Clemente Orozco. One of Orozco's most important works is on the walls of the Dartmouth College Library: this is *Modern Migration of the Spirit* (Figure 6-13, page 116), in which, as has already been noted, the central figure is a dynamic Christ come back to earth to destroy his cross in a world filled with military equipment, where the name and the cross of Christ have been misused by mankind.

EGG TEMPERA Tempera and fresco were favorite mediums throughout the Middle Ages and early Renaissance, before oil was generally adopted. Tempera painting is usually done on a wooden panel that has been made very smooth with a coating of plaster called "gesso." The colors are mixed with egg yolk (with or without the white). The paint dries almost immediately. There is in tempera painting little blending or fusing of colors; the

Figure 6-11. John Marin (1870–1953), American painter. From the Bridge, New York City. (Watercolor.) Hartford, Conn., The Wadsworth Atheneum.

Figure 6-13. Jose Clemente Orozco. Modern Migration of the Spirit (1932–1934). (Fresco. Baker Library, Dartmouth College, Hanover, N.H.).

Figure 6-12. Michelangelo. Decorative Nude. Detail of Sistine Chapel Ceiling. (Fresco. Photograph by Alinari.)

Figure 6-14. Simone Martini (ca. 1284–1344), Italian painter. Annunciation (1333). (Tempera on wood. Height: 5 feet, 11½ inches. Florence, Uffizi Gallery. Photograph by Alinari.)

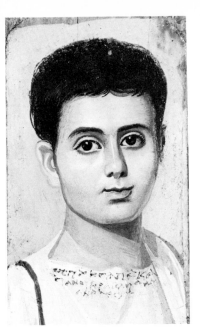

Figure 6-15. Portrait of a Boy (second century A.D.). Fayum, Lower Egypt. (Encaustic on wood panel. Size: about 10 by 16 inches. New York, Metropolitan Museum of Art; gift of Edward S. Harkness, 1917–1918.)

colors are laid on side by side or are superimposed. Hence the painting is composed of a large number of successive small strokes, and the effect is largely linear. It is hard to obtain rich, deep tones or dark shadows. Because tempera paint dries quickly, the artist must be precise and exact in his work. It is a medium well designed for careful detail. The advantage of tempera is its great luminosity of tone, the colors being clear and beautiful. On the other hand, the precision needed tends to produce a certain hardness of outline. Botticelli's *Birth of Venus* and Simone Martini's *Annunciation* (Figure 6-14) show most of the characteristics of tempera.

ENCAUSTIC Wax was used by the Egyptians for portraits painted on mummy cases. There were several different ways of preparing the wax, but in general the color was mixed with warm wax and burned in. This method was also used by the Greeks and the Romans, and it was employed to some extent during the Middle Ages. Paintings with wax have a definite body and a pleasing sheen which seem to show at their best in portraits. *Portrait of a Boy* (shown in Figure 6-15) dating from the second century after Christ is an example. In recent years painting in wax has been revived by some modern painters, notably Diego Rivera.

PASTEL In pastel, pigments in the form of powders are compressed lightly into sticks. Its colors are brilliant, and it is a very flexible medium, one in which very rich and varied effects may be produced. As a medium, however, it has never won a high place, because no one has yet discovered a way to preserve it in its original freshness. Even if it is covered almost at once with a fixing medium or with a protecting surface such as glass, the chalk rubs and the picture loses some of its brilliance. One of the outstanding artists in this medium is Edgar Degas (Figure 6-16, page 118). Degas used the pastel to combine drawing and color; drawing set the figures in motion, and color dissolved the moving forms in a mist of surface tones.

ILLUMINATION In the Middle Ages, when books were lettered by hand, the pages were often decorated with gold, silver, and bright colors. Capital letters, especially, were made large and important. Decorative borders were common, and frequently the artist added miniature paintings of people or scenes. In the page from the Tickhill Psalter shown in Figure 6-17, page 119, all the capitals are emphasized, but special attention is given the initial letter B, with which the first Psalm begins, *"Beatus vir qui non abiit in consilio impiorum"* ("Blessed is the man that walketh not in the counsel of the ungodly"). Each half of the letter is filled with a miniature, and there are further miniatures at the foot of the page. These miniatures tell the story of the anointing of David, the supposed author of the Psalms. The miniatures were made of tempera or pen and ink.

MOSAIC Mosaic, stained glass, and tapestry are usually classed with

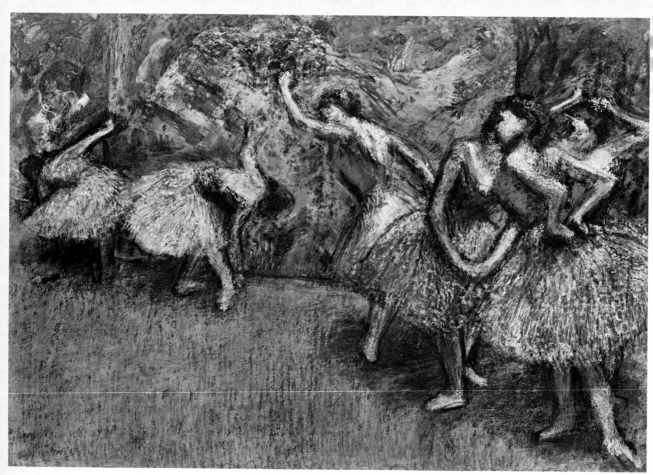

Figure 6-16. Edgar Degas (1834–1917), French painter. Ballet Scene (1907). (Pastel. Size: 30½ by 43¾ inches. Washington, D.C., National Gallery of Art, Chester Dale Collection.)

painting, though the medium is not pigment. A picture in mosaic is made by putting together small pieces of colored glass or stone, called "tesserae." These tesserae are often square. They are set in cement to hold them in place, the underside of the tesserae being roughened to make them fast in the cement. The use of stones makes simplification of design necessary. Moreover, the stones can never be set very smoothly in the cement, and hence the surface is always rough, reflecting light in many ways and creating a lively, vibrant effect. The greatest mosaics were made in the Middle Ages before painting became usual in churches. Some of the most famous are found in the church of S. Vitale at Ravenna (Figure 6-18). The enlargement shows the tesserae clearly (Figure 6-19).

STAINED GLASS Like the mosaic, the stained-glass window is a kind of patchwork. It is made by combining many small pieces of colored glass which are held together by bands of lead. In a large window, the lead is reinforced by heavy iron bars that make very heavy black lines in the pic-

Figure 6-17. *First page of the Psalms from the Tickhill Psalter (ca. 1310). (Illuminated manuscript. Size: 12⅞ by 8⅝ inches. New York, Spencer Collection, New York Public Library.)*

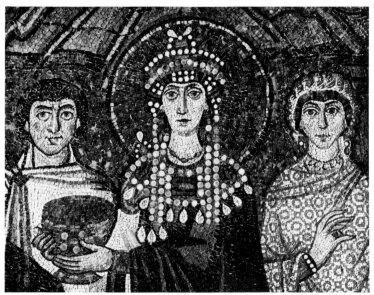

Figure 6-19. *"Portrait of Theodora," detail of Theodora and Her Attendants. (Photograph by Alinari.)*

Figure 6-18. Theodora and Her Attendants (ca. A.D. 525). (Mosaic. Figures slightly above life size. Original mosaic in church of S. Vitale, Ravenna.)

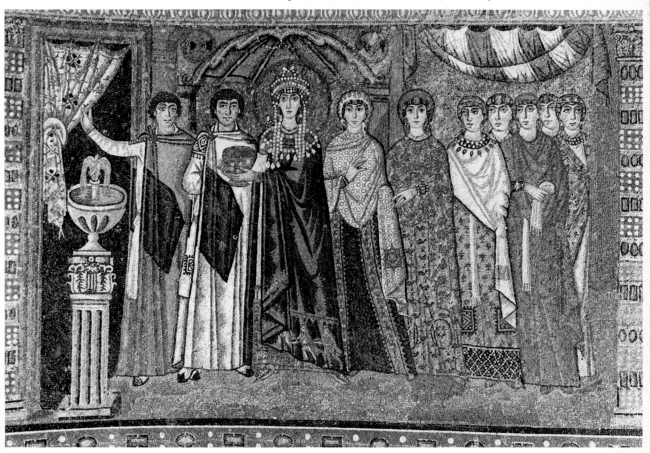

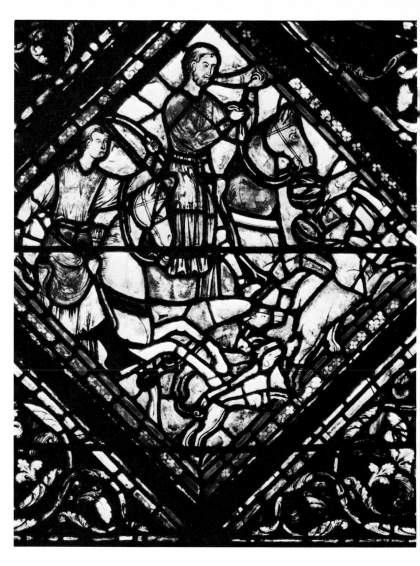

ture. In the Middle Ages, when many people were illiterate, the glass of the church windows served as a "picture book" of Biblical scenes. The windows at Chartres are considered among the greatest of a great period. Our illustration shows one section of the window of *S. Eustace* (Figure 6-20). The saint is shown riding to the hunt, his horn at his lips. At his feet are the dogs, and just before him the stags; behind him is an attendant urging on the chase.

TAPESTRY Tapestries are large fabrics in which a design is woven by hand. In the Middle Ages they were hung on the walls of palaces and in the cathedrals on festive occasions, both as decoration and for warmth. Being of very firm texture, they shut out the cold and helped to preserve

the heat from the fireplace. In the *Unicorn in Captivity* (Figure 6-21) we see the famous *mille fleur*, or "thousand flower," background.

Drawings

Drawings and prints are of special interest to the student, both for their intrinsic value and because they are comparatively inexpensive. In them

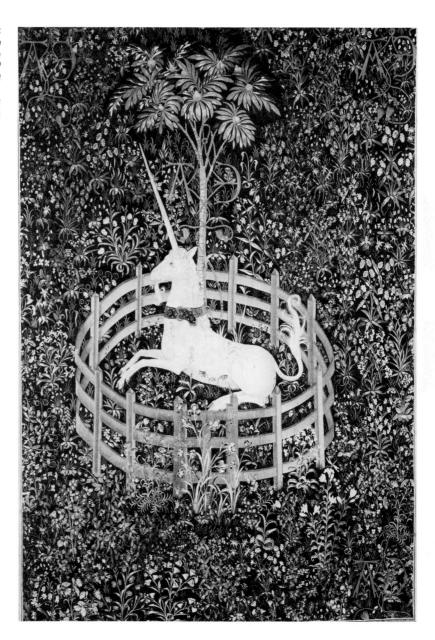

Figure 6-21. The Hunt of the Unicorn: The Unicorn in Captivity (*late fifteenth or early sixteenth century*). (*French or Flemish tapestry, from Chateau of Vertueil. Silk and wool with silver and gilt threads. Size: about 12 by 8 feet. New York, Metropolitan Museum of Art; The Cloisters Collection.*)

Figure 6-22. Jean Auguste Dominique Ingres (1780–1867), French painter and pencil portraitist. Lady and Boy (1808). (Pencil drawing. Size: 9¾ by 7½ inches. New York, courtesy Metropolitan Museum of Art; bequest of Mrs. H. O. Havemeyer, 1929. H. O. Havemeyer Collection.)

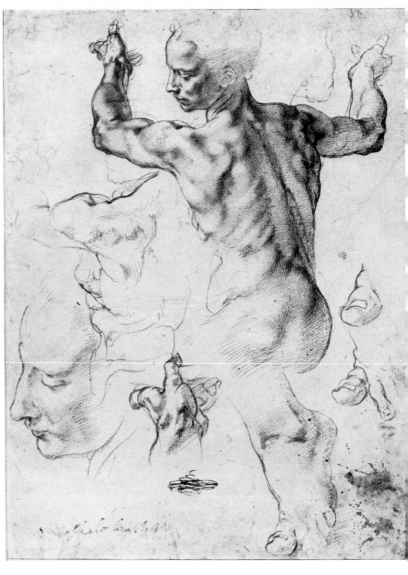

Figure 6-23. Michelangelo. Studies for Libyan Sibyl (Fig. 3-24). (Red chalk. New York, Metropolitan Museum of Art; Joseph Pulitzer Bequest, 1924.)

even the person of small means can afford original works, often by important artists.

A drawing may be a finished work, as in Ingres's *Lady and Boy* (shown in Figure 6-22); or it may be made as a study for a painting to be completed, like Michelangelo's studies for the *Libyan Sibyl* (shown in Figure 6-23). Notice Michelangelo's sketches of the big toe, and his change from the masculine face which appears in the center to the feminine face at the left.

Drawings are known chiefly by the mediums used, as pencil, pen, silverpoint, and charcoal. *Pencil* is one of the most common because of its

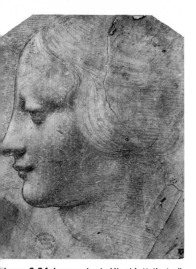

general utility, especially for making rapid notes. The French artist Ingres made many delicate and crisp pencil portraits as one means of support while he was living in Rome. A typical example is the *Lady and Boy*.

Silverpoint, a drawing made with a gold or silver wire on a specially prepared paper, is often very pale in tone and has little vitality but is very delicate and warmly shadowy. The difference between the line of the pencil and that of silverpoint can be seen by comparing the Ingres portrait with the *Head of a Woman*, after Leonardo (Figure 6-24).

Ink makes a clear, crisp, often sketchy and spontaneous line; often ink is combined with a wash as in the Rembrandt drawing *S. Peter and S. Paul at the Beautiful Gate of the Temple* (Figure 6-25).

Figure 6-24. *Leonardo da Vinci (attributed) (1452–1519), Italian painter. Head of a Woman. (Silverpoint with white on bluish paper. New York, Metropolitan Museum of Art; Hewitt Fund, 1917.)*

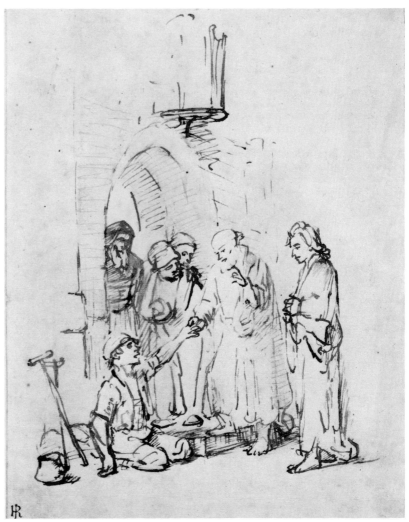

Figure 6-25. *Rembrandt Harmensz Van Rijn (1606–1669), Dutch painter. S. Peter and S. Paul at the Beautiful Gate of the Temple. (Pen and bister, washed. New York, Metropolitan Museum of Art; Rogers Fund, 1911.)*

Figure 6-26. *Alfred Robaut (attributed), French painter. The Forest of Coubron (1872). (Charcoal. Size: 17 by 11¾ inches. Reproduced by permission of Fogg Art Museum, Harvard University, Cambridge, Mass.; bequest of Grenville L. Winthrop.)*

Figure 6-27. *Georges Pierre Seurat (1859–1891), French painter. The Artist's Mother (ca. 1883). (Conté crayon on paper. Size: 12⅞ by 9½ inches. New York, Metropolitan Museum of Art; Joseph Pulitzer Bequest, 1951, from Museum of Modern Art, Lillie P. Bliss Collection.)*

Bister is a brown pigment made by mixing the soot from burning wood with a little binder.

Charcoal is one of the oldest mediums for drawing. The charcoal is made by roasting wood in a closed vessel. This medium is capable of a great variety of tones from the darkest to the very light, as is shown in Robaut's *Forest of Coubron, 1872* (Figure 6-26).

Chalk is another medium that has been used from the earliest times. It is found in white, black, and red. The red was especially desired for figure sketches like Michelangelo's sketch for the *Libyan Sibyl* (shown in Figure 6-23). *Conté crayon* is one of the chalks; it is less waxy than the schoolroom type of crayon and much more durable than pastel. Seurat

Figure 6-28. Kyosai (1831–1889), Japanese painter. Animals, Children, and Men. (Brush drawing. Height: 10⅞ inches. New York, Metropolitan Museum of Art; Fletcher Fund, 1937.)

used it to produce rich shadows, great brilliancy of light, and strength of tones (Figure 6-27).

Drawing with a *brush* is characteristic of the Chinese and Japanese, who, it will be remembered, write with a brush instead of a pen. The brush gives very quick results and allows great freedom of handling. Kyosai's *Animals, Children, and Men* (Figure 6-28) is an example.

Prints

A print is something printed; that is, it is the impression left on paper or some other surface from an inked plate. Ordinarily the printing is in black ink on white paper. The plate is made by the artist, and usually he does the printing. For these reasons a print is considered the authentic work of an artist and is signed by him. The number of copies that are made from any plate depends on the design, the kind of print, and the wishes of the artist. Often an artist decides on a certain number—thirty, fifty, one hundred—and destroys the plate when that number has been reached.

There are five major types of prints: *woodcut, engraving, etching* (and related processes), *lithograph*, and the *serigraph*, or silkscreen print. Each print can be distinguished by the way the plate is made. Therefore, it is convenient to know both the kind of line characteristic of a print and the way the plate is made.

WOODCUT The woodcut, as the name implies, is made from a plate of wood. The design stands out in relief, the remaining surface of the block being cut away. A wood block prints just as do the letters of a typewriter. Since the lines of the design are of wood, they can never be very fine, and woodcuts can be identified by their firm, clear, black lines, such as those we see in Dürer's *Crucifixion* (shown in Figure 6-29, page 126), and his *Four Horsemen* (Figure 5-3, page 92). The design is left standing in

Figure 6-30. Karl Schmidt-Rottluff (1884–), German painter and printmaker. The Miraculous Draught of Fishes (1918). (Woodcut. Size: 5½ by 19⅝ inches. From Kristus, a portfolio of nine woodcuts, published by Kurt Wolff, Leipzig, 1919. Collection of Mrs. Gertrude A. Mellon, New York. Photograph, Museum of Modern Art.)

Figure 6-29. Albrecht Dürer. The Crucifixion. (Woodcut. New York, Metropolitan Museum of Art; gift of Henry Walters, 1917.)

relief, and any part of the plate that is not cut away will print a solid black. Older makers of the woodcut, like Dürer, used solid blacks very sparingly. In modern prints, such as *The Miraculous Draught of Fishes* by Schmidt-Rottluff (Figure 6-30), large areas of black are used in the design.

The woodcut is made from a plate sawed parallel to the grain of the wood. The print often shows the grain. In recent years prints have been cut from linoleum as well as from wood. Sometimes these prints are called linoleum cuts, but there is so little difference between the two that ordinarily no distinction is made, and both are called woodcuts.

Colored woodcuts are made by preparing a separate block for each color to be used; only the parts to be printed in one color appear on the block of that color. The finished print, however, will show more shades than there are blocks, because one color is printed on top of another and the colors are mixed. The Japanese, especially, have excelled in this type of woodcut, though the technique has been used widely (Figure 6-31).

ENGRAVING An engraving is in many ways the opposite of a woodcut. In the woodcut, the parts that are to be black are left standing, and the remainder of the block is cut away. In engraving, the lines of the design

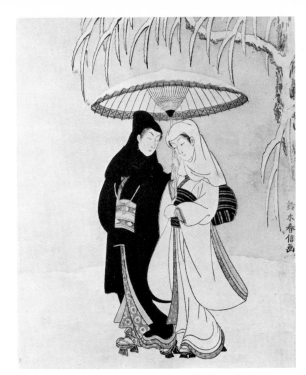

Figure 6-31. *Suzuki Harunobu (1725–1770), Japanese print-maker. Lovers under Umbrella in Snow. (Wood block. Size: 11 by 8 inches. New York, Metropolitan Museum of Art; Rogers Fund, 1936.)*

Figure 6-32. Martin Schongauer (1440–1491), German painter and engraver. The Annunciation (undated). (Engraving. Size: 6½ by 4¾ inches. Boston, Museum of Fine Arts.)

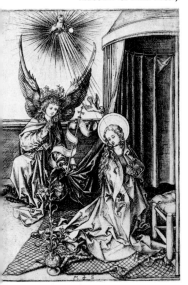

are cut into a metal plate; these lines are then filled with ink and transferred from the plate to the paper. The lines of an engraving are cut by hand with an instrument called a *burin,* and since the copper plate is hard to cut, they are very fine, much finer than the lines of a woodcut. For the same reason they are hard and stiff, precise and formal. Shadows are made by lines either very close together or crossing at regular angles. Blake's engraving *When The Morning Stars Sang Together* (Figure 3-18, page 64) shows the typical quality of the line. Other examples of engravings are Dürer's *Knight, Death, and the Devil* (Figure 5-2, page 92) and Schongauer's *Annunciation* (Figure 6-32).

ETCHING Etching differs from engraving in the way the lines are made. In engraving, as we noted, the lines are cut directly in the plate by hand. In etching, the plate is covered with a coating of a thin, waxlike material called a "ground." Through it the etcher draws his design. He does not attempt to cut the plate itself; he merely scratches through the wax, leaving the metal uncovered. The plate is then put into an acid bath, and the design is *etched,* or eaten, into the plate. The lines on an etched plate are made much more easily than on an engraved plate, and we see the difference in the finished print. The etched lines have the freedom of a penciled line, go in any direction, and cross at any angle. In *Why Does He Run?*

MEDIUMS OF THE VISUAL ARTS 127

Figure 6-33. Paul Klee (1879–1940), Swiss painter and printmaker. Why Does He Run? (ca. 1932.) (Etching. Size: 9⅜ by 11¹³⁄₁₆ inches. The Klee Foundation and Kornfeld and Klipstein, Bern, Switzerland.)

Figure 6-35. Rembrandt Harmensz Van Rijn. Three Trees (1643). (Etching. Size: about 8⅜ by 11 inches. New York, Metropolitan Museum of Art; bequest of Mrs. H. O. Havemeyer, 1929. H. O. Havemeyer Collection.)

Figure 6-34. Francisco Goya. Pobrecitas (Poor Little Things) from Los Caprichos (Caprices) (1793–1798). (Etching and aquatint. New York, Metropolitan Museum of Art; gift of M. Knoedler & Co., 1918.)

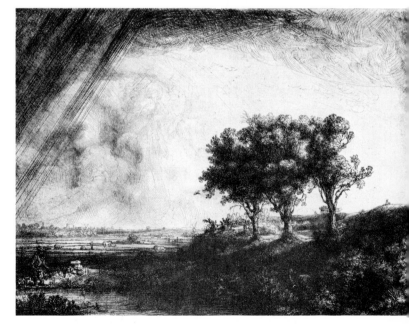

Figure 6-36. Francis Haden (1818–1911), English artist. Eglamlock. (Mezzotint. Size: 5¹⁵⁄₁₆ by 8¹⁵⁄₁₆ inches. New York, Metropolitan Museum of Art; Harris Brisbane Dick Fund, 1917.)

Figure 6-37. Francisco Goya. Back to His Grandfather, from Los Caprichos. (Aquatint. New York, Metropolitan Museum of Art; gift of M. Knoedler & Co., 1918.)

(shown in Figure 6-33), Klee uses his etching needle almost like a pencil or a pen.

Obviously neither etching nor engraving can show solid blacks as can the woodcut, and in both prints grays must be made by putting lines close together or by crisscrossing. The etched lines are very clear in Goya's *Pobrecitas* (shown in Figure 6-34) and in Rembrandt's *Three Trees* (Figure 6-35).

DRYPOINT, MEZZOTINT, AQUATINT *Drypoint* stands halfway between engraving and etching. It is like engraving in that the lines are cut directly in the metal. It is like etching in that the needle is held as a pencil and is used freely. It merely scratches the metal. As it scratches, it leaves a little ridge at one side like the ridge left by a pin run across a cake of soap. This ridge, called the "burr," takes the ink and makes a very rich, velvety line. A similar ridge is thrown up in engraving, but it is cleared away before any prints are made. Drypoint can rarely be distinguished from etching in a photograph, but in the original the rough line of the drypoint is clear. In the Rembrandt etching (Figure 6-35) the heavily shaded portions at the lower right are in drypoint.

Mezzotint and aquatint are two means of giving a solid tone to a print. *Mezzotint* is made on a copper plate which is artificially roughened by an instrument known as a "rocker" or "cradle." The engraver then scrapes away more or less of the roughness in the parts he wants light. The parts not scraped, or only partially scraped, make a rich, velvety black like the burr of the drypoint. Mezzotint is frequently combined with some other type of print, such as etching or drypoint (Figure 6-36).

In *aquatint*, powdered resin is sprinkled on the plate and heated so that it adheres to the plate. When the plate is immersed in the acid, the parts not protected by the resin are bitten, and a very fine shadowy gray is produced (Figure 6-37).

LITHOGRAPHY The lithograph is the most recent of the four common types of print. It was discovered just before 1800, whereas woodcuts, engravings, and etchings go back to the fifteenth and sixteenth centuries. In a lithograph the design is drawn with a heavy greasy crayon on a specially prepared stone, and ink impressions are made from it. Every line or shadow made on the stone is transferred to the paper; in fact, a lithograph looks very much like a charcoal or chalk drawing. And it is the only print that can show tones shading one into the other as in a drawing or a painting. Daumier's *Strangers in Paris* (Figure 13-10, page 261) and Bellows' *Dempsey and Firpo* (Figure 6-38, page 130) both show the characteristic shading of the lithograph. Signac gives us the same scene in two mediums. One is a lithograph, *Le Port de St. Tropez II* (Figure 6-39, page 130) and the other is a pen and watercolor drawing, *St. Tropez: Soleil du Soir* (Figure 6-40, page 130).

SERIGRAPH The serigraph (or silkscreen) process is a method of making prints with oil instead of ink. A piece of silk is stretched on a wooden

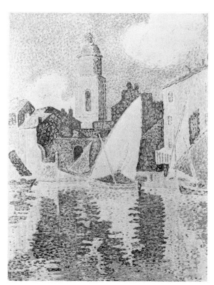

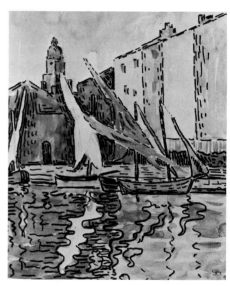

Figure 6-39. Paul Signac (1863–1935), French painter. Le Port de St. Tropez II (1897–1898). (Color lithograph. Size: 17¼ by 13⅛ inches. Boston, Museum of Fine Arts.)

Figure 6-40. Paul Signac. St. Tropez: Soleil du Soir (1894). (Watercolor. Size: 10½ by 8 inches. Los Angeles, County Museum of Art; Mr. and Mrs. William Preston Harrison Collection.)

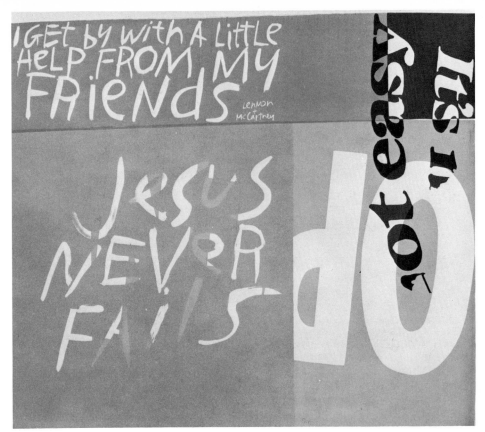

Figure 6-41. Sister Corita. Jesus Never Fails. (Serigraph. Size: 30 by 36 inches. New York, The Brooklyn Museum: Henry L. Bateman Fund.)

frame, and a design is imposed on that screen by stopping out (or blocking out) those areas which the artist does not want to print. A series of such frames are prepared, each one equivalent to one of the major colors in the design (this may be compared with the color woodcut process, discussed above). The sheets of paper constituting the "run" are then subjected to each of the screens in rotation, the oil colors being squeezed through the screen—or silk mesh—where the stop-out chemical has not been applied. In some cases colors are superimposed in part on preceding colors so that a certain amount of blending is achieved. The total effect is more like a dark-toned gouache than an oil painting, but the result is a whole run of what appear to be paintings rather than prints (Figure 6-41).

The serigraph is widely used in commercial art as well as in conventional art forms. The poster, one common example of the use of serigraph, often falls between commercial and noncommercial art. It is, of course, used to advertise products, theatrical performances, concerts, motion pictures, and—most interestingly for our purposes—art exhibitions. Posters for art exhibitions are generally designed by the exhibiting artist himself and commercially distributed as reproductions after the exhibition closes. It is therefore possible for the average person to have a "special" silk-

Figure 6-42. Marc Chagall (1890–).
Bible/Editions Verve 33–34 (1956).
(Lithograph. Size: 25 by 16¼ inches.
New York, Museum of Modern Art; gift
of Mourlot.)

screen or lithographic design (as a reproduction rather than as a signed print) made by an artist like Picasso, Calder, Rauschenburg, Kelly, Vasarely, or Chagall (Figure 6-42).

As in other art forms—sculpture and painting, for example—there is a marked tendency among contemporary printmakers to mix the various mediums, to break down distinctions among mediums that were generally typical of traditional practice. Although, as we have just seen, it was always possible to have etching and aquatint on the same plate, as in the Goya print (Figure 6-37, page 129), or etching and drypoint, as in Rembrandt's *Three Trees* (Figure 6-35, page 128), the fact remains that these combinations exist within the traditional framework of etching practice—that is, lines etched into and below the surface of the plate. Generally, the five major areas—woodcut, engraving, etching (and related practices), lithograph, and serigraph—remain separate fields for the traditional artist. More recently, one finds examples of such mixtures as etching and lithography, where the artist first prepares an outline of the figure as an etched design printed, for example, as a white outline, and then works out a series of woodcut-type blocks, one for each color, and applies them much as one would apply the color blocks for a Japanese woodcut print. This results in a finely drawn outline of the main subject and a flatly worked-out series of bold color areas as background, combining the advantages of two different mediums on one print.

7. THE MEDIUMS OF MUSIC

Music, like literature, is an art that deals with sound. Literature makes use of words, which are sounds; and a writer must be concerned with the effect produced by the sounds of the words he uses. But words are not only sounds; they also have meanings. They refer to specific things other than themselves, such as objects and ideas. Music also makes use of sounds, but in music these sounds have no specific meanings beyond themselves. Unlike words, they do not refer to objects and ideas. This does not mean, however, that music cannot suggest something other than itself. In fact, one of the pleasures that the listener may derive from music results from making just such extramusical associations. But there is no generally agreed upon designation for the sounds used in music, and different listeners may make quite different—and in some cases opposed—associations upon hearing the same musical sounds. Moreover, unlike disagreements about words, there is no generally accepted basis, such as a dictionary, for determining which listener is correct. In other words, musical meaning, unlike verbal meaning, is largely a subjective matter.

Music and literature also differ in the way they produce sounds. In literature all sounds are produced by the human voice, whereas in music the human voice is but one of a number of possible instruments. These various musical instruments are the means by which the composer communicates to the listener; they are his mediums of expression. Like any artist, the composer must choose his medium for any given composition according to the requirements of his artistic conception. It is helpful for the listener to have some understanding of the various musical instruments most frequently used in our culture and of the kinds of sounds they produce.

Before turning to the individual instruments, however, it should be pointed out that music is one of the performing arts. With few exceptions, musical instruments do not play themselves automatically, so that even after the composer has shaped his ideas for the medium he has chosen, the piece will not yet be "ready" for the listener. The instruments, and thus the composition itself, must be performed. As a result, the musical experience encompasses a three-way relationship involving the composer, the performer, and the listener. The performer is not simply a passive go-between; he takes an active role in *interpreting* the work of art. The same composition may sound quite different when played by two performers whose interpretations differ. This is one of the most interesting aspects of music and explains why repeated hearings of the same work need not become boring. Two performances, even by the same performer, will never be exactly the same.

HOW INSTRUMENTS MAKE SOUND

Most instruments have three things in common: a vibrator, a resonator, and a system for producing and regulating fixed pitches.

Pitch will be discussed in more detail in Chapter 10. Here it will suffice to say that pitch is a special kind of sound produced by a particular kind of vibration. All sound, of course, is caused by vibrations, but sounds of definite pitch are created by regular, or periodic, vibrations. To take a simple example, the sound produced by speaking results from irregular vibrations and is thus not of definite pitch, while that produced by singing results from regular vibrations and is thus definite in pitch. There are many different pitches, ranging from very high to very low, the relative "height" of the pitch being determined by the number of vibrations per second. For example, when an object such as a string vibrates regularly 20 times per second, it produces a very low pitch; whereas when it vibrates 3000 times per second, it produces a very high pitch. Most musical instruments are confined to a rather limited range of pitches. Thus we distinguish between low instruments (that is, instruments capable of producing pitches only within a low range) and high instruments (those capable of producing pitches only within a high range). To take the human voice as an example, the female voice normally has a higher pitch range than the male voice. The piano is an instrument with a quite extended range, including both very low and very high pitches, as well as those in between.

The vibrator, then, is the part of the instrument which produces the periodic vibrations. The resonator is any material used to resound or bounce these vibrations away from the instrument so that they are amplified and can be heard at a distance. Finally, since most instruments are capable of playing more than one pitch, there is a system for determining which pitch within the range of the instrument will sound at any given moment. To use the piano as an illustration, the vibrators are the strings, the resonator is a wooden sounding board placed beneath the strings, and

the means of determining pitches is a keyboard with a separate key for each of eighty-eight possible pitches.

THE PRINCIPAL MUSICAL INSTRUMENTS

There are three main types of instruments: instruments which are bowed, instruments which are blown, and instruments which are struck. These in turn are divided into four traditional groupings. The instruments which are bowed are the *strings*. Those which are blown fall into two groups: the *brasses*, so named because they are usually made of brass; and the *woodwinds*, so named because they were all originally made of wood. (The modern flute and piccolo are almost always made of metal.) The fourth group is made up of instruments which are struck, *percussion* instruments.

The most common string, woodwind, and brass instruments used in Western music are listed below in order of range, from highest to lowest. Their size corresponds to their pitch, smaller instruments producing faster vibrations and thus higher sounds, and larger instruments producing slower vibrations and thus lower sounds.

STRINGS	WOODWINDS	BRASSES
violin	piccolo	trumpet
viola	flute	French horn
cello	clarinet	trombone
bass	oboe	tuba
	English horn	
	bass clarinet	
	bassoon	
	contrabassoon	

There are two kinds of percussion instruments: those that produce *definite pitch*, and those that produce *indefinite pitch*, or noise. Here are some of the most commonly used.

PERCUSSION OF DEFINITE PITCH	PERCUSSION OF INDEFINITE PITCH
tympani	snare drum
xylophone	bass drum
marimba	cymbals
chimes	gong
glockenspiel	tambourine
(harp)	castanets
	triangle

String Instruments

In string instruments, the vibrator is the string itself, made of gut or wire. The four strings of the bowed instruments are made to vibrate when rubbed by a bow of horsehair made sticky by resin. Since the sound of a vibrating

string is too small to be heard at a distance, a resonator is needed. It is the vibrations of the wooden box, along with the vibrating air inside the box, that act as the resonator.

Pitch is determined in string instruments by the length, thickness, and tautness of the four strings. When a string is vibrated at full length, a specific tone is produced. Other pitches are made by *stopping*—that is, by putting one's finger at a certain point on the string and pressing it to the fingerboard. In effect this shortens the length of string that vibrates and so raises the pitch. A large number of tones can thus be made from each of the four strings.

Woodwind Instruments

In the woodwinds, vibrators are of two kinds, a column of air and a reed. In the flute and piccolo, air blown across the opening near the head of the tube is split into two columns, part of the air going over the instrument, and part being forced through the tube. Of course the air blown across the instrument is lost, but its function is to create a steady pressure on the air being forced through the instrument. The same principle is involved in making sounds by blowing across a bottle or jug. In this case air is both the vibrator and the resonator. The air passing through the tube and the tube itself help to resonate the sound.

A single thin, wooden *reed* (now sometimes of synthetic material) is the vibrator used in the clarinet, bass clarinet, and saxophone. When air is forced into the mouthpiece, the reed flutters rapidly; and as the air is forced through the tube of the instrument, the tube becomes the resonator.

Double reeds are used by the oboe, English horn, bassoon, and contrabassoon. Air forced between the two reeds causes them to vibrate, and again the tube with the column of air passing through it is the resonator.

Pitch in woodwind instruments is determined by the length of the tube. The very short length of the piccolo makes it capable of playing the highest pitches in the orchestra, while the sixteen feet of tubing in the contrabassoon make it the lowest pitched of all orchestral instruments.

Variety and control of pitch in woodwinds are obtained through the use of a series of holes stopped up by the performer's fingers or by keys which shut the holes. By opening and closing these holes, the length of tube is changed, producing different pitches, much as stopping produces changes in string length and thus changes pitches on bowed instruments. When all the holes of the tube are closed, air passes through the entire length of the instrument and produces the lowest pitch.

In addition to the system of holes, pitch can be altered by overblowing: if the performer forces more air into the instrument than it can comfortably respond to, higher tones can be produced. This technique is used, for example, in the flute, where overblowing can raise the pitch one or two octaves.

Brass Instruments

In the brasses, the performer's lips are the vibrators. They are held tightly against the specially shaped mouthpiece and vibrate when air is forced through them into the instrument. The brass walls of the tube are the resonator. As in the case of the woodwinds, pitch is determined in the brass instruments by the length of tube through which the air must pass. Again, variety and control of pitch are achieved by changing the length of tube; however, in the brass instruments, valves and sliding tubes are used in place of holes.

Valves are used in the trumpet, horn, and tuba. When these valves are depressed, air is instantly diverted into different lengths of tube, creating different pitches. The trumpet, for example, can produce seven lengths of tube with its three valves.

The trombone has one tube fitted tightly over another; these can be telescoped in and out to lengthen the tube and change the pitch. The trombone is often popularly called the "slide trombone" because of this. Since there are no fixed valves on a trombone, the player has to rely on his ear to find the right position for the tone wanted.

Percussion Instruments

DEFINITE PITCH Tympani, or kettledrums, are large copper "kettles" with skin (or plastic) stretched over the top and tightened by "taps" around the edge. These instruments can be tuned to definite pitch by tightening or loosening the taps. Today some tympani are tuned by foot pedals, which perform the same function as taps but enable the performer to change pitch much more quickly. The vibrator is the skin of the drumhead, which the performer strikes with sticks—some soft, some hard —and the resonator is the copper walls.

A xylophone is a series of bars of hard wood placed side by side like the keys of a piano, each bar having a different length and thus producing a different pitch. The bars are made to vibrate when struck with wooden or rubber beaters. The xylophone has no resonator.

The marimba is simply a xylophone with a resonator. Small tubes suspended under the wooden bars resonate the sound of the vibrating wood.

Chimes are tubular bells, metal tubes hung from a frame and struck with a hammer. The tube acts as resonator.

The glockenspiel is a set of steel bars played with hammers. The sound produced by the vibrations of the bars is adequate, so that no resonator is used.

Finally, the harp is really a cross between a string instrument and a percussion instrument of definite pitch. Its strings are always plucked and produce a silvery tone quality.

INDEFINITE PITCH The snare drum, or side drum, is a relatively small

military instrument. Parchment is stretched over the top and bottom of a circular wooden frame, making two drumheads. The top drumhead is beaten with two wooden sticks; the bottom drumhead has strings of gut or wire stretched across it, which give a dry, rattling sound when vibrating. Both separate strokes and long, muffled rolls are possible on the snare drum. The walls of the drum are the resonator.

The bass drum is relatively large and also has two drumheads. These are made of skin and are beaten with padded sticks. The performer can make rolls as well as single beats. The resonator, like that of the snare drum, is the walls of the drum.

Unlike the snare drum and bass drum, most of the other percussion instruments of indefinite pitch have no resonator, their initial vibration being adequately loud. This is true of all of the following.

The tambourine is a small wooden hoop over which skin is stretched, with metal disks on the rim. It can be shaken, hit with the hand, or banged on the knee.

Castanets are two hollowed-out pieces of hard wood which are snapped together by the hand. The two pieces may or may not be connected.

The triangle is a small steel rod bent in the shape of a triangle with one corner left open. It is suspended by a string and hit with a metal rod which is rapidly beaten against two sides.

Keyboard Instruments

The harp, as we have seen, does not fit clearly into any one of the four instrumental groups. A similar situation exists with the keyboard instruments. Although these are normally included with the percussion group, they constitute a special set which may be considered singly. The piano, celesta, harpsichord, and organ are all keyboard instruments of definite pitch, but each has physical properties quite different from the others. The piano is basically a string instrument in which the strings are struck by hammers attached to a keyboard; the celesta, often considered a percussion instrument of definite pitch, has steel plates which are hammered; the harpsichord is a string instrument whose strings are plucked by quills or leather or brass tongues attached to the keys; and the organ is a wind instrument, its sounds being made by air forced through pipes.

RANGE

The range of an instrument, as has already been noted, has to do with the total number of tones it can produce, from highest to lowest, and is determined largely by the size of the instrument. Large objects vibrate more slowly than small ones, and slower vibrations create lower tones. Small objects produce faster vibrations and hence higher tones. Thus the range of a cello is lower than that of a trumpet. The total pitch range is divided

into four basic areas: soprano, alto, tenor, and bass. These names correspond to the names given to different types of human voices: high female (soprano), low female (alto), high male (tenor), and low male (bass). Further, each range is divided into three *registers*, high, middle, and low. Thus we speak of the high register of a bassoon, the middle register of a violin, the low register of a trumpet, etc.

To give an idea of the relative range of the instruments discussed, here is a chart comparing them, along with the human voice, to the piano keyboard. The overlapping of ranges as seen here becomes dramatically clear. This is one of the reasons that *timbre*, which will be discussed next, is so important to the composer.

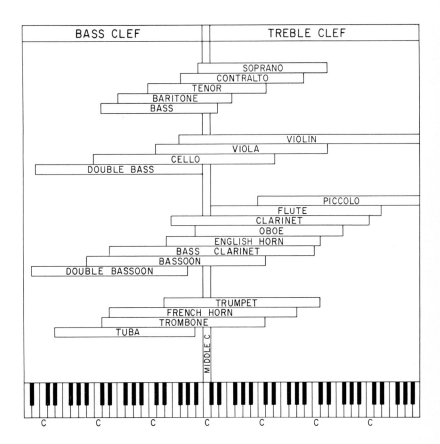

TIMBRE

Timbre, or tone color, is the individual quality of the sounds produced by an instrument which distinguishes them from those produced by other instruments. Thus although a flute and oboe have similar ranges, they can be distinguished because they have different timbres.

When a composer conceives a musical idea, aside from the limitation of range he must think in terms of musical line, tone color, and volume—which means that he must imagine the instrumental sound as part of his idea. An oboe melody, for example, seems just right for the oboe. Although the same pitches could be played on a violin, clarinet, or trumpet, the particular quality of sound produced by the oboe seems to be more suitable for the particular effect desired. But another melody, of course, might be more suitable for the clarinet or the viola—or for that matter, for any other instrument. Sometimes, however, a composer will assign the same melody first to one instrument and then to another, in order to lend it a somewhat different character in its second appearance. Great orchestrators, such as Hector Berlioz, Richard Strauss, and Igor Stravinsky, have a genius for using instruments, either singly or in combination, which can best enhance their musical ideas.

COMBINATIONS OF INSTRUMENTS

The instruments listed on page 135 are those most commonly found in Western music of the past 250 years. The composer, of course, is free to use them in any combination he wishes, but certain combinations—or ensembles, as they are usually called in music—have been found to be particularly satisfying and consequently have been used repeatedly, thereby attaining the status of traditional musical mediums in our culture. We may now consider some of these.

The Symphony Orchestra

The symphony orchestra is a large ensemble which includes all the principal instrumental types. The modern orchestra is composed of four sections corresponding to the four instrumental groupings listed previously: the string section, the woodwind section, the brass section, and the percussion section. With the exception of the percussion section, each of these sections has at least one instrument which falls into each of the four basic ranges: soprano, alto, tenor, and bass.

We shall now turn to a discussion of each of the orchestral sections and of the individual instruments which make them up.

THE STRING SECTION The strings form the backbone of the orchestra. They are largest in number and are divided into first and second violins (the first normally playing in a somewhat higher range than the second), violas, cellos, and basses, each of these five parts being played by several performers. The leading first violinist, who is in charge of the string section, is called the "concertmaster."

Violin. The highest member of the string section is the violin. The violin has a wide range of tones which can be sustained indefinitely. It can play very quietly or loudly; it can play very slowly or extremely fast.

Because of its expressive, voice-like quality, its range, and the special effects it can produce, the violin plays a particularly important role in the orchestra.

Viola. Slightly larger than the violin, the viola has thicker strings and a heavier bow; it can be thought of as an alto violin. The viola has never been considered as much a solo instrument as the violin, being used more often for harmony than for melody. Nonetheless, it can do everything the violin can do, though in a lower range. The viola is best suited to passages that reveal its warm, rich tones.

Cello. This instrument, sometimes called the "violoncello," is much larger than either the violin or viola; it has to be held between the knees of a seated performer. Its strings are thicker and heavier than those of the viola, the bow is shorter and heavier, and it has a lower range. The tone of the cello is rich and romantic, deep and full. It is a favorite instrument for solo passages. If the violin is the soprano of the string section and the viola the alto, the cello is the tenor.

Bass. The bass, known also as the "contrabass" or "double bass," is the largest member of the string family. It rests upon the floor, and the performer stands to play it. Because of its great size and the depth of its tone, it has a limited range of expression. It is most often used as a support, supplying the bass tones for the string choir or orchestra, though occasionally it is given a solo part.

Some of the special effects possible on each of the string instruments are as follows:

Spiccato:	Playing with short, crisp strokes of the bow
Saltallato:	Bouncing the bow on the string to produce light, detached tones
Martellato:	Hammering the bow on the string, making each note separate and emphatic
Tremolo:	Making the bow quiver on the string to produce a shimmering effect
Sul ponticello:	Bowing near the bridge to produce a thin, eerie sound
Pizzicato:	Plucking the strings (used frequently on the double bass in jazz)

THE WOODWIND SECTION Unlike the string section, the woodwind section is made up of instruments which have strikingly different timbres. Whereas the cello's sound is not radically different from that of a violin except for its deeper range, the various woodwinds produce quite different colors. Thus this group is particularly useful for supplying timbral contrast in the orchestra.

Flute. The flute is a tube of metal approximately 27 inches long. Its sound is often described as silvery, haunting, or liquid. It is very agile and can play rapid, brilliant scale passages. In its lower register the sounds

are mellow and rather ethereal, but in its upper register the sound is thinner, more brilliant.

Piccolo. This instrument is really a smaller flute. It is constructed like the flute and can be played by all flutists. It is approximately half the length of the flute and produces shrill and piercing tones. It has a higher range than the flute and adds a sharp edge of brilliance and bite when it is heard with other instruments.

Oboe. The body of the oboe is a tube of wood which gets wider toward the end. It is especially good at expressive solos because its sound is reedy and penetrating. The oboe's slightly nasal tone gives it a plaintive or melancholy quality, but it can also be quite lively.

English horn. Despite its name, the English horn is a larger oboe. Its relationship to the oboe is roughly that of the violas to the violin. The oboe and English horn look very much alike, except that the English horn has a bulge in its bell. Its range is slightly lower, and its sound is richer and even more plaintive than the oboe's. It is usually given the slower, more expressive line to play.

Clarinet. Among the woodwinds, the clarinet is perhaps the most versatile instrument. It has a very wide range, within which it produces three distinct tone colors: in its lowest register it makes rich, hollow tones sometime called "barrel tones"; in its middle register the sound is smooth and of medium thickness; in its upper range the sound is thin and shrill. The clarinet is capable of great expression. It can go from a barely audible sound to one quite loud, play lyrical lines with great finesse, or do rapid scale passages. For these reasons it often takes the part of the violin in band music.

Bassoon. The bassoon and contrabassoon are, respectively, the tenor and bass of the oboe family. The bassoon has approximately eight feet of wooden tube doubled back upon itself (the contrabassoon has sixteen), and the performer supports the instruments by snapping it to a sling worn around the neck. The bassoon produces two distinct colors: in its upper register, it makes a whining, nasal sound not unlike the saxophone, while in its lower register the tone is gravelly, dry, and gruff. The bassoon's upper register is good for expressive solos, but the lower register, unless for reasons of humor, is not. Rather, this register is used for bass harmony, adding a special edge to the overall effect.

THE BRASS SECTION Although the brasses are less agile than the strings and woodwinds, their assertive, penetrating sound is very useful for producing various orchestral effects, ranging in quality from great solemnity to raucous excitement. Their ability to play very loudly is also helpful in creating climaxes and for adding sudden punctuations to soft passages played by the other sections.

Trumpet. The trumpet has both a bright, brassy sound which can ring and pierce, and a soft, muted sound made by inserting a mute (a cone-shaped piece of wood or metal) into the bell of the tube. Because of

its military history, it is often associated with battle calls and is extremely effective in strident passages where triumph or fury is intended.

French horn. This instrument, referred to simply as the *horn,* has been developed from the hunting horn, and its ability to project sound across great distances is still evident. The horn normally has a smooth, mellow tone, but it can be made to sound very brassy. By placing a mute or his hand into the bell, the performer can get a muted sound which is both distant and haunting. By pushing his hand far into the bell and blowing with greater force, he can produce an extremely brassy, almost threatening sound. The horn is a versatile instrument; as a solo instrument it is very satisfactory because it has a wide range and can be loud or soft, lyrical or dramatic. It also has the ability to blend well with every other instrument and is often used in harmony for its full, rich tones.

Trombone. There are two kinds of trombone: tenor and bass. When one speaks of the trombone, he usually means the tenor. The two are alike in construction, but as would be expected the bass trombone has a lower range. The trombone's tone is rich and mellow. It can play softly, but it is more often used for dignified, grandiose melodies.

Tuba. This instrument is the bass of the brass section and is therefore most often used to reinforce the harmony for the orchestra. Its sound is rather like that of the bass trombone, but fuller, richer, and more powerful.

THE PERCUSSION SECTION Until the twentieth century, percussion instruments were used sparingly in the orchestra. The only ones to appear regularly in eighteenth- and nineteenth-century orchestras were the tympani, which were used primarily to supply strong accents and were normally heard in conjunction with the brasses. It is not unusual, however, for modern compositions to require very large percussion sections which are used quite prominently. For example, Ravel's *Rapsodie Espagnole* ("Spanish Rhapsody") requires three percussionists playing a great variety of instruments.

The number of instruments used in the orchestra varies according to the demands of the music. In the early days of its development, the orchestra was much smaller than it is now, Bach, for example, who lived in the first half of the eighteenth century, used a very small group, often consisting of no more than twenty players. Haydn's orchestra (late eighteenth century) had about forty players. By Wagner's time (the middle of the nineteenth century) it was not uncommon for orchestral pieces to require over sixty players, and by the turn of the century—in the music of Strauss and Mahler, for example—there are pieces written for more than one hundred players.

On page 144 is a table which gives a typical dispensation of a small, medium, and large orchestra.

	SMALL	MEDIUM	LARGE
STRINGS			
First violins	8	12	16
Second violins	8	12	16
Violas	6	10	12
Cellos	4	8	10
Bass	2	4	8
WOODWINDS			
Piccolo		1	1
Flute	2	2	2
Oboe	2	2	3
English horn		1	1
Clarinet	2	2	3
Bass clarinet		1	1
Bassoon	2	2	3
Contrabassoon		1	1
BRASS			
Trumpet	2	3	4
French horn	2	4	6
Trombone		2	3
Tuba		1	1
PERCUSSION			
Tympani	1	1	1
Other		1	2
Harp		1	2
TOTAL	41	71	96

It is apparent that an orchestra today must be flexible if it is to play music from different periods. Most of the major orchestras now have approximately ninety players, but they reduce the number of players in order to play earlier music and occasionally hire extra players in order to play compositions requiring a particularly large number. There are pieces for orchestra which feature one soloist throughout, such as a pianist or violinist. These soloists are usually not members of the orchestra but are brought in especially in order to play a particular composition with the orchestra.

The String Orchestra

The composition of a string orchestra is the same as that of the string section of a full orchestra. Although a few string orchestras exist as such, pieces for this ensemble are normally performed by the string section of a full orchestra.

The Band

Like the orchestra, the band is a large ensemble, but it has no strings. It makes use of a greater number of brass, woodwind, and percussion instru-

ments, including several—such as the saxophone—not normally found in orchestras.

Chamber Ensembles

Music written for small groups with only one player to each part is known as *chamber music.* As is true of large ensembles, there are several combinations which are frequently encountered. Most common is the *string quartet,* which consists of two violins, a viola, and a cello. Also popular are the *piano trio* (piano, violin, and cello) and the *woodwind quintet* (flute, oboe, clarinet, bassoon, and French horn). There is also a great deal of chamber music written for one orchestral instrument (for example, a violin) and a piano. The piano, because of its ability to sound several tones simultaneously, is particularly useful in small combinations. The piano's capacity to present complex musical textures by itself has also made it a favored solo instrument, and a vast literature has been written for piano alone, as well as for the other two principal keyboard instruments, the organ and the harpsichord. As might be expected, there is considerably less music for solo orchestral instruments, which normally play only one note at a time.

VOCAL MEDIUMS

Like instruments, voices are also combined into groups, for which they are traditionally divided into the four basic ranges: soprano, alto, tenor, and bass. Sometimes a fifth category, the baritone, is added between the tenor and the bass.

If each of the four parts is sung by many singers, the group is a *chorus,* or *choir.* Choral music may be either accompanied or unaccompanied. If unaccompanied it is known as *a cappella* music (*cappella* is the Italian word for "chapel"; thus, music "for the chapel," where in earlier times no instruments were allowed). A chorus may be accompanied by any group of instruments or by a solo keyboard instrument; it is frequently used in combination with the orchestra. There is music for the male chorus and the female chorus as well as for the more common mixed chorus.

As with instrumental music, there is also music for smaller vocal groups, such as the *vocal quartet,* consisting usually of one soprano, one alto, one tenor, and one bass. Even more prominent is the solo song with keyboard accompaniment, for which there is a large and varied literature.

In addition to the different ranges, solo voices are also categorized according to their timbre, or quality of sound. Thus we distinguish between *lyric* and *dramatic* sopranos (or altos, etc.), the lyric voice having a lighter, more flexible quality than the dramatic voice.

Vocal music is a particularly attractive medium for composers; for although the human voice lacks the agility of most orchestral instruments, it more than compensates for this with its warm, expressive quality. Also, the voice is able to make a more immediate and personal impression upon the listener. Moreover, the singer's ability to perform words as well as

music, a technique obviously unavailable to instruments, opens up an important new musical dimension: the setting of texts to music.

There are two ways in which the composer may approach the problem of setting a text. First, he may conceive of his composition as a musical "commentary" on the text, and attempt to evoke a musical quality analogous to the literary quality of the original. [Schubert's song *Die Forelle* ("The Trout") is an example of this approach.] Or he may use the text as a means of clarifying verbally the extramusical meaning of his music. As we noted at the opening of this chapter, music itself is largely ambiguous in reference to things outside itself. Through use of a text the composer may be able to specify more precisely his intentions. (An example is the last movement of Beethoven's Symphony No. 9.)

SPECIAL ENSEMBLES

It is important to keep in mind that certain mediums are particularly useful for certain kinds of music. The instruments and combinations of instruments that we have considered were developed gradually over a period of many years to meet the requirements of a particular kind of music. There is no reason to assume, however, that they are necessarily superior to other instruments and instrumental combinations designed for other types of music. To take a current example, the rock band is obviously better suited for the performance of rock music than the symphony orchestra. In the field of concert music too, as music evolves composers search for new mediums more congenial to their changing musical ideas. In twentieth-century music, for example, it has become increasingly common for composers to choose "special" combinations for the unique purposes of particular compositions. Two examples are *L'Histoire du Soldat* ("The Soldier's Tale"), by Igor Stravinsky, written for clarinet, trumpet, trombone, violin, bass, percussion, and narrator; and *Le Marteau sans Maître* ("The Hammer without a Master"), by Pierre Boulez, for flute, xylophone, vibraphone, guitar, viola, various nonpitched percussion instruments, and alto voice.

One particularly significant trend in recent years has been the development of electronic instruments, which many contemporary composers feel are more versatile than traditional instruments and more suitable for achieving the sounds they want for their music. Karlheinz Stockhausen's *Gesang der Jünglinge* ("Song of the Youths") is an example of a composition produced electronically. In this piece the sounds are originally generated both by purely electronic means and by "natural" means (a boy's voice), but all the sounds are then electronically manipulated so that the final result is a completely electronic composition.

Finally, it should be remembered that other cultures make use of instruments which are different from ours, but which, like ours, have been developed for the purposes of performing a particular kind of music. The Javanese gamelan orchestra, for example, is made up primarily of several gong-like or chime-like instruments constructed of different kinds of ma-

terials (wood, bamboo, and metal); it has a ringing timbral quality, unlike anything in Western music, which is uniquely suited to Javanese music.

INTERPRETATION IN ENSEMBLE MUSIC

The problem of interpretation is considerably more complex in the performance of music for ensembles than in that of solo music, for the interpretation must be worked out in cooperation among the various players. In chamber music the interpretation is normally arrived at through common agreement, although in some cases one player may have the main responsibility (this is frequently true of the first violinist in string quartets). In chamber music, even if one player is chiefly responsible for the interpretation, there is nevertheless no director as such during the performance. Thus the players must always listen to one another extremely carefully; precisely for this reason, many musicians prefer to perform chamber music over any other type.

In the early days of the orchestra, when the group was still relatively small, there was no director. As orchestras grew in size, however, the problem of keeping all the players together and agreeing upon an interpretation became increasingly difficult. From about 1825, orchestral directors —or *conductors,* as they are usually known—became a regular feature of any large ensemble. The conductor's importance has grown steadily, until today he is considered to be the most valuable and important man in the orchestra.

The duties of today's conductor are both demanding and varied. He is in charge of the personnel of the orchestra. It is he who auditions performers and decides who will be a member of the orchestra and what part each member will play within his own section.

The conductor also decides what music will be performed. The performance of obscure works, the introduction of contemporary works, or the choice of traditional works is his responsibility. Moreover, he must decide what will make a balanced individual concert. These decisions are, of course, tempered by the proficiency of the group, the amount of rehearsal time available, what instruments and how many performers the music calls for, the demands of musicians' unions, and often the taste of the public which helps to support the group.

Aside from the demands of business, the conductor must be a kind of supermusician. He must know thoroughly the mechanics of every instrument in the orchestra. From the conductor's podium he reads simultaneously on his score the notes of every instrument, and should be able to detect and correct any error on the part of the performers. He must know the score perfectly and also have knowledge of the general style of the composer whose music is being played. It is in terms of musical performance, however, that the conductor succeeds or fails, for ultimately, the kind of performance given rests upon his interpretation.

The following are some of the things we see the conductor do at a

performance: he sets the speed and controls the rhythm; he adjusts the volume from time to time, asking some players for softer sounds and others for more volume, so that the audience gets the correct mixture of both volume and tone color; he cues the performers, making sure that each instrument enters precisely when it should; and most important, he indicates the mood of a particular motive, phrase, or section of music. He is the voice that determines the expressive quality of the performance.

MUSICAL EXAMPLES

There is no substitute for actually hearing the sounds produced by the various instruments and instrumental combinations. There are two recordings currently available which are designed to introduce the orchestral instruments:

> The Instruments of the Orchestra (Vanguard 1017/8)
> The Orchestra and Its Instruments (Folkways 3602)

In addition, a number of specific compositions illustrate clearly the timbre of the various instruments. Some of these are:

> The Young Person's Guide to the Orchestra by Benjamin Britten
> Bolero by Ravel
> Nutcracker Suite by Tchaikovsky
> Peter and the Wolf by Prokofiev
> Concerto for Orchestra by Bartók

Compositions for other mediums, such as the band and the various chamber ensembles, are also readily available on record. To list just a few examples:

> Serenade in C for String Orchestra by Tchaikovsky
> Symphony in B flat for Band by Hindemith
> String Quartet, Op. 18, No. 1 by Beethoven
> Sonata in D minor for Violin and Piano, Op. 103 by Brahms
> Symphony of Psalms for Chorus and Orchestra by Stravinsky
> Frauenliebe und Leben, Op. 42 for Soprano and Piano by Schumann

A good way to hear the effect of medium upon musical composition is to compare several chamber pieces with several orchestral pieces. The former tend to be much more intimate and subdued than the latter, which are usually more brilliant and extroverted in character. Choice of medium is an integral part of the composer's overall conception, and the importance of its contribution to the final artistic result can scarcely be overemphasized.

8. LITERATURE AND THE COMBINED ARTS

LIMITATIONS OF THE SUBJECT IN LITERATURE

The medium of literature is language, and as we have said, language may deal with anything that can be put into words. Language has a great advantage in that it is the only medium in any art which is used by everyone. Many of us do not try to draw or paint, or cannot play or sing, but we all talk. We may talk much or we may talk little, we may express our ideas easily or with difficulty, but we talk. Furthermore, we use this medium creatively. We make up new sentences to express our ideas.

Set against this advantage of literature as a medium is a corresponding disadvantage. Literature is the only art whose medium is not international. A painting in fresco loses its characteristic quality if it is copied in oil—there is an essential change—but if one knows it in fresco he recognizes it in oil, can see that it is the same picture. In the same way, a symphony written for an orchestra loses something that is essential when it is played on the piano, and yet one recognizes it as the same. But if a poem is translated into another language, one has no idea what it is about unless he knows the other language. To the person who knows both languages there is perhaps no greater difference between a poem in French and its translation into English than there is between the symphony played by the orchestra and an arrangement of that symphony for the piano; but to anyone who does not know both languages one version is gibberish.

Words are symbols and therefore are incomprehensible to those who do not know them. A symbol is by nature arbitrary. It has a certain meaning because that meaning has been agreed on and for no other reason. In the story "Ali Baba and the Forty Thieves," there is no intrinsic reason why the door should open if one said, "Open sesame" rather than "Open barley" or "Open wheat," but *sesame* was the word that had been agreed

upon for that purpose, and the door would open for no other word. There is no reason why the symbol "4" should stand for four rather than for three or six. And so it is with most words. With a small group of words, such as *bow-wow, moo-moo,* and *baa,* the sound is supposed to convey the meaning, but the number of such words is negligible, and they do not really convey any meaning. With the vast majority of words the sound has no natural and inevitable relation to the meaning. We are accustomed to associating the sound of the word *dog* with a certain animal, but there is no essential connection between the two. The French word for dog is *chien,* the German, *Hund,* the Latin, *canis;* and there is nothing in any one of the sounds to indicate that particular animal were it not so understood by the people who speak that language.

LANGUAGE IN LITERATURE

The Languages of the World

The mediums of literature are the various languages of the world: English, French, German, Italian, Russian, Chinese, Japanese, and so on. And as is true of all mediums of all arts, each has its own special characteristics, and what can be said in one cannot be said in another. It is said that the novelist Conrad wrote his novels in English rather than in French, a language he knew much better, because in French he could not say what he wanted to say. A recent writer on the subject of communication has said, "When I read French I need to become as a different person, with different thought; the language change bears with it a change of national character and temperament, a different history and literature."[1] In a small way all of us have experienced this change in assuming a dialect. The man who talks as an American Negro, a Southerner, or an Irishman assumes the character and personality of that person for that time.

A delightful account of the difficulties with a foreign language is found in Clarence Day's *Life with Father.*[2]

I got out another Bible that Mother had lent me. This one was in French, and it sometimes shocked me deeply to read it. As my belief was that when God had created the world he had said, "Let there be light," it seemed to me highly irreverent to put French words in His mouth and have Him exclaim, "Que la lumière soit!" Imagine the Lord talking French! Aside from a few odd words in Hebrew, I took it completely for granted that God had never spoken anything but the most dignified English.

Instead of the children of Israel fearing lest the Lord should be wroth, the French said "les enfants d'Israel" were afraid lest "le Seigneur" should be "irrité." This word "irrité" appeared everywhere in the French version. It wasn't only the Lord. Cain was "très irrité." Moise

[1] Colin Cherry, *On Human Communication,* M.I.T. Press, 1957, p. 70.
[2] Clarence Day, *Life with Father.* Copyright 1935 by Clarence Day. Used by permission of Alfred A. Knopf, Inc.

(which seemed to me a very jaunty way of referring to Moses) was "irrité" again and again. Everybody was "irrité." When my regular Bible, the real one, impressively described men as "wroth," their anger seemed to have something stately and solemn about it. If they were full of mere irritation all the time, they were more like the Day family.

The Question of Translations

In a very real sense no translation is ever more than an approximation of the original. The sound of the original is lost completely; only the sense is preserved, and the sense cannot be put into another language with complete accuracy. Sometimes a single translation is made so nearly perfect that it is accepted as an adequate rendering of the original. An example is Longfellow's translation of Goethe's "Wanderer's Night Song":

Über allen Gipfeln
Ist Ruh,
In allen Wipfeln
Spürest du
Kaum einen Hauch;
Die Vögelein schweigen im Walde.
Warte nur, balde
Ruhest du auch.
> —Johann Wolfgang von Goethe
> (1749–1832, German poet, dramatist, and novelist),
> "Wanderers Nachtlied" (1780)

O'er all the hill-tops
Is quiet now,
In all the tree-tops
Hearest thou
Hardly a breath;
The birds are asleep in the trees:
Wait; soon like these
Thou too shalt rest.
> —Henry Wadsworth Longfellow (1807–1882, American poet)

But all too often translations either fail to be good English or fail to be like the original. If it is necessary to use a translation, the best practice is to compare several versions, by different translators, for often a different translation gives a new insight into a passage. The Bible is a good book to study in this connection because there are many different translations easily available. Suppose we take the passage in Matthew when Jesus is talking about divorce; it ends with the words we all know: "What therefore God hath joined together, let no man put asunder." The disciples, however, are not satisfied and ask about the law of Moses. Moffatt's translation of their question is: "Then why did Moses lay it down that we were to divorce by

giving a separation-notice?"[3] but Phillips's is: "Then why did Moses command us to give a written divorce-notice and dismiss the woman?"[4] In the King James and Moffatt versions, the answer is that it was because of "the hardness of your hearts"; the New English Bible gives a different interpretation: "It was because you were so unteachable."[5] Phillips gives it an entirely new sense: "It was because you knew so little of the meaning of love that Moses allowed you to divorce your wives." Jesus ends this speech with the statement that adultery is the only ground for divorce, and again the disciples object and the translations differ. The King James version reads: "If the case of the man be so with his wife, it is not good to marry." Moffatt: "There is no good in marrying." The New English Bible: "If that is the position with husband and wife, it is better to refrain from marriage." Phillips: "If that is a man's position with his wife, it is not worth getting married."

Literature in English

In a text of this kind it is not safe to assume that the readers will know more than one language. Therefore, we are limiting our study of literature to one medium, English. In doing so we are obviously restricted and are at a disadvantage. In the other arts we can study the work of all countries with equal ease. We can hear the music of Russia, see the sculpture of Greece, and enjoy the architecture of France and the paintings of Italy as clearly and as easily as we can those of England. In literature we are confined to writings in English or to translations from other languages into English.

Fortunately, the English language is a very flexible medium, and a very wide variety of effects can be obtained in it. Fortunately, also, it is a language with a very great literature. But the fact remains that, taking up only English, we are missing other and different types of effects to be obtained in other languages.

THE COMBINED ARTS

By definition, the combined arts are those which use more than one medium. The special emphasis of a dance is on the movements of the body, but the dancer employs also costume and lighting, usually music, and sometimes stage scenery. The theater presents a story told in dialogue and acted out on the stage; usually it also employs scenery, costumes, furniture, and lighting, and at times music. Motion pictures use not only these

[3] *The Bible: A New Translation* by James Moffatt, copyrighted in 1935 by Harper & Row, Publishers, New York. Used by permission.
[4] *The Gospels,* translated into Modern English by J. B. Phillips, copyrighted in 1952 by The Macmillan Company, New York. Used by permission.
[5] From *The New English Bible, New Testament.* © The Delegates of the Oxford University Press and The Syndics of the Cambridge University Press, 1961. Reprinted by permission.

elements but also such things as space larger than any stage area; simultaneous presentation of actions at more than one point in time; far more complex lighting effects; and different treatments of sound.

Ideally, the various mediums are combined with just the right emphasis on each to make clear the idea in the mind of the artist. One of the major problems of the artist is deciding which of his mediums he will stress at any particular time.

An example is found in *Hamlet,* in the scene in which Hamlet renounces Ophelia. Hamlet, a young man just returned from the university, is sorely perplexed by the condition in which he has found matters at home. His father is dead, and his mother has married again so quickly that Hamlet contemptuously says she did it to economize on the breads and meats baked for his father's funeral. Shortly afterward he learns from a ghost that his father was murdered. Hamlet does not know whether to believe the ghost or not, and he needs help desperately. For a long time he has been in love with Ophelia, and naturally he turns to her now. But, looking into her face, he realizes that she cannot help him; so he shakes his head and leaves the room without saying a word. This might seem just the scene to be enacted on the stage. But, instead, Shakespeare uses words only. Ophelia tells her father about it:

My lord, as I was sewing in my chamber,
Lord Hamlet, with his doublet all unbrac'd,
No hat upon his head, his stockings foul'd,
Ungart'red, and down-gyved to his ankle,
Pale as his shirt, his knees knocking each other,
And with a look so piteous in purport
As if he had been loosed out of hell
To speak of horrors,—he comes before me. . . .

He took me by the wrist and held me hard;
Then goes he to the length of all his arm,
And, with his other hand thus o'er his brow,
He falls to such perusal of my face
As he would draw it. Long stay'd he so.
At last, a little shaking of mine arm,
And thrice his head thus waving up and down,
He rais'd a sigh so piteous and profound
That it did seem to shatter all his bulk
And end his being. That done, he lets me go;
And, with his head over his shoulder turn'd,
He seem'd to find his way without his eyes,
For out o'doors he went without their help,
And, to the last bended their light on me.
 —William Shakespeare (1564–1616, British poet and dramatist),
 Hamlet, II, i, 77–84, 87–100

The scene as described by Ophelia is so vivid that most people who read the play remember the event as one that took place on the stage. Why did

Shakespeare simply have Ophelia tell about it? There probably are several reasons. One may be that in this way he could kill two birds with one stone, the father is told at the same time that we learn of the action. This would be a good but unimportant reason. A more important consideration might have been that such a scene would not be easy to enact. The most likely reason might be that Shakespeare wanted to be sure that the audience would understand the scene as he meant them to; he therefore interprets it for them in words.

The mediums used in the combined arts are the mediums used in the separate arts. In this short discussion we shall attempt only to show the mediums that are used in each art and to state some of the possibilities and limitations that arise from their being combined.

Drama

Drama is usually classified as literature because the most important part of a play is the dialogue spoken by the characters. As action, however, whether presented on the stage or visualized by the mind, it involves many other mediums. There are of course the actors, for each of whom we have costume, speaking voice, and all his actions. For the story as a whole we have setting and properties. The possibilities in each type of medium are almost limitless. A slight change in costume may be used to indicate that years have passed or that the person has grown richer or poorer. The accent may betray nationality or social status, and the manner of speaking may indicate character. The actor may make use of all the movements of the dancer as well as those of the ordinary person in walking, running, or standing.

We must always keep in mind that most plays were written to be performed and that, as a result, there is a world of difference between reading *Hamlet* as literature and performing it or seeing it performed. Many people find a great deal of Shakespeare relatively uninteresting if they only read it, but find that the plays come to life when they are performed well. With ancient Greek drama the difference between reading and performing is even greater. Euripides' *Medea,* which we discussed earlier, reaches its climax as theater with the off-stage murder of the two children, and an unearthly scream by the mother, whose effect no amount of reading could begin to convey and which, once heard, is never forgotten. In reading *Medea* one does not experience this emotional element; indeed, it is not present in the text but has been added by the modern actress and director. A very instructive experience for the student would be to read this short play and then listen to the recording made by the distinguished actress Judith Anderson.

In many of the great periods of the theater the setting has been of very little importance. In the Greek theater, for instance, the setting was the same for all plays, a street before a building. In the Elizabethan theater also, it was very simple, consisting of only a few pieces of furniture to indicate the type of room—for example, a bed for a bedroom. The Greeks and

the Elizabethans, moreover, had no control over lighting; both performed their plays in the daytime with natural lighting. Now the producer has full control over the lighting of his play, and it has become common to use all sorts of settings. The producer can change both elements to suit the performance; both have become mediums for the artist just as truly as speech, action, or costume.

Since the seventeenth and eighteenth centuries, with the development of opera and theater as organized art forms with special buildings and equipment, it has been possible to do far more in the way of special effects. We can still see skillfully built equipment in the private royal theaters at, for example, Versailles in France and Drottningholm in Sweden, and in some other seventeenth- and eighteenth-century buildings. When these were built, it was already possible to make certain complicated effects: actors could be raised and lowered, fire could be simulated, people could be made to seem to fly, and lighting arrangements could be very sophisticated. In today's theater we can do even more with electric lighting, electronic sound, turntable stages, and other technological advances.

Dance

"The dance antedates all other forms of art because it employs no instrument but the body itself which everyone has always with him and which, in the final analysis, is the most eloquent and responsive of all the instruments."[6] Dance is the most personal of all the mediums of art. If we think of a dance as organized movement, we will be interested in the examples given by Curt Sachs in his *World History of the Dance* (p. 988). He cites instances of animals that dance: the stilt birds and the anthropoid apes. In their dances he finds a series of the essential dance motifs: the circle and ellipse, forward and backward steps, hopping, stamping, and whirling. We cannot go into the early history of man without finding dance. Greek vases show many examples of dancers. The Noh dancing of ancient Japan is about six hundred years old.

The movements of dance may be classified under two headings: (1) movements within the body, such as movement of the head, arms, or torso within a certain space, and (2) movement from one space to another, such as walking, running, and jumping. A dance may be performed by a single dancer or by any number of dancers.

Dance exists in the three dimensions: time, space, and dynamics. Space, of course, determines the position of the dancer in relation to his background: in the center, to one side, in front, to the back. It also determines the posture of the body—standing, lying, crouched, stooped, running, still, etc. The time, of course, may be fast or slow, and its dynamics determine the rhythm.

In general we distinguish between a folk dance and an art dance. Folk dance is part of the ethnic traditions of a country or district—Spain

[6] John Martin, *Introduction to the Dance*, pp. 14–15.

or Andalusia, Germany or Bavaria—in which are preserved certain melodies, rhythms, costumes, and folk symbolism. Folk dances have cultural significance and inherent beauty. The art dance may be either a solo performance or a group arrangement (for example, a ballet). An art dance may or may not be related to a folk tradition. *Petrouchka,* by Igor Stravinsky, takes traditional Russian folk melodies, tales, and costumes, and creates a new, highly artificial and beautiful form. Ballets like Tchaikovsky's *Swan Lake* are less directly related to folk origins. *Swan Lake,* romantic in melody and symbolist in meaning, is performed by dancers wearing the canonical and traditional ballet costumes as they have come down through the nineteenth and twentieth centuries.

Opera

Opera comprises three mediums, which in order of importance are: music, drama, and spectacle. These make opera one of the most appealing of the arts, but they also make it one of the most complex and difficult. The music alone demands a full symphony orchestra, a conductor, one or more choruses, a choral conductor, and solo singers.

The dramatic demands of opera begin with the libretto, or "book of words," upon which the opera is based. A good libretto gives us the essence of character and situation quickly and thoroughly. The composer who finds a librettist with whom he can work well is a man blessed. One of the happiest combinations of composer and librettist is that of Gilbert and Sullivan in the area of operetta (literally, "small opera"—and also opera light in character). In opera itself, a great combination was that of Verdi and Boito. In making Shakespeare's *Othello* into a libretto for Verdi's opera *Otello,* Boito made a number of effective changes. For example, he omitted the entire first act of the play, keeping only Othello's courtship speech, which becomes a duet between Othello and Desdemona. In the opera, Desdemona prays to the Virgin Mary before she is strangled, although that scene does not appear in the play.

In the integration of mediums so different as music and drama, compromises must be made. One is in the matter of time. For obvious reasons, singing a script takes longer than speaking it. In opera, then, quite often the dramatic action must be either slowed down or stopped altogether while a musical idea progresses. Conversely, while the dramatic action moves forward, we cannot expect to linger over a long, beautiful melody. Within this perpetual compromise there is no doubt that drama suffers more than music. Since music is the most important medium in opera, it must succeed, no matter what the fate of the dramatic action. Opera stands or falls on the quality of its music. Even an excellent libretto is inadequate if the music to which it is set is inferior. On the other hand, a trite libretto can be sustained by memorable music. Furthermore, one can forgive an opera singer whose acting ability is limited, but no matter how fine the acting, one does not forget or forgive bad singing.

Spectacle involves anything of a visual nature which can be integrated with the opera plot. Dances which are complete works in themselves are

found in many operas. Exotic sets and costumes also constitute spectacle, especially when they are changed often for the visual delight of the audience. Spectacle also occurs when there is an emphasis on the realm of nature, such as the use of fire, water, or animals in the production. Verdi's *Aïda* is an example; in the scene of the triumphal march, trumpeters on horseback, camels, chariots, and large numbers of performers can be used when the opera is staged with spectacle in mind. As Verdi matured, however, he used fewer and fewer extraneous visual effects, until in his last two operas, *Otello* and *Falstaf,* there is no spectacle: we have only the bare bones of music and drama. And although his earlier operas are still enjoyed, these two are considered his finest work. Therefore, it can be said that spectacle is not necessary to opera.

Film

Film, one of the most recent arts, shares with the other arts certain advantages as well as limitations. Obviously, it can bring to life the physical appearance and actions of any living being—human or animal—in a uniquely factual way, anything or anyone from Picasso painting a picture to Balto the sled-dog bringing serum to an isolated northern community. It can also reproduce scenes from nature, with the camera moving about freely like our own eyes but having certain mechanical advantages that the human eye does not possess. It can take us from place to place instantaneously, create an illusion of space comparable only to the achievement of certain kinds of painting, and—most important—give impressions of different points of time through use of the flashback technique. In the 1971 version of *Death in Venice,* as has been mentioned, the director brings in a variety of early events from the life of his composer-hero to help explain his psychological problems in the fictional present. Properly handled (that is, with skillful use of closeups, dissolves, and other techniques), the camera can present the observed facts selectively to make them symbolic or to stress their importance.

Let us examine some of these points in the classic Russian film *Potemkin,* the story of a group of sailors on a naval ship of that name in the harbor of Odessa at the outbreak of the Russian Revolution in 1917. Driven to desperation by the inhuman conditions aboard ship, and encouraged by the general political situation, the sailors mutiny against their officers. A series of quickly viewed episodes moves us from one level of action to another: a quick close-up of the face of a tyrannical officer gives us an instantaneous impression of him as a smug bourgeois; then he is seen being thrown overboard. This visual miracle—and it is such—is made possible by the technology of the film process; it is this, coupled with the artistry of the photographer, editor, and director, that allows the full emotional impact of the sailors' revolutionary act to be conveyed. In the next passage, we close in on the officer's pince-nez eyeglasses, left swinging back and forth on a projecting strut. He himself is gone, but this symbol of his bourgeois quality still trembles in the breeze. The Revolution has begun. Another example from *Potemkin* is the way the implacable and

apparently irresistible power of the Czarist forces is projected for us in famous scene which takes place in the city of Odessa. A squad of Russia soldiers are spread out in a line on the wide steps of the magnificent wate front staircase; they move down in step, their rifles at the ready, sweepin everyone—rebel or not—before them. The camera gives us a momentar view of a baby's carriage rolling down the marble steps after the mothe has been shot down in the indiscriminate firing.

Obviously, this kind of drama and tension is not the exclusive provinc of the motion picture. Edgar Allan Poe's short story *The Pit and the Per dulum* is a famous example of extreme tension created in words alone But the visual and symbolic effects created in *Potemkin* seem to call fort a uniquely intense response. Perhaps this is because both sight and soun are used on the most immediate, even brutal, level. It seems to be tru that what we see and hear affects us more directly, and therefore mor intensely, than what we receive in the form of printed words—our sense are more engaged.

Several "translations" of existing literary works into filmed drama were cited in Chapter 5 when we discussed the distinguishing characteris tics of different mediums. There have been a number of very successfu film adaptations of literary works. However, the great contribution of filr to the world of art must be in the field of original dramas. Among the mos interesting of these are the German films of the 1920s and 1930s, films o social milieu, like *The Blue Angel,* portraying post-World War I Berlin. Th protagonist in this film, an unattractive middle-aged professor, falls hope lessly in love with a cabaret singer (played by Marlene Dietrich), and hi infatuation becomes a symbol of man's inability to control his own destiny The Italians, whose socially oriented realistic films are of somewhat late date (*Open City* and *The Bicycle Thief* are outstanding examples) have long and honorable history in this area. The French also, in such films a the atmospheric *Sous les toits de Paris,* offer a characteristic combinatio of the romantic and the realistic. More recently they have produced a num ber of outstanding films of political comment. These include *La guerre es finie,* in which Yves Montand plays the role of a professional Spanish revolu tionary, and—again with Montand—the more recent *Z,* a story of politica repression in Greece, and *Confession,* about an anti-Soviet Czech officia Even leaving aside Montand's excellent performances in these films, th films are important expressions of political awareness.

PART THREE
ORGANIZATION

9. ELEMENTS OF THE VISUAL ARTS

MEDIUM AND ELEMENTS

Medium and elements are together the materials the artist uses in creating a work of art. The distinction between them is easy to see but hard to define. Both answer the question: What is it made of? but from different points of view. If, for instance, we say that a building is made of brick and stone, we are talking of the medium; if we say it is made of right angles and vertical lines, we are talking of the elements. If we say that a piece of music is played on the horn, the oboe, or the piano, we are talking of the medium; if we say that it is fast or slow, or that it has a good tune or a catchy rhythm, we are talking of the elements. If we say that a picture is made of oil or watercolor, we are talking of the medium, but if we say it is made of red and green and blue, we are talking of the elements.

An element can be known only in some medium, but as an element it is independent of medium. If we see a straight line we necessarily see it as done in some medium—as a chalk line, a pencil line, or an ink line, or the line described by the corner of a house—but when we think of line we do not necessarily connect it with any medium. And so we talk of line dissociated from medium. Similarly, if we hear the song "America," we must hear it sung by some person or played on some instrument, but we think of it as a tune without regard to any instrument. Therefore, when we study elements, we consider them with no attention to the means by which we know them. The medium is the physical means through which we can come into contact with a work of art; the elements are its qualities or properties. Mediums are concrete; elements are abstract.

THE ELEMENTS

The elements of the visual arts are seven:

1. Line
2. Value (light and dark)
3. Light and shadow (chiaroscuro)
4. Color
5. Texture
6. Volume
7. Space (including perspective)

Line

Line is the simplest, most primitive, and most universal means for creating visual art. Ask a child to draw an apple, a man, or a house: he will make it first in lines; that is, he will try to outline it. Lines are of many different kinds. They may be broad, or so faint we can hardly see them. They may be ragged, or clear and distinct. Often lines are felt and not seen, as when one object or person points to something we do not see. Often the felt lines are more important than the seen lines.

As a matter of fact, there is no such thing as line. What we see as lines are marks made on paper, or contours of objects. The round vase has no edge, no line, but we see one just as we see the corner of a building as a line. Or we may see shadows as lines.

Lines always have direction. They are always active. They always seem to be moving, and we follow them with our fingers, our gestures, or our eyes. Color has none of this activity. We see a wall of blue or red with no idea of motion of any kind, but whenever we see a line we begin to follow it no matter how long or winding its path.

STRAIGHT LINES Lines are straight or curved; straight lines are horizontal, vertical, or diagonal. The horizontal line is primarily the line of rest and quiet, relaxation and contemplation; a long horizontal line gives a sense of infinity that is not easily obtained in any other way. Horizontal lines are found in landscapes; the quieter the landscape, the more prominent the horizontals. In Rembrandt's *Three Trees* (Figure 6-35, page 128) the sense of rest and quiet and peace derives largely from the long line of the horizon.

The vertical line is the line of a tree or of a man standing, the line of chimneys and towers. The vertical line is a line of rest, but it is not the rest of relaxation we find in the horizontal. The vertical is poised, balanced, forceful, and dynamic. The vertical is a line of potential action, though it is not acting. The early Greek bronze found at Delphi, known as *The Charioteer* (Figure 6-3, page 109), is purely vertical except for the arms, which are outstretched to hold the reins. Even a slight deviation from the vertical takes away from its force; in the caryatids of the Erechtheum (Figure

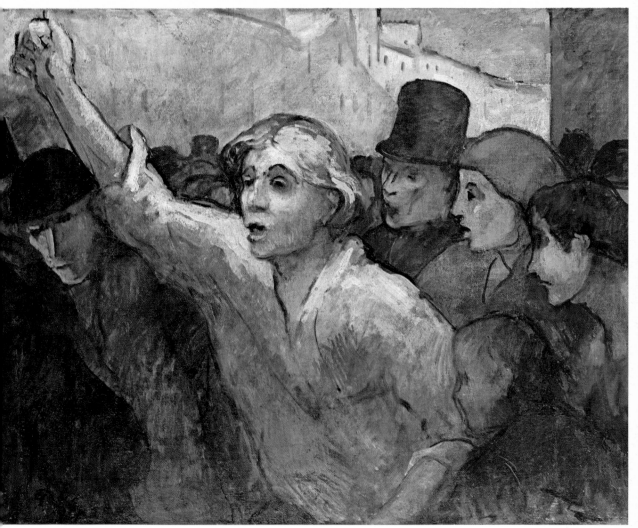

Figure 9-1. Honoré Daumier. The Uprising (1860?). (Oil on canvas. Size: 4½ by 44½ inches. Washington, D.C.; Phillips Collection.)

2-1, page 20), for example, each figure is perfectly straight except for one bent knee, but that break from the vertical gives a sense of relaxation. One feels that the load is not too heavy and that the maidens can easily hold up the roof for a few more centuries.

The diagonal is the line of action. A man running makes a diagonal line with his body and leg; a beating rain, a tree in a hard wind, almost everything in action assumes a diagonal line. The degree of action is shown in the angle of the diagonal. The diagonal that approaches the vertical shares the force and self-sufficiency of the vertical; the diagonal that approaches the horizontal shares its abandonment. At an angle of forty-five degrees the diagonal represents the maximum of action, being halfway between the independence of the vertical and the powerlessness of the horizontal. In Daumier's painting *The Uprising* (shown in Figure 9-1)

Figure 9-2. Raymond Duchamp-Villon (1876–1918), French sculptor. The Horse (1914). (Bronze. Size: 15¾ inches high. New York, Museum of Modern Art; Van Gogh Purchase Fund.)

Figure 9-3. El Greco. Purification of the Temple (1595–1600). (Oil on canvas. Size: 41⅜ by 50 inches. Copyright Frick Collection, New York.)

the forward movement of the mob is shown in the diagonals, especially in the upraised arm of the leader. In Duchamp-Villon's statue (shown in Figure 9-2) the horse's head is turned to one side and his feet are drawn together for action. The energy and incipient action of the statue are derived primarily from its diagonals.

Diagonals meeting at sharp angles form jagged lines that are harsh and unpleasant; they connote confusion, disturbance, lightning, battle, war and sudden death. In El Greco's *Purification of the Temple* (shown in Figure 9-3) the main interest is centered on Christ and the tradesmen who are being driven away. The lines made by their arms and bodies are predominantly diagonal, meeting at acute angles. In contrast, the figures to the right of the center are quiet, being formed largely of vertical and curved lines.

CURVED LINES Curved lines show action and life and energy; they are never harsh or stern. Most of the sights to which we attach the adjective "pleasing" have curved lines: rounded hills, trees bent with fruit, curved arms and cheeks.

Curves may be single or double, slow or quick. A quick curve is an arc of a small circle, the type of curve found on a fat baby. A slow curve is an arc of a large circle, the type of a long, thin face. A single curve is but a single arc; a double curve turns back on itself in an S shape. The double slow curve is the famous "line of grace" or "line of beauty" of Hogarth. The quick curve is more exuberant than the slow curve; when used in great abundance it becomes coarse and gross.

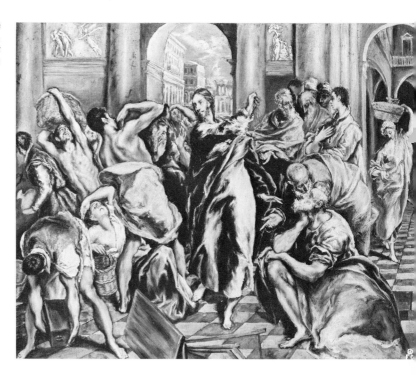

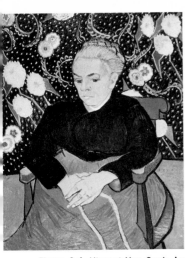

Figure 9-4. Vincent Van Gogh. La Berceuse (Mme. Roulin Rocking the Cradle) (1889). (Oil on canvas. Size: 36 by 28 inches. Art Institute of Chicago; Helen Birch Bartlett Memorial Collection.)

A great deal of the elegance of Harunobu's *Lovers under Umbrella in Snow* comes from the long single curves. In contrast, Van Gogh's *La Berceuse* (shown in Figure 9-4), with its round curves, is solid and substantial. All the curves are ample; the flowers and other ornaments in the background are circular.

Examples of the characteristics of lines are to be found everywhere. In advertisements, the shape of the letter and the quality of the line are frequently used to indicate the character of the thing advertised. For example, the lettering that advertises farm machinery may also try to suggest its product, in solid, heavy, square strokes that sit flatly on the paper. Articles that are supposed to appeal to the dainty or the fastidious will be advertised in thin lines with slow curves.

Lines make shapes, and often we are conscious of line primarily as the shapes formed. In Rembrandt's *Three Trees* we see the line of the horizon but the shape of the trees. Miró's *Painting* (shown in Figure 9-5) is one of similar shapes. We are not sure what, if anything, they represent. We can distinguish a seated dog in the upper left, and there is a suggestion of horned cattle across the background. The whole, however, is a scene of quiet and beauty. In his *Sunday on the Island of La Grande Jatte* (Figure 9-6) Seurat has united the picture largely through the repetition of the same or similar shapes.

Figure 9-5. Joan Miró (1893–), Spanish painter and printmaker. Painting (1933). (Oil on canvas. Size: 68½ by 77¼ inches. New York, Museum of Modern Art; gift of the Advisory Committee. Photograph, Museum of Modern Art.)

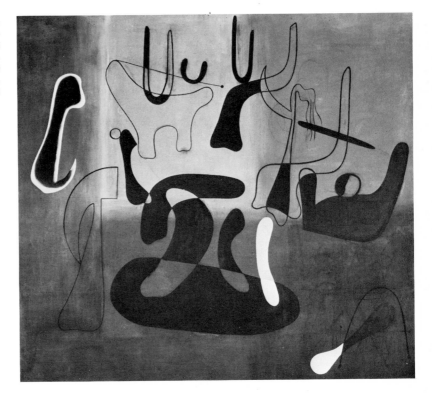

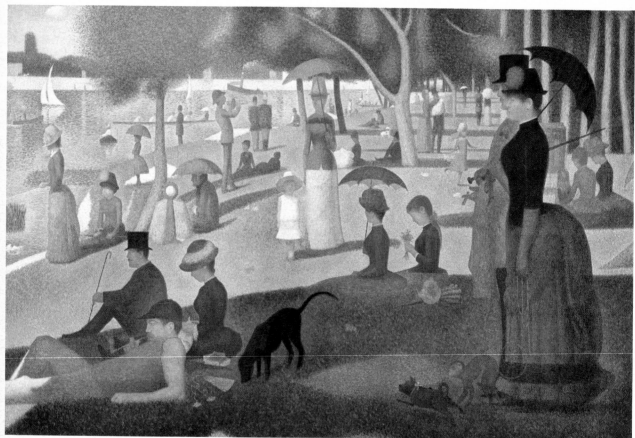

Figure 9-6. Georges Pierre Seurat. Sunday on the Island of La Grande Jatte (ca. 1886). (Oil on canvas. Size: 81 by 120⅜ inches. Art Institute of Chicago; Helen Birch Bartlett Memorial Collection.)

Value (Light and Dark)

Value has to do with the amount of light in a given painting or graphic work of art. We may also say that *value* is the name given to relative degrees of light, or that it indicates the degree of luminosity—that is, the presence or absence of light. In ordinary speech the term *light and dark* is often used instead of *value;* although this does indicate that values go from light to dark, it is rather ambiguous in that it does not indicate the various possible degrees of lightness or discriminate among them. White is recognized as the highest value and black as the lowest; a point halfway between them can be called "medium"; the point halfway between white and medium may be called "light"; and the point halfway between medium and black may be called "dark." This gives us a fairly exact scale of values:

White⟶light⟶medium⟶dark⟶black

Values that do not fit any of these points may be defined in terms of the nearer value; we may, then, speak of a value halfway between dark and medium, or of a light value very close to white.

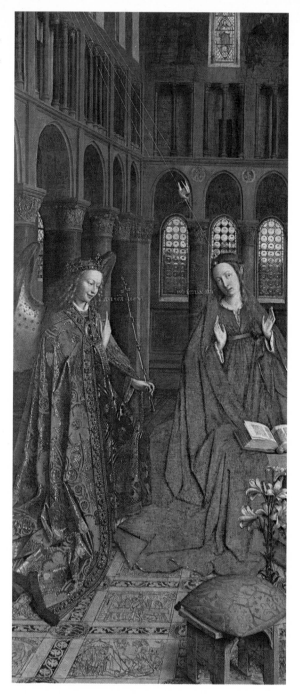

Figure 9-7. Jan van Eyck (1370–1440?), Flemish painter. The Annunciation (ca. 1425–1430). (Transferred from wood to canvas. Size: 36½ by 14⅜ inches. Washington, D.C., National Gallery of Art; Mellon Collection, 1937.)

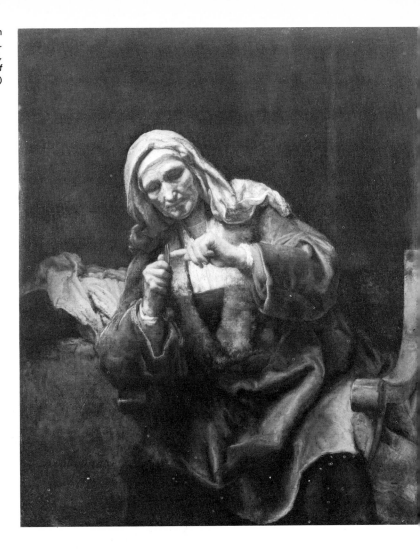

VALUES IN PAINTING In architecture and sculpture values change with
the light; in painting values are fixed. When a painter makes an area dark
or light, puts in a shadow or leaves it out, it stays that way regardless of
the time of year or the source of light. The painting should of course be
placed where it can be seen clearly, but its essential values do not change.

In studying the values of a painting we notice first the value tone.
Is the picture predominantly light or dark? In Rembrandt's Old Woman
Cutting Her Nails (shown in Figure 9-8) the values are dark; in Ingres's
Lady and Boy they are light. And there are paintings which have an inter-
mediate shade, an overall grayish effect, such as we see in Jan van Eyck's
Annunciation (Figure 9-7, page 167), where the light is diffused.

A second question asked about contrasts in value is: Are they great
or small? We have just mentioned Van Eyck's Annunciation as a painting
with a diffused light and little contrast. Ordinarily we have greater contrast
of light and dark, as in Titian's Young Englishman (shown in Figure 9-9).

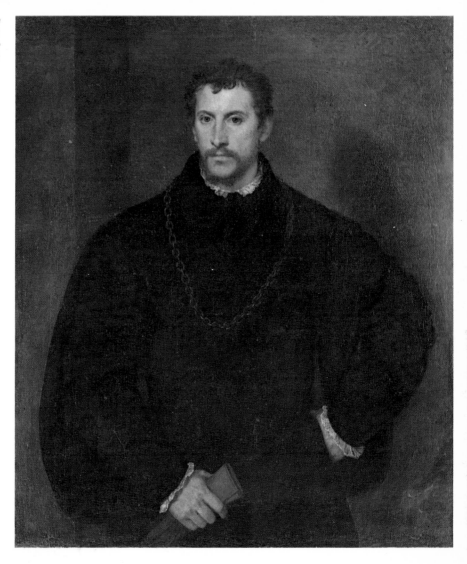

where the white hands and head shine out against the dark background and the chain occupies a position halfway between them. Often an artist has a particular fondness for one set of values. Rembrandt is outstanding for his contrasts in value, as in the *Old Woman Cutting Her Nails.* In this painting light is concentrated on head, hands, and dress, with some clothes in the background, and indeed seems to emanate from them. Any natural light source would of necessity have given greater light to the clothes and the other surfaces.

The next point to notice about values is the way they are separated one from another. Do they merge one into the other, or are they separate? Are the boundary lines blurred or distinct? In the Rembrandt we have just mentioned, boundaries are kept clear in the foreground, but in the background all sense of boundary lines is lost.

Another point to consider about values in painting is the character of the dark areas. Is there a single flat surface, or is it subtly varied? This is really a matter of slight variations in value within a single tone, variations so slight as to be almost imperceptible. The shadows of Rembrandt have such variations. In the *Old Woman Cutting Her Nails* there is only a little light in the picture; the remainder of the scene is buried in darkness. But this darkness is not hard blackness, against which one might strike his head, but a soft, penetrable shadow; one feels that he can see into the shadow. The effect is much the same as that which is produced by a small light in a large room; only a small space is clearly lighted, and the light fights against the shadows in the remainder of the space.

Light values can have important emotional connotations. If we examine various Rembrandt paintings—the reproductions in this book and other books, or (much better) some originals—we will find examples of this. In both the *Man with the Golden Helmet* (Figure 19-5, page 401) and the *Old Woman Cutting Her Nails* a certain mystery and grandeur have been created by the predominantly dark values. The predominantly light values of Titian's *Bacchus and Ariadne* (Figure 3-7, page 52) contribute enormously to the sense of *joie de vivre*—the joy of living—that permeates this work. Let us imagine, if we can, Ryder's *Death on a Pale Horse* (shown in Figure 9-10) done in the light values of the Titian. If this were the case, the emotional mood would be entirely changed. It is the hazy and dark values that are largely responsible for the mood of mystery and doom, and the strong contrast between the light values of the background and the dark values of the foreground add to the mystery. (This work was inspired by a tragedy of which Ryder had personal knowledge; someone he knew had lost all his money at a racetrack and then committed suicide.)

Light and Shadow (Chiaroscuro)

LIGHT AND SHADOW IN PAINTING Light and shadow or light and shade (sometimes known as *chiaroscuro*, from the Italian word for "light and dark") should be distinguished from value. Light and shadow is a means

Figure 9-10. Albert Pinkham Ryder (1847–1918), American painter. The Race Track or Death on a Pale Horse (ca. 1910). (Oil on canvas. Size 28¼ by 35¼ inches. Cleveland Museum of Art; J. H. Wade Collection.)

of modeling a figure in depth, a means of articulating the form. The Michelangelo painting shown in Figure 3-22, page 66, is an example. Here we see the light coming from the right side of the figure and casting a shadow on the left side, more or less in the way this actually happens in nature. Renaissance painting is rich in examples of this kind; the painting after Leonardo (shown in Figure 6-24, page 123) is an example.

Chiaroscuro may also be used in ways more subtle than this plastic or figure-building function. For example, let us examine Rembrandt's *Man in the Golden Helmet* (Figure 19-6, page 402) and Titian's *Young Englishman* (Figure 9-9, page 169). In the Rembrandt we see not only the light falling on one side of a face or form; we also see the figure as a whole emerging from the darkness of the background in very gradual transitions, each one of which has its own component of light and shadow. This creates a feeling of mystery, a darkness of mood, and a sense of unexperienced depths. In the Titian painting, chiaroscuro is used to concentrate our attention on the two most expressive parts of a portrait—the face and the hands.

LIGHT AND SHADOW IN THREE-DIMENSIONAL ART In painting, the effects of light and shadow must be simulated; but in the three-dimensional arts (such as sculpture and many of the applied arts—pottery, armor, furniture) shadows occur naturally under almost all light conditions. The same is true of architectural design and ornament in general. A molding, whether inside or outside a building, can be seen because of the way different surfaces reflect the light. Patterns in shingles or in the arrangement of boards or brick can hardly be seen except by means of the shadows they cast. A cornice casts a shadow on the wall below and makes a definite change in the design. An architect frequently makes a model of the building he is designing in order that he may learn the exact effects of the shadows. One of the beauties of the cathedral of Notre Dame in Paris is found in the varied carvings of the façade, and in the play of lights and shadows over them.

If the artist has not studied the effects of shadows carefully, he may find the finished work quite different from the one he planned. French's

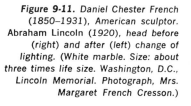

Figure 9-11. Daniel Chester French (1850–1931), American sculptor. Abraham Lincoln (1920), head before (right) and after (left) change of lighting. (White marble. Size: about three times life size. Washington, D.C., Lincoln Memorial. Photograph, Mrs. Margaret French Cresson.)

Figure 9-12. Lapith and Centaur (ca. 447–443 B.C.), metope from southwest corner of Parthenon. (Pentelic marble. Height: 3 feet, 4 inches. Athens. Photograph, Saul Weinberg.)

statue of Lincoln, for example, was made in the studio with an overhead light. When it was placed in the Lincoln Memorial in Washington, all the light came from below. This lighting completely changed the expression of Lincoln's face, making it little better than a caricature, as can be seen in Figure 9-11. Fortunately the lighting could be and was easily changed, and now visitors to the Lincoln Memorial see the statue as French planned it.

In relief sculpture, light and shadow are especially important, since the design can usually be seen only in the shadows cast. In *high relief* the figures project from the background; they are almost in the round. The shadows are deep and the lines bold and distinct, as in the metope (panel of relief sculpture) of the Parthenon (shown in Figure 9-12). In *low relief* the figures are only slightly raised from the background. The shadows are not very deep, and the lines are delicate, as in the *Panathenaic Procession* (shown in Figure 9-13) also from the Parthenon. Therefore, a low relief should be in a dimly lighted place where the light shadows make clear the outlines of all the figures. A high relief would be in bright light, because the higher the relief, the deeper the shadows. In high relief, moreover, the design must be very simple; if there are too many figures, the shadow of one figure tends to hide its neighbor. In low relief the design may be more complicated. In the reliefs on the Parthenon both these points were observed. The *Panathenaic Procession* is found in the frieze, which was placed on the wall of the building where it was protected from direct sunlight by a row of columns. The metopes were placed above the columns, where they received direct sunlight.

The examples given so far have had to do with rather static effects of light and shadow, dealing as they do with the placing of an object with reference to a constant light. But as we all know, natural light changes continuously; it is alive and dynamic, and as Walter Gropius, the designer of the Bauhaus, has said, "Every object seen in the contrast of changing day

Figure 9-13. Panathenaic Procession (fifth century B.C.), detail of Parthenon frieze. (Pentelic marble. Height: 40 inches. London, British Museum.)

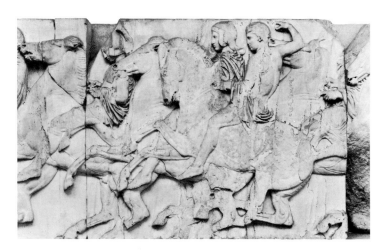

light gives a different impression each time."[1] And he continues: "Imagine the surprise and animation experienced when a sunbeam, shining through a stained-glass window in a cathedral, wanders slowly through the twilight of the nave and suddenly hits the altarpiece." This constant change and constant tension have much to do with the charm of stained-glass windows. Not only does each window have its own color and design, but it is constantly changing.

In modern domestic architecture we have other significant examples. Rooms may be built so that they take advantage of the shifts in daylight through the house and in the patio and garden.

Color

All the effects obtained through line and value alone may be increased by the use of color. Colors may be warm or cold, advancing or retreating, light or heavy, attractive or repulsive, in tension or in suspension.

When we examine color we find three qualities or attributes: hue, value, and intensity. Hue is that quality by which we distinguish one color from another. The three primary hues are red, blue, and yellow. All others can be made from them. The secondary hues are green, violet, and orange, each being halfway between two of the primary colors: orange is halfway between yellow and red, etc. This relation is easily seen on this diagram:

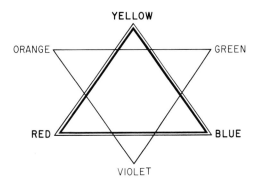

The diagram shows each hue opposite its complement. Two hues are said to be complementary when between them they contain the three primary colors. The complement of yellow is violet. Since violet is made of red and blue, yellow and violet contain all the primary colors. Complementaries intensify each other if placed close together. Red and green mixed make a gray, but a red near a green makes each color seem brighter than when alone.

[1] Walter Gropius, *The Scope of Total Architecture*, Harper & Row, Publishers, Inc., 1955, p. 41.

Colors are either "warm" or "cool." The greens and blues on the right of the palette, from yellow to violet, are cool; the reds and oranges on the left of the palette, from violet to yellow, are warm. Yellow and violet are considered neither warm nor cool. The cool hues probably seem cool from their association with cool subjects in nature: green grass, green trees, blue sky, and blue or green water. The warm hues are associated with warm objects: red coals and orange fire. The cool colors are for the most part restful and quiet. The warm colors are more exciting, but we tire of them more quickly. The warm colors always seem closer than the cool colors; therefore, they are called *advancing colors,* and the cool colors are called *retreating colors.* If red, green, and blue circles are placed one beside the other, the red seems closest to the spectator, and the blue farthest away. For this reason warm colors are usually put in those parts of a picture which are nearest the spectator, and the cool colors are reserved for the distance and the shadows.

Colors can of course be known only in values. There are light blues, dark blues, medium blues. Any color may be seen at any degree of darkness, from a dark that can hardly be distinguished from black to a light that is almost white. In some colors, however, a good deal of confusion is produced by the fact that certain values have been given special names. A light red, for instance, is called "pink"; and dark yellows and oranges are called "brown."

The last attribute of color is intensity. Colors differ in intensity or vividness. Two colors may both be blue, one just as dark as the other, but one may be more intense than the other. Powder blue is a dulled blue; old rose is a dulled red. When a hue is found in its most vivid form, it is said to be in full intensity. The same hue dulled is said to be partly neutralized. A hue completely neutralized loses its color and becomes a gray.

Though each color has certain very definite properties, it is almost never seen alone. A color is changed by the presence of other colors. It reflects, and changes with, all the colors around it. It looks dark beside a lighter color and light beside a darker color. A blue placed beside a violet makes the violet seem red, and a red placed beside a violet makes the violet seem blue. Delacroix was merely stating emphatically the influence of colors on each other when he said that he could paint a face of the mud from the streets if he were allowed to select the colors that were to go around it.

Painting is predominantly the art of color, but color is also important in sculpture and architecture. In terra cotta, the surfaces are colored; and houses made of wood are usually painted. In the other mediums of sculpture and architecture the color of the material is itself a factor in the appeal of any work—the rich brown of polished wood or bronze, for instance, or the creamy whiteness of ivory or marble.

Colors have very definite psychological and emotional connotations. Black, of course, is death; white is innocence and purity; blue is the color of heaven and truth, the color of the Virgin Mary. Red stands for blood and for both love and hate. Yellow represents divinity, the sacredness of red

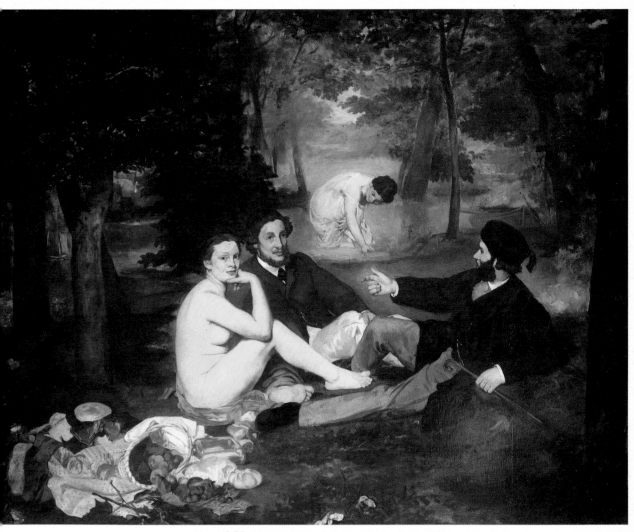

Figure 9-16. Edouard Manet. Luncheon on the Grass. (*Oil on canvas.*)

vealed truth, as in S. Peter. It also stands for degradation, treason, and deceit. Brown signifies spiritual death—the renunciation of the world—and for this reason it is the color of the Franciscan and Capuchin orders. In modern painting, color is often used for itself and for its connotations without regard to the natural color of the object painted.

Texture

Texture has to do primarily with the perception of touch. It is the element that appeals to our sense of the feel of things—rough or smooth, bumpy or slippery. It is the difference we feel between satin and velvet, between

linen and silk, between the roughness of tweed and the smoothness of serge, between marble and bronze. Texture is first known by actually touching objects. Later it is interpreted by the eye without physical contact, although there is always a sense of contact; it is as though we had run our hands over the marble or the satin even if we have not touched it.

Texture is found in all the visual arts. In many cases, differences in textures are due primarily to differences in medium. We know the different "feel" of brick and concrete, of shingles and smoothly dressed boards, of rough and polished stone, of wood and bronze. We feel the smooth bronze of the Maillol (Figure 9-14, page 174) and the rough skin of the *King of Judah* (Figure 6-2, page 108). In painting, the term *texture* is used to describe the representation of skin, cloth, metal, jewels, furniture, etc. In Van Eyck's *Annunciation* we are very conscious of the heavy silk and the jewels of the angel's dress, the gold and jewels of her crown, the wood of the footstool, the silk of the cushion on the stool, the tiles of the floor.

In the type of picture known as "still life" the representation of texture may be the primary interest. As the name suggests, still life represents inanimate objects, such as flowers, fruits, and vegetables. These subjects offer abundant opportunity for the display of texture, and with them are combined other effects, the play of light on china or glass, the gleam of a knife blade, the color of wine, or even the rich glow of freshly baked bread. One painter of still life is the American William Harnett. In his *Just Dessert* (Figure 9-15, page 174) he depicts the texture of the grapes and the pewter vessels. In paintings such as this there is very little interest in subject; interest is found entirely in color and texture and in their organization in the design. In Manet's painting *Luncheon on the Grass* (Figure 9-16, page 175) we have the interest of still life in the basket, the rolls, and the fruits that are scattered around, while the figures remain the center of the picture.

Volume

Volume is often called "solidity." It is that quality of an object which enables us to know that it has thickness as well as length and breadth. As children we lift and punch, pinch and squeeze objects to find if they are solid, but soon we learn to interpret solidity by sight.

If we use only our eyes, we perceive volume primarily in two ways. The first is by contour lines, that is, by outlines or shapes of objects. The second is by surface lights and shadows. When we look at Michelangelo's *Cumaean Sibyl* (shown in Figure 9-17), we see the figure as rounded and solid. In it both ways of judging volume are found. We see the outlines of the face, the shoulder, the headdress, and we notice the subtle shadows in face and dress.

Usually the artist uses all the means at his disposal, and usually he achieves the effect he desires. Not all the means are necessary, however. The Japanese give the effect of solidity through the use of line alone, a

in the Harunobu print (Figure 6-31, page 127). They leave out shadows because they say that shadows are temporary and that only the permanent should be represented in painting. Their work, however, is done so skillfully that one may look at it a long time without realizing that the colors are flat and the shadows are missing. In Rembrandt's *Old Woman Cutting Her Nails*, volume is secured almost entirely through shadows.

Since painting is two-dimensional, it can only suggest volume. The shadows and contour lines are painted in and do not change. Sculpture is three-dimensional: the outlines and the shadows change with each shift in the position of the person viewing them. And we obtain not one but many different impressions from a single work, as we see in the two views of the Roman portrait (shown in Figure 9-18 and Figure 9-19). In José de Rivera's *Construction #1* (shown in Figure 9-20), or in Maillol's *Ile de France*, the photograph shows the work from a single point of view, but we are aware that it would present a different appearance if the camera were moved. The shadows and the contour lines would both be changed. These statues by José de Rivera and Maillol also illustrate the difference in emphasis referred to earlier. *Construction #1* depends almost entirely upon linear effect, whereas in the *Ile de France* the surface modeling in the body is all-important. These two statues illustrate another point of importance in sculpture. Maillol's not only is three-dimensional but also is solid. José de Rivera's is not solid; it seems to comprise the space within the composition as well as the material of which it is made.

Architecture, like sculpture, always exists in three dimensions. A great building, like a great statue, is seen from many points of view. As we walk around it or through it, the appearance changes with each shift in our position, and each view should be pleasing.

Figure 9-18. Roman Portrait (first century B.C.). (Marble. About life size. New York, Metropolitan Museum of Art; Rogers Fund, 1921.)

Figure 9-19. Profile view of Roman Portrait, Figure 9-18.

Figure 9-20. José de Rivera (1904–), American sculptor. Construction #1: Homage to the World of Minikauski (1955). (Forged stainless steel. Size: 21½ by 19¼ by 15½ inches. New York, Metropolitan Museum of Art.)

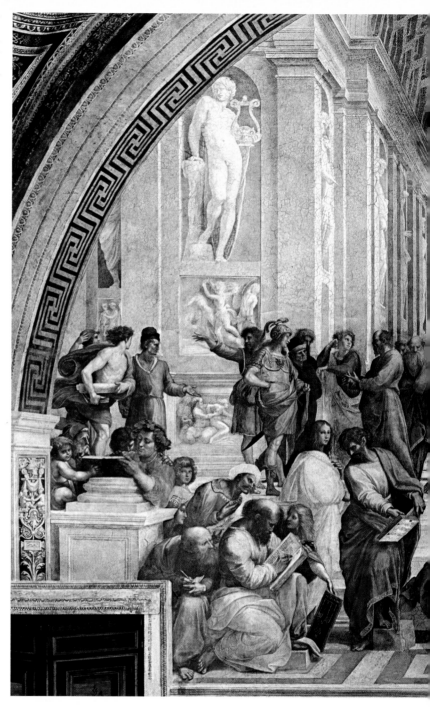

Figure 9-21. Raphael (Raffaello Sanzio) (1483–1520), Italian painter. School of Athens (1509–1511). (Fresco. Figures about life size. Rome, Vatican, Stanza della Segnatura. Photograph by Alinari.)

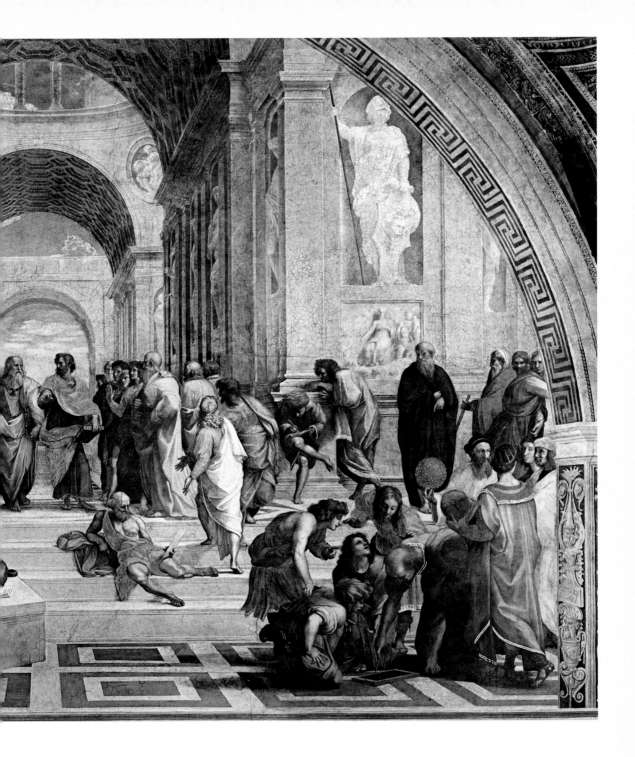

Space

The two arts in which space is of great importance are architecture and painting. Architecture is primarily an art of space. The other arts exist in space; architecture uses space as one of its elements. We can see the exterior of a building only as it appears in space. And if we are within a building, we see it as enclosing space. One of the great beauties of a building like S. Sophia (shown in Figure 9-22) or the church of S. Apollinare in Classe (shown in Figure 9-23) comes from the sense of majesty one gets when he enters the building and feels the spaciousness of the interior. Painting does not deal with space directly as does architecture; it can only represent space on a two-dimensional surface. To the extent that it devises every conceivable kind of device for the simulation of space or for the creation of spatial tensions, its relation to space is perhaps far more subtle than that of any other art. The most obvious techniques for creating space in painting are the various types of perspective.

PERSPECTIVE This is the technical means by which we perceive distance in painting, the means by which we are made to see the position of objects in space. There are two major types of perspective, having to do with two kinds of data on which we form opinions or make judgments about distance. These are known as "linear perspective" and "aerial perspective."

Linear perspective has to do with the direction of lines and the size of objects. Everyone has stood in the middle of the road, or on a railroad track, and noticed that the sides of the road, or the tracks, seem to rise and meet in the distance. In the same way two parallel rows of vertical

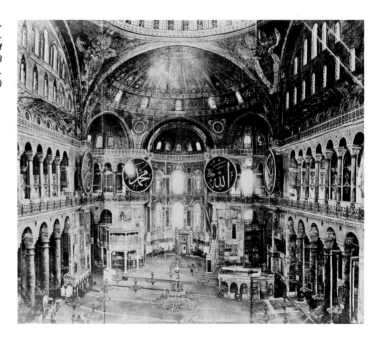

Figure 9-22. S. Sophia (A.D. 532–537, restored A.D. 558, 975), interior. Anthemius of Tralles and Isidorus of Miletus, architects. (Width of nave: 108 feet; height of central dome: 180 feet. Istanbul. Photograph, Bettmann Archive.)

ORGANIZATION

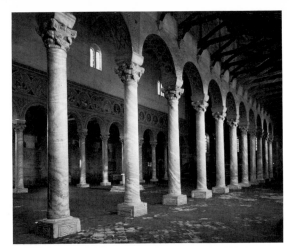

Figure 9-23. S. Apollinare in Classe (*second quarter of sixth century*). *Interior looking toward apse. (Marble, mosaic, and plaster; wooden roofing. Length: 150 feet; width: 98 feet. Ravenna. Photograph by Alinari.)*

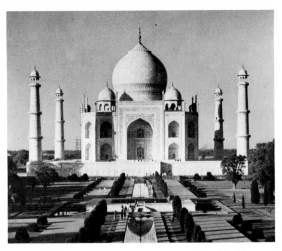

Figure 9-24. Taj Mahal (*seventeenth century*). (*Marble. Length: 186 feet; width: 186 feet; height: 187 feet. Temple built by Shah Jehan in memory of his wife. Agra. Photograph, Press Information Bureau, Government of India.*)

objects seem to meet in the distance, but the tops of the farther objects fall to the level of the eyes. These facts can be easily demonstrated in the photograph of the Taj Mahal (examine Figure 9-24). The lines of the pool, the paving, and the low trees rise and tend to meet, whereas the tops of the minarets fall as they recede and come together. If the camera is placed at one side, not between the parallel lines, the lines tend to meet just as in the examples studied, but at one side. This can be clearly seen in the picture of the aqueduct at Segovia (Figure 14-11, page 289). Curved lines above the level of the eye seem to drop and those below the eye to rise, as we see in the picture of the *Colosseum* (Figure 9-25).

Figure 9-25. Colosseum (A.D. 72–82), *travertine exterior. (Restorations in brick. Length: 620 feet; width: 513 feet; height: 157 feet. Rome. Photograph, Trans-World Airlines, Inc.)*

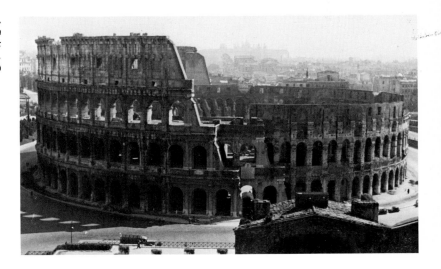

In painting, of course, lines do not vary as they do with the position of a camera; therefore, the artist must paint his lines of perspective, as Raphael has done in the *School of Athens* (Figure 9-21, page 178) and as Dali has done in his *Last Supper* (Figure 3-16, page 61). We notice how the lines of the pavement and the arches converge on the heads of Plato and Aristotle, the two principal figures in Raphael's scene; and how the ceiling and table lines in the Dali converge on the head of Christ.

Objects appear smaller as they recede into the distance. This is a necessary corollary of the facts we have been studying about the direction

Figure 9-26. *Mantegna (1431–1506), Italian painter. Pietà (1459). (Tempera on canvas. Size: about 32 by 26 inches. Milan, Brera Gallery. Photograph by Anderson.)*

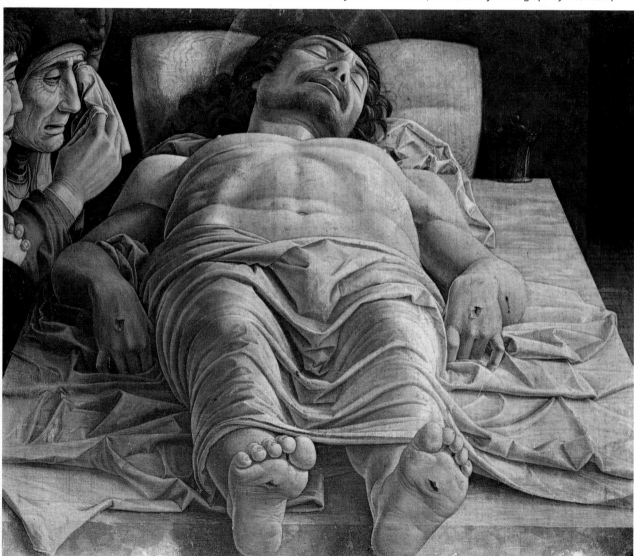

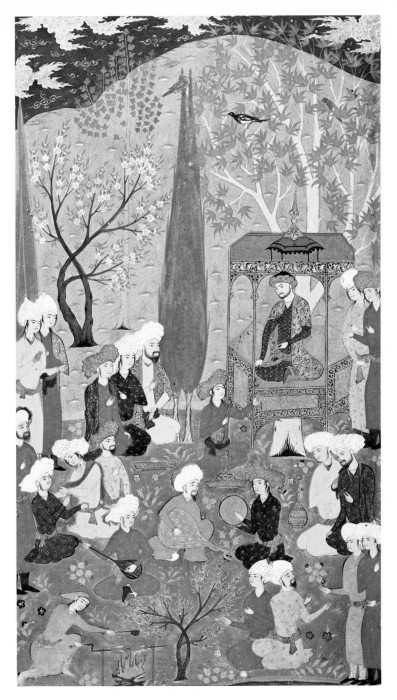

Figure 9-27. *Khusrau and His Courtiers* (sixteenth century), Persian miniature.

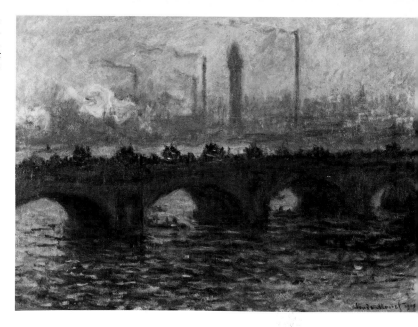

of lines, and it is illustrated in the examples already given. In the photograph of the Taj Mahal, the minarets are of equal height, but those farther away look smaller. In the *School of Athens* the arches are drawn successively smaller. And if we study the picture, we find that Raphael has adapted the height of the men to the distance. Measured in inches, the figures of Plato and Aristotle are shorter than those of the men in front.

Foreshortening is a term of linear perspective applied primarily to the human figure. The best way to understand this device is to look at examples of it. In Mantegna's *Pietà* (Figure 9-26, page 182) the body of Christ is foreshortened.

Obviously, foreshortening is a problem only for the painter. The sculptor makes his figure of normal size. Seen from one point of view an arm appears full-length; from another, it seems foreshortened. The arms of the *Charioteer* are seen in full length if the statue is viewed from the side; if the statue is seen from the front, the arms are foreshortened. The painter, however, is limited to one point of view and must choose one pose for each figure. Botticelli drew the arms and legs in full length, as though he were trying to avoid the problems of foreshortening. Michelangelo, on the other hand, liked foreshortened poses for his paintings.

Aerial perspective has to do with changes in appearance due to atmosphere. Objects become lighter in color and hazier in outline as they approach the horizon. In Monet's *Waterloo Bridge* (shown in Figure 9-28) the buildings on the horizon are so hazy that they can hardly be seen.

Accurate painting of aerial perspective is at its best in landscape painting, and among the greatest of landscape painters are the Chinese.

With a few blurred outlines they give an impression of a foreground and a background with infinite space in between. A very good example is the landscape scroll of Tung Yuan (shown in Figure 9-29).

In Oriental pictures we find also a *diagonal perspective*; horizontal and vertical lines appear as diagonals, and a square appears as a diamond. There is no diminution in size as objects recede in the picture. In the miniature of *Khusrau and his Courtiers* (Figure 9-27, page 183) we can see a good example of this kind of perspective.

Linear perspective as discussed in this chapter is primarily an affair of the Renaissance. Artists like Raphael, Perugino, and Leonardo were very careful to make perspective lines clear and exact. Before that time artists in general did not show realistic perspective. In the paintings of Giotto the buildings and landscapes that form the background for the figures are more nearly symbols than actual presentations. In the *Flight into Egypt* (Figure 9-32, page 188) the mountain and trees are intended only to give the *idea* of mountain and trees.

In the course of the nineteenth century the invention and the development of photography made the skillful representation of perspective lines,

Figure 9-29. Tung Yuan (Sung epoch), Chinese painter. Landscape scroll (*late tenth century*). (*Brush drawing. Size: about 1 foot, 3 inches, by 5 feet. Boston, Museum of Fine Arts.*)

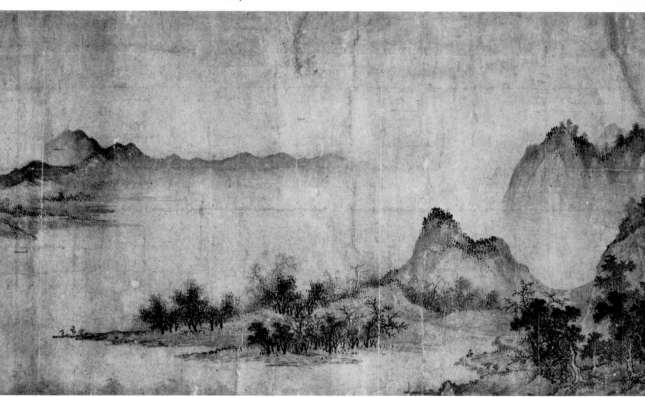

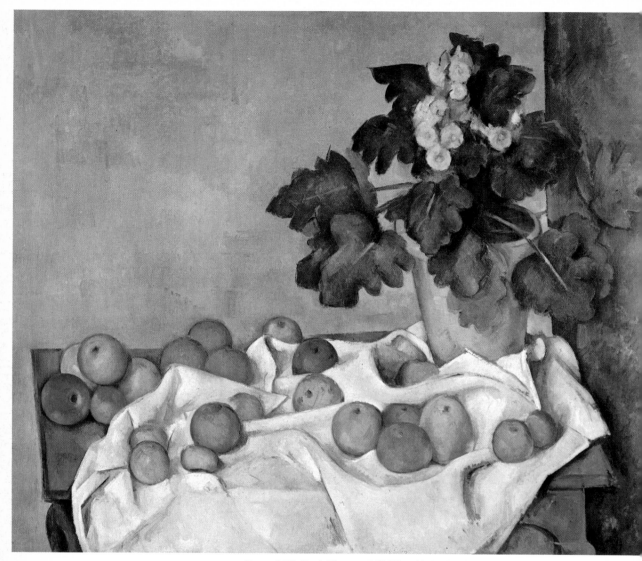

Figure 9-30. *Paul Cézanne. Still Life with Apples (ca. 1890–1900). (Oil on canvas.
Size: 27 by 36½ inches. New York, Museum of Modern Art; Lillie P. Bliss Collection.)*

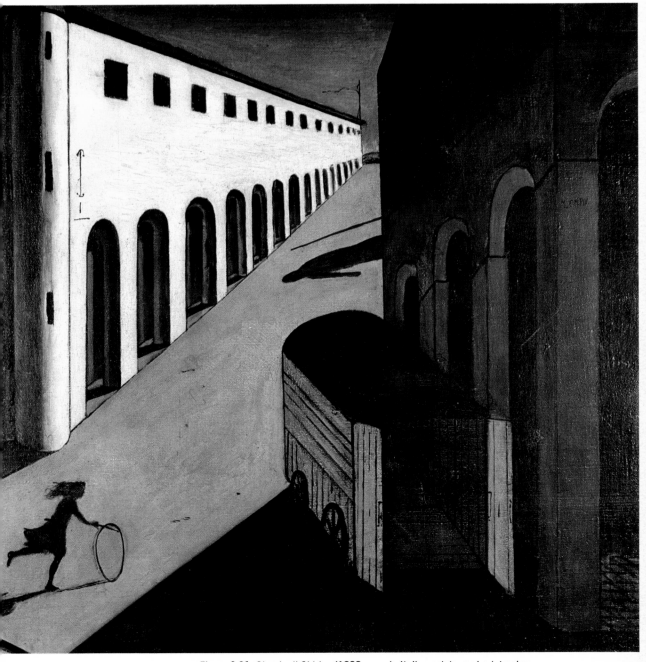

Figure 9-31. Giorgio di Chirico (1888–), Italian painter and printmaker. Melancholy and Mystery of a Street (1914). (Oil on canvas. Size: 34⅜ by 28⅛ inches. Collection of Mr. and Mrs. Stanley R. Resor.)

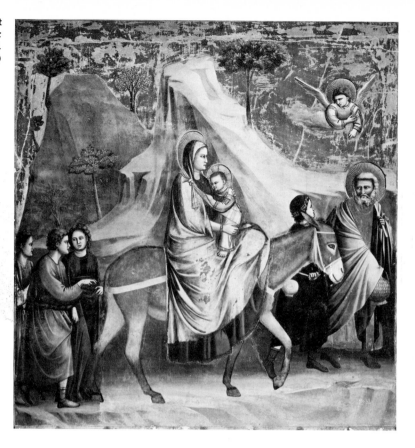

or even aerial perspective, rather superfluous. The emergence of impressionist painting, with its emphasis on light and the momentary appearance of objects under that light, also diminished the importance of conventional spatial representation. With the post-impressionist movement, particularly the art of Cézanne, a new kind of space emerged, a space which was artistic rather than representational. Compare one of Cézanne's still-life pictures (see Figure 9-30, page 186) with one by Harnett (Figure 9-15, page 174). In the Harnett we are chiefly conscious of the texture of the objects; in the Cézanne the fruit and the table are tilted toward us so that they seem to be coming out of the picture rather than going back into it as do the objects in conventional perspective. At the same time the foreground objects are related very closely to the background, so that the distinction between foreground and background begins to disappear. What results is a new, artistic kind of space which has less to do with what we see than with the rearrangement of reality into a new visual experience.

Many modern examples of tampering with perspective for an effect can be found. In the woodcut by Schmidt-Rottluff (Figure 6-30, page 126) the two scenes of the story are juxtaposed, and difference in size is the

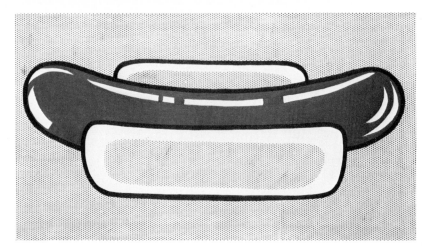

only indication of a difference in space. In his *Melancholy and Mystery of a Street* (Figure 9-31, page 187) Giorgio di Chirico has changed the perspective lines to give an impression of uneasiness. "At first glance the scene looks solid enough, and yet we feel that the unconcerned little girl with the hoop is endangered by a world that is about to crack along invisible seams or to drift apart in incoherent pieces."[2]

In modern painting, a whole succession of movements have treated space as an aesthetic device which unites form, line, texture, and other elements. The earliest movements of the twentieth century—Fauvism (Matisse and others), cubism (for example, Picasso and Braque), expressionism (for example, Schmidt-Rottluff), and geometric abstraction (for example, Mondrian)—begin with naturalistic space as a point of departure. Artists of these schools manipulated space in various ways: the Fauves and expressionists by intensifying color; the cubists by fragmenting form and showing simultaneously facets that cannot be seen all at once in nature; the geometric painters through tensions of form and color.

Some more recent movements, such as abstract expressionism (for example, Pollock) and color-field painting (for example, Louis) are not interested in representing space. The abstract expressionists are, rather, interested in the *act* of painting; the color-field painters, in the impact of pure color sensation. Other contemporary movements may maintain some illusion of space. Pop artists such as Lichtenstein, for example, derive their subjects from sources like contemporary advertisements (Figure 9-33) and are often concerned to reproduce modern objects accurately. Op (or "optical") artists such as Victor Vasarely (see Figure 9-34, page 190) create an illusion of spatial movement by the manipulation of geometric forms and colors, often producing images which are visually very stimulating. Both pop and op are, clearly, responsive to the stimulation of the senses that is often characteristic of modern commerce and industry.

[2] Rudolf Arnheim, *Art and Visual Perception*, p. 242.

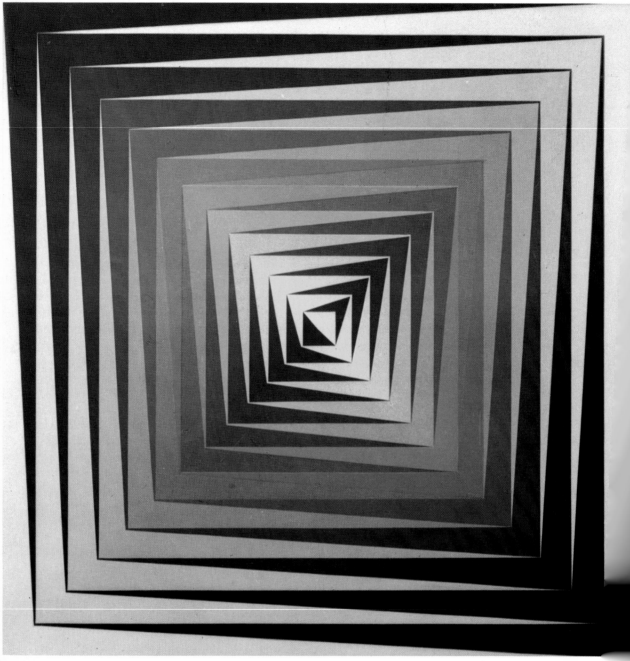

Figure 9-34. *Victor Vasarely (1908–), Hungarian artist. Casiopée (1957).*
(Collection Denise René, Paris)

10. ELEMENTS OF MUSIC

THE NOTATION OF MUSIC

It will be helpful for the reader of this chapter to have a knowledge of some of the rudiments of musical notation. Taking the piano keyboard as a point of departure, each white key is designated by a letter of the alphabet, ranging from A through G (Example 1).

EXAMPLE 1

Each black key has two names. For example, the black key between C and D is called C sharp (C♯) if it is thought of as a half step above C, and D flat (D♭) if it is thought of as a half step lower than D. Likewise, the black key between F and G may be F♯ or G♭, etc.

Pitch Notation

As was pointed out in Chapter 7, music employs sounds with regular vibrations called "pitches." Pitches are indicated by the placement of *notes* on *staffs*. For ordinary purposes the notes are arranged on two staffs, each of which has five lines and four spaces (Example 2); each line and space represents one white note on the keyboard.

EXAMPLE 2

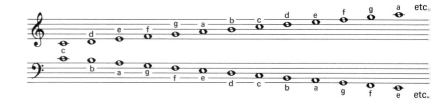

The C at the beginning, which is located between the two staffs, represents middle C on the piano. The staff above it is the *treble clef,* or more accurately, the G *clef,* because the symbol at the left curls its tail around the second line, reserved for the note G. The lower staff is the *bass clef,* or the *F clef,* because the two dots next to its symbol indicate the note F. The black notes of the keyboard are indicated by placing a sharp sign (♯) or a flat sign (♭) before the note in question. The higher the pitch, the higher will be its placement on the two staffs.

Durational Notation

Duration, or the length of time a note is held, is indicated by signs which have relative values. Example 3 shows some of the most important relationships, starting with the whole note, and moving downward to the half note (which has half the durational value of the whole note), then to the quarter note (which has half the value of the half note), and so on.

EXAMPLE 3

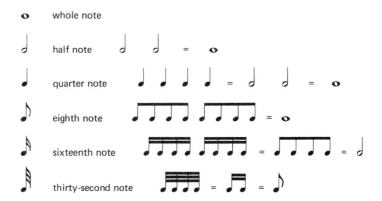

A dot placed after a note prolongs it by half again its length; thus $\mathbf{\text{𝅗𝅥}\cdot} =$ 𝅗𝅥 + ♩, or ♩ + ♪ + ♪; 𝅘𝅥𝅮· = ♩ + ♪, or ♪ + ♪ + ♪. Every kind of note has a corresponding kind of *rest* to indicate that nothing shall be sounded (Example 4).

EXAMPLE 4

▬	whole rest
▬	half rest
𝄽	quarter rest
𝄾	eighth rest
𝄿	sixteenth rest
𝅀	thirty-second rest

SOUND

Music, as we have seen, is an art whose basic material is sound. Since musical sounds, unlike the sounds in literature, have no meaning outside themselves, music may be said to deal with "pure" sound—that is, music deals with sound solely for its own sake. Yet music is not meaningless; it organizes the sounds it uses so that they "assume" meaning. This meaning is not, however, derived from things outside the sounds, as are the meanings of words; rather, it results from the internal relationships which the sounds acquire through their use in a musical composition. One tone is made to lead to the next in an orderly and logical way, with the result that the total effect seems to "make sense" (and thus be "meaningful") to our ears. It is precisely this quality of organization which distinguishes music from the random sounds that we hear about us every day. Thus the "composition" of music can be defined as the "organization of sound," and the study of music is to a large extent concerned with the various methods composers employ to relate sound to one another in order to give them musical significance.

Before turning to these methods, it will be helpful to consider the general characteristics of sound itself, for much can be learned from this about the kind of art music is. Perhaps the most important feature of sound, at least as far as music is concerned, is that it is experienced temporally, and not (except in a limited sense) spatially. That is, when one tone moves to another, it does so only as time passes, and not as its

physical "place" changes. The fact that the musical experience is essentially temporal rather than spatial is immensely important and does much to explain the unique nature of music. In other arts which deal with time, such as drama and dance, space also plays an important role; but music is almost completely temporal. Since most of our experience is largely spatial (or a combination of space and time), music tends more than the other arts to be removed from the world of our everyday activities. This can pose a problem, for it requires the perceiver to develop a faculty which he is unaccustomed to using in isolation—namely, the ability to listen. But it has the distinct advantage of making music and the musical experience an absolutely unique phenomenon.

TONE

Music may make use of any type of sound, but there is one particular kind which is of much greater importance than all others: *tone*. All sound waves are created by vibrating objects, but in the case of tones, these vibrations are "periodic," which means that the vibrations occur at equal intervals of time. As a result of this, tones are easily distinguishable from all other sounds.

The Components of Tone

Tone is the basic sound material with which the composer works. In order to understand how the composer organizes tone, it is necessary to know its principal components. There are four of these, some of which will already be familiar to the reader from Chapter 7.

PITCH The pitch of a tone is determined by the frequency of vibrations per second: the more vibrations per second, the higher the pitch.

DURATION The duration of a tone is determined by the length of time the vibration remains audible.

VOLUME The volume, or loudness, is determined by the amplitude (that is, the breadth) of the vibration.

TIMBRE Objects vibrate not only as a whole but also in subdivisions. Thus in the case of a string, in addition to the movement of the whole string, each half of the string will also vibrate independently, as well as each third, each fourth, etc. Timbre is determined by the relative strength of these subdivisions (none of which, however, is strong enough to be heard as a separate pitch). Whereas the trumpet and flute, then, can produce the same pitch—for example, middle C—the fact that the two instruments have different shapes and are made of different materials causes the vibrating air column to subdivide differently, producing different

timbres. It is timbre, then, which enables us to distinguish between instruments.

Frequently the words "tone" and "pitch" are confused, even among musicians, but the distinction between them is very useful in talking about music. "Tone" includes *all* the characteristics of a given musical sound: its pitch, its duration, its volume, and its timbre. Three of these four components—duration, volume, and timbre—are found in all sounds, but in order for a sound to be designated a tone, it must have definite pitch as well. Since music normally makes use of pitch as well as the other three components, it consequently uses tones as its basic structural material. Nevertheless, it is possible to compose music without pitch, making use solely of the other three components. An example of this would be African drum music, which is performed exclusively on non-pitched percussion instruments.

THE ORGANIZATION OF THE ELEMENTS

The four components of tone constitute the basic elements of music. We may now consider how these elements have been organized in Western music of the last 250 years.

The Organization of Pitch

There exist in nature a virtually infinite number of possible pitches. Since pitch is determined by vibration, any change in the number of vibrations per second will create a new pitch. Thus it is possible to conceive of pitch as existing in a continuum, moving from the lowest possible pitch we can hear through thousands of minute changes to the highest. In order to get some idea of what this would mean from the listener's point of view, imagine a siren which begins on a very low pitch and then moves gradually upwards to a very high one. Theoretically, the siren's wail consists of a distinct series of thousands of pitches; yet one really does not hear distinct pitches. The distance from one pitch to the next is so small that the ear is only aware of a kind of upward "glide."

This illustrates an important point for understanding musical organization: there are too many pitches in nature for the human ear to be able to perceive clearly defined relationships among them. As a consequence, music uses only a few of the possible available pitches. This is true of not only Western music but the music of all cultures.

In Western music the "pitch spectrum" is limited to a total of twelve different pitches. In order to understand how this pitch system works, it is necessary to understand the principle of the octave. If we arbitrarily take a pitch created by 440 vibrations per second, a pitch which is designated by the letter A, the pitches related to this one by multiples of two

and divisors of two are felt to be so similar to it that they are also called A. Thus the pitches created by both 220 (half of 440) and 880 (twice 440) vibrations, as well as 110 (half 220) and 1760 (twice 880) vibrations, etc., are also called A's and the relationship between such similar pitches is called the relationship of the "octave." Thus if we begin at 440A and move upwards in pitch, when we get to 880A we feel that we have returned to the same pitch, though in a higher register. The importance of this principle cannot be overstated, for it enables us to organize pitch between the relatively close poles of the octave. All musical systems throughout the world (with the exception of a few recent experimental systems) divide the octave into a certain number of pitches, and in Western music this number is twelve. If we start on A, then, and move upward, we pass through twelve different pitches. When we get to the thirteenth pitch, we are back again at A.

SCALES A *scale* is a stepwise succession of pitches up through the octave. The two most important scales used in recent Western music are the major and minor scales, each of which consists of a selection of seven pitches out of the total twelve possible. The relationship of *intervals* (an interval being the distance between two pitches) in the major scale is shown in Example 5.

EXAMPLE 5

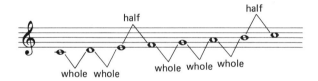

The words *whole* and *half* refer to the distance between the successive steps in the scale. Thus the fact that there is a whole step between the first and the second pitch indicates that one of the twelve tones, a tone between these two pitches, is omitted from this scale. As can be seen, there are five such whole steps, indicating that five pitches have been omitted. (This must be the case, of course, since only seven of the twelve possible pitches are used.) The two half steps (between the third and fourth tones and the seventh and eighth tones), however, are adjacent pitches in the total fund of twelve pitches, and thus no pitches have been omitted between them. One final point: the eighth tone in the scale is not a new pitch; it is the same pitch as the first, but placed one octave higher. The entire scale can now be repeated up through the next octave.

The minor scale also consists of seven different pitches, as shown in Example 6.

EXAMPLE 6

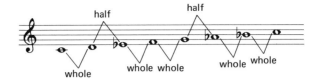

This is a different selection of the twelve possible pitches. There is now a half step between the second and the third pitches, which means that the third pitch is not the same as in the previous scale (a difference which is indicated by the flat sign placed before the note). The sixth and seventh notes are also different (and also have flat signs). But again, five pitches have been omitted, and the eighth pitch is the same as the first, only an octave higher. Such seven-note scales are known as *diatonic* scales; and the fact that they are the most commonly used scales in Western music explains why we have only seven letter names (A through G), rather than twelve, to attach to different pitches.

It should be pointed out that a scale is only an abstract arrangement of the pitches which form the basis of a given composition. Thus in a scale the pitches are placed in the simplest possible relationship: in stepwise succession. It is important to realize, however, that in an actual composition the succession of pitches may or may not be stepwise, as we shall see later in this chapter when we study melody. A scale, then, is not itself a musical composition, or even part of a composition, but only a simplified way of presenting the different pitches used in such a composition.

TONALITY *Tonality* is a principle through which one particular pitch receives more emphasis than others and is thus felt to represent a "center" (not, of course, in a spatial sense) around which the other notes move and to which they wish to return. This central pitch is the *tonic*. Thus a composition which uses the C major scale and treats C as a tonic is said to be in the *tonality* (or in the *key*) of C major; and a composition which uses the C minor scale, again treating C as a tonic, is said to be in C minor. The principle of tonality can be illustrated by taking a well-known tune which begins and ends on the tonic (such as "America") and stopping on the next to last tone. The piece will sound unfinished—or "unresolved," as one says of music—because the last tone will not be the tonic (in the case of "America" it will be the note above the tonic in the major scale). Most Western music is tonal in organization, a fact which helps to give it a highly developed sense of unity and order.

The tonality, or key, of a musical composition is indicated by a *key signature,* which is placed at the beginning of the piece. The key signature is determined by the scale which forms the basis of the piece in question.

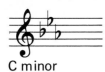

C minor

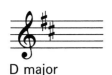

D major

Thus since the C minor scale (Example 6) has three flats in it, the key signature for the key of C minor consists of three flats (above, left). This indicates that here all B's, E's, and A's will be lowered to B♭'s, E♭'s, and A♭'s respectively. Similarly, since the D major scale has two sharps in it (F♯ and C♯), the key signature for D major has two sharps (below, left). C major has no key signature (or more precisely, a key signature consisting of no sharps or flats), since the C major scale (Example 5) has no accidentals (sharps or flats).

It was pointed out that a scale is an abstract arrangement in stepwise order, of the pitches forming the basis of a composition. We may now add to this that the first and last notes of a scale are always the tonic, or central pitch. Looking back at the C major scale (Example 5), it will be noted that the tonic C is the first and last note. Further, the note that leads back to the tonic at the end of the scale (that is, the B before the C an octave higher than the first C) is only a half step removed from the tonic. The fact that the B is so close to the tonic makes it seem to "point to" the tonic, thus emphasizing the tonic as a goal. We call this seventh degree of the scale the *leading tone,* because it "leads" to the tonic. Looking now at the C minor scale (Example 6), however, we see that in this case there is a *whole* step between the seventh pitch and the tonic. As a result of this, in actual compositions using the minor scale the seventh degree is frequently raised (in the case of C minor, from B flat to B natural) in order to place it as close as possible to the tonic. This is not done at all appearances of the seventh degree (if it were, we would simply make the alterations a normal part of the minor scale) but only when the composer wishes to emphasize particularly the role of the tonic as the central pitch.

The Organization of Duration

That aspect of music which has to do with the organization of durations is referred to as *rhythm.* Rhythm is usually considered the most basic musical element; music can exist without pitch; but because it is temporal, it cannot exist without duration. Like pitches, durations exist in an infinite continuum in nature; and it is possible to imagine—by analogy with the pitch continuum of the siren—an endless succession of durational units, the first one being so short that it is barely distinguishable, and each succeeding unit being slightly longer, exceeding the previous one by only a fraction of a second. But, as with pitch, the human ear is unable to distinguish clearly between such small differences in duration. Consequently, music confines itself to durations which have a clearly perceptible relationship to one another. In Western music this relationship is usually based upon multiples of either two or three. Example 3 on page 192 gives the notation of the duple relationships. As can be seen from this table, each duration is half as long as the one above it. Thus two half notes are required to equal one whole note, two quarter notes to equal a half note (and four quarter notes to equal a whole note), and so forth. Because the durations are limited to those having such relatively simple relationships,

they can be organized into a clearly defined rhythmic system. We may now turn to a consideration of this system.

METER Western music of the past few centuries uses a rhythmic system known as *meter*. Meter, as the name implies, is a way of measuring durations in a fixed, regular pattern so that the listener becomes aware of a basic pulse, which is something like the ticking of a clock. In popular music and dance music this pulse is normally beaten out explicitly (for example, by a drum), but in concert music the pulse is often only implied by the actual durations of the music. When we tap a foot to such music, however, we make the beat or pulse explicit. The familiar melody in Example 7, for instance, has quarter-note pulses, although there are few actual quarter notes in it. The beat is only implied.

EXAMPLE 7

This raises the question: Why do we hear pulses when they are not explicitly stated in the music? The pulse represents a kind of "common denominator" for all the different durations; and since the human mind tends to simplify the information it receives in order to make it more easily comprehensible, it seeks out a common duration within which all the actual ones will fit. In Example 7 this is the quarter note; the eighth notes and sixteenth notes relate quite simply to the quarter note in multiples of two (two and four respectively). Even the dotted eighth plus sixteenth rhythm, which is found at the first and sixth beats, is related by a multiple of two, namely four, though in a somewhat more complicated way: four sixteenths equal one quarter, and a dotted eighth (which equals an eighth note plus one sixteenth, or three sixteenths in all) plus a sixteenth equal four sixteenths.

The beat or pulse, however, is only a part of meter. The metrical system not only groups the various durations into beats; it also groups the beats themselves into larger pulses called "measures." *Measures* are created by accents: certain beats are stressed at regular intervals so that the other, unstressed, beats seem to group themselves around the stressed ones. This can be illustrated by reciting a series of numbers: one, two, three, four, etc. In this case we have beats (if the numbers are recited regularly), but since the numbers do not group themselves into larger

patterns, there are no measures. Now if we recite the series of numbers, stressing every other number, the numbers will group themselves into larger units of two beats each: ONE two, THREE four, FIVE six, etc. In the case of the larger pattern, it seems more natural to count ONE two, ONE two, etc., thus expressing the grouping numerically. This is exactly how measures are counted in music: the number ONE is always placed on the first, stressed, beat of each measure. It should be pointed out, however, that the first note of a piece does not necessarily carry the stress; instead of beginning on the *downbeat* (the name given to the first beat), it may begin on an *upbeat*.

Meter can now be defined as a regular grouping of beats. In Western music the most common meters are *duple* (groupings in two) and *triple* (groupings in three). Example 7 is an example of duple meter: it can be counted ONE two, ONE two, etc. An example of a song in triple meter is "America," which can be counted ONE two three, ONE two three, etc: MY coun-try 'TIS of thee, SWEET land of LIB-er-ty, etc.

Meter is indicated by a *time signature*, which is placed at the beginning of the piece, just after the key signature. The numerator tells us how many beats there are in each measure, and the denominator tells us which kind of note (quarter, half, or whatever) is being used for the beat. Thus Example 7 has a time signature of 2/4, indicating that there are two quarter notes in each measure. As can be seen in this example, each measure —or "bar," as the measure is also called—is indicated by a "bar line," which runs perpendicular to the staff lines. In 3/4 meter—which is, incidentally, the meter for waltzes—we have three quarter notes per measure. In 4/4 meter, which is the meter of marches, we have four quarter-note beats per measure; 4/4 meter is also considered duple, since the third beat receives a subsidiary accent grouping the measure into two parts, but unlike 2/4 meter, each of these parts consists of two independent beats (ONE two, THREE four). The difference between a 4/4 measure and two 2/4 measures is that in the case of the 4/4 measure the third beat is not of equal importance to the first. It is important to remember that the beats are only common denominators of the actual durations, so that there may be few actual quarter notes in a composition in 4/4 meter.

Example 8 shows the time signatures for the more common meters.

EXAMPLE 8

ORGANIZATION

As the fraction indicates, 6/8 meter has six eighth notes to the measure; 6/8 has aspects of both duple and triple meter. It is duple in that the fourth beat receives a subsidiary stress, which groups the measure into two parts; but each part consists of three eighth notes and is thus triple (ONE two three, FOUR five six). (Again, the difference between a 6/8 measure and two 3/8 measures is that in the 6/8 measure the fourth beat is not of equal importance to the first.) In 9/8 meter the fourth and seventh notes receive subsidiary accents, so that both the overall division of the measure and the subsidiary divisions are triple (ONE two three, FOUR five six, SEVEN eight nine).

TEMPO The meter in which a piece of music is written has little to do with the actual *tempo*, or speed, of the music. Durational notation, as we have already seen, is relative: it shows the length of each note with reference to the other notes of the piece, but that is all. We can say in general that songs written with half notes as the unit of value tend to go more slowly than songs written in quarter notes, and songs written in eighth notes tend to go faster, although there are many exceptions to this.

As a result of this ambiguity, the composer must indicate the tempo, which may be defined as the speed of the basic duration of a piece (that is, the pulse). It may be given by an exact indication (for example, ♩ = 60), which means that there are 60 quarter notes in a minute (thus each quarter would equal one second); or it may be stated less precisely by an indication such as "slow," "moderate," or "fast." Italian words are normally used for this, such as *largo* (slow), *allegro* (fast), and *presto* (very fast).

MELODY

A *melody* is a succession of single tones, which are placed in a pattern and which give a sense of continuity. Leaving volume and timbre aside for the moment, melody, then, consists of a series of pitches and durations. Since most melodies in Western music are tonal and metrical, the pitches and durations are organized in such a way that all the pitches relate to one central tonality and all the durations relate to a basic metrical pattern.

As far as pitch is concerned, melody may be defined as a specific ordering of the pitches of the scale used. Normally the notes will not appear in their scalar order, although there are exceptions to this: the hymn "Joy to the World" (Example 9) outlines a descending major scale.

EXAMPLE 9

If this melody is compared with the scale in Example 5, it will be seen that the pitches are the same, but they occur in reverse order. Note, however the effect the different durations of the pitches have upon the scale. If each pitch in the melody were sung for the same length of time, it would sound like a scale, not like a melody.

In Example 10 the melody begins with an ascending major scale, then breaks off into larger intervals, not related by step.

EXAMPLE 10

This composition is in the tonality of B flat major; that is, it is based on a major scale beginning on B flat, which is written as in Example 11.

EXAMPLE 11

The melody, however, begins not on the first degree of the scale but on the fifth degree, and then moves up through the sixth and seventh degrees to B flat, the tonic. From there it moves on through all seven scale degrees to the B flat an octave higher.

Most melodies, however, do not follow the scale even this closely. Thus the melody in Example 12, which like the preceding one is in B flat major, reorders the tones considerably: although it begins with a scalar succession (descending from the fifth degree down to the second, then up to the first in the higher octave), it then uses the notes of the scale in an order entirely unique to this melody.

EXAMPLE 12

Melodic Repetition

One of the most important means of giving a melody a sense of unity is repetition. The melody in Example 13, for instance, begins with two measures which are repeated exactly in measures 3 and 4.

EXAMPLE 13

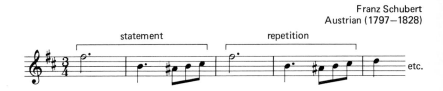

When melodic patterns are repeated at a different pitch level, the repetition is called a "sequence." The *sequence*, like the simple repetition, repeats both the intervallic and durational relationships of the original, but the repetition begins on a different scale degree. There is a sequence in "America" ("*Land* where our fathers died, *land* of the Pilgrims' pride") in which the repetition begins one scale degree lower. Example 14 has a sequence in which the original statement starts on the fifth degree (the piece is in the key of C minor); the repetition (which begins at the end of the second measure) starts on the first degree.

EXAMPLE 14

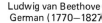

Ludwig van Beethove
German (1770—1827

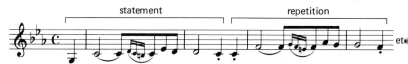

Both simple repetitions and sequential repetitions may be varied. In Example 15, the melody in the first two measures is repeated with a varia-tion of the second of the two measures.

EXAMPLE 15

Finally, Example 12 should be examined for varied repetitions of the first two measures. Although the pitches change considerably, the rhythm in all the following two-measure groups (i.e., measures 3–4, 5–6, 7–8, etc.) remains similar enough to be easily recognizable; furthermore, the upward leap at the beginning of measures 2, 4, 6, 8, 10, 12, and 14 (after which the leap suddenly appears more frequently) helps to establish the similarity between the two-measure groups.

When such a short melodic unit is consistently varied and developed through part of a composition, it is referred to as a "motive." A *motive*, un-like a melody, does not seem complete in itself but is only part of a large statement. A famous example of an evolving motive occurs in Beethoven's Symphony No. 5 (Example 16), where the opening motive dominates the entire movement.

EXAMPLE 16

Ludwig van Beethove
German (1770—1827

Notice that in the first repetition in our example the repetition is exact, except that the motive occurs one octave higher. Then the second repetition is a sequence of the first, retaining the same intervallic and rhythmic relationships but beginning on a different scale degree. In the third repetition the interval between the third and fourth note is changed (from an interval of a third to a fourth), and in the final repetition the interval is changed to a second and its duration is altered so that the motive now moves upward instead of downward.

The development of motives is one of the most important devices available to the composer. It provides for two qualities which are essential to musical works of extended length: unity and variety. One of the more interesting aspects of music is its ability to bring together convincingly these two seemingly contradictory qualities.

Types of Melodic Motion

Melodies which move primarily by step (whether by half step or whole step) are said to be *conjunct*. Example 9, for instance, is completely conjunct. Melodies which make use of large intervals between pitches are said to be *disjunct*. Example 12 begins with conjunct melodic motion, but there is a leap of a seventh between the fourth and fifth notes (since there are seven scale degrees between the fourth and fifth notes, the interval between them is called a "seventh"). Most melodies, like this one, consist of a mixture of conjunct and disjunct motion. The more disjunct the melody, the more agitated it is likely to seem.

MUSICAL TEXTURE

Melody is a horizontal, or linear, concept: it refers to successions of tones in time. *Texture,* on the other hand, is a vertical concept: it refers to the relationships among simultaneous events in music. Music which consists entirely of only one melody is said to have a *monophonic* texture (*mono,* "one"; *phonic,* "sound" or "voice"): in monophonic music, only one event occurs at a time.

Counterpoint

Much folk music is monophonic, as is much medieval Western music and the music of many other cultures. More recent Western concert music, however, tends to have a more complex texture. If two or more melodies are played simultaneously, the texture is said to be *polyphonic* (*poly,* "many"; *phonic,* "sound" or "voice"). Another word frequently used for "polyphonic" is "contrapuntal," and the noun corresponding to this is *counterpoint* ("point" is an old name for "note"; hence, "counterpoint" means "note against note"). Counterpoint, then, is the combination of two or more melodies.

There are two ways in which counterpoint (or polyphony) can be achieved. In the first type, a melody creates its own counterpoint by starting at different times. A piece which is constructed entirely according to this first technique is called a "round," a familiar example being "Row, Row, Row Your Boat" (Example 17).

EXAMPLE 17

The basic melody consists of four measures, and the entrances of the voices are one measure apart. Thus by the fourth measure all four parts are going simultaneously, each one singing a different measure of the melody. It should be clear from this procedure that a round could go on indefinitely, but the normal practice is to let each voice drop out after it has sung the tune three or four times.

IMITATION AND CANON When one voice repeats what has just been said by another voice, it is called "imitation." And when one voice continues to imitate another exactly it is said to be in *canon* ("canon" means "strict rule"). A good example of a canon is found in Example 18.

EXAMPLE 18

César Franck
French (1822—1890)

All rounds are in canon, each voice entering on the same pitch.

Music in canon may be written for any number of parts, but canons are usually for two, three, or four parts. The round we were just looking at, "Row, Row, Row Your Boat," is for four parts, while the Franck sonata is for two.

Separate Melodies

The second way in which counterpoint can be achieved is by combining two or more different melodies, a technique which can be illustrated by playing or singing simultaneously Dvorak's "Humouresque" and Foster's "Swanee River," or "There's a Long, Long Trail' and "Keep the Home Fires Burning." The putting together of two separate melodies has long been used in vocal and instrumental music and is found in both serious and popular works. Examples 19, 20, and 21, from Beethoven's Symphony No. 7, present an excellent example of the interweaving of two different melodies. The first time the melody (which is primarily rhythmic in interest) is heard, it is alone (Example 19). The second time it is heard (Example 20), a new melody has been added to it, just a bit lower in range which is more melodic in character and seems almost to caress the original melody. Finally (Example 21), the two melodies are exchanged, and now the first melody appears beneath, while the other melody is above.

EXAMPLE 19

Ludwig van Beethoven
German (1770—1827)

EXAMPLE 20

ORGANIZATION

EXAMPLE 21

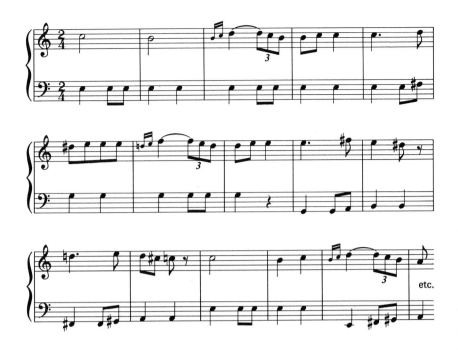

In music since the time of Bach (the first half of the eighteenth century), the tendency has been to put together melodies that are at least somewhat different, as has been done here by Beethoven, so that they may be heard more independently. The following are some important devices to help differentiate melodies used in contrapuntal textures.

CONTRAST IN RHYTHM If the melodies have contrasting rhythms, they are more easily distinguishable. Thus in Franck's Sonata for Violin and Piano (Example 18), one instrument holds a note while the other has shorter durations.

CONTRAST IN DIRECTION If one melody ascends while the other descends, or if one stays on one pitch while the other moves, the melodies are easily heard separately. The latter possibility is illustrated by Beethoven's Symphony No. 7 (Examples 19 through 21), where the lower note tends to dwell on one pitch while the upper one moves.

CONTRAST IN REGISTER One voice is usually higher than the other. In "Row, Row" the voice gets higher in each of the first three measures. In Beethoven's Symphony No. 7 the secondary melody is first lower than the primary one and then above it.

Harmony

When two or more pitches are sounded simultaneously, a *chord* is formed.
Harmony refers to the relationship of the tones within the chord and the
relationship of the chords to one another in a progression of chords.

The *triad* is the basic chord in the tonal system. As the name implies,
there are three different pitches in a triad, and there is an interval of a
third between the two lower tones and between the two upper tones. In a
major triad, the bottom third is major and the upper is minor; in a minor
triad the bottom third is minor and the upper is major (Example 22).

EXAMPLE 22

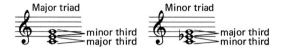

Triadic chords can be played in three positions, each position having one
of the three tones of the triad as its bass, or lowest note (Example 23).

EXAMPLE 23

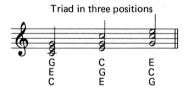

In the tonal system, chords are derived from the major and minor scales.
The most important tone harmonically, as well as melodically, is the tonic,
the first degree of the scale. The tonic triad (I)[1] in a major piece (i.e., a
piece based on the major scale) is a major triad; in a minor piece it is a
minor triad. (Compare Example 23 with Examples 5 and 6.) Next in
harmonic importance to the tonic triad is the *dominant* triad (V), which is
built on the fifth tone of the scale. The dominant triad seems to "point to"
the tonic, harmonically emphasizing its role as the central pitch, much as
the leading tone does melodically. Thus a V–I progression (Example 24)

[1] Roman numerals are used to signify the scale degrees on which chords are built.

seems to define the tonality; it produces a sense of stability and completion.

EXAMPLE 24

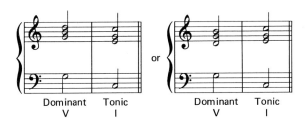

If we play Example 24 backwards, we have a I–V progression. In this case we get a feeling of incompleteness, leading us to expect further chords until we arrive at one which will be stable and final. Such stable progressions, which define keys, are called "cadences."

It is possible to build chords on all degrees of the scale. After the I and V chords, the most common chord is the subdominant, or IV, chord. There are many pieces, in fact, which are made up entirely of the chords on I, IV, and V, such as "America," "My Bonnie Lies over the Ocean," and the traditional blues in jazz. In harmonically more complex music, however, it is not unusual to find chords based on all the possible degrees of the scale.

CONSONANCE AND DISSONANCE *Consonance* in music is that which we associate with stability restfulness, and accord. *Dissonance* is that which we associate with instability and incompleteness. Consonance and dissonance are to a large extent relative concepts, varying considerably from one musical culture to another, and even from period to period within the same culture. In the tonal system, however, the terms are fairly clearly defined. For example, any chord which is not a triad is a dissonance and requires "resolution," which is achieved when it moves to a consonance, a triad. Likewise, any pitch in the melody which does not occur in the chord accompanying it is also dissonant. Thus if the note B is supported by a C major chord (C-E-G), it will be dissonant and will be heard as wanting to resolve upwards to C, the nearest chordal tone (Example 25).

EXAMPLE 25

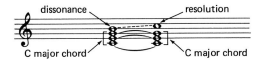

Even within the tonal system, however, it is important to realize that the terms "consonance" and "dissonance" are to a certain extent relative: that is, whether a particular pitch or chord sounds consonant or not may well depend upon its context. Thus the note B, while dissonant when supported by a C major chord, will sound consonant if supported by a G major chord (G-B-D), which contains the pitch B as a chordal tone. Similarly, the major chord on G will sound relatively dissonant (unstable) in the key of C major (where it represents the dominant, or V) but will sound consonant in the key of G major (where it represents the tonic, or I).

The importance of consonance and dissonance in the tonal system cannot be stressed enough. Consonances supply stability and are thus closely associated with the whole concept of the tonal center, which itself represents the principal stable pitch in a composition. Dissonance, on the other hand, supplies much-needed tension. Indeed, part of the effect of arriving at the central pitch depends upon the ability of the music to move away from that pitch, thus creating instability and a need to return to the tonic later in order to reestablish stability. As a result of this, tonal music tends to be extremely dynamic in nature, making use of constant alternation of moments of tension and relaxation in virtually limitless combinations.

HOMOPHONIC TEXTURE As we saw previously, polyphonic texture depends upon the concept of counterpoint. *Homophonic* texture (*homo*, "same"; *phonic*, "sound" or "voice"), on the other hand, depends upon the concept of harmony, for it is a texture in which there is only one principal melody, with all the other simultaneous notes combining to form chordal support for this melody rather than being part of melodies themselves. Thus homophonic texture consists of two basic parts: a melody and a chordal accompaniment. The relationship between the two, however, may vary considerably. In Example 26 the melody is above the chordal accompaniment.

EXAMPLE 26

Frédéric Chopi
Polish (1810—1849

The melody may also be below the accompaniment, as in Example 27.

EXAMPLE 27

Occasionally the melody even appears in the middle of the chordal accompaniment (Example 28).

EXAMPLE 28

Since in this last example the first part of the melody is played alternately by the left and right hand (so that its position changes from the bass to the treble clef), a dotted line has been added between the notes of the melody to aid the reader in following it. The bass of the accompaniment is below the melody, while the rest of the accompaniment is above it. It should also be noticed that in this example the chords which make up the accompaniment (i.e., the grouped notes in the treble clef) are not stated simultaneously, but are *arpeggiated,* which means that each note of the harmony is sounded separately. Nevertheless, the effect is not that of a melody (despite the fact that it is, strictly speaking, a succession of tones) but rather that of an elaborated chord. This stems mainly from the fact that the rhythmic-pitch pattern of the accompaniment is so simple and regular that it acquires no melodic interest of its own.

Finally, although the distinction between harmony—the vertical, or simultaneous dimension in music—and counterpoint—the horizontal, or successive dimension—is a useful one, it should be realized that both elements are almost always present, at least in latent form. In music with complex textures consisting of more than one melody at a time, there will of necessity be both a vertical *and* a horizontal dimension. Thus in a contrapuntal texture consisting, say, of three simultaneous melodies, the vertical coincidence of the melodies at any given moment will necessarily result in chords, and in tonal music these chords will normally be triads. Similarly, in homophonic music, consisting of a melody with accompaniment, the accompanimental parts will normally have at least some melodic interest as they move successively from chord to chord. Thus, the distinction between counterpoint and harmony can be said to be one of emphasis: if the emphasis is on the horizontal, or melodic, aspect of the music, the texture will be polyphonic and thus primarily contrapuntal in conception; if it is on the vertical, or chordal, aspect, the texture will be homophonic and primarily harmonic in conception. Furthermore, textures are frequently encountered in which the two aspects seem to be more or less in balance, so that it is difficult to say which texture predominates; and in longer compositions it is common for the texture to change frequently in order to achieve variety and contrast.

THE ORGANIZATION OF TIMBRE AND VOLUME

Of the four basic musical elements, pitch and duration (or rhythm) are the two primary elements in Western music, and we have seen that each of these elements has a system of organization which can be considered independently. Timbre and volume, on the other hand, are secondary elements which support the primary ones and which, since they depend upon pitch and rhythmic factors, do not lend themselves to independent analysis. This point can be illustrated by thinking of the same musical composition played first on a piano and then by an orchestra, or played on a piano first softly and then loudly. The pitches and rhythms will remain the same, and con-

sequently we will think of the two performances simply as two different versions of the same piece. But if we try to turn this experiment around, keeping the same timbres and the same level of volume but changing the pitches and durations, what we hear will sound like two completely different compositions.

We have discussed timbre in some detail in Chapter 7, and here it will suffice to add that the skillful composer will mix his vocal and instrumental colors so as to support the pitch and rhythmic organization of his work. Taking texture as an example, one of the ways a composer can differentiate between melody and accompaniment in a homophonic texture is through the use of different timbres for the different textural components. Thus an accompaniment may be given to the strings while the melody is played on a flute; or in a two-part contrapuntal texture one melody may be given to a clarinet while the other is in the bassoon.

The word *dynamics*, which is frequently used in place of *volume* in describing music, refers to the relative loudness and softness of the music. Such gradations of intensity, like the terms for tempo, are traditionally indicated by Italian words, for which there are abbreviations: *p* (for *piano*, meaning "softly"), *mf* (for *mezzo forte*, meaning "somewhat loudly"), *f* (for *forte*, meaning "loudly"), etc. Like timbre, dynamics are useful for clarifying texture: e.g., a melody is normally played somewhat louder than its accompaniment.

OTHER MUSICAL SYSTEMS

In this chapter we have so far concentrated on the tonal pitch system and the metric rhythmic system that have dominated Western music of the last 250 years or so. It is important to keep in mind, however, that other cultures have different musical systems; and within the Western world, other systems are found in folk music and in music written before 1700 and after 1900. We shall now consider briefly some of these other musical systems.

The Pentatonic Scale

The pentatonic scale, unlike the seven-note major and minor scales, contains only five pitches (Example 29).

EXAMPLE 29

This scale is particularly prominent in Chinese and in African music, but it is also found in Western folk music and occasionally in recent Western concert music (for example, in the music of Claude Debussy, a French composer who was active at the turn of the twentieth century). One of the many versions of the ballad "Barbara Allen" (Example 30) is in the penta tonic scale starting on C.

EXAMPLE 30

As she went on the high-way home, She heard the church-bell knell-ing.___

And eve-ry stroke___ it struck her name, Hard-heart-ed Bar-bara Al-len.___

Note that the pitches F and B, the two pitches which distinguish this scale from the C major scale (compare Example 29 with Example 5), do not appear in this melody.

The Whole-tone Scale

The whole-tone scale is composed of six different pitches, each a whole tone from its nearest neighbor (Example 31).

EXAMPLE 31

all whole steps

The last whole step brings the scale back to C, the first pitch, only now an octave higher. The whole-tone scale is particularly interesting, as it reveals no internal organization: all the steps between the scale degrees are the same (compare the intervals in Example 5 and Example 29). As a result there is no principal pitch (tonic) with a unique position in the scale, and the pull to the tonic, so characteristic of the major scale, is completely absent. Because of this, the whole-tone scale has received relatively little

use in Western music, although Debussy, who was particularly interested in experimenting with unusual scalar types, did make fairly frequent use of it (Example 32).

EXAMPLE 32

Claude Debussy
French (1862–1918)

Chromaticism

The major and minor scales both consist of a selection of seven of the twelve possible pitches. The five pitches omitted from these scales are referred to as *chromatic* tones. When chromatic pitches occur within the context of the tonal system, they sound very dissonant; furthermore, since they do not belong to the key, or tonality, they tend to weaken the sense of the tonic, or central tone. In virtually all concert music of the last 300 years, chromatic tones have been used to some extent, but normally with sufficient discretion not to upset the seven-tone diatonic scale on which the composition is based (or, in other words, with insufficient emphasis to call the scale into question). One of the interesting developments in concert music in the nineteenth century, however, was a tendency to use more and more chromatic tones with ever greater emphasis. Toward the end of the century, this increasing chromaticism reached a stage where it frequently became difficult, if not impossible, to tell just which tone was the tonic—for example, in the music of Wagner and Mahler. Example 33, Berg's sonata, composed in 1907–1908, is extremely chromatic music.

It is still tonal (there is a V–I cadence on B minor, the key of the piece, from the last beat of the second complete measure to the first beat of the third), but the sense of tonality has become ambiguous because of the chromaticism of the piece, which gives the music a strongly expressive, "straining" quality. In the first two measures it is impossible to say what the goal of the progression will turn out to be: so many chromatic tones are used (all but one of the twelve possible pitches—only the note B natural is missing—appear in this brief passage) that the listener cannot be sure which scale is the basic one, or which pitch represents the tonic.

EXAMPLE 33

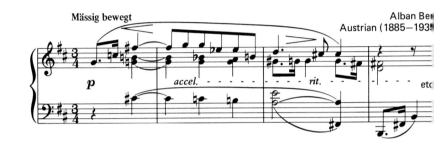

Mässig bewegt

Alban Ber
Austrian (1885–193!

Atonality

The tendency toward increased chromaticism finally led some composers to abandon completely the idea of organizing music around one principal tone. They began to write what is called "atonal" (i.e., "non-tonal") music, a term which clearly indicates how conditioned we are to tonal music. The earliest atonal pieces date from about 1910. Such pieces, which use all twelve pitches with more or less equal emphasis, are completely chromatic and may be said to be based upon the chromatic scale (Example 34).

EXAMPLE 34

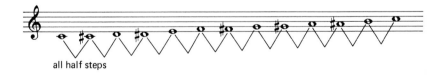

all half steps

This scale makes use of all the possible pitches within the Western musical system; and like the whole-tone scale, it has no internal organization— each step is a half step.

The Twelve-tone System

In the 1920's the composer Arnold Schönberg devised a system of pitch organization based on the chromatic scale but designed to give that scale a form which could relate the pitches of an atonal composition. Schönberg arranged the twelve chromatic pitches in a series, which he called a "twelve-tone row." The series, or row, represented a specific ordering of the twelve possible pitches. The particular arrangement of pitches could vary from one composition to the next, but once a row had been decided upon for a given piece, it became the standard for that piece, and the entire composition would then be based upon that row. The row may be played forward (the "original" form) or backward (the "retrograde" form); it may be inverted, that is, played "upside down," by changing all ascending intervals to equivalent descending ones, and vice versa (the "inversion"); and the inversion may also be played backward (the "retrograde inversion"). All four forms of the row may also be "transposed"—that is, they may be repeated by beginning on a different pitch and then preserving all the following intervallic relationships.

In the twelve-tone system there is no tonic; thus the music is atonal. There is a basic reference point, as there is in the tonal system; but whereas in the tonal system the reference point is a seven-note scale (which may be placed in any order) with one tone as the tonic, in the twelve-tone system the reference point is a special, nonscalar ordering of all twelve tones. Everything in the composition—melody, harmony, counterpoint, etc.—is derived from the row. Unlike tonal music, the chords used are rarely triads but are made up of whatever combination of pitches is dictated by the row. Example 35 is from a piece by Schönberg. The variant arrangements of pitches for the row are shown on page 220.

EXAMPLE 35

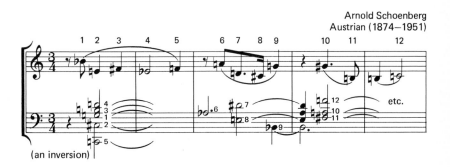

Arnold Schoenberg
Austrian (1874–1951)

Example 35 continued on page 220

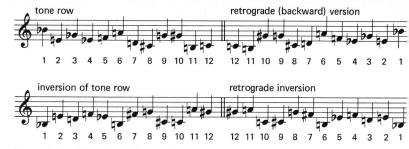

Nonmetric Rhythm

Much non-Western music is not metric in organization: the accents do n
group themselves into a single regular pattern. The rhythmic organizatic
of African drum music, for example, is at times extremely complex ar
irregular. In recent Western music there has also been a tendency on th
part of some composers to move away from metric rhythm. Not surpri
ingly, the earliest efforts in this direction occurred about 1910, just at th
time that the first atonal pieces appeared. Example 36, by Igor Stravinsk
was composed in 1913. Although the sixteenth note functions as a puls
the larger groupings of the pulse are quite irregular, as can be seen b
the various time signatures, which frequently change from measure t
measure (3+2+3+3+4+2, etc.).

Not only are the groupings in this example irregular, but frequently
beat which is weak within the measure is given a strong accent (which
called a "syncopation"), and strong beats in the measure are at times con
pletely suppressed so that they do not sound at all (measure 4).

The tendency toward nonmetric rhythm has reached the point whe
in recent years compositions have been written (by John Cage and Kar
heinz Stockhausen, among others) in which there is no longer even
grouping of the durations into basic pulses. An example is Stockhausen
Refrain, a piece for piano, celesta, and vibraphone written in 1960. Sinc
there is no sense of rhythmic pulse at all, the durations in this work see
to occur almost at random. For example, bursts of notes at very hig
speeds may suddenly be followed by very long, sustained tones, with n
suggestion of a common denominator to help the listener group them
Clearly this music will have a completely different rhythmic effect from tha
of traditional music; but it reflects a recent tendency to open up new area
for experimentation with different kinds of rhythmic relationships.

Timbre as the Principal Element

It was stated previously that pitch and rhythm are the primary elements i
Western music, with dynamics and timbre assuming only a secondary rol
One of the most interesting developments in recent years, however, ha
been a tendency on the part of certain composers to emphasize timbre a

ORGANIZATION

EXAMPLE 36

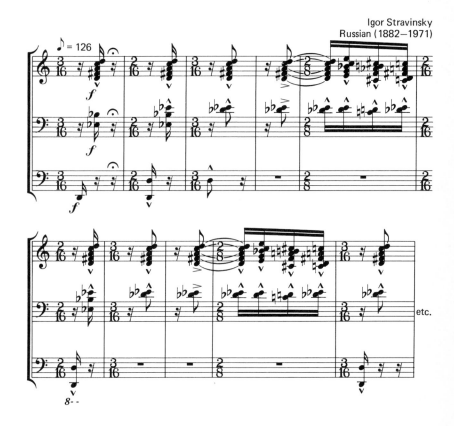

Igor Stravinsky
Russian (1882—1971)

the expense of both the pitch and the rhythmic organization. In a piece such as Krzysztof Penderecki's *Threnody to the Victims of Hiroshima,* a work written in 1960 and scored for fifty-two stringed instruments, the pitch and rhythmic relationships have become so complex that they reveal little sense of organization; they seem rather to have been chosen primarily to exploit certain timbral effects. Indeed, the instruments are treated in such novel ways—for example, they are given notes so high that no distinct pitch is perceptible, and placed in such dense textures that the individual components are lost in a total mass of sound—that the listener's attention is almost completely focused on the unusual "noises" (as opposed to pitches) that he hears. It may even surprise the listener to learn that all this is being produced by a "normal" string orchestra, for the sounds seem utterly unlike the pitched sounds usually associated with this ensemble. In such works it is the effect of the instrumental colors—their own distinctive sound and their relationships to one another—which becomes the principal musical ingredient, a fact which reflects a striking departure from traditional Western musical practice.

11. ELEMENTS OF LITERATURE– SENSE

The medium of literature is language, and language, as we know, is composed of words that are combined into sentences to express ideas, emotions, or desires. Words have both sound and meaning. The word *horse*, for instance, stands for the sound *horse* and the animal *horse*. These are usually associated and are separated only by an effort; yet they are distinct. To understand literature we must know both sound and sense. We begin with sense, or meaning.

MEANING

The first and last rule in knowing literature is that one should know what the words mean. It is always a temptation to guess when one is uncertain, but it is never safe. One of the authors remembers seeing the school for retarded children in Frankfort, Kentucky, when he was a child. People called it the "feeble-minded" institute. When he got home he told his mother that there was a sign in front of the building which said *Eleemosynary Institute*. His mother asked, "Do you know the meaning of eleemosynary?" "Of course," said he; "it means feeble-minded." The word comes from the Latin *eleemosynarius*, "charitable." For the student who has studied foreign languages, meaning is often clear without a dictionary, as in the case of *eleemosynary*. This is especially true of Latin, because we have taken many of our words from the Latin. Often we have a Latin word and a Germanic (English) word for the same thing, as in the Latin *paternal* and the English *fatherly*, or the Latin *annual* and the English *yearly*. Usually there is a slight difference in connotation; the English is often simpler, more explicit, or more expressive of powerful emotions.

The ending of Ernest Hemingway's novel *A Farewell to Arms* is a example of the simplicity of short native words. In this passage, on three words are not of native origin: *statue, hospital,* and *hotel.* The hero' sweetheart has died, and he has driven everyone from the room.

But after I had got them out and shut the door and turned off the light
it wasn't any good. It was like saying good-by to a statue. After a while
I went out and left the hospital and walked back to the hotel in the rain.
 —Ernest Hemingway (1899–1961, American novelist),
 A Farewell to Arms (1929)

Some words we do not know, because they are archaic. We do not use ther now, or not in the same sense they once had. In the ballad "Sir Patric Spence," an *"eldern knight"* is an elderly knight, and a "braid letter" is . large letter, one which contains official directions.

Technical Terms

Technical terms belong to the general class of learned words but are dis tinguished as being the language of a particular profession, business, o trade. Often technical words get into the ordinary language; examples ar *tuberculosis, static, carburetor, ignition, wavelength.* A great part of thi book is devoted to the technical language of the arts. In each art som of the terms have become general knowledge, whereas others have re mained terms for the specialist. In architecture, for instance, *cornice pediment, column,* and *frieze* are fairly well known; *architrave, entablature basilica,* and *clerestory* are more likely to be familiar only to specialists.

Idiom

Idiom is a form of expression peculiar to one language, as, for instance *wait for* as against *wait on; need of* as against *need for.* We do not notic an idiom if it is correctly used. Boswell uses an idiom that is now obsolet when he says "They then repaired to one of the neighboring taverns. . . .

Dialect, Provincialisms

A dialect is the language of a certain part of a country, as, for instance the Scottish dialect or the Irish dialect. A provincialism is a word or phras peculiar to a province or a small section of a country; for example, "Y'a hurry back now" for "Come and see us soon."

New Words

Some words we are conscious of as new: *burglarized, extradited, educa tionist, tycoon.* Some of these get into the permanent language.

New meanings are constantly being given to words, or the meaning of words change. Some of these changes have come about very graduall

and naturally over a long period of time. The word *treacle,* which now means molasses, comes originally from the Greek θηριον (*therion*), which means *"wild beast."* This change in meaning, though startling at first, has come about very naturally; the word was first used for anything that had to do with a wild animal; then it came to mean the medicine that was good for the bite of a wild animal; and, since that medicine was usually sweet and sticky, it came to mean any such sweet and sticky substance; hence, molasses. In the same way the word *hound,* which originally meant any kind of dog, as it does today in German (*Hund*), came to mean only a certain type.

Modern writers often put two or more words together, as *toycolored, fatbellied, everloving.*

Often one word has several different meanings. A class of students knew only that the word *bar* in Tennyson's "Crossing the Bar" meant some kind of a barrier. One said he knew it was not a saloon but that it was something like that. Hence Tennyson's lines "And may there be no moaning of the bar / When I put out to sea" were meaningless to him. Another such word is *macaroni.* In the eighteenth century a "macaroni" was a dandy, a man who got himself dressed in the very latest fashion. And so it makes sense when we sing of Yankee Doodle that he "stuck a feather in his cap/And called it macaroni."

Similarly, the same thing may be called by one name in Great Britain and a different one in the United States. Thus an elevator in England becomes a *lift*; gasoline is *petrol.*

Allusions

For finding meanings of words like those we have been discussing, the dictionary is a safe recourse. Even if a single word is used in several different senses, each use is recorded in the dictionary. There is no such speedy help in the case of allusions. An allusion is an indirect reference to some place, person, event, quotation, or the like; the writer usually supposes that his readers will be familiar enough with it to recognize the allusion. In Cummings' "in Just-spring" the old balloon man is said to be *goat-footed*; this is an allusion to a satyr, and here it connotes the woods and the joyousness of spring.

In Milton's sonnet "On His Blindness," there is an allusion to the parable of the talents in Matthew 25. A little further on we find another allusion, when Milton has Patience say;

"God doth not need
Either man's work or his own gifts. Who best
Bear his mild yoke, they serve him best. His state
Is kingly: thousands at his bidding speed,
And post o'er land and ocean without rest;
They also serve who only stand and wait."
—John Milton (1608–1674, English poet),
"On His Blindness" (ca. 1655)

This is a clear allusion to the saying of Jesus, "For my yoke is easy and my burden is light."

A reference is an *explicit* mention of the same sort of subjects that an allusion implicitly mentions. For example, Wordsworth refers directly to Greek mythology when he wishes to

Have sight of Proteus rising from the sea,
Or hear old Triton blow his wreathed horn.
> —William Wordsworth (1770–1850, British poet),
> "The World Is Too Much with Us" (1807)

If he had omitted the actual names "Proteus" and "Triton," then he would have been alluding to these gods, not referring to them.

Connotations

The connotations of a word are the allied meanings or associated ideas that are called to mind when the word is used. The word *father*, for instance, has always had the same meaning: the male parent. Its connotations are love, kindliness, protection, greater experience, guidance, wisdom. Not all male parents show these qualities. Some fathers are cruel, unkind, foolish; but if one wants to make it clear that a father is of this kind, he must state the fact definitely, for the connotations of the word *father* make one suppose just the opposite. The word *spinster* originally meant "a person who spins"; now it means "an unmarried woman" and has much the same connotations as *old maid*. The cowboy herds cattle, but the word *cowboy* connotes youth, bravery, adventure, and romance; *cattle herder* merely a person who herds cattle. *Oxford* is much more than a town or university; it connotes culture, leisure, gentlemen, the future statesmen of the British Empire.

Chaucer, in describing the Pardoner in the *Canterbury Tales*, says he "had hair as yellow as wax, but smooth it hung as does a hank of flax." The comparisons leave the impression that his hair was also dirty, full of foreign particles as wax and flax are likely to be, and uncombed, matted together like strands of flax. When Chaucer says that the Miller had, on the very tip end of his nose, "a wart, and thereon stood a tuft of hairs red as the bristles of a sow's ears," we know more than the color of those hairs. Almost the only good thing Chaucer has to say of the Friar is that "his eyes twinkled in his head aright, as do the stars in the frosty night"—a comparison which somehow restores a little confidence in the man. gives him a place in the great out-of-doors, and helps us to understand the confidence people had in him in spite of his worldliness.

IMAGERY

Examine the following lines:

St. Agnes' Eve—Ah, bitter chill it was!
The owl, for all his feathers, was a-cold;
The hare limp'd trembling through the frozen grass,
And silent was the flock in woolly fold:
Numb were the Beadsman's fingers, while he told
His rosary, and while his frosted breath,
Like pious incense from a censer old,
Seem'd taking flight for heaven, without a death,
Past the sweet Virgin's picture, while his prayer he saith.
> —John Keats (1795–1821, English poet),
> "The Eve of St. Agnes" (1820)

From this stanza we get a much clearer sense of cold than if we were told that the thermometer registered ten below zero. The difference is that Keats has managed to make us conscious of the ways we are conscious of cold. To some people these are almost like a physical experience, and for everyone they have a certain vividness as they call to mind the sensations described. Sense impressions of this kind are called "images." *Imagery* is the general name for the functioning of the imagination in the production of images. We may say that an image is the mental duplication of a sense impression. The most common kind of imagery is visual: we are made to *see* what the author is talking about.

William Butler Yeats' short poem "When You Are Old" is filled with the poet's own highly personal imagery:

When you are old and gray and full of sleep,
And nodding by the fire, take down this book,
And slowly read, and dream of the soft look
Your eyes had once, and of their shadows deep;

How many loved your moments of glad grace,
And loved your beauty with love false or true,
But one man loved the pilgrim soul in you,
And loved the sorrows of your changing face;

And bending down beside the glowing bars,
Murmur, a little sadly, how Love fled
And paced upon the mountains overhead
And hid his face amid a crowd of stars.
> —William Butler Yeats (1865–1939, Irish poet),
> "When You Are Old" (1892)[1]

[1] From *Collected Poems* by W. B. Yeats. Copyright 1956 by the Macmillan Company, N.Y.

Imagery is not all visual. The other senses may also be "duplicated" by means of images. In the last stanza of Walt Whitman's poem "To a Locomotive in Winter," we have vivid auditory and motor images in addition to visual ones.

Fierce-throated beauty!
Roll through my chant with all thy lawless music, thy swinging lamps at
night,
Thy madly-whistled laughter, echoing, rumbling like an earthquake,
rousing all,
Law of thyself complete, thine own track firmly holding,
(No sweetness debonair of tearful harp or glib piano thine,)
Thy trills of shrieks by rocks and hills return'd,
Launch'd o'er the prairies wide, across the lakes,
To the free skies unpent and glad and strong.
— Walt Whitman (1819–1892, American poet),
"To a Locomotive in Winter" (1876)

Shakespeare's little song from *Love's Labour's Lost* (quoted on page 40) is outstanding for its clear auditory images as well as its visual images: the shepherd *blows* his nail, the owl sings "*tu-whit; tu-who,*" Joan *keels* ("stirs") *the pot, coughing drowns* the parson's sermon, and the roasted crab apples *hiss* in the bowl.

Motor images are important for various reasons. In addition to conveying the sense of movement, for whatever reasons the poet may have in mind (as in Whitman's poem "To a Locomotive in Winter," quoted above), they may convey a general sense of the limitless power of nature. Shelley's "Ode to the West Wind" is an example:

O wild West Wind, thou breath of Autumn's being,
Thou, from whose unseen presence the leaves dead
Are driven, like ghosts from an enchanter fleeing,

Yellow and black, and pale, and hectic red,
Pestilence-stricken multitudes: O thou,
Who chariotest to their wintry bed

The winged seeds, where they lie cold and low,
Each like a corpse within its grave, until
Thine azure sister of the Spring shall blow

Her clarion o'er the dreaming earth, and fill
(Driving sweet buds like flocks to feed in air)
With living hues and odors plain and hill:

Wild Spirit, which art moving everywhere;
Destroyer and preserver; hear, oh hear!

In Shelley's "To a Skylark" the flight of the bird symbolizes man's possible freedom from earthly bonds and from the material aspects of earthly existence:

> Higher still and higher
> From the earth thou springest
> Like a cloud of fire;
> The blue deep thou singest,
> And singing still dost soar, and soaring ever singest.

Keats is a poet who is outstanding for both the wealth and the vividness of his imagery. He has images even of such sensations as touch, taste, smell, and temperature, which are not usually considered of first importance. In "The Eve of St. Agnes" the lover spreads before his sleeping lady a table on which are heaped all sorts of delicacies. The scene is made vivid by the touch of the smooth linen and the creamy cheese, the taste of the candied apple and the syrups flavored with cinnamon; all these things are made romantic by the fact that they have been brought from a distance, "from silken Samarcand to cedared Lebanon."

> And still she slept an azure-lidded sleep;
> In blanched linen, smooth, and lavendered,
> While he from forth the closet brought a heap
> Of candied apple, quince, and plum, and gourd;
> With jellies smoother than the creamy curd,
>
> And lucent syrops, tinct with cinnamon;
> Manna and dates, in argosy transferr'd
> From Fez; and spiced dainties, every one.
> From silken Samarcand to cedared Lebanon.
> —Keats, "The Eve of St. Agnes" (1820)

In his "Ode to a Nightingale" Keats wants to get away from the world

> . . . where men sit and hear each other groan
> Where palsy shakes a few sad, last, grey hairs . . .

and he imagines himself in a garden at night; he cannot see the flowers, but he knows they are there by the smells, which are much stronger than in the day:

> I cannot see what flowers are at my feet,
> Nor what soft incense hangs upon the boughs,

But, in embalmed darkness, guess each sweet
 Wherewith the seasonable month endows
The grass, the thicket, and the fruit-tree wild;
White hawthorn, and the pastoral eglantine;
 Fast-fading violets cover'd up in leaves;
 And mid-May's eldest child,
The coming musk-rose, full of dewy wine,
 The murmurous haunt of flies on summer eves.
 —Keats, "Ode to a Nightingale" (1819)

In fact, any sensation can be brought clearly before the mind in imagery

FIGURES OF SPEECH

Words, being symbols, have no meaning in themselves; their only meaning
is what is given to them by convention. Moreover, a symbol can never be
specific; it is always abstract or general. We call words "abstract" or "con
crete" as they signify abstractions or concrete objects; we say *truth* and
honor are abstract, *dog* and *lilac* are concrete. But these concrete words
are themselves abstractions in that they stand for a whole class of objects.
The dog may be any one of a large number of species, of any known color.
And when we say *lilac*, we may mean any variety of lilac, in any color, or
any one of the other sensations concerned with lilac: its fragrance, the
shape of the flower or the leaf, the bush on which the flower grows.

Because of this indefiniteness of words there have grown up certain
deviations, or roundabout methods of expression, that attempt to make
more clear the exact meaning. If, for instance, Coleridge had simply men
tioned ice that was green, he would have left it to us to imagine the shade
of green; but he gives the exact shade when he says:

And ice, mast-high, came floating by,
As green as emerald.
 —Samuel Taylor Coleridge (1772–1834, British poet),
 The Rime of the Ancient Mariner (1798)

But he can make us realize even more clearly the color of hair, the feeling
of fear, and the sound of the departing souls by stating his point
indirectly:

Her lips were red, her looks were free,
Her locks were yellow as gold:
Her skin was as white as leprosy,
The Nightmare Life-in-Death was she,
Who thicks man's blood with cold.

Fear at my heart, as at a cup,
My life-blood seemed to sip!

The souls did from their bodies fly,—
They fled to bliss or woe!
And every soul, it passed me by,
Like the whizz of my cross-bow!
　　　　—The Ancient Mariner

Such indirect methods of expression are called "figures of speech."

Simile and Metaphor

The most common, and therefore the most important, of the figures of speech are the simile and the metaphor. Both depend upon the comparison of one thing to another. The simile puts in the word of comparison; the metaphor leaves it out. The simile says: *The ice was as green as emerald;* the metaphor says: *The ice was emerald.* The simile says: *Fear was like a monster which sipped my blood;* the metaphor says: *Fear sipped my blood.* The simile would say: *Thou, Peter, art like a rock;* the metaphor says: *Thou art Peter, and upon this rock I will build my church.*
　　　The simile says:

　The pale purple even
　　　Melts around thy flight
　Like a star of Heaven
　　　In the broad daylight
Thou art unseen, but yet I hear thy shrill delight

　Keen as are the arrows
　　　Of that silver sphere,
　Whose intense lamp narrows
　　　In the white dawn clear
Until we hardly see—we feel that it is there.
　　　—Percy Bysshe Shelley (1792–1822, British poet),
　　　　"To a Skylark" (1820)

Shelley here directly compares the skylark to a "star of Heaven in the broad daylight" and its shrill delight to "the arrows of that silver sphere" —the star.
　　　The metaphor says:

The Lord is my shepherd;
I shall not want.
He maketh me to lie down in green pastures:
He leadeth me beside the still waters.

He restoreth my soul:
He leadeth me in the paths of righteousness for his name's sake.
　　　—Psalm 23

Keats uses metaphor in the first eight lines of his sonnet "On First Looking into Chapman's Homer" when he identifies poetry with rich kingdoms. In the last six lines he uses two similes as he tries to tell how he felt when he read Chapman's translation of Homer: first, like an astronomer who discovered a new planet; and second, like Cortez when he discovered the Pacific.[2]

Much have I travell'd in the realms of gold,
And many goodly states and kingdoms seen;
Round many western islands have I been
Which bards in fealty to Apollo hold.
Oft of one wide expanse had I been told
That deep-brow'd Homer ruled as his demesne;
Yet did I never breathe its pure serene
Till I heard Chapman speak out loud and bold:
Then felt I like some watcher of the skies
When a new planet swims into his ken;
Or like stout Cortez when with eagle eyes
He stared at the Pacific—and all his men
Look'd at each other with a wild surmise—
Silent, upon a peak in Darien.
　　　—Keats, "On First Looking into Chapman's Homer" (1816)

Many of our most common expressions involve similes or metaphors. We say one person has a "heart of gold" and another is as "slow as molasses in January." Both simile and metaphor are used very commonly by all people at all times. It is hard to find a paragraph of prose or verse that does not contain either a simile or a metaphor.

　　Both simile and metaphor are based on comparison. In each, comparison is made of one thing to something essentially unlike it for the purpose of showing one point of resemblance. The power of either figure of speech rises, of course, from the implications and suggestions of the comparison. In "A Song for Simeon" T. S. Eliot has a simile about an old man's life:

My life is light, waiting for the death wind,
Like a feather on the back of my hand.[3]

[2] A well-known mistake. It was of course, Balboa, not Cortez, who was the first European to look upon the Pacific Ocean.

[3] From *Collected Poems*, 1909–1962, by T. S. Eliot, copyright 1936, by Harcourt, Brace and World, Inc.; copyright © 1963, 1964, by T. S. Eliot. Reprinted by permission of the publishers.

By this comparison, Eliot emphasizes the everyday character of the scene, the sense of the nearness of death in everyday life. In another very famous example, Eliot compares an evening to a patient on an operating table:

Let us go then, you and I,
When the evening is spread out against the sky
Like a patient etherized upon a table.
　　　—T. S. Eliot (1888–1965, American poet),
　　　　"The Love Song of J. Alfred Prufrock" (1917)[4]

Other Figures of Speech

Next to simile and metaphor, perhaps the most important figures of speech are *metonymy* and *synecdoche*. The two terms are often used interchangeably, because synecdoche is a broader application of metonymy. In metonymy, we use one word for another that it will logically suggest and be related to; for example, the word *sceptre* or *crown* may be used to refer to the man who carries the sceptre or wears the crown. We use the word *Shakespeare* to mean the plays and poems of Shakespeare; we use the phrase *the bar* to mean the legal profession.

Synecdoche includes this use of one word to suggest another, related term; but it goes further. In synecdoche a part is used to represent the whole, or the whole to represent a part. When one says that something will "bring my gray hairs down to the grave," he is using a part of the body for the whole body. Similarly, one may say that "the United States won the Davis Cup," meaning that the United States tennis team won it. Here the term for the whole (the United States) refers to a part of it (the tennis team).

There are several other ways of writing classed among the figures of speech: personification, apostrophe (address), hyperbole (exaggeration), litotes (understatement), antithesis (statement of contrasts), and irony. Irony is found in an expression which says one thing but really means the opposite, as when a person announces that he has good news when in reality he has bad news.

Three types of irony have been distinguished: irony of statement, irony of situation, and dramatic irony. An example of irony of statement was given above when we mentioned speaking of bad news as good news. A famous example is found in Job's cry to his so-called comforters: "No doubt but ye are the people, and wisdom shall die with you." Another is found in Antony's funeral oration in Shakespeare's *Julius Caesar:*

Brutus is an honorable man;
So are they all, all honorable men.

[4] *Ibid.*

Swift is one of the greatest writers of irony. In the essay which he called "A Modest Proposal for Preventing the Children of Poor People from Being a Burden to Their Parents," he suggests that the babies of the Irish should be fattened and sold for meat.

Irony of situation, as the name indicates, makes a contrast between a situation as it is thought to be and as it is. Edwin Arlington Robinson's "Richard Cory" makes such a contrast:

Whenever Richard Cory went down town,
We people on the pavement looked at him;
He was a gentleman from sole to crown,
Clean favored, and imperially slim.

And he was always quietly arrayed,
And he was always human when he talked;
But still he fluttered pulses when he said,
"Good morning," and he glittered when he walked.

And he was rich—yes, richer than a king—
And admirably schooled in every grace:
In fine, we thought that he was everything
To make us wish that we were in his place.

So on we worked, and waited for the light,
And went without the meat, and cursed the bread;
And Richard Cory, one calm summer night,
Went home and put a bullet through his head.
 —Edwin Arlington Robinson (1869–1935, American poet),
 "Richard Cory"[5]

Dramatic irony is found when the members of the audience have knowledge not held by the characters on the stage. A characteristic example is found in *Romeo and Juliet,* when Romeo tells of his happy dream and gives his assurance that all will be well. Because the audience knows what tragedy will follow, all the lovers' optimism and good faith is overshadowed by doom.

GRAMMAR

Knowing a language is not just a matter of knowing words. To get the sense of a passage we must know how the words fit together as well as the meaning of each word. The rules which state how words fit together make up grammar, which is a statement of the accepted sense relationships of words. Each language has its own method of expression, its own way of putting words together to make sense—in short, its own grammar.

[5] From *The Children of the Night* by Edwin Arlington Robinson. (Charles Scribner's Sons, 1897).

Those of us who have always spoken English have no difficulty with the usual simple arrangements of words. But often an author cannot express his idea clearly if he uses only the usual, simple arrangements, and so he deliberately distorts. The opening lines of *Paradise Lost* are not easy reading, but through them Milton has made us realize the magnitude of the task he has set himself, and the exalted mood in which he is beginning it.

Of Man's first disobedience, and the fruit
Of that forbidden tree whose mortal taste
Brought death into the World, and all our woe,
With loss of Eden, till one greater Man
Restore us, and regain the blissful Seat,
Sing, Heavenly Muse, that, on the secret top
Of Oreb, or of Sinai, didst inspire
That shepherd who first taught the chosen seed
In the beginning how the heavens and earth
Rose out of Chaos: or, if Sion hill
Delight thee more, and Siloa's brook that flowed
Fast by the oracle of God, I thence
Invoke thy aid to my adventurous song,
That with no middle flight intends to soar
Above th' Aonian mount, while it pursues
Things unattempted yet in prose or rhyme.
 —Milton, *Paradise Lost*, I, 1–16 (1667)

In this and in most older writings the relationships among words are always in accordance with the established rules of grammar, though it may be hard to get the sense because of the way words and phrases are piled on each other. In some more recent poetry the authors do not write in complete sentences; they achieve emphasis by a reference here and an exclamation there, and leave us to put them together, as E. E. Cummings does in "here's a little mouse," on page 236.

From this discussion of words and grammar, several points of importance emerge. The first is that it is essential to know the meanings of words and to understand their relationships. It is not necessary to know the grammatical name for any relationship. It is only a matter of convenience that we say *John* is the subject and *Henry* is the object in the sentence *John struck Henry;* but it does matter that we know how to indicate who got hit. And it does matter that when we sing of Yankee Doodle calling himself a "macaroni," we do not think of a dish of wheat paste and cheese.

The second point is that when an author departs from the simplest form of words and of sentence structure, he does so for a purpose. The change from normal word order in literature is exactly the same as distortion in the visual arts. A good writer does not fail to write simply—or a good artist to draw realistically—because he does not know how, but be-

cause he can express what he has to say better in the form that is n[
entirely natural and simple. And our question here is just the same as [
was in the case of distortions: Why did he do it this way? In the openin[
lines of *Paradise Lost* the effect is like that of an organ that begins quiet[
and gathers momentum until it finally bursts out into full diapason with th[
rolling "Sing, Heavenly Muse!" When Keats says "some watcher of th[
sky" instead of the more commonplace *astronomer*, he makes us think c[
the long, lonely hours the man spends gazing at the stars before his fait[
is rewarded and he sees a planet "swim into his ken."

here's a little mouse) and
what does he think about, i
wonder as over this
floor (quietly with
bright eyes) drifts (nobody
can tell because
Nobody knows, or why
jerks Here &, here,
gr (oo) ving the room's Silence) this like
a littlest
poem a
(with wee ears and see?

tail frisks)
 (gonE)
"mouse",
 We are not the same you and

i, since here's a little he
or is
it It
? (or was something we saw in the mirror)?

therefore we'll kiss; for maybe
what was Disappeared
into ourselves
who (look). , startled
 —E. E. Cummings (1894–1962, American poet),
 "here's a little mouse" (1926)[6]

[6] From *Poems 1923–1954*, Harcourt, Brace and World, Inc.; Copyright 1923, 1926,
1944, 1951, 1954 by E. E. Cummings.

12. ELEMENTS OF LITERATURE—SOUND

ELEMENTS OF SOUND

The sound of words is important in making the total sense, for no two words, no two sounds, ever have exactly the same meaning. In *The Two Gentlemen of Verona* there is a little song that begins:

Who is Silvia? What is she,
 That all our swains commend her?
Holy, fair, and wise is she;
 The heaven such grace did lend her,
That she might admired be.
 —William Shakespeare (1564–1616, British poet and dramatist),
 The Two Gentlemen of Verona, IV, ii, 39–43 (ca. 1592)

Here the name *Silvia* ostensibly is only a name; but actually it has two important qualities. On the one hand, it suggests a wood nymph, and elusiveness. But more important, it is part of the poet's alliterative scheme, in which the letter s plays a major part—it occurs twice in line 1, once in line 2, twice in line 3, and once each in lines 4 and 5. The poet, like the painter, chooses his elements carefully; if we were to change the name *Silvia* to almost any other woman's name—Alice, Peggy, Margaret, Louise, Phoebe, Laura, Hortense—the effect would be spoiled; the charm gone. Or take a single line from Milton:

And I shall shortly be with them that rest.
 —John Milton (1608–1674, British poet and essayist),
 Samson Agonistes, line 598 (1671)

Change the sound, keeping as nearly as possible the same sense. *Short* means *soon; them* has the same meaning as *those;* and *that* as *who;* fact, *those who* is a more common English idiom than *them that.* Make the substitutions, and the line reads:

And I shall soon be with those who rest.

There is no appreciable difference in sense, but the line is no longer the same kind of poetry.

It is important, therefore, to know what effects are derived primarily from the sound of words. There are three categories under which we can study the uses of sound in literature:

1. The sound of letters and words: tone color
2. The sequence of sounds in a free pattern of accents: rhythm
3. The sequence of sounds in a fixed pattern of accents: meter

Tone Color—Definition

The literary term *tone color* is borrowed from music; the writer achieves effects somewhat comparable to those of different instruments by the sounds of the words or letters he uses. Compare the opening lines of Blake's "Introduction" to *Songs of Innocence* with the opening lines of "The Congo" by Vachel Lindsay for contrast in tone color. The first seems to have the timbre of a high-pitched, sensitive, delicate instrument, such as the flute; this matches the spirit of the piece. The second has the sound of a deep, heavy instrument, like a drum or a tuba, which has an intense, insistent, powerful beat.

Piping down the valleys wild,
 Piping songs of pleasant glee,
On a cloud I saw a child,
 And he laughing said to me:

"Pipe a song about a Lamb!"
 So I piped with merry cheer.
"Piper, pipe that song again;"
 So I piped; he wept to hear.
 —William Blake (1757–1827, British poet, painter, and engraver),
 "Introduction" to *Songs of Innocence* (1787)

Fat black bucks in a wine-barrel room,
Barrel-house kings, with feet unstable,
Sagged and reeled and pounded on the table,
Pounded on the table,
Beat an empty barrel with the handle of a broom,
Hard as they were able,
Boom, boom, BOOM,

With a silk umbrella and the handle of a broom,
Boomlay, boomlay, boomlay, BOOM.

> —Vachel Lindsay (1879–1931, American poet),
> "The Congo," opening lines (1914). By permission of The Macmillan Company, publishers.

Three Types of Tone Color

All effects of tone color depend on repetition. It may be repetition (1) of words, (2) of sentences or phrases, or (3) of single sounds.

REPETITION OF WORDS The simplest and clearest example of tone color is the repetition of words. The repetition of a word, though it may become wearisome, is one of the most effective devices in literature. In the "Introduction" to *Songs of Innocence*, for example, the reiteration of the word *pipe* emphasizes the childlike quality of the verse.

Mark Anthony's famous funeral oration in Shakespeare's *Julius Caesar* (Act III, Scene II) is a good example of the use of repetition to achieve an effect. This is the speech beginning "Friends, Romans, Countrymen, lend me your ears":

Here, under leave of Brutus and the rest,—
For Brutus is an honorable man;
So are they all, all honorable men,—
Come I to speak in Caesar's funeral.
He was my friend, faithful and just to me:
But Brutus says he was ambitious;
And Brutus is an honorable man.
He hath brought many captives home to Rome,
Whose ransoms did the general coffers fill:
Did this in Caesar seem ambitious?
When that the poor have cried, Caesar hath wept;
Ambition should be made of sterner stuff:
Yet Brutus says he was ambitious;
And Brutus is an honorable man. . . .

By the constant, ironic repetition of the phrases "honorable man" and "ambitious," contrasted with Anthony's version of Caesar's life, a remarkable dramatic effect is created.

REPETITION OF SENTENCES OR PHRASES In the device known as *anaphora* a group of words or a sentence is repeated. In the last act of Shakespeare's *Merchant of Venice*, Lorenzo and Jessica have arrived at Belmont and are waiting for the return of Portia and the others. As they wait, they beguile the time by playing a game in which they picture other famous lovers. Each speech begins with the words *In such a night*; the phrase serves as a musical motive and as a constant reminder of the beauty of the scene.

Lorenzo. The moon shines bright. In such a night as this,
When the sweet wind did gently kiss the trees
And they did make no noise, in such a night
Troilus methinks mounted the Troyan walls,
And sigh'd his soul toward the Grecian tents,
Where Cressid lay that night.

Jessica. In such a night
Did Thisbe fearfully o'ertrip the dew,
And saw the lion's shadow ere himself
And ran dismay'd away.

Lorenzo. In such a night
Stood Dido with a willow in her hand
Upon the wild sea banks, and waft her love
To come again to Carthage.

Jessica. In such a night
Medea gathered the enchanted herbs
That did renew old Aeson.

Lorenzo. In such a night
Did Jessica steal from the wealthy Jew,
And with an unthrift love did run from Venice
As far as Belmont.

Jessica. In such a night
Did young Lorenzo swear he lov'd her well,
Stealing her soul with many vows of faith
And ne'er a true one.

Lorenzo. In such a night
Did pretty Jessica, like a little shrew
Slander her love, and he forgave it her.

Jessica. I would out-night you, did no body come;
But, hark, I hear the footing of a man.
—Shakespeare, *The Merchant of Venice*, V, i, 1–24 (ca. 1595)

Winston Churchill's famous address to the Commons after Dunkir
on June 4, 1940, makes constant use of the phrase *We shall fight.*

We shall go on to the end, we shall fight in France, we shall fight on the
seas and oceans, we shall fight with growing confidence and growing
strength in the air, we shall defend our Island, whatever the cost may
be, we shall fight on the beaches, we shall fight on the landing grounds,
we shall fight in the fields and in the streets, we shall fight in the hills;
we shall never surrender, and even if, which I do not for a moment be-
lieve, this Island or a large part of it were subjugated and starving, then
our Empire beyond the seas, armed and guarded by the British Fleet,
would carry on the struggle, until, in God's good time, the New World,
with all its power and might, steps forth to the rescue and the liberation
of the old.
—Winston Churchill (1874–1965, British statesman),
Dunkirk: Address to Commons, June 4, 1940

Ferlinghetti's poem "I Am Waiting," from the collection *A Coney Island of the Mind*, emphasizes impatient waiting for a renaissance of wonder by the constant repetition of the words *I am waiting*, with almost the effect of an orator's plea:

and I am waiting
for the American Eagle
to really spread its wings
and straighten up and fly right
and I am waiting
for the Age of Anxiety
to drop dead
and I am waiting
for the war to be fought
which will make the world safe
for anarchy
and I am waiting
for the final withering away
of all governments
and I am perpetually awaiting
a rebirth of wonder
 —Lawrence Ferlinghetti (1919– , American poet),
 "I Am Waiting"[1]

REPETITION OF SINGLE SOUNDS Subtle examples of tone color are found when single sounds are repeated. These sounds are usually single letters. They are not always the same letters, however, for often two letters have the same sound (corner, kick), and some single letters have two sounds (corner, cedar). Besides rhyme there are three types of tone color based on the repetition of single sounds: alliteration, assonance, and consonance.

Alliteration is the repetition of accepted sounds that begin words: *P*eter *P*iper *p*icked a *p*eck of *p*ickled *p*eppers. When used to extremes, as in the Peter Piper rhyme, alliteration may become obnoxious, but when well used it is pleasing. The use of alliteration is almost universal. Here is an example:

Once upon a midnight dreary, while I pondered weak and weary,
Over many a quaint and curious volume of forgotten lore—
While I nodded, nearly napping, suddenly there came a tapping,
As of someone gently rapping, rapping at my chamber door.
" 'Tis some visitor," I muttered, "tapping at my chamber door—
Only this and nothing more."

[1] Sixteen lines from *A Coney Island of the Mind*. Reprinted by permission of the publisher, New Directions Publishing Corporation.

Deep into that darkness peering, long I stood there wondering, fearing,
Doubting, dreaming dreams no mortal ever dared to dream before;
But the silence was unbroken, and the stillness gave no token,
And the only word there spoken was the whispered word, "Lenore!"
This I whispered, and an echo murmured back the word, "Lenore!"
 Merely this and nothing more.

.

Open here I flung the shutter, when, with many a flirt and flutter
In there stepped a stately raven of the saintly days of yore.
Not the least obeisance made he; not a minute stopped or stayed he;
But, with mein of lord or lady, perched above my chamber door—
Perched upon a bust of Pallas just above my chamber door—
 Perched, and sat, and nothing more.
 —Edgar Allan Poe (1809–1848, American poet and short story
 writer), "The Raven" (1845)

In these passages from "The Raven" alliteration is liberally sprinkled throughout: *weak* and *weary*; *quaint* and *curious*; *nodded, nearly,* and *napping; doubting, dreaming,* and *dreams; dared* and *dream; silence* and *stillness,* etc. The passage from "The Congo" quoted on page 238 also has alliteration: *black, bucks, barrel, beat, broom, boom, boomlay.*

Assonance is the effect obtained from the repetition of accented vowel sounds, as in *foolish, crooning; race, make; free and easy; mad as a hatter.* The effects to be gained from assonance are delicate and varied.

Break, break, break,
 On thy cold gray stones, O Sea!
And I would that my tongue could utter
 The thoughts that arise in me.
 —Alfred, Lord Tennyson (1809–1892, British poet),
 "Break, Break, Break" (1842)

In the second line of this stanza, for example, the words do not themselves express any great grief, yet we have a sense almost of desolation. The explanation is to be found in assonance. *Oh* is universally a cry of grief and mourning; the person who cannot be consoled laments *Oh, oh, oh.* Tennyson uses the word *O* only once, but he repeats the sound two other times in the short line:

On thy cold gray stones, O Sea!

In popular speech we use assonance in expressions like *time out of mind* and *slap-dash.*

Consonance is sometimes called "slant" rhyme. *Consonance* is a general term for the effects produced by the repetition of accented consonant sounds when one of them is not at the beginning of a word. Often both consonants occur at the ends of the words, as in o*dds* and e*nds* or stru*ts* and fre*ts.*

Consonance is not so nearly obvious as alliteration and is not so common, but it produces many subtle effects. In the verses from *The Raven* quoted above we find *napping* and *tapping; dreary* and *weary; rapping* and *tapping; peering, wondering,* and *fearing; shutter* and *flutter; unbroken* and *token,* etc.

Our examples of alliteration and assonance have necessarily come from traditional poetry, particularly from the writers of the nineteenth century, who often used almost pictorial devices and exaggerated effects. Contemporary poets like Elizabeth Bishop, Delmore Schwartz, Stanley Kunitz, Theodore Roethke, and others create their most picturesque effects in a much less elaborate, but equally effective, manner. The passage by Elizabeth Bishop quoted on page 19, from her "Little Exercise," is as atmospheric as anything in Poe or Tennyson:

Think of the storm roaming the sky uneasily like a dog looking for a place to sleep in. Listen to it growling.

RHYME Two words are said to rhyme when they are identical in sound from the vowel of the accented syllable to the end, provided the sounds that precede the accented vowel are not identical. *Cry, buy; face, place; sorrow, tomorrow; running, cunning*—these words rhyme. *Wright, write, right* do not rhyme because the letters before the accented vowel do not differ in sound. *Romantic* and *chromatic* do not rhyme because they are not identical in the syllables following the accented vowel. A rhyme is said to be "masculine" if the rhyming portion of the words is a single syllable, and "feminine" if the rhyming portion is more than one syllable. *Cry, buy; face, place* are masculine rhymes. *Sorrow, tomorrow,* and *cunning, running* are feminine rhymes.

Rhyme usually comes at the end of a line and follows a set pattern. Rhyme is indicated by the letters of the alphabet, *a* being used for the first rhyming word, *b* for the second, *c* for the third, etc.

My heart leaps up when I behold	*a*
A rainbow in the sky:	*b*
So was it when my life began;	*c*
So is it now I am a man,	*c*
So be it when I shall grow old	*a*
Or let me die!	*b*
The Child is father of the Man:	*c*
And I could wish my days to be	*d*
Bound each to each by natural piety.	*d*

—William Wordsworth (1770–1850, British poet),
"My Heart Leaps Up" (1802)

If a poem is divided into stanzas, the same rhyme pattern will usually be used in each stanza. In the "Introduction" to *Songs of Innocence* all the stanzas rhyme *abcb* except the first, which rhymes *abab.*

A great deal of poetry, of course, does not rhyme. There is no rhyme, for example, in the passage from Shakespeare's *Merchant of Venice* quoted on page 240.

As early as the nineteenth century rhyme as such began to disappear from a great deal of poetry. A good example is the work of the American poet Walt Whitman, whose elegy for Abraham Lincoln, "When Lilacs Last in the Dooryard Bloomed," begins:

When lilacs last in the dooryard bloomed,
And the great star early droop'd in the western sky in the night,
I mourn'd, and yet shall mourn with ever-returning spring.

Ever-returning spring, trinity sure to me you bring,
Lilac blooming perennial and dropping star in the west,
And thought of him I love . . .

 —Walt Whitman (1819–1892, American poet),
 "When Lilacs Last in the Dooryard Bloomed" (1865, 1881)

Since the time of Whitman we have learned not to look for rhyme and to accept poetry for its other virtues and beauties, for its expression of profound and universal feelings, for its presentation of eternal truths in a new, less mannered, form. Here is an example from a contemporary poet, Stanley Kunitz, of expression of a universal emotion—the sense of loss. The lines are from Kunitz's "Father and Son":

Now in the suburbs and the falling light
I followed him, and now down sandy road
Whiter than bone-dust through the sweet
Curdle of fields, where the plums
Dropped with their load of ripeness, one by one.
Mile after mile I followed, with skimming feet,
After the secret master of my blood,
Him, steeped in the odor of ponds, whose indomitable love
Kept me in chains. Strode years; stretched into bird;
Raced through the sleeping country where I was young,
The silence unrolling before me as I came,
The night nailed like an orange to my brow.

 —Stanley Kunitz (1905– , American poet),
 Passport to the War (1944)[2]

Rhythm

Rhythm as defined in *A Prosody Handbook*, by Karl Shapiro and Robert Beum, is "the total quality of a line's motion, and is the product of several

[2] *Selected Poems: 1928–1958* by Stanley Kunitz. Atlantic-Little Brown and Company, Boston, 1958. Copyright 1958 by Stanley Kunitz.

elements, not of stress and quantity alone." Shapiro and Beum say later, "Probably no two lines of poetry, and no two sentences of prose, have exactly the same rhythm" (page 60). Rhythm is found in all literature, as in all music; and it is the same in literature as in music.

To a certain extent all speech is rhythmic, for it is grouped in phrases; only a child just learning to read gives the same emphasis to every word. However, some speech is more rhythmic than other speech; the term *rhythmic* is usually reserved for that speech which excites the ear.

Compare the rhythms of these three examples. In the first, one has a disagreeable sense of being constantly jerked up; he cannot get into the swing of the sentence; there are no pauses. The other two are, in contrast, very rhythmic.

Mr. Davies does not let his learning cause him to treat the paintings as material only to be studied by the Egyptologist with a critical and scientific eye.

The young spirit has awakened out of Eternity, and knows not what we mean by Time; as yet Time is no fast-hurrying stream, but a sportful sunlit ocean; years to the child are as ages. . . . Sleep on, thou fair Child, for thy long rough journey is at hand! A little while, and thou too shalt sleep no more, but thy very dreams shall be mimic battles; thou too, with old Arnauld, wilt have to say in stern patience: "Rest? Rest? Shall I not have all Eternity to rest in?"

> —Thomas Carlyle (1795–1881, English philosopher and essayist), *Sartor Resartus* (1833)

And as we dwell, we living things, in our isle of terror and under the imminent hand of death, God forbid it should be man the erected, the reasoner, the wise in his own eyes—God forbid it should be man that wearies in well-doing, that despairs of unrewarded effort, or utters the language of complaint. Let it be enough for faith, that the whole creation groans in mortal frailty, strives with unconquerable constancy: Surely not all in vain.

> —Robert Louis Stevenson (1850–1894, Scottish poet, novelist, and essayist), *Pulvis et Umbra*

The examples above are prose, but rhythm is of course found in poetry as well. Often the phrase is practically identical to the line, as in the following:

Shall I, wasting in despair,
Die, because a woman's fair?
Or make pale my cheeks with care,
'Cause another's rosy are?
Be she fairer than the day.
Or the flowery meads in May!
 If she be not so to me,
 What care I how fair she be?

> —George Wither (1588–1667, British poet), "Shall I Wasting in Despair"

More often, however, the phrase is not the same as the line. It may end in the middle of a line, or it may carry over from line to line. Note how Tennyson varies the rhythmic effects in the last lines of "Ulysses":

> Come, my friends.
> 'Tis not too late to seek a newer world.
> Push off, and sitting well in order smite
> The sounding furrows; for my purpose holds
> To sail beyond the sunset, and the baths
> Of all the western stars, until I die.
> It may be that the gulfs will wash us down;
> It may be we shall touch the Happy Isles,
> And see the great Achilles, whom we knew.
> Tho' much is taken, much abides; and tho'
> We are not now that strength which in old days
> Moved earth and heaven, that which we are, we are,—
> One equal temper of heroic hearts,
> Made weak by time and fate, but strong in will
> To strive, to seek, to find, and not to yield.
>
> —Alfred, Lord Tennyson, "Ulysses" (1842)

Meter

English is a language of pronounced word accent. Words of more than one syllable have at least one accent. Words such as *dismay, avoid, contend* have the accent on the second syllable. A few words of two syllables, such as *baseball* and *blackbird*, have accents on both syllables. *November, lemonade, vertical, butterfly* have three syllables each. In *November*, the accent is on the second syllable, in *lemonade* on the third, and in *vertical* on the first. *Butterfly* has accents on the first and third syllables. *Commemorate* has four syllables, with a primary accent on the second syllable and a secondary accent on the last syllable.

Sometimes a poet puts words together so that these accents come in a regular order. Take, for instance, the lines quoted from Tennyson's "Ulysses." The accented and unaccented syllables tend to alternate—first an unaccented, then an accented syllable. The last two lines are absolutely regular:

> Made weak by time and fate, but strong in will
> To strive, to seek, to find, and not to yield.

This pattern is not kept with absolute regularity throughout the poem, but it is sufficiently regular for us to recognize it.

Any such regular recurrence of accent is called "meter." The meter in which an unaccented syllable is followed by an accented syllable is

known as *iambic*. It is so common as almost to be the universal meter of English poetry, but there are other meters. The accent may come on the first syllable instead of the second, as here:

Jenny kissed me when we met,
 Jumping from the chair she sat in;
Time, you thief, who love to get
 Sweets into your list, put that in:
Say I'm weary, say I'm sad,
 Say that health and wealth have missed me,
Say I'm growing old, but add,
 Jenny kissed me.
 —Leigh Hunt (1784–1859, British journalist, essayist, and poet),
 "Rondeau" (1838)

Or the accent may fall on every third instead of every second syllable. It may fall on the third, sixth, and ninth syllables, as in "Annabel Lee":

It was many and many a year ago,
 In a kingdom by the sea,
That a maiden there lived, whom you may know
 By the name of Annabel Lee;
And this maiden she lived with no other thought
 Than to love and be loved by me.
 —Edgar Allan Poe (1809–1849, American poet, short story writer,
 and critic), "Annabel Lee" (1849)

It may come on the first, fourth, and seventh syllables, as in these lines:

Just for a handful of silver he left us,
 Just for a riband to stick in his coat—
Found the one gift of which fortune bereft us,
 Lost all the others she lets us devote . . .
 —Robert Browning (1812–1889, British poet),
 "The Lost Leader" (1845)

Each of these meters is identified by the pattern of accented and un-accented syllables, and the unit is called a "foot."

TYPES OF FEET The names and symbols of the meters may be tabulated, with ∪ for an unaccented syllable, and / for an accented one.

 Iambic: ∪ /

 ∪ / ∪ / ∪ /
 To strive, to seek, to find

Trochaic: / ∪

/ ∪ / ∪
Jenny kissed me

Anapestic: ∪ ∪ /

∪ ∪ / ∪ ∪ / ∪ ∪ / ∪ /
It was many and many a year ago

Dactylic: / ∪ ∪

/ ∪ ∪ / ∪ ∪ / ∪
Just for a handful of silver

A spondaic foot, called a "spondee," is composed of two accented syllables. For obvious reasons the spondee cannot be used in an entire poem or even in an entire line. It is one of the important ways of introducing variety. It emphasizes by slowing up the speed of the line. Milton, for instance, uses spondees in *Paradise Lost* to stress the enormous size of Satan:

So *stretched out huge* in length the Arch-*Fiend lay.*
 —Milton, *Paradise Lost,* I, 209 (1667)

And Tennyson emphasizes the slow passage of time in "Ulysses" by substituting spondees for iambs:

The long *day wanes;* the slow *moon climbs;* the deep
Moans round with many voices.

The length of a line is named according to the number of feet in it.

 One foot—Monometer
 Two feet—Dimeter
 Three feet—Trimeter
 Four feet—Tetrameter
 Five feet—Pentameter
 Six feet—Hexameter
 Seven feet—Heptameter
 Eight feet—Octameter

Trimeter, tetrameter, and pentameter are the line lengths most commonly used. The lines just quoted from "Ulysses" are pentameter; "The Lost Leader" is in tetrameter; "Rondeau" is in tetrameter until the last line which is dimeter; "Annabel Lee" alternates tetrameter and trimeter. Ordinarily a line is designated by the kind of foot and the number of feet in a line, as iambic tetrameter, spondaic pentameter, etc.

As we have already pointed out, many of the traditional devices of poetry—the assonantal and consonantal relationships, the intricate rhyming schemes—are not much used in contemporary poetry. The same can be said of the various metrical devices just examined; many modern poets do not use them. The rhythms of the contemporary poet are likely to be subtler, more personal. The metrical schemes in the tortured poetry of Delmore Schwartz are an example of modern usage; another example is this shocking short poem by Randall Jarrell:

From my mother's sleep I fell into the State,
And I hunched in its belly till my wet fur froze.
Six miles from earth, loosed from its dream of life,
I woke to black flak and the nightmare fighters.
When I died they washed me out of the turret with a hose.[3]
　　—Randall Jarrell (1914–1965, American poet),
　　　"The Death of the Ball Turret Gunner" (1945)

The reader will have noticed that Jarrell's poem, although the meter is not regular, does contain a rhyme; and it should be mentioned that many traditional poetic devices are still to be found, so that an understanding of them remains useful in approaching contemporary as well as older poetry.

VERSE FORM

In traditional poetry, a poet usually decides on the kind of meter, the line length, and the rhyme scheme he wants and sticks pretty closely to that combination throughout his poem. This is called the "verse form." Since the passage we read from "Ulysses" is in iambic pentameter without rhyme, we expect the entire poem to be in that verse form, and it is. Similarly, we expect Poe to keep to stanzas of six lines of anapestic verse alternating tetrameter and trimeter, with the even lines rhyming.

Traditional Forms

A traditional poet may make a new verse form, but usually he does not. Some forms have been used so much that they have been given names by which they may be easily identified. The number of named forms is too great for a complete list to be given here, but a few of the more common terms are these:

 I. General terms
 A. *Couplet:* any stanza of two lines.

[3] From *Randall Jarrell: The Complete Poems*, Farrar, Straus and Giroux, Inc., N.Y. 1950. Copyright 1945, 1950 by Mrs. Randall Jarrell.

B. *Triplet:* any stanza of three lines.

C. *Quatrain:* any stanza of four lines.

II. Specific terms

A. *Ballad meter:* four lines of iambic verse alternating tetrameter and trimeter. Rhyme *abab*, or *abcb*. Commonly used in ballads Also called "*common meter*" from its use in hymns. Tradition ally the most popular of all quatrains.

She dwelt among the untrodden ways
 Beside the springs of Dove,
A Maid whom there were none to praise
 And very few to love:

A violet by a mossy stone
 Half hidden from the eye!
—Fair as a star, when only one
 Is shining in the sky.

She lived unknown, and few could know
 When Lucy ceased to be;
But she is in her grave, and, oh,
 The difference to me!
 —Wordsworth, "Lucy" (1800)

B. *Sonnet:* fourteen lines of iambic pentameter. The sonnet is one of the most elegant and subtle poetic forms. Within the short space of its fourteen lines, the poet can project an emotional universe. This form is the product of the late middle ages in Italy (Petrarch, in the fourteenth century) and the early seventeenth century in England (the age of Shakespeare). Ordinarily the poet states an idea in the first eight lines (the octave), and gives an explanation or an answer in the last six (the sestet). There are two types of sonnet, distinguished by their rhymes.

1. Italian, or Petrarchan: *abba abba* (octave); *cde cde* or *cdcdcd* (sestet).

The world is too much with us: late and soon,
Getting and spending, we lay waste our powers.
Little we see in Nature that is ours;
We have given our hearts away, a sordid boon!
This Sea that bares her bosom to the moon;
The winds that will be howling at all hours,
And are up-gathered now like sleeping flowers;
For this, for everything, we are out of tune;
It moves us not.—Great God! I'd rather be
A Pagan suckled in a creed outworn;
So might I, standing on this pleasant lea,
Have glimpses that would make me less forlorn;

Have sight of Proteus rising from the sea;
Or hear old Triton blow his wreathed horn.
 —Wordsworth, "The World Is Too Much with Us" (1807)

> 2. English, or Shakespearean: three quatrains with alternating rhyme and a couplet.

Let me not to the marriage of true minds
Admit impediments. Love is not love
Which alters when it alteration finds,
Or bends with the remover to remove.

O, no! it is an ever-fixèd mark
That looks on tempests and is never shaken;
It is the star to every wand'ring bark,
Whose worth's unknown, although his height be taken.

Love's not Time's fool, though rosy lips and cheeks
Within his bending sickle's compass come;
Love alters not with his brief hours and weeks,
But bears it out even to the edge of doom.

If this be error and upon me proved,
I never writ, nor no man ever loved.
 —Shakespeare, Sonnet 116 (publ. 1609)

> C. *Spenserian stanza:* eight lines of iambic pentameter followed by one of iambic hexameter. Rhyme *abab bcbcc*. A graceful verse invented by Spenser for *The Faerie Queene.*

And more to lulle him in his slumber soft,
A trickling streame from high rock tumbling downe,
And ever-drizling raine upon the loft,
Mixt with a murmuring winde, much like the sowne
Of swarming Bees, did cast him in a swowne.
No other noyse, nor peoples troublous cryes,
As still are wont t'annoy the walled towne,
Might there be heard; but carlesse Quiet lyes
Wrapt in eternall silence farre from enimyes.
 —Edmund Spenser (1552–1599, British poet),
 The Faerie Queen, I, ɪ, 41 (1590)

> D. *Blank verse:* unrhymed iambic pentameter.

When I see birches bend to left and right
Across the line of straighter darker trees,

I like to think some boy's been swinging them.
But swinging doesn't bend them down to stay.
> —Robert Frost (1875–1963, American poet),
> "Birches" (1916)

Other Types of Verse

ACCENTUAL VERSE This is verse that holds to a fixed number of accents in a line. Old English poetry was of this type; there were usually four accents to each line. In the second section of "Ash-Wednesday" T. S. Eliot has used this meter successfully, two accents to a line:

Lady of silences
Calm and distressed
Torn and most whole
Rose of memory
Rose of forgetfulness.
> —T. S. Eliot (1888–1965, American poet),
> "Ash-Wednesday" (1930)[4]

FREE VERSE Free verse is built on the rhythm of phrase. Its unit is the strophe, a separate section of extended movement within a poem. Unlike the stanza, which is a group of lines repeating a given metrical pattern, the strophe does not have to be any fixed length. It is composed of a number of phrases subtly balanced so as to constitute a complete cadence. Whitman's "When Lilacs Last in the Dooryard Bloomed," from which we have already quoted two opening verses of three lines each (page 244), continues with a five-line verse:

O powerful western fallen star!
O shades of night—O moody tearful night!
O great star disappear'd—O the black murk that hides the star!
O cruel hands that hold me powerless—O helpless soul of me!
O harsh surrounding cloud that will not free my soul.
> —Walt Whitman (1819–1892, American poet)

By now we can take it for granted that great poetry need not have alliteration, assonance, rhyme, traditional regular rhythms, or even fixed stanza patterns. Here, not only does Whitman give us a five-line stanza after two three-line stanzas; he continues with units having six lines, eight, seven, thirteen, etc. Each strophe seems to have a different emotional quality and

[4] From *Collected Poems 1909–1962* by T. S. Eliot, copyright 1936 by Harcourt, Brace & World, Inc.; copyright © 1963, 1964, by T. S. Eliot. Reprinted by permission of the publishers.

a purpose of its own, and the poet is free to use whatever form best suits his purpose at different stages of the poem.

HEBREW METER Hebrew meter is often classed with free verse; it is based on parallelism of phrases, one clause or phrase being balanced against another of similar structure. It is, of course, found most conspicuously in the Bible.

Purge me with hyssop, and I shall be clean;
Wash me, and I shall be whiter than snow.
Make me to hear joy and gladness;
That the bones which thou hast broken may rejoice.
Hide thy face from my sins,
And blot out all mine iniquities.
Create in me a clean heart, O God:
And renew a right spirit within me.
Cast me not away from thy presence;
And take not thy holy spirit from me.
 —Psalm 51:7–11

THE HAIKU AND THE TANKA The haiku and the tanka, two Japanese forms, are based on syllable count. The haiku contains 17 syllables in three lines of 5, 7, and 5 syllables. The tanka contains 31 syllables in five lines of 5, 7, 5, 7, and 7 syllables. Naturally they cannot be translated into English of the same count. The poet Issa (1763–1828) wrote this haiku after the death of his only child.

The world of dew
Is a world of dew and yet,
And yet.[5]

All haiku, like this poem, are concentrated on a single vivid moment. The following haiku by Onitsura (1661–1738) is more humorous, and expresses the universal desire to write poetry on a beautiful evening.

Is there, I wonder,
A man without pen in hand—
The moon tonight![6]

Bashō (1644–1694), who is generally considered Japan's greatest poet, says that a haiku should have both change and permanence. It should

[5] Donald Keene, *Anthology of Japanese Literature*, p. 21.
[6] *Ibid.*, p. 26.

look for the virtues of the old and at the same time express the present, a modern solution. One of his best-known haiku is this:

The ancient pond
A frog leaps in
The sound of the water.[7]

The tanka is similar, though longer. This one is by the Emperor Gotoba (1180–1239):

When I look far out
The mountain slopes are hazy
Minase River—
Why did I think that only in autumn
The evenings could be lovely?[8]

[7] *Ibid.*, p. 39.
[8] *Ibid.*, p. 36.

13. ORGANIZATION IN THE VISUAL ARTS

WHAT IS ORGANIZATION?

It has been said that man is most godlike in his demand for order. He is constantly trying to transform his chaos into a world of order. The mind is confused, if not balked, when it cannot find some order. The "order" in a work of art is its organization. In our study thus far we have been considering the elements found in works of art, but the elements are only the materials used by the artist. Now we begin to study the ways elements are combined to make a whole.

The primary demands made of any organization are two: (1) it must make sense, and (2) it must be interesting. The first of these demands has to do with the arrangement of parts, the overall design or plan of a work. Plan might be called the skeleton of the work of art. Plan covers the entire work—whether it be a symphony that lasts an hour or a song that is over in a minute, whether it be a novel of a thousand pages or a poem of two lines, whether it be the ceiling of a large chapel or the picture on a postage stamp. Whatever the size or the medium, we demand an orderly arrangement of parts which reflects a plan.

The names by which we identify plans differ in the various arts. In music we usually speak of "forms"—rondo, sonata, minuet, etc.—whereas in literature we talk of "types," such as novel, essay, and epic. In the visual arts there are no generally accepted names as such, but we may describe plans by obvious terms, such as "pyramidal," and "symmetrical."

Plan is essential because it holds the work together, but it is not interesting as such. Two works following identical plans may differ widely in interest and value. The sonnet form has been used in very great poems, but the same form is found in poems of no value. The value of a rondo

does not come from the rondo form, but from the music written in that form. In any of the arts, interest comes from the way the form is used—from the elements of which the plan is made and from their interrelations. This may be called the "organic structure" of the work. If the plan is compared to a skeleton, the organic structure corresponds to the flesh and blood with which the skeleton is covered. Another analogy for organization is an orchestra. The different elements play with and against each other as do the instruments of an orchestra; and so this organic structure or organic unity of a work of art is sometimes called its "orchestration."

For organic structure there is one rule that holds, in all the arts—that of unity and variety, or repetition and contrast. The elements used must be repeated enough to become familiar but varied enough in character to provide contrast. In this way we have the satisfaction of recognizing the familiar coupled with the surprise or tension of the unfamiliar. One of the most beautiful passages in Handel's *Messiah* comes in the singing of the contralto solo "He shall feed His flock," which is followed immediately by the soprano solo "Come unto Him, all ye that labor." The tune is the same, but the soprano sings it a fourth higher. With the differences in words and in pitch, not only is the song not repetitious, but many hearers do not even know they are hearing the same tune.

BASIC PLANS IN THE VISUAL ARTS

In the traditional visual arts, plan is simply the arrangement of the parts, with one place given special attention as the center of interest. In the *Sistine Madonna* (Figure 13-4, page 258) the plan consists of four groups: the Madonna and Child at the top of the canvas in the center, S. Sixtus on the left (with the papal crown at his feet to identify him), S. Barbara on the right (the building which identifies her as the patron of buildings is hardly to be seen above her right shoulder), and at the bottom of the picture two cherubs. The formal arrangement is seen even more clearly in the organizational drawing (Figure 13-1).

Because plan in the visual arts is obvious, there are no well-established names for types of plan, and hence we do not need any assistance in determining types. There are, however, a few obvious arrangements which are used repeatedly. The two most common are the symmetrical and the pyramidal plans; the vertical plan and the radial plan are less common.

Symmetrical Plan

The two sides of this plan are similar and relatively equal. This is a favorite plan in architecture, where the two sides are identical, as in the Vendramin Palace (Figure 13-30, page 273). It is also a favorite in painting or statues, as in the *Annunciation* by Simone Martini (Figure 6-14, page 116) or the *Ludovisi Throne* (Figure 5-4, page 93).

ORGANIZATION

Pyramidal Plan

The pyramid is almost as common in painting as the symmetrical plan is in architecture. The broad base gives a sense of solidity, and the apex gives emphasis. It is the natural shape for a portrait. In the portrait *Madame Cézanne in the Conservatory* (shown in Figure 13-2), the woman's skirt makes the base of the pyramid and her head the apex. The pyramidal plan is often used in representations of the Virgin, as in Giorgione's *Castelfranco Madonna* (Figure 13-5, page 259). The Madonna, though dressed as a simple peasant, is seated on high at the apex of the triangle; S. Liberale and S. Francis are at the corners. In the *Tomb of Giuliano de'Medici* (Figure 13-3) the figures follow the general shape of a pyramid.

Vertical Plan

The vertical plan consists of a single vertical figure or other object. Monuments frequently follow this plan, as do some modern skyscrapers—the Seagram Building in New York (Figure 13-27, page 272), for example. The vertical plan is used a great deal in sculpture, especially in statues of a single figure, like Michelangelo's *David*. It is not so common in painting as in sculpture, but it is sometimes used for full-length single figures, as in Eakins' *Thinker* (Figure 13-6, page 259).

Figure 13-2. *Paul Cézanne. Mme. Cézanne in the Conservatory (1891). (Oil on canvas. Size: 36½ by 28½ inches. Collection of Stephen C. Clark, New York. Photograph, Museum of Modern Art.)*

Figure 13-3. *Michelangelo. Tomb of Giuliano de Medici (ca. 1523–1533). Marble. Height: about 20 feet. Florence, San Lorenzo, New Sacristy. Photography by Alinari.)*

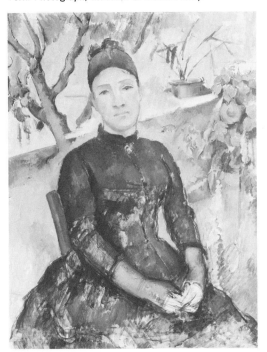

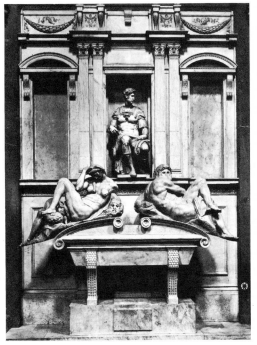

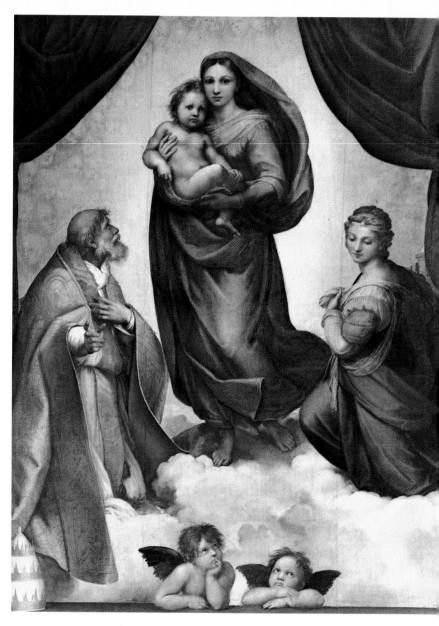

Figure 13-4. Raphael. Sistine Madonna (ca 1515). (Oil on canvas. Height: 8 feet, 8½ inches. Dresden Gallery.)

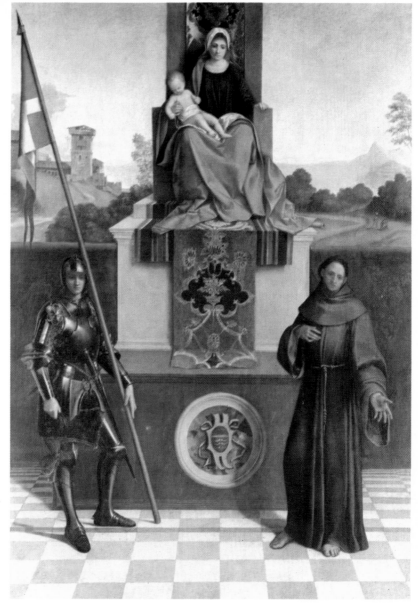

Figure 13-5. Giorgione (ca. 1478–1510), Italian painter. Castelfranco Madonna (1504). (Oil on wood. Height: 7 feet, 6 inches. Castelfranco Veneto, Cathedral. Photograph by Alinari.)

Figure 13-6. Thomas Eakins (1844–1916), American painter and sculptor. The Thinker (1900). (Oil on canvas. Height: 6 feet, 10 inches. New York, Metropolitan Museum of Art; Kennedy Fund, 1917.)

Figure 13-7. Leonardo da Vinci. The Last Supper (1495–1498). (Tempera on plaster. Figures above life size. Milan, S. Maria delle Grazie.)

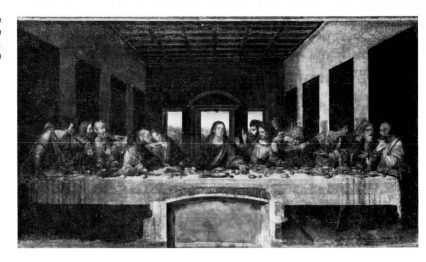

Radial Plan

In the radial plan the lines of the picture form radii which meet at a point in the center. In Leonardo's *Last Supper* (shown in Figure 13-7) all the lines of the ceiling and walls, as well as the hands and faces of the twelve disciples, point to the head of Christ. Leonardo puts his point of focus directly in the center of the picture. In the *Death of S. Francis* (shown in Figure 13-8) Giotto uses a similar organization, but with the focal point at one side. The lines of the painting—the heads and bodies of the saint's followers, as well as lines of the banner—all converge on the head of S. Francis. The one exception is the soul of the saint, which looks ahead as it is being carried through the air.

Figure 13-8. Giotto. Death of S. Francis (ca. 1325). (Fresco. Figures about life size Florence, S. Croce, Bardi Chapel. Photography by Alinari.)

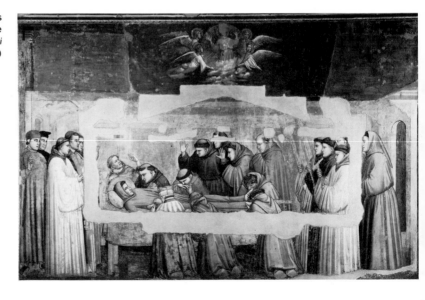

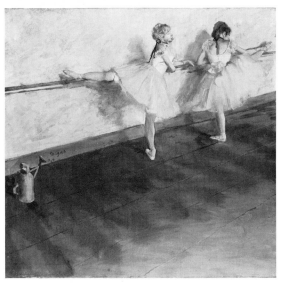

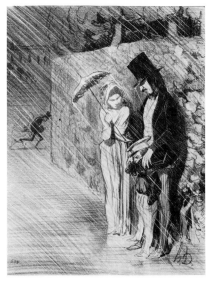

Figure 13-9. Edgar Dégas (1834–1917), French painter. Dancers Practicing at the Bar (1877). (Oil on canvas. Size about 29½ by 30½ inches. New York, Metropolitan Museum of Art; H. O. Havemeyer Collection.)

Figure 13-10. Honoré Daumier. Strangers in Paris. (Lithograph. Size: 8½ by 7 inches. New York, Metropolitan Museum of Art; Rogers Fund, 1922.)

Figure 13-11. El Greco. S. Jerome (ca. 1596–1600). (Oil on canvas. Size 42½ by 34¼ inches. Copyright Frick Collection, New York.)

Plan is often harder to see in abstract and nonobjective art, because these arts are not representational. The organization is based entirely on the repetition and variety of the elements. One color is balanced against another color, one line against another. The abstract expressionist painting by Jackson Pollock shown in Figure 2-23, page 39, is unified only in terms of its centrifugal movement. The artist is not interested in developing a "center of interest" in the traditional sense, nor in creating a traditional balance; rather, he wants to produce a record of the act of creativity. The art which results is unified only intuitively, not planned in the traditional way. Morris Louis, a contemporary color-field painter, creates a unity which consists of the total impression of one color area and the artist's preoccupation with it: here again, the formal plan is not traditional. However, in the work of Mondrian (Figure 2-4, page 22) we can see formal plan used without subject: the various forms and colors are present for their own sake, not as representations of anything else, and the relationship among them is planned also for its own sake. It can be said of much abstract art that the artists are interested in formal aspects to the point where they have abandoned subject in order to concentrate exclusively on form.

BALANCE

As we look at various arrangements or plans in any art, we instinctively demand balance. No matter how the various parts are put together, we want that sense of equilibrium which we call "balance." Some people are

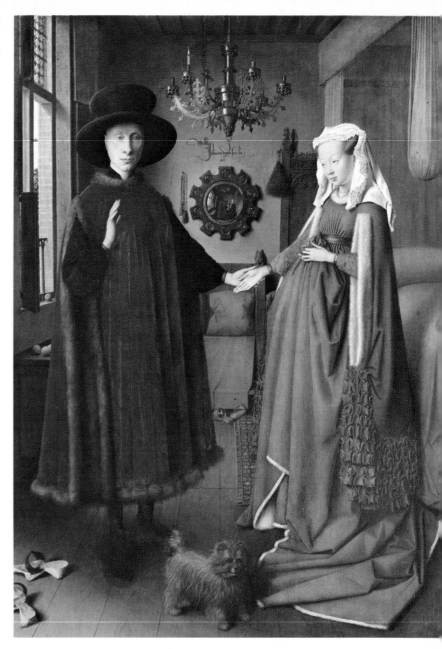

Figure 13-12. Jan van Eyck. *Jan Arnolfini and His Wife* (1434). (Oil on wood. Height: 2 feet, 9¼ inches. Reproduced by courtesy of the Trustees, the National Gallery, London.)

ORGANIZATION

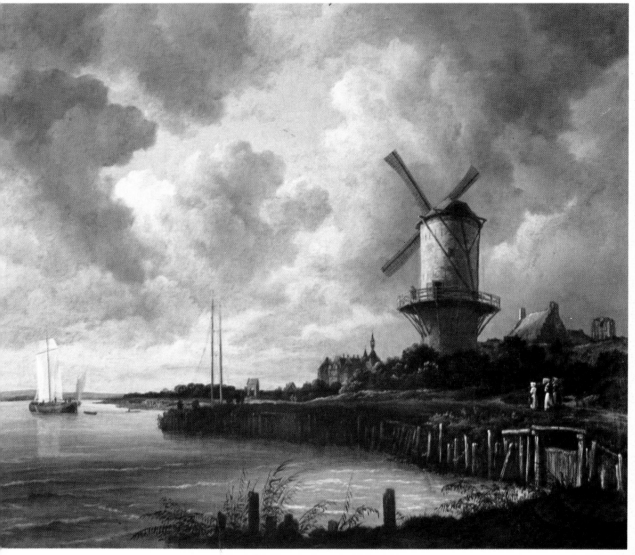

Figure 13-13. *Jacob van Ruisdael (1628–1682), Dutch painter. The Mill. (Size: 2 feet, 9 inches by 3 feet, 4 inches. Amsterdam, Rijks Museum.)*

nervous if they see a picture hanging crooked, and most of us have little satisfaction in looking at the Leaning Tower of Pisa, though we know it has stood for centuries.

Dégas has a painting of two ballet girls, *Dancers Practicing at the Bar* (Figure 13-9, page 261). The two girls are nearly symmetrical; each is poised on one leg, and the raised legs point in opposite directions. The figures are on a diagonal line in the upper right-hand corner of the picture; all the interest points to this one spot. To balance the two dancers, Degas

puts a watering can on the otherwise bare floor. This watering can is essen-
tial. If we take out the can or if we narrow the picture, the girls are n
longer secure at their bar; the plan becomes unbalanced.

One of the most important ways of getting balance is by control c
the direction of lines. One line points in one direction, another in th
opposite direction; and from the two we get a sense of balance. In Giotto'
Flight into Egypt (Figure 9-32, page 188), for example, the entire motio
of the picture is left to right until we come to the figure of S. Joseph
which stops us and turns us back. In Daumier's *Strangers in Paris* (show
in Figure 13-10, page 261) the couple in the distance are moving in on
direction; the couple in the foreground are not moving, but the direction c
their heads and umbrella is in the opposite direction. In El Greco's S
Jerome (Figure 13-11, page 261) the eyes, head, and beard point to th
right, the arms and book to the left. If the picture is cut off just below th
shoulders, the beard seems to be blown as if by a breeze. With the oppos
ing motion of the hands and book, the whole is given living, breathin
balance.

Theoretically, every detail is necessary in a well-designed compositior
if the balance is perfect, a change in a single detail will upset it. This prin
ciple may be more theory than fact, but it is interesting to try to determin
the role played by some detail of a picture. In Jan van Eyck's paintin
Jan Arnolfini and His Wife (Figure 3-12, page 262) we have an interestin
illustration. This is obviously a portrait study. The two figures are place
side by side, the man on the left, the woman on the right. Between ther
are the mirror on the wall and the chandelier. The light of the window, th
man's face, and his hand are balanced by the white of the woman's face
her headdress, and the long cuff on her sleeve. All is regular and as
should be except, apparently, for some slippers on the floor near the ma
and the woman. But those slippers are necessary for the balance of th
picture. Their irregular line balances the irregular line of the white trir
on the woman's skirt. Both lines of white are needed to bring the eye dow
to the lower half of the picture. The importance of the slippers can b
judged in another way also: if we remove the slippers, the man seems t
fall forward.

Asymmetrical balance is one of the beauties of landscape paintings
In van Ruisdael's *Mill* all the interest is on the right, but it is balanced b
the ship and the view to sea (Figure 13-13, page 263). Another frequer
form of balance is the X shape, where two diagonal lines cross, as i
Brueghel's *Parable of the Blind* (Figure 13-14) or Sassetta's *Journey c
the Magi* (Figure 13-15).

In the *Discus Thrower* (shown in Figure 13-16) by Myron, the bod
forms a complete half circle in the long, curved line that begins in th
right hand and goes through the right arm and the body to the left foot
In this statue Myron has, as Kenneth Clark puts it, "created the endurin
pattern of athletic energy." He shows the athlete "balanced in equilib
rium." In Toulouse-Lautrec's *In the Circus Fernando: The Ringmaste*
(Figure 3-17, page 266) the woman on the horse starts a movement tha
is completed in the man on the left with the whip.

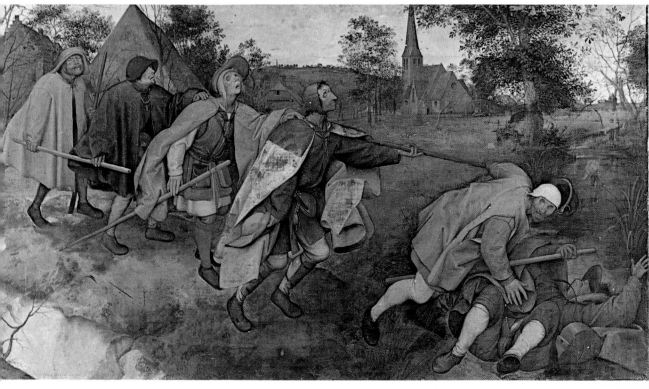

Figure 13-14. Pieter Brueghel the Elder. Parable of the Blind (1568). (*Tempera on canvas. Height: 2 feet 10 inches. Naples, National Museum. Photograph by Alinari.*)

Figure 13-16. Myron (fifth century B.C.), Greek sculptor. Discus Thrower (restored) (450 B.C.). (*Bronze. Height to right shoulder: 5 feet. Rome, National Museum. Photograph by Alinari.*)

Figure 13-15. Sassetta (Stefano di Giovanni) (1392–1450), Italian painter. The Journey of the Magi. (*Tempera on wood. Size: 29 by 15¼ inches. New York, Metropolitan Museum of Art; bequest of Maitland F. Griggs, 1943.*)

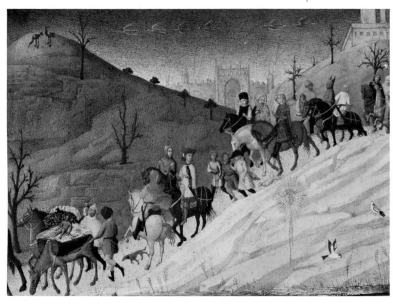

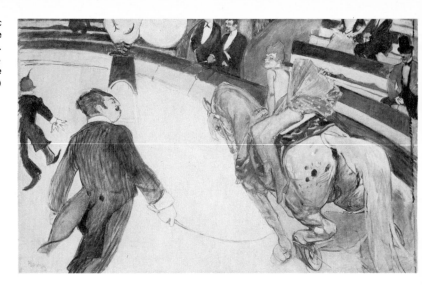

PROPORTION

Proportion is the aspect of plan that has to do with the comparative size of the parts of a single work. This is a matter of *relative* size, never absolute size. A picture is not too large or too small in itself but too large for this space or too small for that. One side of a rectangle is not too long or too short except in proportion to the other. An inch is very little in computing the distance from New York City to Chicago, but it is a good deal on the end of a nose.

In the visual arts, proportion at its simplest can be seen in the arrangement of objects on an indefinite surface or field, as in wallpaper, carpets, and cloth. A plaid is nothing but a number of straight lines crossing at right angles; the interest of the plaid depends on the arrangement of these lines in relation to one another. In a polka-dotted pattern there are two elements, the size of the dot and the space between dots. Change the size of the dots or the space between them—i.e., change the proportions— and the pattern is changed radically.

Such patterns offer simple problems of proportion, because the elements are judged only by their relation to one another. But problems in proportion are found wherever there is a question of relative size or length. In dress design, proportion determines the length of the sleeve or coat, the space between buttons. In interior decoration, it governs the length of curtains, the height of the mantel, the size of the picture over it. The beauty of printed pages in books depends largely on the proportions used in filling the page: the space at the top and the bottom, the width of the margins, the size of the type, and the space between the lines. Proportion also determines our judgments of the beauty of the human body in life

and in art. Is the head too large or too small? Are the legs and arms too long? Are the hips too large? In painting, proportion determines not only the shape of the frame—its height in comparison with its width—but also the placing of the subject in the frame, i.e., whether the center of interest is to be high or low, right or left.

What are good proportions and what are bad? This is like asking: When is a steak cooked enough? or: What is a long walk? People do not agree. The critic gives the ultimate answer: That is good which seems good; that is in good proportion which we find pleasing. But people have always wanted to know definite rules; accordingly, various people have tried to make exact formulas for pleasing proportions.

Polyclitus, a Greek sculptor of the fifth century B.C., wrote a treatise on the proportions for the ideal human figure, which he called *The Canon*, or "The Rule." Then he made a statue to illustrate his principles, also called *The Canon*. It is not certain just what this statue was, but it is believed to have been the *Doryphorus*, or "Spear Bearer" (shown in Figure 13-18). Unfortunately, the original, probably in bronze, is lost,

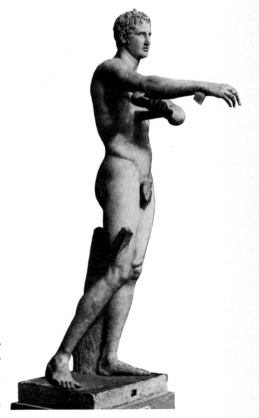

Figure 13-18. Polyclitus (fifth century B.C.), Greek sculptor. Doryphorus (ca. 440 B.C.), Roman copy in marble of bronze original. (Height: 7 feet. Naples, Museum. Photograph by Alinari.)

Figure 13-19. Lysippus (fourth century B.C.), Greek sculptor. Apoxyomenos (second half of fourth century B.C.), Roman marble after bronze original. (Height: 6 feet, 8½ inches. Rome, Vatican. Photograph by Alinari.)

and the stone copy that is in the museum at Naples is not good; the copyist has had to make certain additions because of the weight of the stone—a tree stump to support the legs, and a bar between the hips and the right arm. Nevertheless, one can see the general proportions of the original. Polyclitus had a mathematical formula for the figure: the head is one-seventh the height of the entire body, and all details are worked out in terms of a fixed ratio.

A century later Lysippus introduced a new canon with a smaller head and a slimmer body, the head being only one-eighth the height of the body. The statue that has been most commonly associated with these new proportions is the *Apoxyomenos*, or "Strigil Bearer" (Figure 13-19, page 267), a figure of a young athlete holding the strigil, a curved scraper which athletes used to remove oil and dust from the body after exercise.

Often proportions are changed to indicate position and power. A ruler, for example, may be made larger than his subjects. In *the Palette of King Narmer*, an Egyptian relief of the fourth millennium B.C. (shown in Figure 13-20), we see the king dealing with his subjects. One he has seized by the hair of his head, two others are crouched below, and off to the left is a fourth figure. The king is represented as much larger than any of the other figures. In the Laocoön the two sons of the priest are represented as much smaller than their father.

Figure 13-20. Palette of King Narmer. *Egyptian, Second Dynasty (ca. 2900–2800 B.C.). Original, found at Hierakonpolis, now in Cairo Museum. (Slate. Height: 25 inches. Photograph, New York Metropolitan Museum of Art; Dodge Fund, 1931.)*

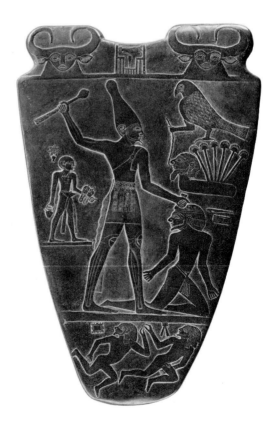

ORGANIZATION

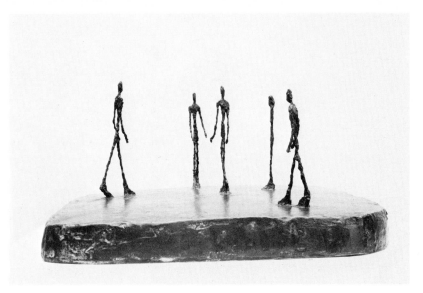

Figure 13-21. Alberto Giacometti (1901–1966), Italian sculptor. City Square (La Place) (1948). (Bronze. Size: 8½ by 25⅜ by 17¼ inches. Collection, The Museum of Modern Art, New York.)

Proportion has been differently applied in different times, but generally there is a certain consistency at any one time in a given culture. We say, for example, that there is such a thing as Renaissance proportion or Greek proportion. In the twentieth century, serious art does not seem to be characterized by any one proportion. We see a variety, from the squat figures of a Dubuffet to the elongated figures of a Giacometti sculpture (for example, Figure 13-21). Fashion illustrations, illustrations for advertising, and illustrations for light fiction in magazines, however, are striking examples of consistent application of an artificial, idealized proportion, whose outstanding features are extreme slimness and length of legs.

THE FRAME

In the arrangement of parts, consideration must be given to the frame and the relation of the parts to the frame. Whether we look at the facade of a building, a statue, or a painting, we have a certain area or surface that is to be filled. Within this area the space should seem neither crowded nor empty. The camera offers interesting possibilities for experimentation, for with the finder on the camera, the artist can try different types of content in different relationships to the frame. The stage illustrates another challenge; the proscenium arch offers a frame, and the problem of the director is to fill that frame agreeably with stage set, characters, and lighting. Since theater and dance are arts of both time and space, the director deals with a content that is constantly changing; at any moment, however, the stage is supposed to show a scene in which the frame is filled agreeably.

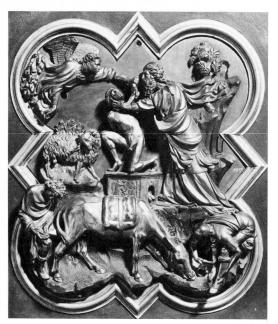

Figure 13-22. *Filippo Brunelleschi (1377–1446), Italian sculptor and architect. Sacrifice of Isaac (1402). Competition for Gates of Baptistery, Florence. (Bronze. Size: about 1½ feet square. Bargello, Florence. Photograph by Alinari.)*

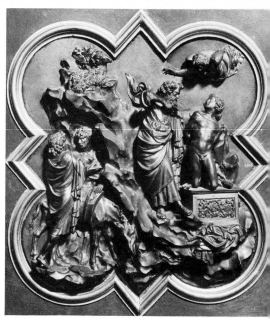

Figure 13-23. *Lorenzo Ghiberti. Sacrifice of Isaac (1402). Competition for Gates of Baptistery, Florence. (Bronze. Size. about 1½ feet square. Bargello, Florence. Photograph by Alinari.)*

Since the design must fill the shape, the choice of shape partly determines the design of the picture. Moreover, the lines of the enclosing shape strengthen or oppose the lines of the design. In a picture that rectangular or square, all the vertical or horizontal lines are strengthene by the lines of the frame. So powerful are these lines that an artist usual tries to cover them in some way, to fill in the corners by the use of tree or shrubbery, or in some other way to change the severe right angle to more graceful curve. The square is difficult to work with because it is a center and corners; there is no neutral ground, as it were. We have goo design in the square in the metopes from the Parthenon and in the pane of the "Gates of Paradise." But because of its difficulty the square is rela tively rare in art, and the rectangle is preferred. The rectangle has th advantage of being in straight lines, and yet it has much free space in th middle that is neither exact center nor corner, and in this central space th design is usually placed. If it is standing on its short side it shares some thing of the strength of the vertical; if it is on its long side it partakes the peace of the horizontal. Most of the illustrations in this book are re tangular.

Complex shapes are not always easily filled. An illustration is foun in the reliefs made by Brunelleschi and Ghiberti showing the *Sacrifice Isaac* (shown in Figure 13-22 and Figure 13-23). Since these tw reliefs were offered in a competition for the north gates of the Baptister

ORGANIZATION

at Florence, they have the same shape, the same general treatment in high relief, and the same subject. The same figures are shown: Isaac kneeling on the altar; Abraham arrested by the angel just as he is about to kill his son; the servants of Abraham; and the ram which was the actual sacrifice. But the arrangement of the figures in the two compositions is entirely different. Brunelleschi has put Isaac in the center and crowded the other figures into the corners; the scene is confused. Ghiberti has divided the relief in two by a diagonal line, with Abraham and Isaac on one side and the servants on the other. His plan is clearer, simpler, and better.

The circle is a difficult shape. It is always the same; the eye tends to go around and around it without stopping, and there is a general tendency for a picture to seem to roll over if it is in a circular frame. Some of the best examples may be obtained from Greek vase painting. The cylix, or drinking cup, was ordinarily ornamented on the inside; hence the Greek draftsman had many opportunities to try his hand at filling a circular shape, and he succeeded admirably. A favorite cylix painting shows two women putting away their clothes. It is attributed to Douris (Figure 13-24).

Raphael's famous *Madonna of the Chair* (shown in Figure 13-25) is a good example of the Renaissance use of the circular composition. Where the Greek vase painter had to fill an already existing form, Raphael has

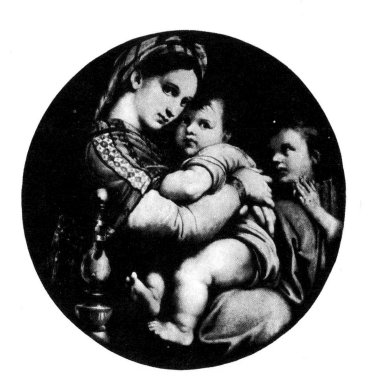

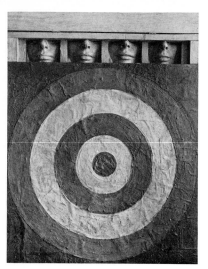

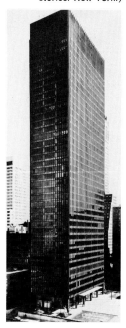

chosen to integrate the figures of this story by forcing them into the outlin of the circle. The left side and head of the Madonna follow the circle, a do the back of the Child and the arrangement of the youthful S. John th Baptist. The closeness and intimacy thus conveyed by the artist are e hanced by the intertwining of the arms of the mother and child, the litt feet moving left to conform to the circle.

It is interesting to compare these two works with a modern pictur in the same shape—Jasper Johns's *Target* (shown in Figure 13-26). Her the subject itself has dictated the circular outline.

The lunette, or half moon, is largely associated with architecture an sculpture. It is found most often in the tympanum, or sculptured spac over a door. (We studied an example in the tympanum at Chartres.) It ha the rich curve of the circle but is held steady by its horizontal base.

Architecture is conceived as a three-dimensional entity, and its pr mary purpose is the defining and enclosing of space. But because w generally encounter a building head on, it presents a two-dimensiona enframed surface to our eyes. Thus the facade of the Parthenon (Figur 13-33, page 277) is a repeated vertical rhythm of columns which make th building appear taller. The balanced horizontals and verticals of Notr Dame de Paris (Figure 14-25, page 298) result in a controlled calm. Moder office buildings like the Seagram Building (shown in Figure 13-27) presen a front and a side frame within which the vertical motif dominates an gives these buildings their special character. A variant of this type is see in the Inland Steel Building (shown in Figure 13-28), which presents much greater variety of enframements and visual interest for the spectato In the United Nations Secretariat building (shown in Figure 13-29) w have both a variety of enframements and a playing off of mass agains mass.

UNITY AND VARIETY

So far we have said little about unity and variety, but it can be seen in an one of the examples we have used. Take the *Sistine Madonna* (Figur 13-4, page 258). It seems simply made, as though anyone could put th various parts together, but it is worthwhile to see what devices Raphael ha used. The lines of the painting are predominantly curves, as we see in th small diagram. Then, the figures are also unified by their glances. The Pop looks to the Virgin, who looks to the saint, who looks in turn to the putt (cherubs) below, a seemingly obvious and at first glance naïve use o repetition.

The Vendramin Palace on the Grand Canal at Venice is an interestin study in repetition and variety (examine Figure 13-30). It was built by th Vendramin family at the end of the fifteenth century. To this palace Wagne retired in 1882, and there he died a year later. One is impressed first b the repetition; the façade of the building shows a single grouping of win dows repeated many times. There is, however, no lack of variety; the door way takes the place of the central window on the first floor, and the plac

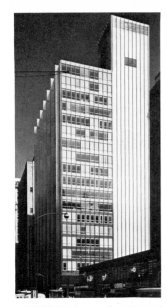

Figure 13-28. Skidmore, Owings, and Merrill, contemporary American architects. Inland Steel Building (1958). (Steel and glass. Main building 19 stories, tower 25 stories. Chicago, Illinois. Photograph, Bill Hedrich, Hedrich-Blessing, Chicago.)

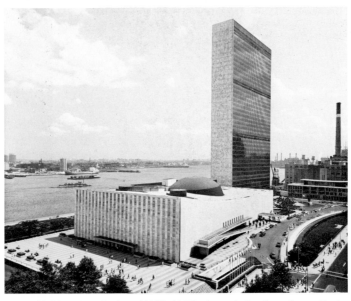

Figure 13-29. United Nations (1948–1950). General view from the north of permanent headquarters, New York. (Glass panels, marble piers, and aluminum. General Assembly Building in foreground: Auditorium 380 feet long, 160 feet wide. Marble and glass Secretariat, 39 stories. Extreme right, part of the library. Wallace K. Harrison, Director of Planning. Photograph, United Nations.)

Figure 13-30. Palazzo Vendramin-Calergi (1481–1509). Pietro Lombardo (ca. 1435–1515), Italian architect. (Marble. Length: about 80 feet; height: about 65 feet. Venice. Photograph by Alinari.)

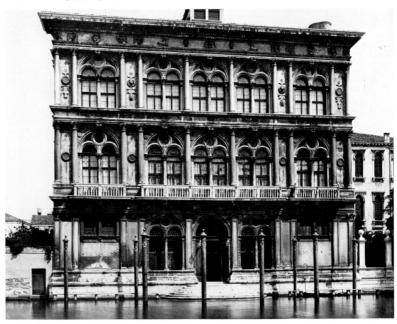

Figure 13-32. Fra Angelico (1387–1455), Italian painter. Annunciation
(ca. 1440). (Fresco. Figure three-fourths life size. Florence, S. Marco
Dormitory. Photograph by Alinari.)

Figure 13-31. Drawing of the Annunciation, Figure 13-32. (Gordon Gilkey.)

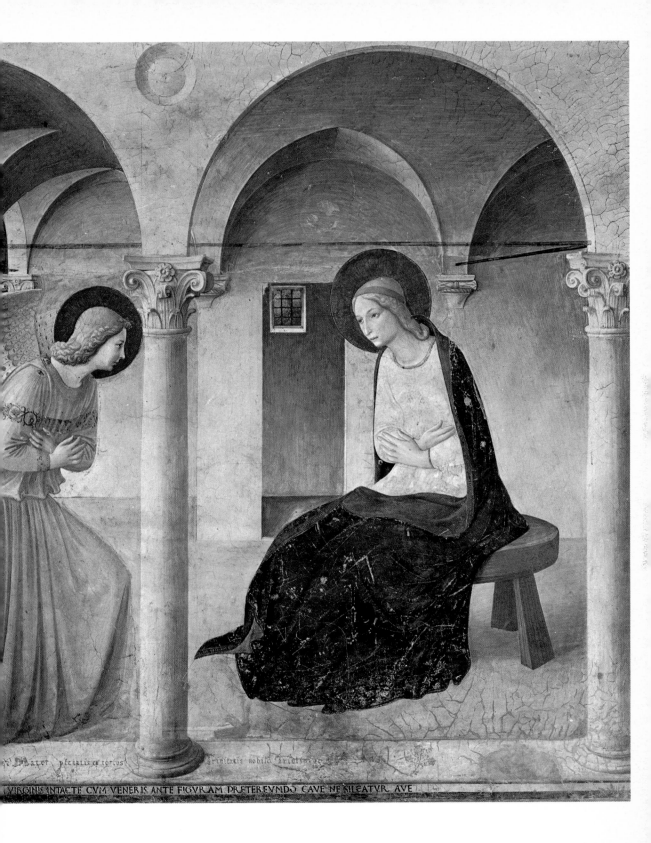

VIRGINIS INTACTE CVM VENERIS ANTE FIGVRAM PRETEREVNDO CAVE NE SILEATVR AVE

of the two end windows is left blank except for small openings. The first and second stories are separated by a balustrade, the second and third by a cornice. Moreover, the columns separating the windows are varied; those on the first floor are pilasters, undecorated except for a molding at the side; those of the second story are round and grooved; and those of the third story are round without grooves. The most important device for securing variety, however, is in the arrangement of the windows. The three central windows are grouped together, but the end window is set off by a narrow panel with two engaged columns. This motive, repeated at the corner of the building, brings a distinct relief in the long line of windows; it is a breathing space, as it were, that makes the façade seem easy and comfortable.

In a cathedral like that of Pisa (Figure 14-17, page 293) we trace the many repetitions and variations of the round arch. In the Egyptian temple (Figure 14-4, page 283) the sequence of rooms one after the other makes a subtle progression in darkness, from the open court at the front through the shadows of the hypostyle hall with its columns to the dark, mysterious chamber of the priest.

These ways of producing variety are fairly obvious. More subtle is the means used in the Parthenon (shown in Figure 13-33). At first glance the building seems to show nothing but repetition, no variety except in the alternation of triglyphs and metopes in the frieze. In the Parthenon, however, there are many subtle variations that do not strike the observer at once. The columns are smaller at the top than at the bottom; about one-third of the way up the shaft of the column there is a slight swelling, or convex curve, known as the *entasis* of the column. Moreover, the columns incline at a very slight angle; it has been calculated that the corner columns are slightly larger than the others and are placed closer together. The steps and the entablature both rise in a very slight convex curve.

It has been suggested that by means of such refinements the Greeks were attempting to counteract certain optical illusions. Two long parallel lines tend to look hollow or to approach each other in a concave curve; hence the slight curve outward was introduced in the columns. A column seen against the sky looks slighter than one seen against the background of a building; hence the corner columns were larger and closer together. This, of course, cannot be proved; nor does it matter whether the architects introduced these changes to correct optical illusions or whether they introduced them merely as a means of giving variety to the building and so improving its appearance. It is certain, however, that these changes were intentional. Similar refinements have been introduced in many buildings— St. Mark's in Venice and the old library of Columbia University in New York City are two examples. And it is certain that much of the beauty of the buildings is due to the lack of stiffness, the sense of a unified, almost breathing whole, resulting from these slight variations from the exact rule.

Repetition in sculpture and painting is normally not so exact as the repetition that is characteristic of the industrial arts and architecture. In architecture, one half of a building may be, and often is, just like the other

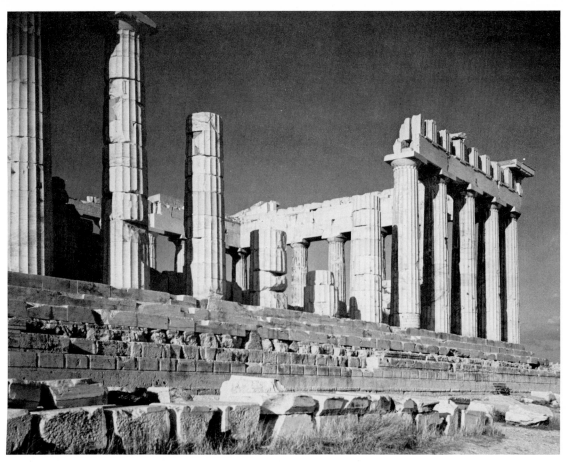

Figure 13-33. Parthenon (447–432 B.C.). (Athens; photograph, Trans World Airlines.)

half; but in a picture or a statue the two sides cannot be the same. If, for instance, the artist wants to repeat the line of a woman's hair, he may repeat it not as hair but as a cloud or tree or scarf. This kind of repetition, therefore, is not obvious. We see the cloud as cloud and the tree as tree, and we do not see that they are repeating the line of the woman's hair. In the *Annunciation* of Fra Angelico (Figure 13-32, page 274), for example, the curve of the angel's body repeats the curve of the Virgin's body (Figure 13-31, page 274). The round curve of the Virgin's halo is repeated in the neckline of her dress, the stool on which she is seated, and the arches above her head. The arches on the side of the angel are seen in perspective, and they repeat the shape of the angel's wing until the whole seems to be alive with the motion of wings. To stabilize the curves and to give variety, Fra Angelico has introduced many straight lines—in the columns, the fence, the trees, and even the doorway, which has a rectangular picture showing through it.

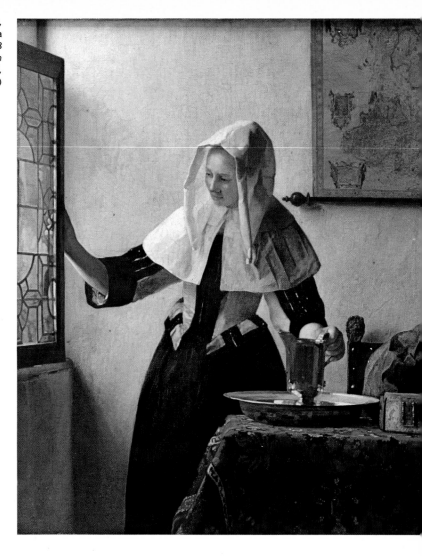

In Vermeer's *Young Woman with a Water Jug* (shown in Figure 13-34) the composition is worked out primarily in terms of the straight lines of the map and the slow curve which we find in the young woman's cape. In the Medici Tomb (Figure 13-3, page 257) we find repetition of lines in the bodies of the three figures. In the figure of Night the arm and the head make a complete half circle, and this curve is repeated in the curves of the body.

In *The Young Englishman* (Figure 9-9, page 169) Titian has made his design primarily in the three white spots of the head and two hands. It is, however, united in repeated circles of head, beard, and chain, with circular lines in the lace at neck and hands. There is also an interesting study in values.

ORGANIZATION

It is interesting to see how these principles of formal design may be applied to contemporary art. As was noted when we discussed plan, the various formal elements are used to widely different degrees in different kinds of modern art: a Mondrian, we suggested, is planned far more traditionally than a Pollock. It is perhaps helpful to think of various works of visual art as forming a sort of continuum. In all art which is at all representational, there is a certain amount of tension between form and content. That is, we look at a painting as a picture *of* something but also as a design, as colors placed on a flat surface. Similarly, we see a statue as a representation of something but also as a piece of material which is a shape. When the work of art is very realistic—that is, very like the object it represents or pictures—then it requires an act of will on the part of the viewer to see it purely as a formal design. This is what we have been doing in the preceding paragraphs: saying "This is not a woman's head but the apex of a pyramid," and the like. When a work of art is not particularly realistic, we can see it as a design much more easily; indeed, we may have to perform an act of will to see it as a representation at all. In certain impressionist paintings, one must stand at a certain angle and concentrate in a certain way to make the "picture" emerge. In some post-impressionist and cubist paintings—like Duchamp's *Nude Descending a Staircase* (Figure 5-8, page 100)—it is not difficult to see the representation and the design simultaneously, for they are of equal interest. In Mondrian's *Broadway Boogie-woogie* (Figure 2-7, page 25), representation is of far less importance than formal design. What has happened in a painting like this—indeed, in a great deal of abstract art—is that the artist has become interested in form almost to the exclusion of content. Without the title, there would be no content at all: simply a formal design existing entirely for its own sake, because it is interesting and aesthetically satisfying by itself.

A great deal of modern abstract art seems to have this character. When we look at it and try to analyze it, we cannot speak of "this arm" balancing "that foot" or "the apple in the bowl" placed in the central point formed by "the table and the corner of the chair." We must adjust our way of describing what we see; we must say that "the dark oblong in the upper right" is balanced against "the red splash to the left of center." But what we are doing is no different, essentially. A design, a sculptural shape, an arrangement of colors will often contain much the same formal aspects as a picture of a bowl of apples, or a statue of an athlete, or a picture of waves breaking on the shore. When we are discussing simply organization, it is not really important whether the artist has chosen to make his design stand for some object in the "real world" or whether he has created the design simply for its own sake. Even a Jackson Pollock painting, which at first glance may seem to be totally unorganized, must be an aesthetically satisfying arrangement if it is to deserve the name of a work of art. Analyzing such a work is difficult; it is not easy to say exactly how balance is achieved, or how repetition and variety are produced. But a good work of art, no matter how far it departs from tradition, will not look unbalanced,

or dull, or confused, or out of proportion. It will satisfy the viewer, not make him uneasy or displeased. Eventually, one may see even in non-representational art a certain emotional content: a design which is purely a design may yet be ominous or serene, tranquil or violent, sweet or harsh; and one can respond just as fully to such a design as to a representation of a mother and child, a battle, or a vase of roses. And if this occurs, one must learn again to filter out the "content" in order to be able to analyze the organization as such.

14. ORGANIZATION IN ARCHITECTURE

Of all the arts, architecture is the only one used in one way or another by everyone. It is difficult not to be interested in where one may be living, working, worshipping, or even ultimately entombed. Looking about us today, we notice a wide variety of styles, a situation that often creates some confusion if we are not aware of what we are looking at. But such variety has always existed, since buildings survive the time of their construction and live into succeeding phases of design. The modern museum on upper Fifth Avenue in New York designed by Frank Lloyd Wright for the Guggenheim family (Figure 14-1, page 282) contrasts startlingly with the surrounding apartment houses of only one generation earlier. Conversely, the early nineteenth-century Trinity Church in downtown New York (Figure 14-2, page 282) was engulfed first by the skyscrapers of the early twentieth century and then by new commercial structures designed since World War II.

A building, whatever else it may be, is a practical thing which must be measured by the standards of its own era rather than ours. It is for this reason that we now take a rather long look at various types of buildings as they have evolved through history.

EGYPTIAN ARCHITECTURE (4000–2280 B.C.)

Egyptian architecture is closely bound up with religion. The *ka*, or "vital force," was dependent upon the body for its life; if the body was destroyed, the ka ceased to exist. Hence pyramids were built to preserve the body,

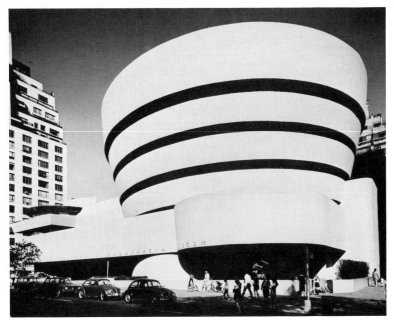

Figure 14-1. Frank Lloyd Wright (1869–1959), American architect. Solomon R. Guggenheim Museum. (New York, The Solomon R. Guggenheim Museum.)

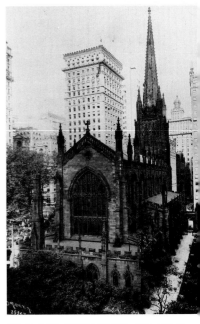

Figure 14-2. Trinity Church. (New York, The Byron Collection, Museum of the City of New York.)

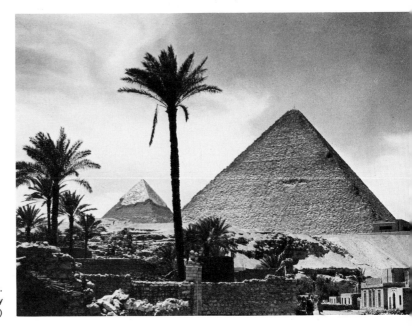

Figure 14-3. Pyramids of Giza (ca. 2700–2200 B.C.). (Photograph by Trans World Airlines Inc.)

that the ka might be safe. The most striking group of pyramids is at Giza, where there are the great pyramids of Khufu, Khafre, and Menkure (Figure 14-3).

Great as were the pyramids, however, they did not protect their dead from robbers and marauders, and later tombs were cut in rocky cliffs. A temple adjoined each tomb, and, as the tombs were made more inaccessible, these temples developed independently. The great temples are those at Karnak, Edfu, and Luxor. They followed the same basic plan. First was the *pylon*, a huge gateway covering the entire front of the building. The temple itself, as we have said when discussing the adaptation of plan to function, was composed of a series of halls (examine Figure 14-4). In one of these halls the roof was supported by rows of columns (*hypostyle*). In the temple at Karnak and in some of the other temples, the center columns are higher than those next to the wall, thus making a *clerestory* for the light to enter (Figure 14-5).

Egyptian columns are primarily of two types, the flower and the bud. In the flower columns, the flower makes a wide, bell-shaped capital. In the bud columns, the uppermost part of the capital is smaller than the lower, like the bud of a flower. The model of the hypostyle hall at Karnak shows the clerestory and the columns; the central columns have flower capitals, the aisle columns, bud.

An outstanding characteristic of Egyptian art is its size. This probably due to the nature of the country, for in the desert everything swallowed up, and only the very large stands out in the wide stretches of sand. But even with this in mind one can hardly grasp the enormous size of Egyptian buildings. The columns of the Great Hall at Karnak are large enough for a hundred men to stand on top of each capital.[1] The Great Hall at Karnak is 338 feet wide and 170 feet deep, furnishing a floor area about equal to that of the cathedral of Notre Dame in Paris, although this is only a single hall of the temple.[2] The pyramid of Khufu at Giza is 481 feet in length and covers about 13 acres.[3]

MESOPOTAMIAN ARCHITECTURE

Of all the great palaces and temples of the Mesopotamians, Chaldeans, Babylonians, and Assyrians, very few examples are left; the brick, either unbaked or only partially baked, has crumbled away. The distinguishing characteristic is the *ziggurat*, or tower, built at successive levels, with ramps leading from one platform to the next. In many respects the ziggurat is like the modern building with setbacks. Because of the use of brick, however, the Assyrians developed the arch and its multiple, the canopy-shaped vault—destined to be among the most important and influential devices in the history of architecture.

GREEK ARCHITECTURE (1100–100 B.C.)

Greek architecture in its most characteristic form is found in the temple, a low building of post-and-lintel construction, as was the Egyptian temple. In this type of construction, two upright pieces, *posts*, are surmounted by a horizontal piece, the *lintel*, long enough to reach from one to the other. This is the simplest and earliest type of construction, and it is more commonly used than any other. Barns are good examples, since the beams are exposed and can be seen. Post-and-lintel construction is well adapted to wood, because wooden beams are strong and are able to uphold the weight of a roof; at the same time they are long, so that a large building may be

[1] James Henry Breasted, *The Conquest of Civilization*, Harper & Row, Publishers, 1926, Plate IX, p. 98.

[2] *Ibid.*, Fig. 61, p. 96.

[3] *Ibid.*, p. 64.

Figure 14-6. Temple of Apollo (*sixth century* B.C.). (*Porous limestone, originally covered with stucco. Height of columns: 23⅔ feet. Old Corinth. Photograph, Royal Greek Embassy.*)

erected. However, wooden beams are not permanent; they may burn, rot, or be eaten by insects. Stone lintels, in comparison, are enduring; but they cannot be obtained in as great lengths, and they stand much less weight than wood; therefore, in stone buildings the distance between posts must be small. A typical example of post-and-lintel construction is found in the ruins of the Temple of Apollo at Old Corinth (Figure 14-6).

The typical Greek temple had columns in front and often at the back also. Sometimes the entire building was surrounded by a row of columns, with a double row of columns in the front and back of the building and a single row at the side. The Parthenon belongs to this class. In the pure Greek style all columns are fluted.

Figure 14-7. The Doric Order. (*Drawing by Thad Suits.*)

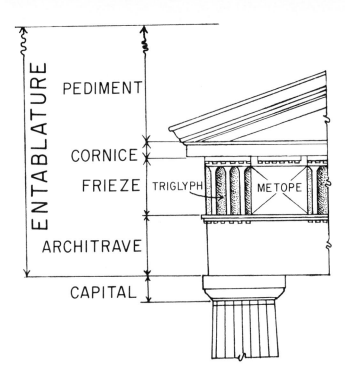

There are three styles of Greek architecture, Doric, Ionic, and Corin-thian. The Doric (shown in Figure 14-7) is seen in the Temple of Apollo at Old Corinth, and in the Parthenon, one of the greatest temples ever built. The Doric column has no base; the bottom of the column rests on the top step. The capital is very plain; a flat block, or slab, is joined to the column by a simple curve looking something like a cushion. The frieze is divided into *triglyphs* and *metopes;* the triglyph is a square slab having two vertical grooves (or glyphs) in the middle and a half groove at each end; the metope, which alternates with the triglyph, is also square. Metopes are often carved, as in the Parthenon (Figure 9-12, page 172).

The Ionic column is taller and slenderer than the Doric. It has a base and the capital is ornamented with scrolls, or volutes, on each side. In the Ionic order the frieze is continuous instead of being divided into triglyphs and metopes. The architrave below the frieze is stepped; that is, it is divided horizontally into three parts, each being set in slightly. The greatest example of the Ionic order is the Erechtheum, which is unfinished and, unlike most Greek temples, irregular in shape. Like all examples of the Ionic order in general, the Erectheum is characterized by great elegance and grace. The Ionic column is found also in the little temple of Athena Niké at Athens (Figure 14-8).

The Corinthian column is distinguished from the Ionic by still greater height and by its capital, which shows two rows of acanthus leaves with volutes rising from them. The Corinthian, although an authentic Greek order, was last to be developed and was not so much used as the Doric and

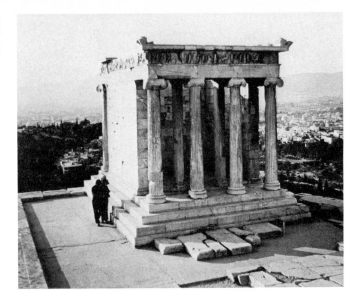

the Ionic. The Temple of Zeus at Athens (second century) has Corinthian capitals (Figure 14-9).

ROMAN ARCHITECTURE (1000 B.C.–A.D. 400)

Roman architecture follows the general lines of the Greek, with significant changes. The temple is no longer the typical building; equally important are civic buildings, baths, law courts, amphitheaters, aqueducts, and bridges.

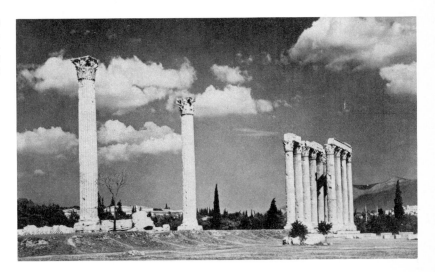

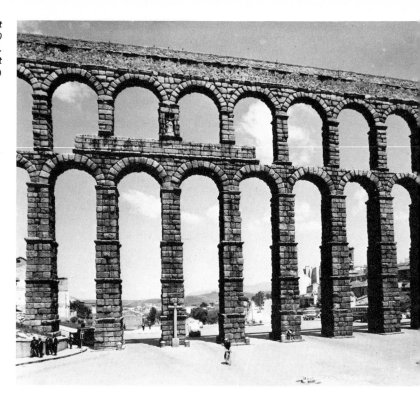

Figure 14-10. Segovia Aqueduct (*first century* A.D.). (*Granite. Length: 2,700 feet; height: 102 feet. Segovia. Photograph, Spanish National Tourist Office.*)

Structurally, the most important innovation of the Romans was the arch, which was widely used by the Romans although they had not invented it. Next to the post and lintel, arch construction is historically of greatest importance. An arch is made of wedge-shaped stones that are arranged with the small side of the wedge turned down toward the opening. When the stones have been put in place by means of scaffolding or centering, their shape keeps them from falling, as we can see in the aqueduct of Segovia (shown in Figure 14-10). Each stone of the arch, by its weight, exerts constant pressure on the stones on each side of it, and the arch is held in position only by an exact balancing of these pressures. If that balance is upset, the arch collapses. As the old Arabic proverb has it, "An arch never sleeps." (In the thirteenth-century cathedral of Beauvais, in France, the arched vaults of the nave collapsed because the building was raised too high and therefore exercised too much downward pressure on them. The dome of S. Sophia in Istanbul (sixth century after Christ) collapsed the first time it was erected, killing a large number of workers. It was an expensive lesson for the builders, who were successful in their next attempt.)

Another characteristic of Roman architecture is the flat round dome that covers an entire building, as in the Pantheon (Figures 14-11 and 14-12).

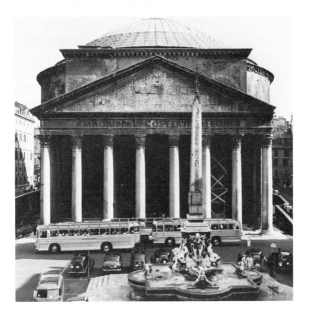

Figure 14-11. Pantheon (A.D. 120–124; portico A.D. 202). Brick, mortar, and concrete, originally faced on the exterior with pentelic marble and stucco. Height of columns: 46½ feet. Rome. (Photograph, Italian State Tourist Office.)

When the Romans used the same designs as the Greeks, they did not use them in exactly the same way. Roman columns are taller and thinner, and often, as in the Pantheon, they are not fluted. The Corinthian column was used extensively, as was the composite column, an invention of the Romans made by combining the Ionic volutes with the Corinthian acanthus-circled bell. The orders were not kept separate, but were stacked, or super-imposed, as in the Colosseum (Figure 9-25, page 181), where those on the

Figure 14-12. Pantheon (A.D. 120–124), interior. (Cement dome; wall decoration and pavement of marble and porphyry. Diameter of rotunda: 142 feet. Rome. Photograph, Alinari.)

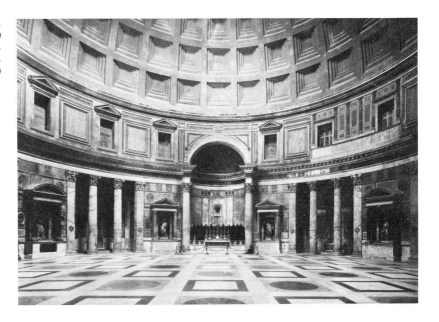

first floor are Doric, those on the second are Ionic, and those on the third are Corinthian. Moreover, the elements borrowed from the Greeks were sometimes used only as ornaments, whereas the Greeks had used them structurally. In the Colosseum, again, the columns between the arches and the entablature above them are not essential to the structure of the building; this is seen in that part of the building from which the outer layer of concrete has been torn away; the columns are missing, but the arches stand as before.

BYZANTINE ARCHITECTURE
(A.D. 200—1453; GOLDEN AGE—SIXTH CENTURY AFTER CHRIST)

During the Middle Ages, religion again took an important place; the most important buildings were the church and the cathedral. But architecture developed on different lines in the East and in the West.

Eastern, or Byzantine, architecture takes its name from Byzantium later called Constantinople and now called Istanbul. Byzantine architecture is characterized by a great central dome with half domes grouped around it. The dome, which is rather flat, reminds one of the Pantheon but is fitted to the building in a different way. In the Pantheon the round dome just covers the round building. In the Byzantine building the dome has to be fitted to a square area, and the space between the arches and the dome is filled by curved triangles (pendentives) on which the dome rests. This gives greater height and makes the interior more spacious and inspiring. A dome supported in this way is called a "dome on pendentives."

The greatest example of Byzantine architecture is S. Sophia, or Church of the Divine Wisdom, in Istanbul (Figure 9-22, page 180). The Byzantine type has been widely used for the churches in Russia, for Mohammedan mosques, and for Jewish synagogues.

WESTERN ARCHITECTURE IN THE MIDDLE AGES
(A.D. 400—1500)

During the medieval period Western architecture passed through three stages of development known as Early Christian, Romanesque, and Gothic. These three styles developed one out of another: the Romanesque was an outgrowth of the early Christian, and the Gothic of the Romanesque. As in all such cases, there is never any sharp line to be drawn between styles; there is never a time when one can say definitely that before that time all buildings are one style and after that time they are another. Accordingly we shall attempt to trace the development of the styles by discussing their prominent characteristics.

In basic plan, the three Western styles follow the general type of the Roman basilica, a long rectangular building divided by pillars into a central nave and aisles (examine Figure 14-13). Sometimes there is one aisle

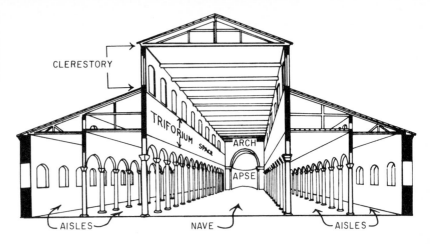

CLERESTORY

TRIFORIUM SPACE

ARCH

APSE

AISLES

NAVE

AISLES

on each side of the nave; sometimes there are two. Often the nave is higher than the aisles, and, therefore, there is opportunity for clerestory lighting. Between the clerestory windows and the columns there is necessarily a space in which there can be no windows because of the roof over the aisles. This space, which was later used for the triforium, was decorated differently in different periods and is one of the significant features in determining the style of a building. At one end was a semicircular apse, which was used for the high altar. It was traditionally at the east, and that part of the church was known as the "choir."

In the early churches the building was one simple rectangle with an apse. Later, the plan was adapted to the shape of a cross by the addition of cross aisles between the nave and the choir. The arms thus made are known as "transepts." Directly opposite the high altar, i.e., at the west, was the main entrance.

Early Christian Architecture (A.D. 400–700)

The early Christian church, of which S. Apollinare in Classe at Ravenna (Figure 9-23, page 181) is an example, does not have transepts; the clerestory is heavy and the windows are small. The columns separating the nave from the aisles follow the Roman orders with flat lintels or round arches between them. The interiors of early Christian churches were often decorated with mosaics, as is the case in S. Apollinare.

Romanesque Architecture
(Eleventh and Twelfth Centuries)

Romanesque architecture is an extension and development of the Early Christian basilica exemplified by S. Apollinare in Classe. Examples are

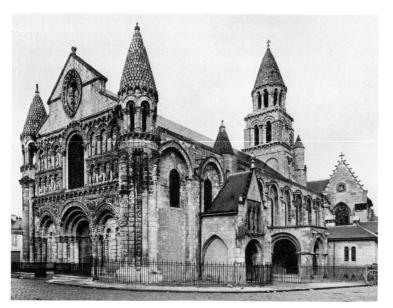

Figure 14-14. Notre Dame la Grande, Poitiers (*eleventh century*), side view showing façade. (*Archives Photographiques, Paris.*)

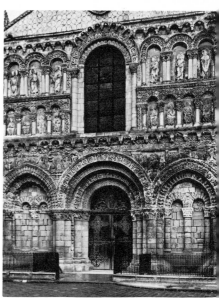

Figure 14-15. Notre Dame la Grande, Poitiers (*eleventh century*), close-up of façade. (*Archives Photographiques, Paris.*)

Notre Dame la Grande at Poitiers (exterior shown in Figure 14-14 and Figure 14-15) and the Abbaye-aux-Dames (interior shown in Figure 14-17) at Caen, in France. Where the Early Christian style is structurally light, with a simple, lightweight, flat wooden roof, the Romanesque has very heavy walls with small window openings and a heavy stone arched or vaulted roof inside. In this respect it resembles the Roman style—hence the name *Romanesque* ("Roman-ish"). Although the plan is still that of the basilica, with a wide nave and narrower and lower side aisles, it does have transepts (crossings) partway down the nave. These crossings offer additional entrances on the north and south sides of the building, which, like all churches, is oriented from west to east, from the setting to the rising sun. Romanesque churches, unlike Early Christian churches, are ornamented with sculptured portals.

This heavy style appeared in France, Germany, Spain, and indeed all of Europe, with the exception of Italy. In Italy a lighter style had developed, based on the basilica, and this persisted throughout the Romanesque and even the Gothic period. A typical instance of this light basilica style is the cathedral at Pisa, with the famous Leaning Tower (shown in Figure 14-16); the delicate arcades and colorful marble stand in remarkable contrast to the powerful external and internal arches of Romanesque stone buildings. The cathedral at Pisa still has the earlier flat wooden roof rather than the heavy stone canopy or vault that is typical of Romanesque architecture.

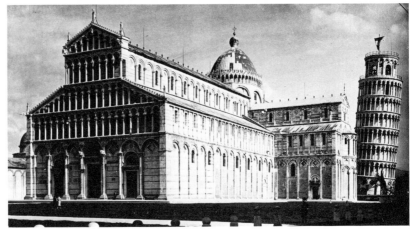
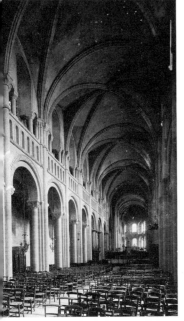

Figure 14-17. Abbaye-aux-Dames, or La Trinité (ca. second half of eleventh century, remodeled twelfth century), interior, looking toward choir. (Stone. Average width of middle aisle: ca. 26 feet; height: ca. 52 feet. Caen. Photograph, Stoedtner.)

The Romanesque style is seen in all its force in the interior of the Abbaye-aux-Dames at Caen (shown in Figure 14-17), where magnificent stone vaulting covers the nave. Notre Dame la Grande has a simple continuous canopy of stone made up of a succession of individual round arches; but here the nave is divided into sections or bays, each one covered with a groin vault. A groin vault is made up of two short barrel vaults at right angles to each other, the short side facing the side aisle and raising the vault to let in light, the wider side facing the axes of the nave itself (see Figure 14-18). Later, it was discovered that diagonal arches or ribs could be built that would support the entire weight of the roof. The space between the ribs could then be filled in with lighter material. This system, known as "ribbed vaulting," is the chief characteristic of Romanesque and Gothic architecture. This construction also made a change in the columns; the ribs of the ceiling had to be supported at the base and were, therefore, carried down to the floor. A number of these ribs made a pier or column.

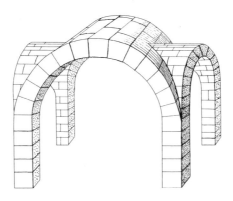

Figure 14-18. Groin vault. (*Drawing by Thad Suits.*)

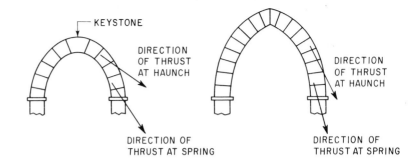

KEYSTONE

DIRECTION
OF THRUST
AT HAUNCH

DIRECTION
OF THRUST
AT HAUNCH

DIRECTION OF
THRUST AT SPRING

DIRECTION OF
THRUST AT SPRING

Figure 14-19. Direction of thrust in round and pointed arch. (*W. D. Richmond, from Sewall,* A History of Western Art, *p. 191. Drawing by Thad Suits.*)

Gothic Architecture (1194–1500)

As the Gothic developed from the Romanesque, the buildings became larger and taller—a change that was made possible by the use of the pointed arch. The thrust of an arch changes with its shape (examine Figure 14-19). In general, the flatter the arch, the greater the thrust; and

Figure 14-20. Amiens Cathedral (*begun 1220*), *perspective cross-section.* (*Drawing by Thad Suits after Viollet-le-Duc.*)

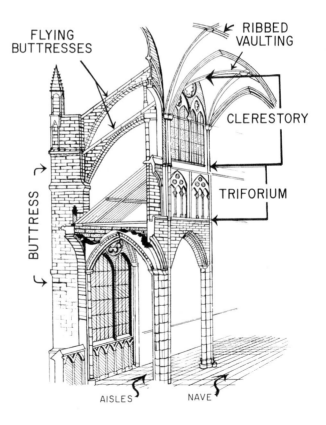

FLYING
BUTTRESSES

RIBBED
VAULTING

CLERESTORY

TRIFORIUM

BUTTRESS

AISLES

NAVE

Figure 14-21. Amiens Cathedral, interior. (Stone. Height: 147 feet; width of middle aisle: 43 feet. Photograph, Clarence Ward.)

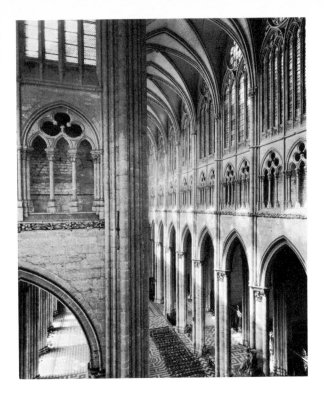

Figure 14-21. Amiens Cathedral, interior. (Stone. Height: 147 feet; width of middle aisle: 43 feet. Photograph, Clarence Ward.)

the steeper the arch, the more nearly the thrust is absorbed in the vertical wall. With the pointed arch, therefore, buildings could be made higher than with the round arch.

With the higher buildings came a new type of buttress. The general shape of the exterior of a cathedral can be clearly seen in the basilica (Figure 14-13, page 291), with its central nave rising above the aisles on each side. In early Christian churches, no extra support was needed for the central section, but as churches grew larger and taller during the Romanesque period, it was found necessary to reinforce this part of the building. If a solid buttress were put up, it would cut off the aisles below (examine Figure 14-14). Accordingly, a plan was devised of making a buttress at the aisle wall from which a half arch was stretched out over the aisle to support the vault of the nave (examine Figure 14-20). Sometimes just one such arch was sufficient; sometimes, as at Amiens (interior, Figure 14-21), two were used, one above the other. These are called "flying buttresses." The lower buttress leans against the point where the vault springs inward and needs additional support; the upper buttress leans against the point where the vaulting curves inward and where it would tend to burst outward if its weight were not counterbalanced by the higher buttress. The photograph of Notre Dame at Paris (Figure 14-22, page 296) shows the flying buttresses as they are actually seen. Perhaps more than any other characteristic of Gothic architecture, they seem to contribute to its mood of soaring aspiration.

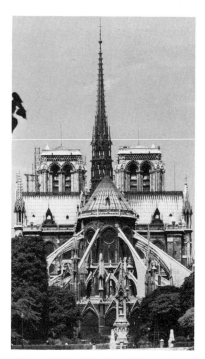

Figure 14-22. Cathedral of Notre Dame, Paris (twelfth and thirteenth centuries), view of apse, showing the flying buttresses. (Length: about 415 feet; height of flèche: about 310 feet. Photograph, Clarence Ward.)

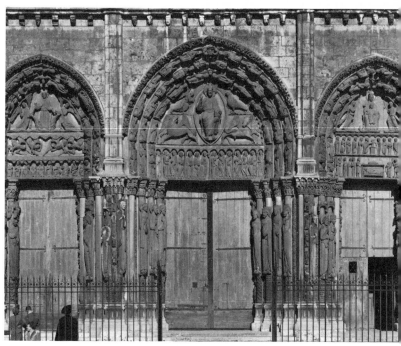

Figure 14-23. Chartres Cathedral (twelfth and thirteenth centuries), west, or "Royal," portal. (Stone. Height of royal ancestors: 20 feet, 6 inches; width of west portal: ca. 50 feet. Photograph by Houvet.)

In the Romanesque cathedral, several small windows were combined in a compound arch; in the Gothic, this process was continued until the arches appeared only as stone tracery. Eventually the windows became so large that the walls ceased to have any function as walls; the roof was supported by the huge buttresses and the entire wall space was filled with stained-glass windows. The triforium space was regularly filled with small arches, and the rose window became large and important. The doorway changed too. In the Romanesque church the façade sometimes had one doorway, sometimes three. The Gothic façade regularly had three doorways. Each was made with multiple orders, like the Romanesque, though the arch, of course, was pointed. The decorations, also, were much more elaborate. In the Romanesque they were relatively simple moldings, with or without carvings of conventional designs, figures, animals, or fruit. In the Gothic the human figure became the characteristic decoration, a recessed doorway being filled with rows of saints or kings.

The west, or "Royal," portal of Chartres Cathedral (shown in Figure 14-23) is an excellent example of early Gothic. It was finished in the middle of the twelfth century and is generally recognized as transitional work, though by common consent it is classed as Gothic. As is usual in Gothic, there are three doorways, with a lintel and a tympanum over

each. Sculpture forms the only decoration. The three portals are treated as a single unit proclaiming the majesty and omnipotence of Christ.

In the tympanum above the central doorway is shown the second coming of Christ when he is to judge the quick and the dead. His right hand is raised in blessing; in his left hand he holds a book. Around him the four evangelists are represented by their symbols. On the lintel below are the twelve Apostles.

The tympanum and the lintels over the right door celebrate the birth of Christ. In the first (lower) are represented the Annunciation, the Visitation, and the birth of Jesus. Mary is lying on a couch and the child is above her in a manger. Joseph stands at Mary's head, and on beyond are angels and shepherds. The second lintel shows the presentation in the temple. In the tympanum Mary is seen in her glory, the Infant in her arms. On each side is an angel swinging a censer.

In the tympanum to the doorway on the left is shown the Ascension. Christ on a cloud is being supported by two angels. On the lower lintel are the Apostles; between them and Christ are four angels who look as though they might be leaning toward the Apostles while they say:

Ye men of Galilee, why stand ye gazing up into heaven? this same Jesus, which is taken up from you into heaven, shall so come in like manner as ye have seen him go into heaven.
—Acts 1:11

On either side of the doorways are rows of kings and queens. They are commonly supposed to be the ancestors of Christ, as told in the first chapter of Genesis; hence the name "Royal" for this portal. They are richly clad in embroidered robes, and each carries in his hand some index to his work or character—a book, a scepter, a scroll; many wear crowns.

These kings and queens are remarkably elongated. Each stands by a column, and is stiffly posed with arms close to the body and never projecting beyond that contour. As Helen Gardner says: "They grow from the columns they rest on—this is what the artist was striving for—to use the human figure to adorn a column and yet not lose the feeling of the column."[4]

In general shape the façade of a Gothic cathedral is a rectangle resting on the short side, and the great height is emphasized by the two towers that usually complete the design. In Notre Dame at Paris (Figure 14-24, page 298) the towers are square and relatively short, but in many other cathedrals, such as Chartres (Figure 14-25, page 298), the towers are tall and pointed.

The Gothic cathedral often took centuries to build, with the result that the same style was not used throughout a building. Part of a building may be in Romanesque, part in early Gothic, and another part in late Gothic. As the ideas of architecture changed, the building itself changed. In the cathedral at Chartres, the towers are not the same; the older tower is shorter, more solid, and more substantial than its younger brother.

[4] Helen Gardner, *Art through the Ages*, p. 314.

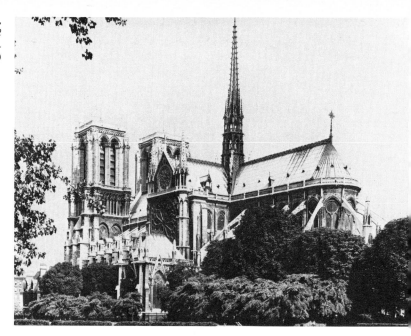

Figure 14-24. Cathedral of Notre Dame, Paris. (*Diameter of rose window: 42 feet; height of towers: 223 feet.* Photograph, Trans World Airlines, Inc.)

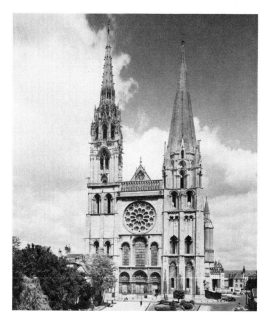

Figure 14-25. Chartres Cathedral. (*Width of façade: 156 feet; height of north tower: 378 feet.* Photograph, Houvet.)

The Gothic style in architecture is known, and rightly known, primaril for its cathedrals and churches. There are also, however, many beautifu palaces, especially in Venice, where the light tracery is reflected in th water of the canals. One of the favorite examples is known as the Cà d'Or (Figure 14-26). It was built in the fifteenth century.

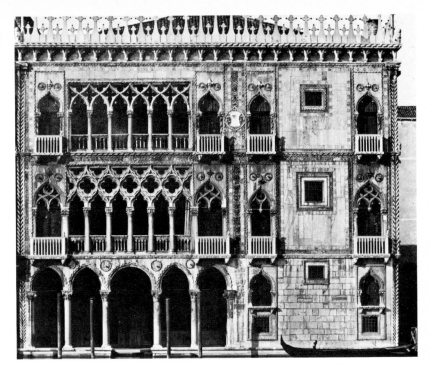

Figure 14-26. Cà d'Oro (1422–ca. 1440). (Venice, Italian State Tourist Office. Photograph, Alinari.)

RENAISSANCE ARCHITECTURE
(FIFTEENTH AND SIXTEENTH CENTURIES)

In Renaissance architecture the cathedral, or temple, is no longer the typical building; secular architecture comes to the fore, as in Roman times. Although Renaissance architecture is a return to the ideals of the Greeks and Romans, it is not a slavish imitation, but rather a free use of the materials found in classic architecture. The designers got their ideas from Greece and Rome, but they used these ideas freely, according to their own tastes, in a way that was original. For example, in the Medici-Riccardi Palace at Florence, designed by Michelozzo, we find the round arches of the Romans. On the first floor a single arch occupies the space of two arches on the second and third floors. In the upper floors, the window space is filled with the compound arch of the Romanesque. At the top of this building there is a large cornice, heavy enough to crown the whole mass of the building. There is also a molding, or "stringcourse," that separates one story from the other.

In the Palace of the Senate at Rome (Figure 14-27, page 300), designed by Michelangelo, we find the stringcourse and the cornice, this time surmounted by a balustrade. In addition, each large window has its own post-and-lintel system. The windows are decorated with pediments; some are triangular, some are rounded. The classical rule would have been only one pediment for one building, and the pediment would have been in scale with the building. Between the windows are flat columns called "pilasters."

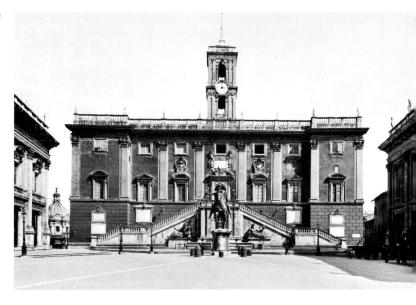

Figure 14-27. *Michelangelo.* Palace of the Senate (*begun 1538*). (*Rome. Photograph, Anderson.*)

The overhanging cornice, the stringcourse, the pilaster, and the ornamental pediment are characteristic features of the Renaissance style. Another feature is the dome on a drum. The Roman dome was so low that it could hardly be seen from the outside. In Renaissance architecture the dome was made small, and it was raised high on a circular drum and surmounted with a lantern. The curve of the dome was changed, too; it was made much steeper, and its sides were ribbed, as we see in the dome of S. Peter's (Figure 14-28).

Figure 14-28. *Michelangelo.* S. Peter's Cathedral (*1547–1564*), apse and dome. (*Stone. Height of dome: 435 feet. Rome. Photograph, Stoedtner.*)

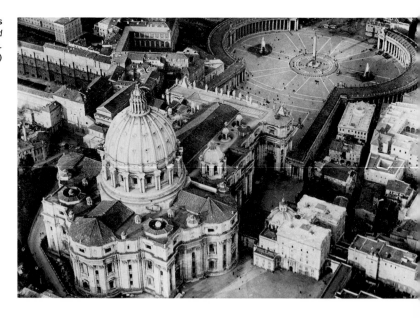

ORGANIZATION

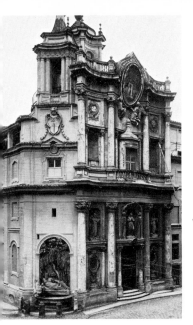

In the smaller building, whether residence, church, or store, the Renaissance produced a type of symmetrical structure of great simplicity and beauty. In England it is known as the Georgian style, and in the United States as the American colonial.

BAROQUE ARCHITECTURE (1600–1750)

Baroque architecture flourished in the seventeenth century and in the opening years of the eighteenth century. It is characterized primarily as a period of elaborate sculptural ornamentation. The architectural framework remained close to that of the Renaissance, although often it was far more spacious, but it had a profusion of carved decoration. Columns and entablatures were decorated with garlands of flowers and fruit, shells and waves. Often alcoves were built into the wall to receive statues, thus making a pattern in light and dark. Surfaces were frequently curved. The churches of this period no longer use the Gothic nave and aisles; the area is filled with chapels which take the place of the aisles. They often have domes or cupolas, and they may or may not have spires. The church of S. Carlo alle Quattro Fontane (shown in Figure 14-29) is an excellent example of the love for ornament, the movement, restlessness, and excitement of the style.

Figure 14-29. Francesco Borromini (1599–1667), Italian architect. S. Carlo alle Quattro Fontane (begun 1635, façade 1667). (Rome. Photograph by Anderson.)

Comparison of the apse and the façade of S. Peter's reveals interesting differences in style. The apse, which was designed by Michelangelo, is a solid, unified whole, an appropriate symbol of the power of the church. The façade, built by Maderna after the death of Michelangelo, is crowded. It covers the drum and is not entirely in stylistic harmony with it. In the façade itself we see the spirit of the Baroque in the massed columns which are doubled for the sake of ornament, the decorative pediments, the pilasters, and the heavy stringcourse (Figure 14-30).

Figure 14-30. Maderna. S. Peter's Cathedral, façade. (Stone, Photograph, Italian State Tourist Office.)

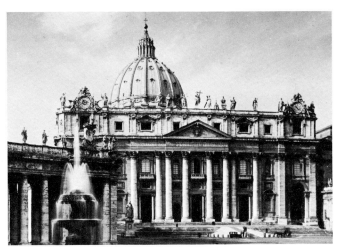

The Palace of the Senate, which has been mentioned as an example of Renaissance style, shows definite leanings toward the Baroque in the stairway and the elaborate doorway with ornamental carvings on each side.

NINETEENTH-CENTURY ARCHITECTURE

The nineteenth century in architecture is known as a period of eclecticism. *Eclecticism* means "freedom of choice"; in art, it means the freedom to choose from the styles of the past. In former times architects had always used the style of their own periods. But in the nineteenth century both architects and clients began deliberately to choose to make a building in the style of one era or another. Hence it happens that we have in almost any American city examples of all the historical styles, from the Greek onward. This self-consciousness about choice of style has produced some good and some bad results. Examples of borrowings from the past are the Gothic motifs in the Brooklyn Bridge and the Gothic-like "gingerbread" decorations on many houses.

The interest in various styles has resulted in the adoption of certain styles as suitable for certain types of building: Gothic for churches, Baroque for theaters, Renaissance for government buildings, and so on.

One objection to eclecticism is philosophical. In the course of historical development, each of the major styles has been evolved to meet the needs of its own age and to express its philosophy. The argument is that to go back to the style of a previous age is essentially false.

MODERN ARCHITECTURE

Skeleton Construction

Skeleton construction is a development of modern times, and on it most of our great modern structures depend. But skeleton construction in its turn was made possible by the development of two new materials: structural steel and reinforced concrete.

Structural steel dates back to 1855, when Bessemer invented his process for the mass production of steel. As the advantages of steel became apparent, it gradually superseded cast iron. These advantages are, primarily, its resilience, strength, and reliability.

Concrete is composed of sand, crushed stone or gravel, water, and cement. When mixed, it is a semifluid which, owing to the cement, dries into a hard, stone-like substance. Forms are made in exactly the size and shape desired. The fluid concrete is poured into them; when dry, it forms a solid substance of just that form and shape. Concrete is very strong and will stand great weight, but it will not stand strain or tension. At the end of the last century, some French engineers discovered that by adding steel rods to concrete they could give it the tensile strength it lacked; in other words, it would then withstand strain. "Reinforced concrete," as this new

material is called, is thus the combination of concrete and steel. It has the strength of concrete, and like concrete it can readily be made into any shape. At the same time, it will withstand strain as steel does. It also has the advantage of being much cheaper than steel and lighter in weight.

In skeleton construction, strong but slender beams of steel or reinforced concrete form the framework of a building, and on it all the other parts are placed or hung. This type of construction has opened many new possibilities in building. First, it has made possible tall buildings, because the skeletons are strong but light. The walls which are hung from the skeleton are merely curtains to keep out cold and air. They may be made entirely of glass. They have no weight to speak of, and they are not essential to the strength of the building. A modern skyscraper, if built of masonry in the old fashion, would need to have the first floors of solid stone to support the weight of the upper stories. In the building of the Inland Steel Company in Chicago, the columns which carry the weight of the building are on the outside. As a result, the entire space on any floor is free of posts or pillars and, if necessary, can be used as a single room (Figure 13-28, page 273).

Moreover, with skeleton construction the building may be set up off the ground on posts so that the ground floor may be used for outdoor living or for a garage or driveway. Another important result of this type of construction is the fact that an opening of any size may be spanned. Lintels of stone are necessarily short, since stone cannot be cut in great lengths and will not bear strain. Lintels of wood are longer, but they are obviously limited. Since steel may be made of any length and strength, a door or a window may be of any desired size.

Skeleton construction also allows freedom in the shape of the house. Concrete is a fluid material and can take any shape. Buildings of wood, brick, or stone tend to be rectangular, partly because of the difficulty of putting a roof on any but a rectangular building. Now, buildings may be made of any shape: circular, round, or square. In the Guggenheim Museum in New York City (Figure 14-1, page 282) the galleries mount in a continuous spiral. In the State Fair Arena at Raleigh, North Carolina (Figure 14-31, page 304), the walls are two opposing parabolas of glass and concrete, with their open ends joined on the ground and their arches rising outward from each other. The arena measures 800 feet across in all directions, and there is not a single column to obstruct the view. The arena seats about nine thousand.

Cantilever Construction

Cantilever is a special form of steel and reinforced concrete construction. The term *cantilever* refers to any member or unit of an architectural design which projects beyond its support. The cantilever principle is often seen in bridges, where each half of the bridge is supported on one side only. The two halves meet in the center to form the bridge, but each half is entirely independent of the other. In most airplanes the wings are attached to the

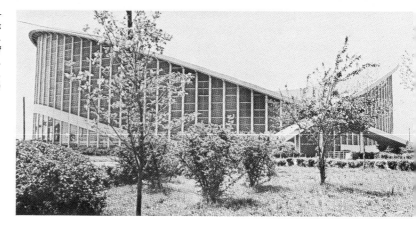

body in a cantilever construction. We see the principle in buildings where the upper story juts out beyond the lower. The two essentials of cantilever construction are, first, that the material used be able to stand the strain (i.e., have the necessary tensile strength), and second, that it be fastened securely at the side where it is supported. This principle, which is very old, has been much used in recent years, because the piece that projects can be larger in steel and reinforced concrete than in older materials.

The cantilever was used rather widely by the American architect Frank Lloyd Wright. In a number of houses he used the cantilever in a veranda, so that the roof projects over the porch with no columns or pillars to hold it up. In one case he had a house projecting over a waterfall by means of cantilevered balconies. For the research building of the Johnson Wax Company (shown in Figure 14-32), Wright erected a tall building in which all the floors are cantilevered from one central column. The floors are alternately square and round. The whole is enclosed in glass. The central column contains elevators and tubes for air conditioning, besides all the passages for the machinery of the building, electric controls, etc.

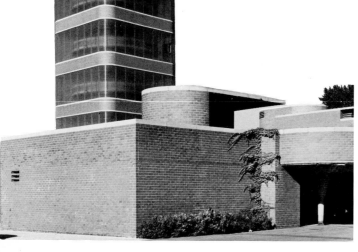

Figure 14-32. Frank Lloyd Wright (1869–1959), American architect. Research and Development Tower of S. C. Johnson and Son, Inc. (1947–1950). (Brick and concrete with walls of glass tubing. Height of tower: 156 feet [50 feet underground]; each floor 40 feet square; each alternate floor 38 feet in diameter. Racine, Wis. Photograph, Johnson Wax.)

Twentieth-century Styles

INTERNATIONAL STYLE The buildings of the twentieth century fall in general into two different categories, known as the "international" style and the "organic" style. Both use the new materials, but their aims and techniques differ. The international style is recognized as a modern style by its severe horizontal and vertical lines, its reinforced concrete, its white walls and flat roofs. There is directness and simplicity in its use of materials and avoidance of ornament. The design is planned very carefully, usually with a *module*, or measure, to determine the exact proportions. The Seagram Building in New York City "is a bronze and glass shaft with every dimension, from total height to smallest bevel, determined by an arbitrary modular system."[5]

Adjectives often applied to buildings in this style are "spare," "aristocratic," "chilly"—and indeed many people find the style cold and forbidding. It is a design that can be imitated easily. Anyone can understand and use the structural elements. There are in this book three examples of this style: the Seagram Building, the United Nations Secretariat Building, and the Inland Steel Building. Of these, the Seagram Building has generally been accounted superior to the other two.

ORGANIC STYLE The organic architecture of the twentieth century is identified primarily with the work of Frank Lloyd Wright. For Wright, architecture is organic when there is organic unity in planning, structure, materials, and site. As Wright said, "I build a home for myself in southern Wisconsin: a stone, wood, and plaster building, make it as much a part of my grandfather's ground as the rocks and trees and hills there are."[6] And again: "Modern architecture, let us now say organic architecture, is a natural architecture: the architecture of nature, for nature."[7]

It is generally recognized now that, after his residences, Wright's ability showed itself best in the various buildings he designed for the Johnson Wax Company of Racine, Wisconsin. The tower of that group of buildings has been discussed. The Administration Building (Figure 14-33, page 306) should be studied for the skill and beauty with which the various elements are harmonized. In the interior of the Administration Building, the columns are made to flare at the top, and some do not reach to the ceiling. They have a decorative effect and give a sense of gaiety and freshness to the room, like sunlight falling through the leaves of trees.

The boast of much modern architecture is that it is organic. Eclectic architecture, as we saw, was primarily decorative. The architect and his client chose a certain façade or a certain treatment of the material because they liked the looks of it, and often it had little, if any, relation to the

[5] John Cannady in Sewall, *A History of Western Art*, p. 925.
[6] Frederick Gutheim (ed.), *Frank Lloyd Wright on Architecture: Selected Writings* (1894–1940).
[7] *Ibid.*, p. 248.

Figure 14-33. Frank Lloyd Wright.
Administration Building of S. C. Johnson
and Son, Inc. (1936–1939), interior.
(400 foot area. Racine, Wis. Photograph,
Johnson Wax.)

actual structure of the building. House plans were frequently presented as floor plans with the exterior to be finished in Gothic, classical, American colonial, or what have you. But when we say of modern architecture that it is "organic," we mean that there is organic unity in planning structure, materials, and site; all are designed to meet exact needs. The needs of the age are many and various: factories, office buildings, laboratories, railroad stations, schools, hospitals, mass housing, airports, broadcasting stations, theaters, churches, homes, dormitories. The demands of each must be studied and met if the building is to be good.

To study in detail one example of a building designed for a special need let us take the Stephens College chapel, designed by Eero Saarinen (shown in Figure 14-34). The chapel was intended primarily as a place for private worship. It was presumed that small functions might be held there such as a wedding, a baptism, or an occasional concert, but such occasions were not to be frequent enough to interfere with private devotions. The chapel was nondenominational: no one was to feel a stranger or unwelcome. Therefore, there were to be no symbols of any one faith, such as the cross, or the star of David: all symbols were to be general.

The building as designed by Saarinen is square, foursquare, close to the earth; walls and roof make one unit, clinging to the ground and at the same time pointing up and ending in the central steeple. The walls are not interrupted by any windows, but at the entrance in the center of each side is a portico of stained glass, serving, Saarinen said, as a small lantern leading to the chapel (Figure 14-35).

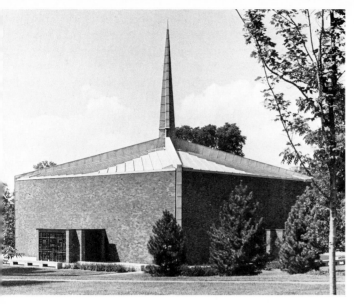

Figure 14-34. Eero Saarinen (1910–1961), American architect. Stephens College Chapel (finished 1956). (Brick. Size: 70 feet by 70 feet. Columbia, Mo. Photograph, Marvin Kreisman.)

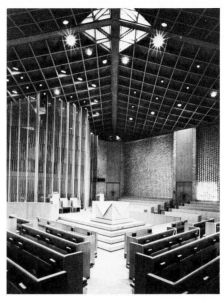

Figure 14-35. Eero Saarinen. Stephens College Chapel, interior. (Photograph, Marvin Kreisman.)

Figure 14-36. Eero Saarinen. TWA Terminal Building, Kennedy Airport. (Photograph, Trans World Airlines by Ezra Stoller Associates. © Ezra Stoller.)

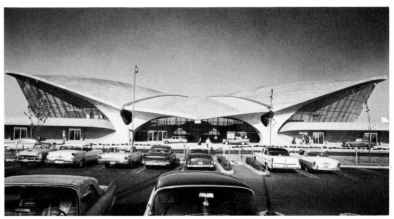

The interior is simple and direct. If one were to draw diagonals from the four corners of the building, he would obtain four equal triangles. One of these is designed for the organ and choir, the other three for the audience. In the exact center of the room is the altar, a plain square block. The light comes primarily from the base of the spire and falls directly onto the altar.

An ambulatory around the entire auditorium is separated from the main chapel by a screen of interlaced brick, which makes a division but at the same time gives a view of the interior and the stained-glass doors beyond. The organ and choir are set behind a screen of wooden pieces, light brown and black. The ceiling is of wood in a square design.

The general effect is of simplicity and greatness. The place is small, but one has vistas of vast spaces; the room is intimate, but its many vistas are conducive to thoughts of the distant and the far away. It is the kind of place where one can get away from the perplexities of the everyday in the contemplation of the infinite.

It was Saarinen who supervised the design of the Trans World Airlines terminal building at Kennedy Airport in New York (Figure 14-36, page 307), completed in 1961, an entirely different sort of building with an entirely different function, which can stand as an example of the tremendous variety of modern architecture.

15. FORM IN MUSIC

As Chapter 10 made clear, music is an auditory art existing in time; consequently, its overall organization must be achieved through temporal means. This is accomplished through the musical articulation of "units of time." For example, a melody "takes up" a certain amount of time and thus articulates that time, setting it off from what occurs before and after it. In this way, units of time are "defined" by units of music. Musical composition, then, in its most basic sense, consists in the creation of these temporal-musical units and in the combination of such units into ever larger units. In addition, the composer must relate all the units to one another in such a way that the largest possible unit, the total composition itself, acquires a sense of interconnectedness and ordered continuity, with the result that it seems to represent not just a final addition of all the smaller parts, but also a complete synthesis of these parts. The result of this process is what we call "musical form."

There are two distinct, though related, meanings of the word "form" as it is applied to music. First, the word may refer to the specific relationships among the various musical elements in a particular composition. In this sense, each composition has its own unique "form" which distinguishes it from all other pieces. The word "structure" is also frequently used with this meaning. A second meaning of "form" refers to certain very general formal relationships, or formal *types*, which are found to be the basis of many different compositions. Thus we can speak of "rondo form," or "theme and variation form" as common to literally hundreds of pieces. It should be emphasized, however, that in this second sense form does not represent a strict and rigid mold into which the music may be "poured," but only a loose abstraction which can be handled quite differently by different composers, or even by the same composer in different pieces.

Thus two compositions sharing the same formal type may vary considerably in their specific formal structures.

FORM AS MUSICAL STRUCTURE:
ANALYSIS OF BEETHOVEN'S BAGATELLE, Op. 119, No. 9

Since form in the first sense mentioned above is unique to every piece it can be studied only through the analysis of individual compositions. A an illustration, Beethoven's Bagatelle, Op. 119, No. 9, will now be examine in some detail in order to show how the various musical elements previously discussed individually (rhythm, pitch, timbre, and dynamics) wor together to create a total, integrated musical structure. Although th specific comments will obviously apply only to this one piece, the genera principles of formal organization which will be illustrated are applicable t a wide range of musical compositions.

We have purposely chosen a piece which is short and relatively simpl in construction, yet one which illustrates, though on a small scale, th subtlety with which a composer of Beethoven's genius shapes his musica material.[1] Our method will be to consider the organization of each of th elements separately (at least insofar as this is possible) and then discuss the interaction of these various elements in creating an overall desig Before beginning, however, it is important that the piece be heard severa times, and then it should be heard again after the analysis has been read (Several recordings of the Bagatelles, Op. 119, are available.) Musica analysis should be thought of as a means of "stretching" our ability t hear music by making us more consciously aware of the various factor which affect our musical perception.

[1] The word "bagatelle" usually refers to something of little value. The term is used b Beethoven, however, to apply to short piano pieces, many of which are of considerab musical interest.

EXAMPLE 1

Ludwig van Beethove
German (1770—1827

Rhythm

A glance at Example 1 reveals that the time signature indicates ¾: that is, the quarter note is the basic pulse and is grouped into metrical patterns of three beats each. The time signature itself, of course, is only a visual indication. How, then, is the meter communicated to the listener? If we look at the music played by the left hand (which is written on the lower of the two staffs, the bass staff) we see that it consists of a series of quarter notes, which are unbroken throughout the piece except in two places: m. (measure) 8 and m.20. Thus the basic quarter-note pulse is *explicitly* stated in this piece, rather than merely implied. Further, it can be seen that the first quarter note of each three-beat group is separated from the others by its placement in a lower register (it is an octave lower than the lowest note on the second and third beats), thereby creating a clear triple

grouping. Turning now to the right hand (the upper, or treble staff), we see that the durations are less regular: there are eighth notes (m.1), quarter notes (m.3), and half notes (m.3). Although all of these are easily synchronized with the basic pulse and the meter, in this piece the left hand is primarily responsible for the underlying metrical organization. The right hand, which has the melody, is thus able to move within the metrical framework with some freedom, relying on the accompaniment in the left hand to articulate the metrical groupings.

Not only are the beats grouped into measures, but the measures are themselves grouped into larger units, which are called *phrases*. Phrases are more or less complete musical thoughts, usually lasting several measures. In this composition the phrases consist of four measures each (thus, like the measures themselves, they are regular); and although they are defined primarily by pitch elements, which will be discussed later, the rhythm does contribute to their demarcation. In the first four measures we can see that the durations in the treble staff tend to slow down (become longer) after the opening eighth notes (at the end of m.2); this process is then repeated in the second phrase (mm.5–8), but this time it is altered at the end so that the music comes to a complete halt on the first beat of the eighth measure (note the rests on the second and third beats in m.8), thus creating a very strong articulation of this phrase. In the third phrase (mm. 9–12), the rhythm in the treble staff is quite different from that of the first two phrases. Although m.9 begins like m.1 (remember, we are discussing only the rhythm), the eighth notes are cut short by the quarter note on the third beat, which prevents the eighth notes from continuing on into m.10 as they had done in m.2. The rhythm of m.9 seems, in fact, like a shortened version of that of mm.1–2 taken together, where the eighth notes were cut off by the quarter note only at the end of the second measure. Further, whereas mm.3–4 had a very different rhythmic shape from mm.1–2, each of the three remaining measures in the third phrase (mm.10, 11, and 12) is rhythmically identical to the first (m.9). The end of the third phrase, however, is rhythmically defined by a *fermata* (the small sign over the notes on the last beat of m.12), which indicates to the performer that he should hold this beat somewhat longer than its normal duration. This long note thus serves to set off this four-measure group much as does the rhythmic halt in m.8, although it seems less final because it occurs on the third beat (which is unaccented) rather than on the first (which is accented). The fourth and fifth phrases (mm.13–16 and mm.17–20) are identical to the first two (mm.1–8) and do not need further discussion.

Pitch

This composition is in the key of A minor, and we shall begin our discussion of the pitch organization by considering how the pitches are derived from the A minor scale. The basic scale is shown in Example 2. The

EXAMPLE 2

minor scale, like the C major scale, has no accidentals (sharps or flats) and thus needs no key signature. Yet a glance at the music reveals the presence of several accidentals, which are reducible to two pitches: G, the seventh note of the scale, is raised to G♯ in measures 4, 7, 9, 11, 12, 16, and 19; and B, the second note of the scale, is lowered to B♭ in measures 3, 7, 15, and 19. The only other accidentals are the naturals (♮) in measures 4, 7, 16, and 19. These indicate that the preceding B♭ is changed back to B (which is now called B natural).

Of the two chromatic alterations of the basic scale (G♯ and B♭), it is the raised seventh degree of the scale (G♯) which is used most frequently. This is done to place G (the seventh tone) closer to A (the eighth tone) so that it "points" toward this tone more convincingly, thus emphasizing the role of A as the tonic. As was mentioned in Chapter 10, this alteration is found in all tonal pieces in the minor, where, as here, it serves to emphasize the central tone. The other alteration, the lowered second degree (B♭), is much less frequent and is used here to create a special chromatic effect desired by Beethoven for this particular piece. It should be noted that after it is lowered, it is in each case raised immediately afterwards by a natural sign to its normal position in the scale.

Harmonically, this piece is relatively uncomplicated, with the triads constructed on A and E, the first (tonic) and fifth (dominant) degrees of the A minor scale (the chords I and V), predominating. The first two measures, for example, are entirely derived from the I chord, which contains the pitches A, C, and E. The bass of the accompaniment (bass staff) has the root of the chord (A), while the second and third beats repeat this A an octave higher and add to it C, the third of the chord. The melody has what is in essence a complicated arpeggiation of the pitches of the same chord, through which it supplies the E, which was missing in the accompaniment, on the fourth eighth note of the second measure. In these two measures one has a very clear illustration of the relationship between melody and harmony, the two in this case being drawn entirely from the same underlying pitches: A, C, and E.

Let us now discuss the melody in regard to its pitch structure. The first two measures, made up exclusively on the three pitches of the A minor triad, consist of a very disjunct (leaping) melodic figure with an overall upward direction. The next two measures, on the other hand, have a completely conjunct (stepwise), descending melodic line. Thus melodically the phrase divides clearly into two parts of equal length, the very active upward thrust of the first part being balanced by the gradual falling motion of the

second. The second phrase (mm.5–8) is melodically almost identical to the first, with one important change: whereas in the first phrase the melody descended stepwise from the high C to G♯ (C–B♭–A–G♯), in the second phrase the last two notes are reversed so that the melody ascends at the end to A, the tonic (C–B♭–G♯–A). Thus the first phrase ends on G♯, the seventh degree of the scale, an unstable tone (the heading tone) which points toward the tonic, whereas the second phrase ends on the stable tonic, which serves to resolve the G♯.

Timbre

Since only one instrument, the piano, is involved, timbre plays a minimal role in this composition; yet there are certain points to be made in regard to Beethoven's use of the instrument to help clarify the overall sense of the piece. First, it should be noted that the melody is the highest element in the total texture and is always clearly separated in register from the accompaniment. Also, the bass notes, which are particularly important for clarifying the direction of the harmonic progression, are always isolated from the rest of the accompaniment. Finally, there is a tendency to thicken the texture by adding tones at the end of each phrase, thus strengthening the important structural points: one note is added to the accompaniment on the second beat of m.3 (the F in the right hand) and two are added on the first beat of m.4 (D and B); and at the terminal tonic cadence (mm.7–8) there are a total of six notes on the V chord in m.7 (which, with m.19, is the "thickest" point in the piece) and five notes on the I chord in m.8. The third phrase (mm. 9–12), which we have already noted to be different in other ways, does not make use of this device but maintains a uniform texture throughout.

Dynamics

In keeping with the general simplicity of the piece, the dynamics move within a quite limited range. The general level is soft (p; that is, *piano*) but note that in both the first and second phrases there is a *crescendo* (meaning "getting louder" and indicated by <) as the end of the phrase is approached (in mm.2–3 and 6–7) and then a drop back to *piano* in the final measure of the phrase. The loudest points are the two marked f (*forte*) on the last beat of m.7 and m.19, which are also the heaviest points in texture. Again, the third phrase, unlike the others, has no contrasts in volume.

Tempo

The words *Vivace moderato* above the first measure indicate that the piece is to be played at a moderately fast speed. Interestingly, Beethoven's manuscript has a slightly different indication: *Vivace assai ed un poco sentimentale* ("Rather fast and a bit sentimental"). Thus he originally

intended to indicate not only the speed but something of the character with which the piece should be played. Since the first printed edition has only *Vivace moderato,* however, it is to be assumed that the composer changed his mind before publication.

The Interaction of the Elements

Now that we have looked at the way Beethoven organizes the individual elements, we may briefly summarize our findings by considering the way the elements work together to create the total shape of the piece. In the first phrase (mm. 1–4) the following factors are involved in defining the first four-measure unit: the harmony moves from I to V (note the ascent of the bass line from A through D to E, where the upward motion comes to a halt); the melody ascends in a disjunct arpeggiation (that is, it leaps through various pitches in the A minor chord), which is balanced by the descending stepwise motion to G♯ in the fourth measure; the rhythm of the melody begins quickly but then slows down as it approaches the fourth measure; the volume increases up to the last measure of the unit; and as the end is approached, the texture thickens. There is a similar sense of overall cooperation in the second phrase (mm.5–8), but here the end is altered so as to make the close more final than the first one. Again, several factors are involved in this change: the harmony now moves from I through V back to I; the melody ends on the tonic pitch, A, rather than on the leading tone, G♯; the rhythm is arranged so that all parts coincide on the first beat of the last measure (m.8) and then come to a complete halt as a result of the two-beat rest (the only place in the piece, except for the final measure, where this occurs); and the texture reaches its thickest point.

We have already noted that the first two phrases form a complementary pair, the second phrase representing a sort of answer to the first which completes what was left unresolved there. The third phrase is quite different from the first two, and again, all elements contribute to its unique role in the composition: there is virtually no harmonic change; the melody is now broken up into four repetitive statements; the rhythm fails to change (and thus progress) from measure to measure, except for the fermata on the last beat of m.12, articulating the end of the phrase; and the dynamics and texture both remain completely unchanged throughout.

Since the last two phrases are identical to the first two, the third phrase may be said to form a short, four-measure middle section which contrasts with the two eight-measure outer sections. Thus the piece falls into three parts, the first and last of which are identical. In mm.1–8 there is an A section (the letter A is here used not to name a pitch but as a designation for the entire section), which forms a complete, self-contained statement, capable of standing by itself. This section is then repeated exactly, as is indicated by the double bar with dots at the end of the eighth measure (called a "repeat sign"). Measures 9–12 form a contrasting section (which we will refer to as B), which, unlike the first, seems

incomplete, incapable of standing by itself. In fact, this section hardly seems to form a "statement" in the sense that the first does, but seems almost to just "mark time." The inconclusive quality of this phrase is beautifully designed to set up the restatement of the A section in mm.13–20, whose reappearance is made especially satisfying as a result of the tentativeness of the middle section. Finally, both the middle and final sections are repeated as a unit, as is indicated by the repeat sign at the end of the piece. The overall shape can thus be diagrammed as follows:

	A	A'	:‖:	B	A	A'
Harmonic progression:	I–V;	I–V–I	:‖:	V ;	I–V ;	I–V–I
Measure numbers:	1–4;	5–8	:‖:	9–12;	13–16;	17–20

Or, more simply,

	A	:‖:	B	A
Harmonic progression:	I–I	:‖:	V ;	I–I
Measure numbers:	1–8	:‖:	9–12;	13–20

It should be noted that the B section, although contrasting, is nevertheless carefully designed to form an organic part of the total design. It maintains several factors carried over from the first section (the texture and the arpeggiated melodic fragment are both reminiscent of the A section); this enables it to form a consistent continuation of what has gone before.

FORMAL TYPES

We will now shift our attention to the second sense of the word "form" by considering some of the standard formal types used in Western music.

Song Form

Vocal music was the first music to develop standard forms. But although forms were often dependent upon the form of the text being sung, some of them, like song form, have been carried over into instrumental music as well.

There are two types of song form which are widely used: *binary* and *ternary*. Binary song form (AB), as its name implies, consists of two parts. The second part is both a contrast and a complement to the first. In binary form some balance of design and some related musical idea are usually present in the two parts. It is somewhat like a question and answer; that is, part A presents a musical idea which is resolved in part B. The two parts are usually divided by a significant pause such as a dominant or tonic cadence. Brahms' famous "Lullaby" (Example 3) is binary, and part B is exactly as long as part A, each being eight measures.

EXAMPLE 3

Johannes Brahms
German (1833–1897)

In this example, part A could stand alone because it ends on a tonic cadence, but part B sounds like a natural extension of it.

Not all binary forms are exactly balanced in length. In Handel's "Harmonious Blacksmith" (Example 4) part B is twice the length of part A. Here part A cannot stand alone, because it ends on a dominant cadence. Part B begins with the tonic and after going through the dominant ends on the tonic.

EXAMPLE 4

Georg Friedrich Handel
German (1685–1759)

Sometimes part B quotes, either at the beginning or the end, a section of part A. In Example 5 we have an exact quotation of the second four measures of part A at the end of part B (the first four measures are also repeated, but in a somewhat altered form), which gives a "rounded," or ABa binary.

EXAMPLE 5

Ternary song form (ABA), or three-part form, like the binary, depends on two distinct thematic sections; but in ternary form there is a full restatement of part A after part B, creating a pleasing symmetrical balance. In some music of this form, the composer will at the end of section B write *Da Capo*, or merely D.C., which means "go back to the head," or beginning—that is, repeat part A. This saves repeating the A section in the score, but obviously it is possible only if the second A section is exactly the same as the first. Example 6 is in ternary form.

EXAMPLE 6

Jean Paul Martini
French (1706—1784)

Allegretto, con moto

Perhaps the most widely used song form is an extended kind of ternary which is sometimes called *quatrain* form (AABA). The extension, the second A, is either an exact repetition of the first A or of such obvious similarity that we call it a second A. Ordinarily the repetition of a section of music is not of any structural significance, since it does not alter the form, which is true in this case. Example 7 is an extended ternary song.

EXAMPLE 7

Ben Jonson, "To Celia"
Music traditional

There are many possible variations to song form; and in the case of some pieces in song form, it may even be difficult to say whether they are binary or ternary. For example, Beethoven's Bagatelle, analyzed on pages 310–311, is a song form, but it seems to contain characteristics of both binary and ternary form. The first section is repeated exactly (mm.13–20) after a contrasting middle section (mm.9–12): this is characteristic of ternary form. However, the middle section is quite short (only half as long as the A section) and incapable of standing by itself; and the B section and the final A section taken together are repeated as a unit (as is the first A section), which tends to divide the piece into two, rather than three parts— these are characteristic of binary form. The important thing is not to force a piece into a given pattern but to attempt to understand its sense.

Theme and Variations

One of the most popular and enduring forms in music is the theme and variation form (A, A1, A2, A3, etc.). In this form there is a constant interplay between repetition and variation, and it is the delight of both composer and listener to see how many ways there are of saying essentially the same thing.

Variations tend to progress by contrast or by increasing elaboration. In either case the variations show more use of ornamentation than the original theme. For the most part, therefore, this form is confined to a light, even witty manner of presenting a theme in several guises. As a result, there are only a few sets of variations that could be called "monumental." Two of the most famous are the *Goldberg Variations* by Bach and the *Diabelli Variations* by Beethoven.

Since the theme of the variation form is usually concise and relatively simple (thus allowing for the elaboration to come), it is often itself in a binary or ternary song form. Handel's "Harmonious Blacksmith" (Example 4), mentioned earlier as an example of binary song form, is a theme for a set of five variations, which progress by increasing virtuosity.

In Examples 8 to 11 we have a theme and variation form by Mozart in which the variations progress by contrast. The theme (Example 8) is binary, but only the first half of the theme is quoted.

EXAMPLE 8

THEME (andante grazioso)

Wolfgang Amadeus Mozart
Austrian (1756–1791)

In Variation I (Example 9) the melody is greatly changed by the use of rhythmic elaboration and chromatic intervals. Notice that whereas in the theme the durations of the notes are predominantly eighth and quarter notes, this variation consists largely of sixteenth notes.

EXAMPLE 9

VARIATION I

In Variation IV (Example 10) the greatest change is in the texture, which is thicker, and in the range, which is higher. Here the melody flows serenely because of the stepwise rise and fall of the melodic line and the eighth notes in the melody (although the accompaniment is in sixteenths).

EXAMPLE 10

VARIATION IV

In Variation VI (Example 11) changes occur in the meter, which become 4/4, and in the tempo, which is speeded up to *allegro*. The last half of the melody is treated quite differently from the first and acts as a finale, or grand flourish, to end the variations.

EXAMPLE 11

VARIATION VI (allegro)

In some variations, particularly those of the nineteenth century, greater freedom is taken. In Schumann's *Symphonic Studies* for piano, for example, there are only incomplete and irregular references to the theme throughout a set of short pieces (the "variations") that follow the theme.

Minuet and Trio

The minuet-trio form makes an easy introduction to the group of larger forms that use the ternary, or ABA, pattern. The first section, which is a minuet, is followed by a second, the trio, and then the minuet is heard again. Both the minuet and trio are in 3/4 meter and are binary. The trio is used as a bridge between the two minuets; since its function is to give a sense of contrast, it is frequently in a key different from that of the minuet and contains melodies of contrasting character. Traditionally the two halves of the first minuet are repeated, as are those of the trio; but there are no repetitions in the restatement of the minuet. This is true of Example 12, from Mozart's *Eine Kleine Nachtmusik* ("A Little Night Music"). In outline the form looks like this:

> A: Minuet—AABaBa (binary, repeated)
> B: Trio—CCDcDc (binary, repeated)
> A: Minuet—ABa (binary, once only)

EXAMPLE 12

Wolfgang Amadeus Mozart
Austrian (1756—1791)

Rondo

The rondo is also an outgrowth of the ABA form, but it is more extended. The main theme, or *refrain,* which is usually a full binary form, alternates with other themes, called "episodes." The *episodes* provide relief from the refrain and contrast in range, texture, and character between restatements of the refrain, and are most often in different keys. The rondo always begins and ends with the main theme.

The shortest possible rondo would be ABABA, or more commonly ABACA. There are numerous rondo designs, the most often used being ABACA or ABACABA, which is exactly balanced like an arch. Within these designs, the treatment may vary. In some rondos, the episodes are developments of musical ideas found in the refrain. In others the reappearance of the refrain is varied, much as it would be in variation form. In still others, when the refrain occurs in restatement, it may be in abbreviated form.

For some reason, many rondos which are the second movements of sonatas or symphonies are not labeled as rondos by the composers but merely given mood and tempo markings. Example 13 is the rondo of the second movement of Mozart's *Eine Kleine Nachtmusik.* The main theme is binary.

EXAMPLE 13

Sonata Form

Sonata form (also known as sonata allegro form, or first-movement form) is a large-scale dramatic form which is frequently used in the first movement of extended compositions with several movements. The form is based on two principal themes which appear in three large sections called the "exposition," "development," and "recapitulation." First-movement form is ternary in its broadest outline, because the recapitulation is a restatement of the themes heard in the exposition.

The *exposition* contains two principal themes and usually several subordinate themes. The main themes, themes A and B, are always in different keys and are connected by "extrathematic" music called a "transition." The *transition,* since it links two themes in different keys, is a "modulating" passage—that is, a passage designed to carry the music from one tonality to another tonality. After the two themes have been stated, there is usually a closing theme before the development.

In the *development* section the two themes are developed in any way the composer chooses. They may appear in new keys, be quoted only in part, be extended, be compressed, or be varied in any way. Often theme A is given preferential treatment, since it is the theme that introduces the form, although this is by no means necessarily the case.

The *recapitulation* is a restatement of the exposition with one important change: theme B is now heard in the same key as theme A. This allows the piece to end on the tonic, as it began.

There may or may not be a *coda* after the recapitulation. The coda used as a flourish to put a conclusive feeling to the end and often explores some phrase or thematic idea from one of the two themes (to this extent it is reminiscent of the development section). The coda always is in the tonic key or at least ends in the tonic key. The sonata form may be mapped as follows:

EXPOSITION
> Theme A, in tonic
>> Transition to theme B (with modulation to key of theme B)
>
> Theme B, in key of dominant or other related key
> Closing theme

DEVELOPMENT
> Varied use of theme A, theme B, or both in new keys, none which is allowed to assert priority over an extended period

RECAPITULATION
> Theme A in original key (tonic)
>> Transition to theme B (no modulation)
>
> Theme B, also in tonic

Example 14, the first movement of Mozart's *Eine Kleine Nachtmusik,* illustrates sonata form very clearly. The development section here is quite short.

EXAMPLE 14

repetition of B2

Closing theme

cadence on the dominant

DEVELOPMENT: Theme A in D major, modulating to

C major for second half of Theme B

modulating variously and

leading to a

traditional passage

RECAPITULATION:
Theme A1 in orig. Key

A2

Theme B 1, in tonic

B2

B2 repeated

The Suite

One of the earliest efforts in the attempt to create instrumental music of extended length was the suite, a collection of dances. In the seventeenth and eighteenth centuries there were usually five dances known collectively as the classical suite: (1) the *allemande*, a rather slow dance in duple meter; (2) the *courante*, a dance of simple rhythm and running passages in triple meter; (3) the *saraband*, a slow, stately, ceremonial dance in triple meter; (4) an optional dance, whose character and meter were not predetermined; and (5) the *gigue*, a fast, lively dance, like the English jig, in compound duple meter. These dances were held together as a unit in two ways: they were all binary and were all in the same key.

Not all suites follow the organization of the classical suite. For instance, in Bach's Suite No. 2 in B minor for flute and strings, the dances include a rondo, a saraband, a bourée (a French dance), a polonaise (a Polish dance), and a minuet. Furthermore, the suite opens with an overture, and ends with a badinerie, a playful piece of music.

The modern suite has no necessary connection with dance forms. It is a collection of separate pieces which have been put together because of some unifying idea, not necessarily musical. Bizet, for instance, put together excerpts from his opera in his *Carmen Suite*. Ravel's suite *Le Tombeau de Couperin* ("In Memory of Couperin") tries to evoke the spirit of former times. Rimsky-Korsakov based his symphonic suite *Schéhérazade* on the *Arabian Nights*. Prokofiev wrote a suite on the adventures of an imaginary figure, Lieutenant Kijé.

The Sonata

The sonata was developed after the suite. It is like the suite in that consists of a series of movements; but these movements, unlike the dance in a suite, are not all in the same key. Traditionally the sonata is made u of three or four movements, and there are very definite traditions concern ing each movement. The first, which is the longest and most complex, usually fast (*allegro*). In contrast, the second movement is slow an tuneful. The third is a dance; in the earlier sonatas the minuet was usec but in Beethoven's time the *scherzo*, which is faster and more vigorou than the minuet but in the same general form, usually replaced the minue It is usually the shortest of the four movements, and when a sonata ha only three movements, it is this one which is normally omitted. The fourt movement, like the first, is a fast movement, marked *allegro* or *presto*, bu it tends to be somewhat brighter, gayer, and less complex than the firs movement.

There are also definite traditions about the form of each movemen The first is usually in sonata form (so called because it is the most char acteristic movement of the sonata). The third, or dance, movement, if ther is one, is always in the minuet-trio (or scherzo-trio) form. For the secon and fourth movements, composers use various forms. Since the secon movement is slow and melodious, the variation form is a favorite; and th rondo form is often found in the last movement.

The sonata is most widely used for long, serious compositions. It given different names, when played on different instruments and wit different combinations of instruments, according to the instruments usec The word "sonata" itself is used when one or two instruments are in volved (as in a sonata for piano or a sonata for clarinet and piano). Th *symphony*, written for a symphony orchestra, is a "sonata" for orchestra The *concerto* is a "sonata" for soloist with symphony orchestra. A *strin quartet* (used as a name for a composition) is a "sonata" for four strin instruments.

Free Forms

There are also musical compositions which do not conform to one of th standard patterns. This is not to say, however, that they are devoid of form On the contrary, they are as carefully structured as the more standar forms; it is just that they tend to develop shapes unique to themselves Some of the names given to various types of such compositions are note in the following paragraphs.

THE PRELUDE This term originally referred to a piece meant to be playe before something else, such as the preludes of Bach (which precede mor complex, contrapuntal pieces, called "fugues") and the *Prelude to Lohengri* by Wagner (which precedes his opera *Lohengrin*). But the word has no become less definite. The preludes of Chopin, for instance, are not prelude

to anything, but independent pieces. The word now enjoys both meanings: a piece to be played before something else, and a separate piece.

THE IMPROMPTU This is really a contradiction in terms, for an impromptu purports to be extemporaneous, which it obviously cannot be, since it is written down and published. However, it has connotations of spontaneity and of rather slight organization.

THE NOCTURNE This is a piece which is supposed to suggest the atmosphere of night. The best known examples are those for the piano by Chopin.

THE ÉTUDE The étude is a technical study, usually of great difficulty. It became important at the time of Chopin and Liszt (nineteenth century).

PROGRAM MUSIC

In Chapter 2, program music was defined as music with subject matter, and little needs to be added to that discussion. However, we may note that program music generally falls into three classes: the imitative, the descriptive, and the narrative.

Imitative music imitates the actual sound of the subject, as in Rimsky-Korsakov's *Flight of the Bumblebee.*

Descriptive music is typified by Beethoven's Symphony No. 6, called the *Pastoral Symphony.* The work describes a day in the country, with a festive gathering of country people. Their pleasure is interrupted by a storm which soon subsides, and the festivities are resumed. Beethoven's own program, usually printed with the symphony, is as follows:

Pastoral Symphony, or a recollection of country life (more an expression of feeling than a portrayal):

1. *Allegro ma non troppo*—The cheerful feelings aroused by arrival in the country
2. *Andante molto mosso*—Scene by the brook
3. *Allegro*—Peasants' merrymaking
4. *Allegro*—Storm
5. *Allegretto*—Shepherd's song: glad and thankful feelings after the storm

In this class, too, belong compositions which try to distill the feeling or atmosphere of a scene, for example, Debussy's "Clair de Lune," which evokes moonlight.

Narrative music attempts to tell a story, or at least to give a musical impression of the story. *The Sorcerer's Apprentice,* by Dukas, which tells the old story of the person who starts a magic charm going and then cannot

stop it, is an example. A common type of narrative music is the *symphonic poem,* or *tone poem,* an orchestral work based upon a story taken from literature. It is of the length and complexity of a symphony but has no prescribed form. The tone poems of Richard Strauss, such as *Don Juan* and *Till Eulenspiegel's Merry Pranks,* are well-known examples of this type.

GENRE

The word *genre* refers not to the particular form of a piece, but rather to the general type of music to which the piece belongs. Thus we distinguish between such different genres as folk music and art music, popular and classical music, vocal and instrumental music, etc. We shall now consider some of the more common vocal genres.

Folk Music and Art Song

A song in the broadest sense is anything sung. *Folk songs* are the songs of the folk, or people. They are communal in that they are the property of the entire community and express the life of the community. Everybody knows them and everybody sings them. They show no trace of individual authorship, or if they ever did, these traces have been lost throughout long ages of singing.

An *art song,* on the other hand, is the work of an individual composer and as such shows his individuality. The German word for song is *Lied* (plural, *Lieder*), and since many of the greatest writers of art songs were German or Austrian (e.g., Schubert, Schumann, Wolff, and Brahms), we refer to their songs as *Lieder.* Each composer tries to make the music of his song fit the words he chooses (which are usually from a poem not written by the composer), but his song is nevertheless characteristic of himself. A song by Schumann is not like one by Schubert. Nevertheless certain songs by certain composers have so much of the simplicity and spontaneity of folk songs that they are accepted and sung by the people as their songs. Such songs are classed as folk songs and are usually found in volumes of folk songs. Examples are the American "Swanee River" and the Bohemian "Songs My Mother Taught Me."

Folk songs are often classified according to subject as hunting songs ("John Peel"), cowboy songs ("Home on the Range"), spirituals ("Nobody Knows de Trouble I See"), etc. They are also classified according to the country from which they come: The "Volga Boatman" is Russian, "Auld Lang Syne" is Scottish, etc.

Folk songs and art songs both follow one of two basic kinds of formal treatment. In *strophic form* the same music is repeated exactly for each stanza. In "Barbara Allen," for example, the same music is used whether one is singing of the "merry month of May," Barbara's scorn of her lover, or her death. The only differences that can be introduced are in dynamics, general expression, and tempo.

In *continuous form*, new music is adapted to each stanza of verse. However, repetition of musical phrases or motives may be and often is used in continuous form. Schubert's Lied *Der Erlkönig* ("The Erl-King") is a classic example of continuous form. Here is the text:

Wer reitet so spät durch Nacht und Wind?
Es ist der Vater mit seinem Kind.
Er hat den Knaben wohl in dem Arm,
Er fasst ihn sicher, er hält ihn warm.

Mein Sohn, was birgst du so bang dein Gesicht?
Siehst, Vater, du den Erlkönig nicht?
Den Erlenkönig mit Kron' und Schweif?
Mein Sohn, es ist ein Nebelstreif.

"Du liebes Kind, komm, geh mit mir!
Gar schöne Spiele spiel' ich mit dir.
Manch' bunte Blumen sind an dem Strand,
Meine Mutter hat manch gülden Gewand."

Mein Vater, mein Vater, und hörest du nicht.
Was Erlenkönig mir leise verspricht?—
Sei ruhig, bleibe ruhig, mein Kind:
In dürren Blättern säuselt der Wind.—

"Willst, feiner Knabe, du mit mir gehn?
Meine Töchter sollen dich warten schön;
Meine Töchter führen den nächtlichen Reihn
Und wiegen und tanzen und singen dich ein."

Mein Vater, mein Vater, und siehst du nicht dort
Erlkönigs Töchter am düstern Ort?—
Mein Sohn, mein Sohn, ich seh' es genau:
Es scheinen die alten Weiden so grau.—

"Ich liebe dich, mich reizt deine schöne Gestalt;
Und bist du nicht willig, so brauch' ich Gewalt."
Mein Vater, mein Vater, jetzt fasst er mich an!
Erlkönig hat mir ein Leids getan!—

Dem Vater grauset's, er reitet geschwind,
Er hält in den Armen das ächzende Kind,
Erreicht den Hof mit Mühe und Not—
In seinen Armen das Kind war tot.

> —Johann Wolfgang von Goethe (1749–1832, German poet, dramatist, and novelist), "Der Erlkönig"

Who gallops so late through wind and night?
A father bearing his son in flight;
He holds him tightly, breasting the storm,
To bear him safely and keep him warm.

"My son, why bury your face thus in fear?"
"Don't you see, father, the Erl-King draw near,
The king of spirits, with crown and with shroud?"
"My son, it is a wisp of cloud."

"My darling child, come, go with me!
I'll play the finest games with thee.
The brightest flowers grow on the shore;
My mother has clothes of gold in store."

"My father, my father, but surely you heard
The Erl-King's whisp'ring, promising word?"
"Be quiet; there is nothing to fear:
The wind is rustling through thickets sere."

"Wilt thou come with me, my boy, away
Where my daughters play with thee night and day?
For my daughters shall come in the night if thou weep
And rock thee and dance thee and sing thee to sleep."

"My father, my father, but do you not see
His daughters lurking by yon dark tree?"
"My son, my son, it is only the light
Of old willows gleaming gray through the night."

"I love thee so, thy beauty leaves no other course,
And if thou'rt not willing, I'll take thee by force."
"My father, my father, he drags me from you;
Erl-King has seized me, and hurts me too."

The father shudders; he spurs through the wild.
His arms strain closer the weak, moaning child.
He gains his home with toil and dread—
Clasped in his arms there, the child was dead.

> —Translated by Calvin Brown[2]

In Schubert's music we hear the galloping of the horse and the thunder of the storm. The voices of the three characters are carefully differentiated: the father's voice is low, calm, assured; the child's voice is high-pitched, afraid, curious, wondering: the erl-king's voice is pleading and ingratiating until he announces that he will take the child by force, when it becomes brusque and harsh. At the end of the song, the galloping and thunder, which have continued throughout, suddenly cease as the father arrives home and finds that the boy is dead.

Almost all folk songs are in strophic form. Art songs are both strophic and continuous. "The Erl-King" has been cited as an example of continuous form; Schubert's *Ständchen* ("Serenade") and *Haiden-Röslein* ("Hedge-roses") are in strophic form.

[2] Calvin Brown, *Music and Literature*, pp. 71–72. Courtesy of Mr. Brown and the University of Georgia Press.

A special type of art song is the *aria*, which is a set piece for solo voice taken from an opera, oratorio, or cantata (which we will discuss next). It may be either strophic or continuous; and it frequently is of considerable technical difficulty—a sort of "showpiece" for the singer, although this is not necessarily the case.

Opera

Opera was originally conceived (ca. 1600) as an attempt to reproduce the effect of the Greek drama in a kind of musical speech called "recitative." The voices followed the accents and natural inflections of speech, but in musical tones. This recitative is more like chant than any other form of music today. The first operas were largely composed of recitatives, and were thus of limited musical interest. Accordingly, songs, or arias were introduced to break the monotony: solos, duets, trios, quartets, choruses, etc. For a time the drama lost its importance, and the music was everything. At this time Gluck (1714–1787), known as the first "reformer" of opera, brought drama back into prominence and insisted that the singers be subordinate to the plot. At the same time he continued to stress recitative and had many set and separable songs and choruses. This concept of opera is also to be seen in the great operas of Verdi and Mozart. Drama is emphasized, and the music still contains some recitative; but there are also arias, duets, and choruses—that is, set pieces which can be detached from the drama and sung in concert. As examples we can cite the arias "Caro nome" from *Rigoletto* and "Celeste Aïda" from *Aïda,* as well as the "Soldiers' Chorus" from *Faust* and the sextet from *Lucia.*

A new and different kind of opera was inaugurated by Wagner. He attempted to make a more unified work, with music and drama of equal importance, and therefore preferred to call his works "music dramas" rather than operas. The voices and the orchestra combine to tell the story. In this way the orchestra, which supplies a kind of musical comment on the action of the story, becomes particularly important. The music is continuous: it is not interrupted for set arias and ensembles by the singers. The vocal line, in fact, is treated almost like an orchestral line, and often the voices are subordinate to the orchestra. The action, too, is continuous: there is no pause from the beginning of an act to the fall of the curtain.

In addition, Wagner devised a new type of musical development. Each character and many of the important objects, places, and ideas in the drama have a musical motive called a "leitmotiv" attached to them: "the sword," "the rainbow," "the ring," "the Rhine," and even such abstractions as "fate." The entrance of a character is announced by his theme in the orchestra, and often the music tells us what the characters themselves do not know. In *The Valkyrie,* for example, when Siegmund is lying in Hunding's house, desolate because he has no sword, the music fairly shouts the sword theme, calling our attention, if not his, to the sword in the tree beside him.

There are a number of distinct types of opera, three of which a
basic: *grand opera* always has a serious subject, is usually tragic, and ha
no spoken dialogue (an example is *Aïda*). *Comic opera* is any opera havin
spoken dialogue, regardless of whether it is comic or not (*Carmen* is a
example). The term derives from that for French comic opera havin
spoken dialogue (*opéra comique*). The third type is *operetta*, which
synonymous with musical comedy or light opera. The subject may be trag
or comic, and there is spoken dialogue. Generally speaking, the music
not as ambitious as in serious opera, and the demands made on th
musicians are much lighter (*The Merry Widow* and *South Pacific* are e
amples).

Oratorio

Oratorio, like grand opera, is an extended piece of music employing th
resources of the orchestra, chorus, and solo singers. It differs from oper
in many ways, however. The subject is usually biblical, and in many of th
great oratorios the words are taken directly from the Bible. Handel'
Messiah and Mendelssohn's *Elijah* are outstanding examples.

Whereas operas are enacted on the stage, the oratorio is sung in con
cert without costume, stage sets, or lighting. The chorus and soloists f
the oratorio are on the stage, and each singer rises when he is to perform
but there is no acting out of the text as it is sung. The recitative is usuall
of greater importance in an oratorio than in modern opera; each aria i
preceded by its recitative. The choruses tend to be polyphonic in structur
and, as befits the subject, are serious and powerful, like the "Halleluja
Chorus" from the *Messiah*, or "The Heavens Are Telling" from Haydn'
Creation. The choruses from opera are likely to sound less serious tha
the choruses of an oratorio. We can see this in the "Soldiers' Chorus
from *Faust*, and the "Anvil Chorus" from *Il Trovatore*, and even th
"Triumphal March" from *Aïda*.

The *cantata* and the *passion* are special forms of the oratorio.
cantata is a small oratorio which may be secular in subject. The subject c
a passion, as the name suggests, is the agony and death of Christ. Th
words follow the text of one of the Gospels. Passions are not numerous
Two of the greatest are Bach's *Passion According to St. John* and *Passio
According to St. Matthew*. A recent example is Penderecki's *Passion Ac
cording to St. Luke*.

Mass

The Mass has been discussed earlier as an essential part of the liturgy o
the Catholic Church, and its five parts were named in Chapter 7. From
very early times the Mass has been set to music, and some of the greates
music of the world has been composed for the Mass. In its music we fin
illustrations of the three great periods in the history of Western music
From the earliest period (before A.D. 1000) we have masses written i

Gregorian chant, which is simple, unaccompanied melody. Disembodied, aspiring, and unworldly, these masses are absolutely cut off from any secular considerations. In the polyphonic period (ca. 1000–1600) we have the great masses of Josquin and Palestrina. In the later periods (from ca. 1600) we have masses of Beethoven and Mozart, and in our own day of Stravinsky and Bernstein.

The *requiem mass* is celebrated for the repose of the dead. It gets its name from the first words of the text: *"Requiem aeternam dona eis, Domine"* ("Give to them, O Lord, eternal rest"). Among requiems we may mention those of Brahms, Verdi, and Mozart, and Benjamin Britten's *War Requiem.*

To summarize our discussion of form, it may be said that form, described in the most general terms, is that which gives music a sense of unity, order, and coherence; in the last analysis, it is the characteristic of music which distinguishes it from all other sound. Indeed, it is only the fact that sound lends itself to formal organization which explains its suitability as a basic material for one of the arts, and which accounts for its presence in some of the most significant artistic expression of our civilization.

16. ORGANIZATION IN LITERATURE AND DANCE

THE BASIS OF PLAN IN LITERATURE

Organization in music and literature is largely a matter of memory and anticipation. We remember what we have heard, and, on the basis of that, we anticipate what is to come. In music, we know when we hear a theme that we have or have not heard it, but we can rarely be very definite. We do not recall the themes and arrangements of music easily. Hence our memories and anticipations are not very clearly formulated. In literature, on the other hand, we remember the events and the ideas of a work clearly and exactly, and we retain the entire organization in our minds with very little difficulty. Therefore, we know the organization of literature much better than we do that of music. And we demand in literature a logical organization. Take, for instance, this sonnet of Shakespeare's:

When, in disgrace with Fortune and men's eyes,
I all alone beweep my outcast state,
And trouble deaf heaven with my bootless cries,
And look upon myself and curse my fate,
Wishing me like to one more rich in hope,
Featur'd like him, like him with friends possess'd,
Desiring this man's art, and that man's scope,
With what I most enjoy contented least;

Yet in these thoughts myself almost despising,
Haply I think on thee; and then my state,
Like to the lark at break of day arising
From sullen earth, sings hymns at heaven's gate;

For thy sweet love rememb'red such wealth brings
That then I scorn to change my state with kings.

> —William Shakespeare (1564–1616, British poet and dramatist),
> Sonnet 29 (publ. 1609)

There is a decided break between the octave and the sestet. In the octave—the first eight lines—the speaker is sad and discouraged. The sestet—the last six lines—says that the speaker's heart soars when he thinks of his love. Moreover, the two quatrains of the octave are clearly differentiated. The first quatrain states the trouble generally; the second gives details. In the sestet, the quatrain relates the change of spirit, and the couplet at the end sums up the whole.

There are as many logical ways of ordering the content of a work of literature as there are of thinking. Sometimes a writer begins with the least important content and goes on to the most important. Sometimes he begins with the simple and goes on to the difficult or complicated. Cause usually precedes effect. In Milton's sonnet "On His Blindness," the octave asks a question and the sestet gives the answer. In the Shakespearean sonnet just quoted, there is the statement of a difficulty and its solution. The writer arranges his ideas in the manner that will make them say what he wants them to say. It is not necessary that the author follow any one particular plan; it is only necessary that there be a logical plan and that it be reasonably clear.

ARGUMENTATION AND EXPOSITION

Argumentation includes all forms of writing that are made with the express purpose of influencing others to do or say or think as the writer wishes. In older times arguments were usually spoken; and the sermon, the oration, and the debate were the usual forms. Since the spread of printing, editorials and articles in newspapers and magazines have competed powerfully with the spoken word. With the development of radio and television people were again commonly reached with the immediacy of the spoken word. Numerous examples may be found, particularly from the time of World War II: the "fireside chats" of President Franklin D. Roosevelt, the heartbroken speech of King George VI announcing England's entrance into the war, the news broadcasts from beleaguered London by Edward R. Morrow, and the exhortations of Prime Minister Winston Churchill—these are not easily forgotten (see page 240). In the period since World War II, television broadcasting has given a new dimension to the spoken address. President John F. Kennedy's inaugural address (1961), with its youthful enthusiasm and sense of dedication, appealed directly to millions of listeners and indeed can stand as a symbol of the new era of communications. Today almost no political event can take place without occasioning a televised message to the public.

Exposition expounds, or explains. Thus it is the fundamental form for all scientific writing. In pure literature it is found chiefly in the treatise and the essay. The treatise is a longer, more thorough, and more finished study than the essay.

The word *essay* was first used by Montaigne, who called his writings "*essais*," or "trials." An essay is an incomplete or partial treatment of a subject. Essays are classified according to subject, as familiar, historical, literary, philosophical.

The *familiar essay* was made popular by Lamb and has kept to this day many of the characteristics he gave it. It is always short and always personal. It is frequently humorous, sometimes sad or pathetic. The subjects chosen are often trivial or fantastic; the interest lies in the presentation of a point of view that is not the usual commonsense, commonplace one. Cowper, for instance, tells of the characteristics of a card table that had grown old in the service of his house; Lamb writes of the children he never had; Stevenson makes a defense of idlers. Always the writer takes a philosophic point of view; he is calm and enjoys the pleasures of the moment; or, if there are difficulties, his attitude toward them is one of acceptance and calm, not of protest.

Many books which are expository in nature do not fit into the category of either essay or treatise. Among these are books of political ideas, such as Plato's *Republic* or Machiavelli's *Prince;* statements of philosophy, such as the *Noble Truths* of Buddha or the dialogues of Plato; and statements of practical wisdom, such as the *Meditations* of Marcus Aurelius and the sayings of Epictetus. To this class also belong books of devotion, such as the *Confessions* of S. Augustine and *The Imitation of Christ* by Thomas à Kempis.

THE LYRIC

The lyric is a poem which expresses a single emotion. It is frequently short, like Landor's four-line poem "On Death":

Death stands above me, whispering low
 I know not what into my ear:
Of this strange language all I know
 Is, there is not a word of fear.
 —Walter Savage Landor (1775–1864, British poet, literary critic,
 and prose writer)

However, it may be a poem of several pages, like Wordsworth's "Ode on Intimations of Immortality." Sometimes the emotional quality is preserved in what is only a fragment, not a complete poem at all, as in these lines from Sappho:

Before the lovely queen each night
The stars in shyness hide their face
As all the earth swims soft and bright
And the full moon rides in her place.
　　　—Sappho (about 600 B.C., Greek lyric poet)[1]

Love and death are the two favorite subjects of lyrics, though any subject may be used. Dylan Thomas tells of his reasons for writing poetry:

In my craft or sullen art
Exercised in the still night
When only the moon rages
And the lovers lie abed
With all their griefs in their arms,
I labour by singing light
Not for ambition or bread
Or the strut and trade of charms
On the ivory stages
But for the common wages
Of their most secret heart.
Not for the proud man apart
From the raging moon I write
On these spindrift pages
Nor for the towering dead
With their nightingales and psalms
But for the lovers, their arms
Round the griefs of the ages,
Who pay no praise or wages
Nor heed my craft or art.
　　　—Dylan Thomas (1914–1953, British poet),
　　　"In My Craft or Sullen Art" (1945)[2]

And Hopkins writes of the grandeur of God:

The world is charged with the Grandeur of God.
　It will flame out, like shining from shook foil;
　It gathers to a greatness, like the ooze of oil
Crushed. Why do men then now not reck his rod?
Generations have trod, have trod;
　And all is seared with trade; bleared, smeared with toil;
　And wears man's smudge and shares man's smell: the soil
Is bare now, nor can foot feel, being shod.

And for all this, nature is never spent;
　There lives the dearest freshness deep down things;

[1] Translated by Marjorie Carpenter.
[2] From *The Collected Poems of Dylan Thomas*, copyright 1953, by Dylan Thomas, and reprinted by permission of the publisher, New Directions, and J. M. Dent & Sons, Ltd.

And though the last lights off the black West went
 Oh, morning, at the brown brink eastward, springs—
Because the Holy Ghost over the bent
 World broods with warm breast and with ah! bright wings.

 —Gerard Manley Hopkins (1844–1889, British poet),
 "God's Grandeur" (between 1876 and 1889)[3]

In the lyric we have the most pronounced use of the various devices of literature, such as assonance, alliteration, meter, rhythm, rhyme, simile, imagery, metaphor, and all the figures of speech. According to Suzanne Langer, the reason why lyric poetry draws so heavily on these devices is that it has so little content in itself. It is "usually nothing more than a thought, a vision, a word, or some other poignant emotion."[4] But because of all these devices it becomes the form in which exact wording is most important. We want to repeat and sing to ourselves separate lines such as these:

It is the blight man was born for,
It is Margaret you mourn for.

Of his strange language all I know
Is, there is not a word of fear.

Fair as a star, when only one
Is shining in the sky.

In drama and the novel one may forget *how* an event was told in the interest of the event itself, but not in the lyric.

A lyric is usually written in the first person: "Death stands above *me*," "Oh the difference to *me*," "In *my* craft or sullen art." And yet it is not in itself personal. We do not feel that we are intruding on the writer. Once the song is written, it is a song for everyone. It acquires a certain timelessness; it lives in a "sort of eternal present."[5]

I'm going out to clean the pasture spring;
I'll only stop to rake the leaves away
(And wait to watch the water clear, I may):
I sha'n't be gone long.—You come too.

I'm going out to fetch the little calf
That's standing by the mother. It's so young,

[3] From *Poems of Gerard Manley Hopkins*, Oxford University Press, Copyright 1948.
[4] Suzanne Langer, *Feeling and Form*, p. 259.
[5] *Ibid.*, p. 268.

It totters when she licks it with her tongue.
I sha'n't be gone long.—You come too.
—Robert Frost (1875–1963, American poet), "The Pasture"[6]

Even when Marianne Moore writes about her father, as in "Silence," the result is not strictly speaking personal, but universal.

My father used to say,
"Superior people never make long visits,"
have to be shown Longfellow's grave
or the glass flowers at Harvard.
Self-reliant like the cat—
that takes its prey to privacy,
the mouse's limp tail hanging like a shoelace from its mouth—
they sometimes enjoy solitude,
and can be robbed of speech
by speech which has delighted them.
The deepest feeling always shows itself in silence;
not in silence, but restraint.
Nor was he insincere in saying, "Make my house your inn.'
Inns are not residences.
—Marianne Moore (1887–1972, American poet), "Silence"[7]

NARRATIVE

The narrative probably comprises more examples of pure literature than all the other types put together, and with good reason. All the world loves a lover, and it is equally true that all the world loves a story. The formula "once upon a time" still has magic to lure us all, young and old.

Plot

The essentials of a narrative are the essentials of every story. First is action, or conflict. The narrative begins with the emergence of a situation that demands solution. Something has happened to disrupt the established order. There will be anxiety, tension, and frustration until the problem is solved. The problem itself may be of any kind—finding a dead body, as in a detective story; falling in love; spending the night in an open boat. The occasion is not limited. It may be serious or frivolous. Chaucer tells a story of three rioters who went out to hunt death and found it. Cervantes tells of the adventures of an old knight who fought windmills.

[6] From *Complete Poems of Robert Frost*, Copyright 1930, 1939 by Holt, Rinehart and Winston, Inc. Copyright 1958 by Robert Frost. Reprinted by permission of Holt, Rinehart and Winston, Inc.
[7] From *Collected Poems* by Marianne Moore. Reprinted with permission of the Macmillan Company. Copyright 1953, Marianne Moore. Copyright renewed 1963 by Marianne Moore and T. S. Eliot.

Whatever the story, it is related in a series of incidents each of which has some relation to the solution of the main problem, and each of which must be credible in terms of that problem. Each of these incidents will bring new knowledge and help reach the solution. This is the *plot*.

Sometimes there are two plots that run side by side; we find this often in Shakespeare's plays. *King Lear* is a good example. In this play the two plots are bound together so that each helps the other; but in addition one is definitely more important than the other. In Tolstoi's *Anna Karenina* the main plot is concerned with the unhappy love of Anna and Vronsky, but counter to them runs the contented life of Levin and Kitty.

Characters

There can be no plot without actors, and so the second requirement of a narrative is *characters*. There must be people who are concerned in the main plot; they are the characters of the story. They answer the question: Why do people do what they do? And every incident should throw light on the characters. Why did the three rioters set out to find death, and how did the old man know where they would find it? Why did Don Quixote charge the windmill? The characters of a narrative usually are human beings. When the characters are animals, the animal names are fundamentally disguises for human beings, as the hen and the rooster in Chaucer's *Tale of the Nun's Priest*. The hen and the rooster, although essentially true to what we know of fowls, nevertheless talk and act as do men and women. Chanticleer shows all the characteristics in which a man is most like a cock, and Pertelote is the eternal feminine. George Orwell's *Animal Farm* (1946) is another example of the use of animal characters; here again these characters are human beings in animal form.

Setting

The setting gives the time and place of the action. The time is always past. It is always "once upon a time." It may be any time in the past, provided it is past. The place may be any place at any time. Jules Verne writes of what happens twenty thousand leagues under the sea; Butler in *Erewhon* tells of people who live in a land that is as logical as ours is illogical. Writers of all ages have told of the land of the dead.

The setting comprises not only the physical character of the place—country, city, lake, etc.—but also all the beliefs, customs, and moral and social values that make up what we usually call the "environment." No matter where it is placed, the setting should fit the action; it should be a place in which those events might take place. Ivanhoe does not belong in *Tom Jones,* and Elizabeth Bennet of *Pride and Prejudice* would not fit in *Main Street.*

Theme

Plot, characters, setting are found in every narrative, but they are not of equal importance. Any one of the three may in some narrative be of greater importance. In *An American Tragedy,* by Theodore Dreiser, the boy is the victim of his environment. Eldridge Cleaver's *Soul on Ice* (1968) is another narrative in which environment—the penitentiary and the ghetto life which brought the narrator to it—is of utmost importance. In Stevenson's *Treasure Island* the action is most important. In Thackeray's *Vanity Fair* the characterization is most important.

All depends on the author's *theme.* This is his point of view, his idea about the tale, what he is trying to say in the story—in short, his understanding of life. This of course is the basis by which action, characters, and setting have been determined. The author decides what kind of character belongs in *Main Street,* and he draws the picture that way.

Narrator

The question "Who is telling the story?" has to do with the *narrator.* There are two favorite devices. One is the omniscient narrator, who knows everything about each character—all he says, does, or thinks. There is never any indication as to who this narrator is or how he gets his information. The other favorite device is to have the story told in the first person by some character who is actually taking part in it.

In the early days of prose fiction the letter or journal was much liked as a way of telling the story. Richardson's *Pamela* is narrated by the heroine in the form of a series of letters to her friend. James Baldwin's nonfictional *Notes of a Native Son* (1955) is in a form very like that of a diary.

Many good techniques for writing a story have to do with the narrator or narrators. A writer need not keep the same narrator throughout the story. In Faulkner's novel *The Sound and the Fury* the first chapter is told by a halfwit. Later material is narrated by a Negro nurse and cook. At the end, Faulkner uses the omniscient narrator.

Ways of Telling a Story

Within the general framework of the narrative there are many ways of telling a story and hence of changing the plan. Ordinarily a narrative starts at the beginning and goes through to the end. *Pride and Prejudice* begins when strangers move into the community and Elizabeth and Darcy have a chance to meet each other, and it continues through many different events until they are safely married at the end. *Vanity Fair* begins when Becky Sharp leaves boarding school as a young girl, and it carries her through all her adventures until she is an old woman.

This is the method followed in the ballad "Sir Patrick Spence." The story is presented in three scenes: the first is at the court when the king and the old knight are discussing plans for the trip; the second is on the seashore when Sir Patrick hears the message and suspects foul play; the

third jumps to the ending after the lords and their ship have gone down. Except for the third stanza, however, there are no connecting links between one part and the other; the reader must guess from the context what has happened.

The king sits in Dumferling toune,
 Drinking the blude-reid wine:
"O whar will I get guid sailor,
 To sail this schip of mine?"

Up and spake an eldern knicht,
 Sat at the kings richt kne:
"Sir Patrick Spence is the best sailor,
 That sails upon the se."

The king has written a braid letter,
 And signd it wi his hand,
And sent it to Sir Patrick Spence,
 Was walking on the sand.

The first line that Sir Patrick red,
 A loud lauch lauched he;
The next line that Sir Patrick red,
 The teir blinded his ee.

"O wha is this has don this deid,
 This ill deid don to me,
To send me out this time o' the yeir,
 To sail upon the se!

"Mak hast, mak hast, my mirry men all,
 Our guid schip sails the morne:"
"O say na sae, my master deir,
 For I feir a deadlie storme.

"Late late yestreen I saw the new moone,
 Wi the auld moone in her arme,
And I feir, my deir master,
 That we will cum to harme."

O our Scots nobles wer richt laith
 To weet their cork-heild schoone;
But lang owre a' the play wer playd,
 Thair hats they swam aboone.

O lang, lang may their ladies sit,
 Wi thair fans into their hand,
Or eir they se Sir Patrick Spence
 Cum sailing to the land.

O lang, lang may the ladies stand,
 Wi thair gold kems in their hair,
Waiting for thair ain deir lords,
 For they'll se thame na mair.

Haf owre, haf owre to Aberdour,
 It's fiftie fadom deip,
And thair lies guid Sir Patrick Spence,
 Wi the Scots lords at his feit.

 —Anon., "Sir Patrick Spence"

The time sequence may, however, also be altered. William Faulkner's story *A Rose for Emily* (1930) begins with the death of Miss Emily and then goes back to tell the story of her life, her old-South aristocratic manner, and her relations with her neighbors.

Sometimes we see one character through the eyes of another, and our understanding of that character changes as our informant learns to know him. In Henry James's *Portrait of a Lady* we see one of the main characters, Madame Merle, through the eyes of the heroine, Isabel Archer. At first Madame Merle is glamorous; then, as Isabel begins to see her more clearly, we learn of her faults and shortcomings.

Another device is to present the story as it was known to different people. This method is used by Browning in *The Ring and the Book*. An old count is tried for the murder of his young wife, who had fled to the home of her foster parents in company with a young priest just before the birth of her son. In the twelve books of the poem Browning tells the story as it appears to many different people—the casual bystander, the wife, the priest who helped her escape, the husband when he appears in court for the trial, the husband just before he is executed for the murder, the Pope before whom the case is tried, and others.

Again, the story may be related a long time after the events have taken place. This is the method followed by Conrad in *Youth:* Marlowe, an old man, tells about the experiences of his youth. It is also used by T. S. Eliot in "The Journey of the Magi," in which one of the wise men remembers his journey to Bethlehem. One of the advantages of this plan is that the narrator can intersperse with the events comments and explanations, criticism and evaluations.

In recent years there has been much emphasis on a new type of narrative—the "stream of consciousness" method—in which all matters are presented in an uninterrupted flow of ideas, sensations, memories, and associations, as they would be presented to the consciousness of any one person. James Joyce and Virginia Woolf are but two of a large number of modern writers who have used this method of writing.

In another modern type of narrative, there is not one sequence of events; instead events are presented in a kaleidoscopic series of pictures focusing on different occurrences of the story. In *John Brown's Body*, for instance, Stephen Vincent Benét paints a picture of the Civil War by giving short scenes that tell what was happening to various people at various times. There is no attempt to make connections among all these scenes, but they all work together to make a unified whole which gives a composite picture.

Types of Narrative Poetry

EPIC Of all the types of narrative, the *epic* is one of the most distinct. It is also one of the rarest. An epic is a long, dignified poem in lofty style; its hero is of more than ordinary strength, and his deeds are of consequence to an entire nation. The authentic, or natural, epic is the product of an age of heroes, of a people just emerging from barbarism, when the individual, as an individual, performed deeds that were or seemed to be superhuman. In the *Iliad*, Achilles and Hector fight side by side with the gods, and are by no means inferior to them. Beowulf, in a foreign country, hears of the damage being done by the monster Grendel and goes across the sea to fight him.

The authentic epic probably originated as a series of songs in praise of the hero, which were later joined into one poem. The author or authors are often not known; if a name, such as Homer, is attached to an epic, it is merely a name, for the poetry does not reflect the personality of the poet. The authentic epic is, as has been said, extremely rare. The *Iliad*, the *Odyssey, Beowulf*, the *Song of Roland, Le Cid*, and the *Songs of the Nibelung* almost complete the list for Western literature.

The literary, or artificial, epic is the work of a single, conscious literary artist. We would expect it to be more common than the authentic epic, but it is not. Vergil's *Aeneid* and Milton's *Paradise Lost* are two works that are given the title "epic" without dispute. The literary epic has a conscious purpose. Vergil is trying to arouse in the people a greater reverence for the gods, the country, and the family. Milton is trying to "justify the ways of God to man."

ROMANCE The medieval romance is, as the name implies, a product of the Middle Ages, being, par excellence, the literary expression of chivalry. It has been defined as a story of love and adventure, or of adventure for the sake of love. Spenser chooses a typical romance subject for *The Faerie Queene*. A lady appears at the court of Arthur asking redress for the great wrongs done to her father and mother; a knight springs up, volunteering for the expedition. He and the lady have many adventures, and in the end the parents are released, and the knight and the lady are married. The medieval romance is usually in verse, though it is sometimes in prose. The fifteenth-century collection made by Malory, *La Morte d'Arthur*, is in prose.

In the age of romanticism the romance was revived, and many authors —Keats, Byron, Swinburne, Tennyson, and others—began to write romantic tales of knights and ladies or other faraway, strange, and ancient people.

The term *romance*, as distinguished from the medieval romance or its modern revival, is used for any work of fiction in which the emphasis is on plot, such as Stevenson's *Treasure Island*. A romance may be either in prose or in verse.

THE BALLAD The ballad is a story told in song. The folk ballad is the story of an important event, told dramatically, and intended for popular

singing. The subject may be any conspicuous event: the death of a suitor, the betrayal of a sister, the hunting of the cheviot, or the adventure of a hero. As in all folk songs, the author is of no importance, and hence he is not usually known.

"O where ha'e ye been, Lord Randal, my son?
O where ha'e ye been, my handsome young man?"
"I ha'e been to the wildwood; mother, make my bed soon,
For I'm weary wi' hunting, and fain would lie down."

"Where gat ye your dinner, Lord Randal, my son?
Where gat ye your dinner, my handsome young man?"
"I dined wi' my true-love; mother, make my bed soon,
For I'm weary wi' hunting, and fain would lie down."

"What gat ye to your dinner, Lord Randal, my son?
What gat ye to your dinner, my handsome young man?"
"I gat eels boiled in brew; mother, make my bed soon,
For I'm weary wi' hunting, and fain would lie down."

"What became of your bloodhounds, Lord Randal, my son?
What became of your bloodhounds, my handsome young man?"
"O they swelled and they died; mother, make my bed soon,
For I'm weary wi' hunting, and fain would lie down."

"O I fear ye are poisoned, Lord Randal, my son!
O I fear ye are poisoned, my handsome young man!"
"O yes, I am poisoned; mother, make my bed soon,
For I'm sick at the heart, and I fain would lie down."
 —Anon., "Lord Randal"

In most ballads, as in "Lord Randal," there is a great deal of repetition, probably because it made the singing easier. This repetition is not exact; each recurrence of a phrase carries the story forward a little. Here, for example, each question adds to our knowledge of Lord Randal's day until we know the truth in the last stanza. The ballad seldom tells a story directly from beginning to end. In "Lord Randal" we begin at the end and learn by degrees what had happened earlier. The ballad form is also used by literary artists; with them it approximates the folk song more or less closely, as in Coleridge's *Rime of the Ancient Mariner*.

Prose Fiction

NOVEL In contrast to the romance, which deals with the strange and unusual, the spectacular and the aristocratic, the novel has to do with the relations of people to each other. It is not so much concerned with how things are done as with why they are done. It presents a series of actions which show why a character does a certain thing, and accomplishes this largely through showing the choices he makes. We learn of his considera

tions, assertions, arguments, demonstrations, and deliberate reflections—the conclusions that determine thought. A story so conceived and made alive is often more vivid than actual experience. Often life seems "stale, flat, and unprofitable," but the interest in a novel must not fall. The people of the book may be dull, but not the book itself. It must have what Henry James called "felt life." The excellence of the novel lies in its life, in its seeming truth, its unity. If it seems to be a true picture of life, if the characters move and work and make the decisions that are true to their natures, we say the novel is true and good.

The novel is a recent form; the earliest works that belong strictly to the type are those of Richardson and Fielding in the eighteenth century. As Langer says, "The novel is peculiarly suited to formulate our modern life by taking our most pervasive interest for its theme—the evaluation and the hazards of personality." Our interest in personality is what makes our world different and most of its problems relatively new.

SHORT STORY The short story belongs to the same general type as the novel, but it is not simply a short novel. It differs primarily in two respects. It is usually concerned with a single crisis, whereas the novel will present many facets of the characters and events; and it is limited in its analysis of character. Faulkner, for instance, gives a complete picture of an entire family in *The Sound and Fury,* whereas in the short story "Barn Burning" he gives only the incidents that resulted in the burning of a barn.

ANECDOTE AND NOVELLA The anecdote and the novella are sometimes distinguished from the short story and sometimes classed together with it. The *anecdote* is a short narrative giving particulars of some interesting episode or event. Often the anecdote gives details of the life of some one person, as when we repeat an anecdote of the life of Abraham Lincoln or of Thomas Jefferson. The anecdote differs from the short story in that it lacks both the plot and the characterization of that form. The *Lives* of Plutarch are now classed as anecdotal.

The *novella* is identified in two ways. The term is most commonly used to designate a narrative that is longer than the short story though it lacks the characteristics of the novel. Many of the stories of Katherine Anne Porter are in this category. Thomas Mann's *Death in Venice* is a novella. Historically, the term is applied to narratives such as we find in the *Decameron* of Boccaccio, short narratives in which story rather than character development is emphasized.

Drama

The novel, the short story, and the drama are now the outstanding forms of narrative. They are alike in following the regular requirements of narrative: in having plot, characters, setting, and theme. But they differ in many ways, the most important being the medium. The short story and the novel use only words: we know the characters only as the narrator tells us

about them. The drama also is basically a story in words—a story witho
words is a *pantomime*—but the words are in dialogue and are acted ou
All information is conveyed to the audience through dialogue except f
what can be told through costume, stage set, and the movements a
gestures of the actors. In the novel the narrator tells what the hero is doin
whereas in the drama we see and hear him as he does it.

This difference in medium demands difference in presentation. F
one thing, a play is relatively short; if it is to be interesting to the audienc
it must not be so long as to be tiring. The reading of a novel may be sprea
out over a winter or be finished in a few hours, but a play must be ov
in a short time. Three hours is the conventional time, though many pla
are shorter or longer. There have been many experiments with longer play
but they have not been very popular. Shakespeare's plays are much long
than the standard three hours, but in his time a play was presented co
tinuously without any breaks for change of scene or costume, or any oth
interruption; it could, therefore, be presented in about the same time as
modern play.

Again, the pace of a play is fast; since the author is limited in tim
he must get across his ideas quickly, and he cannot put in too ma
details. Only the important and the essential can be brought in. Moreove
a play must always be clear. If one gets mixed up in a novel, he can tu
back and see what happened, but in a play there is no turning back. Als
the action on the stage is always in the present. Unlike a novel, a pla
cannot take place in the past tense. Even events which are presented as
sort of flashback must be enacted as if they are taking place in the presen

Drama differs from the novel in yet another way. Since the story
told by the characters, there can be no comment on what is said or do
unless it be by the characters, whereas in a novel the narrator can comme
directly on the scene or the situation. Jane Austen begins *Pride ar
Prejudice* with the statement: "It is a truth universally acknowledged, th
a single man in possession of a good fortune must be in want of a wife
In a play that statement could not stand alone like this; it would of nece
sity be spoken by one of the characters and would show that person
character and point of view. Dramatic form is limited also in that the auth
cannot talk directly to his audience. Ordinarily he cannot in his own pers
explain what has taken place or what kind of people his characters ar
Various attempts have been made to overcome this limitation, but wi
limited success.

A play is customarily divided into acts. An act is part of a larg
whole but distinct and independent insofar as it has its own beginning ar
end. In Shakespeare's time a drama regularly had five acts; now it will mo
often have three. Acts may or may not be divided into scenes, each scer
having its own unity and its own place in the act and the entire play. Th
end of an act usually indicates the passage of time.

In his dialogue the author must provide suggestions which will conne
any act with what went before. In *Macbeth*, for instance, we are told abo
the hero on three different occasions before we meet him. In the openir

ORGANIZATION

scene the witches name Macbeth. In the second scene Macbeth is named again, this time as a great hero in battle. In the third scene Macbeth is heralded by the witches as one who shall be "King hereafter."

Dramatic organization prescribes a single structure to which all plays conform to a greater or lesser degree. First is the *exposition*, which gives the audience any information it needs to know about the past. Then comes the *complication*, or rising action, which involves the hero in a course of action that will materially affect his future. Soon there follows an event which decides the result of the action, whether it be good or bad. This is the *crisis*. From that point the play moves to its inevitable conclusion, known as the *denouement* ("unravelling," "falling action") or *catastrophe*. This pattern follows the general plan of a triangle, as the action rises to a climax in the crisis and falls to the catastrophe.

It goes without saying that no author would follow such a scheme slavishly; yet it is interesting how often this rule holds true. In *Romeo and Juliet*, for example, we first see Romeo winning Juliet; then after the death of Tybalt we have a falling action (denouement) which brings about the death of both Romeo and Juliet. In *Julius Caesar*, Brutus gains in power till the death of Caesar; when he gives Mark Antony the right to speak at Caesar's funeral, he sets his fall in motion.

We get to know the characters primarily through what they say and do. And as we look at the characters, what they think and say must seem inevitable. Everything about a character must count—his words, his actions, his appearance, his expressions and gestures. One should study each character for visible elements that signify mental or spiritual features. Physical features may of course conceal mental and spiritual aspects of the character. When the apparent is the opposite of the truth, we have, of course, irony.

Normally a playwright has visible evidence of character in mind to a great extent. We often accept costume, action, movement, scenery, gesture, sound, and placement of people on the stage without realizing how they came to be. Physical appearance may be significant: Shakespeare makes Falstaff large and fat; Richard III is a hunchback. Details of dress can be expressive of character: for example, Tennessee Williams in *A Streetcar Named Desire* shows Blanche's desires in the bright colors of her clothes, her use of cosmetics, her false furs, her costume jewelry—they reveal her longing to get away from painful reality. Often, however, such visible evidence is supplied by a director working with actors. Thus different productions of a play can give different interpretations of the text.

The setting is one means of emphasizing what is said in the play. First we notice the number of sets. An inside scene naturally and inevitably portrays the world inside, whereas an outside scene is not limited. A play that has all the action take place in one room necessarily has a limited scene, one of limited social context, whereas one that is enacted in many places is more vigorous and has many more approaches to life as it is lived. In the set, we notice the kind of furniture: is it in good or bad taste, old or new, primly proper or poorly kept, in order or disorder? And there is always

evidence of the special scene. A law court may give a sense of order, of tradition. Rich, fertile fields may make one think of wealth and leisure; a crowded tenement will conjure up all the disadvantages of poverty. Again, setting may be a contribution of the director if it has not been indicated in detail by the playwright.

Stage directions give the author's plan for any matter that is not told in the dialogue, and of course they cover all types of information. Recent authors have often used them very exactly. In Sean O'Casey's *Juno and the Paycock* an entire page is given to a description of the room in which the action takes place; it is followed after one short sentence by a description of Juno, the heroine. Such descriptions are very telling to those who read the play but run into the danger of making statements that can hardly be put into action on the stage. In *Juno and the Paycock,* for instance, we are told that Juno has "that look which ultimately settles down upon the faces of the women of the working class."

Shakespeare and the Greeks were much more chary in their directions for the stage. *Macbeth* has only the direction "Scotland—An open place" before the entrance of the three witches. The classic Greek play was performed before the palace; for the opening of *Oedipus the King* the steps of the palace are crowded with suppliants in various attitudes of despair. Invariably, whether it is supplied by the playwright or by those involved in producing a play, the setting contributes to the mood of the play.

DANCE

There are three main purposes for organized dancing: (1) magic or religious ritual; (2) social; (3) entertainment of an audience. Ethnic dancing falls into the first category; spectacular dances fall into the third.[8]

Ethnic Dance

The term *ethnic* is used for religious dances, dances that are designed as hymns of praise to a god, or to bring on good fortune in peace or war. Probably the dances of the American Indian, such as those for rain or for good crops, are the best-known examples. The royal ballets of Cambodia and India are also excellent examples. In the early days of the Christian church, the Christian mysteries were danced by the priests. As late as the eighteenth century, the Shakers in America engaged in dances as a form of worship. Usually such religious dances are traditional; often no one knows exactly how they came into being or where they came from. They are subtle and symbolic in meaning and cannot easily be understood by someone outside the ethnic group. "It is far easier to speak a foreign language without a trace of accent than it is to dance in a foreign idiom with complete purity of style."[9]

[8] Arnold Haskell, *Ballet* (annual).
[9] John Martin, *Introduction to the Dance,* p. 106.

One of the best known and most important examples of ethnic dancing is the *Noh* play of Japan. Though known as a "play," this is actually a composite of dance, song, and music. The Noh play is generally considered one of the highest expressions of Japanese art. It is about six hundred years old. Usually there are only five or six characters in a play: the principal character and those who play opposite him. This principal character is always masked; some of the others may also be masked. The performance is always dignified and reserved, and it never is realistic. Weeping, for example, is indicated only by a hand at the eye. The masks and the costumes worn by the characters add greatly to the beauty of the play (making masks is considered an important art in Japan). The stage is very small, with a raised passageway leading to it from the actors' dressing room through the audience, and is decorated only with branches of pine.

Traditionally, a Noh play consists of a series of short plays arranged according to an established order. The first is about the gods, the second about warriors, the third about young and beautiful women, the fourth about madmen, and the fifth about devils or gods. To relieve the suspense, farces are introduced; often a farce imitates the serious scene performed just before it.

Social Dance

Social, or recreational, dancing is dancing for one's own pleasure; it is usually performed by groups of people who follow definite patterns. Recreational dancing is found primarily in two forms: folk dance and ballroom dancing. Folk dance is often derived from ethnic dance. Many folk dances are still identified with particular countries: the reel, jig, and hornpipe are Irish; the sword and morris dances are English; and the Cossack dances are Russian.

Social, or ballroom, dancing is formal. It was originally made up largely of square dances like the minuet until they gave way to such round dances as the "wicked waltz." The waltz, however, could not keep its place of preeminence; it was followed by a series of dances each of which was disapproved of when it appeared—the bunny hug, turkey trot, shimmy, Charleston, and so on. Some of these changes show the strong influence of two sources, American Negro and Latin American dances. Latin American forms taken over completely include the tango, samba, and mambo. The influence of black music, rhythms, and dance forms has been most striking since World War II, with such forms as the jitterbug, the twist, and various forms of rock becoming prominent in turn. Rock dances popular within the last decade or so include the monkey, chicken, mashed potato, and frug. Many rock dances do not involve bodily contact between partners; the dancers more toward and away from each other, not necessarily performing exactly the same movements. At one point in the development of rock dances, dancers were encouraged to dance to a particular melody in any way they saw fit; this produced a situation where people could, and did, dance without partners.

Spectacular Dance

Certain dances are called "spectacular" because they are viewed by an audience. Acrobatic dance and tap dance need only be mentioned as the less honored members of this class. The important spectaculars are ballet and modern dance.

CLASSICAL BALLET Classical ballet was for many years the supreme expression of the art of dance. More than any other dance, it is subject to a definite and prescribed discipline of body, head, legs, hands, and arms. There are set positions for each of these. There are, for example, five positions or movements of the head: (1) turn, (2) incline, (3) erect, (4) back, and (5) lowered. The language of ballet is always French. Here are some examples of French terms:

> *Pas de deux*——a dance of two
> *Pas de trois*——a dance of three
> *Pas de bourrée*——running on points

The female, to gain lightness, works on her toes (*pointes*), whereas the man jumps and turns in the air (this is the *entrechat*). The male supports the female when she is on points. The female on points has become the main figure of ballet in the popular conception of it. The ballerina usually wears the familiar short skirt (*tutu*).

The subject of a ballet is most often a story, though in recent years abstract subjects have been used, as when the ballet uses a symphony for the accompanying music. The ideal of ballet is beauty of line, grace, and purity of execution rather than any literary concept.

"MODERN" DANCE Modern dance was in its origin primarily a revolt against the strict laws and regulations governing other dance forms, especially classical ballet. Its leader was an American, Isadora Duncan. She wanted art to be "free" and thought of her dancing as a "return to nature." As an artist she felt that she had only to "express herself," and she believed that the function of art is to make a supernatural world, not to imitate the natural.[10] The "ideal of the dance that she saw was 'the divine expression of the human spirit through the medium of the body's movement.' "

The people who followed her are less strident in their utterance and less demanding in their claims, and thus they have produced a new purpose in dance——the expression of emotion.

Expressionist dance uses dance as a basis for direct communication between the dancer and the spectator; it is concerned less with form as such than with the meaning of life and the dancer's relation to it. "Its only

[10] William Boletha and Isadora Duncan, quoted in Magriel, *Chronicles of the American Dance*, p. 196.

aim is to impart the sensation of living, to energize the spectator into keener awareness of the vigor, of the mystery, the humor, the variety and the wonder of life."[11]

Modern dance may be said to have originated in the expressionist desire to get beneath the surface of reality. Just as Beckmann (Figure 2-16, page 33) and Kokoschka have gone beyond mere representation of a form or an emotion, modern dance, beginning with Mary Wigman in the Germany after World War I, looks for essences and for meanings. In Mary Wigman's words, "Art grows out of the basic cause of existence." The idea of the modern dance is not to repeat the traditional movements of the ballet, even though each interpreter might do them better than the last. It is, rather, to use the human body as an instrument. In the way the body moves, unrestrained by formalism or convention, with no emotion barred, no fact held back, the dancer can give the spectator some notion of the meaning of life.

Modern dance has existed for more than half a century, and although it may need some word of explanation, it needs no apology at this point. In the development of the art from Mary Wigman and Isadora Duncan through Martha Graham, Hanya Holm, Anna Sokolow, and others of the middle period (1930–1945) to such contemporary artists as Merce Cunningham and Twyla Tharp, modern dance has contributed much. Classical ballet, of course, has by no means gone out of existence. There are still outstanding performances and new interpretations by such dancers as the Russian master Nureyev and the British ballerina Margot Fonteyn. Some interpreters have modernized the classical ballet for expressive or symbolic purposes: the Netherlands Dance Company and the Alvin Ailey Company are examples.

[11] Martin, *op. cit.*, p. 253.

PART FOUR
STYLE

17. STYLE

WHAT IS STYLE?

Rather than attempt to define style in the arts, let us try to illustrate what we mean when we speak of an artist's style. The American painter John La Farge (1855–1910) tells us in his *Considerations on Painting* how he and two other artists went out sketching in a hilly area. Although they were all painting the same hills under the same sky and atmospheric conditions, the results of their work were three distinctly different pictures. One emphasized the open sky above the hills; the others paid little attention to the sky. Each man devised his own general color scheme to achieve his own special emphasis. Although each man thought he was being true to nature, in fact each one was being true to nature in his own way.

Another story that illustrates how strikingly different results can be produced with the same subject concerns a Parisian model at the beginning of this century. For publicity purposes, she had her portrait painted by the many different artists for whom she had posed over the years. Some two dozen painters all concentrated on the same woman's features; the resulting paintings were a typical Pascin, a typical Chagall, a typical Matisse, and so on. Each man had rendered the set of features to emphasize what was typical of his own technique or manner of expression—the personality of the sitter herself was only secondary.

If painters living in the same place at the same time produce such different results, it is obvious that when the artists are of different eras, the results will be still more dissimilar. Let us compare two paintings of nudes. Giorgione's *Sleeping Venus* (Figure 17-1, page 366) is a beautiful study of a reclining figure. Two centuries later Manet painted a similar figure, in *Olympia* (Figure 17-2, page 367). Giorgione placed his figure out of doors and presented her sleeping. Manet opened her eyes and made her posture more erect. The effect of the paintings is very different. Giorgione's

is calm and idyllic, whereas Manet's is realistic, a frank picture of courtesan, hard and cold-blooded.

We find the same sort of thing in music. Saint-Saëns and Sibelius each composed music inspired by the grace and beauty of the swan, and both used the cello as the instrument most appropriate for the swan; but again each composition reflects its composer. The work of Saint-Saëns is characteristic of Saint-Saëns, and that of Sibelius gives the mood and character of Sibelius.

The differences which we have been talking about are known as differences in *style*. Each artist works with the tools of his own art—subject, medium, and organization—and the student who wants to know what style is will do well to study these tools in detail. What is the subject? How has the artist treated it? Why did he choose it? What are the characteristics of his use of medium? What elements does he prefer? Is the structure clear? Do all the parts fit together to make a whole? The student who considers such questions will soon come to feel that style is not medium, subject, and organization as such, but is rather the personality of the artist showing through them. La Farge said that he and his fellow artists were "different in the texture of their minds." Wölfflin, talking of the paintings of two women, says of one that it is "not . . . less skilfully drawn, but . . . it felt differently." The best definitions of style identify it with personality. This is essentially the famous definition of Buffon: "The style is the man."

SOME CHARACTERISTICS OF STYLE

When we say that style is personality, we do not mean that the artist necessarily obtrudes himself into the work of art. The work is personal and shows the artist's personality, but it does not do so because the artist has tried to show what kind of person he is. The two paintings of nudes we mentioned above bear the imprint of the artist's personality, but this is not what the artists intended to show: they concentrated on portraying the subject, and because they expressed themselves honestly, we learn about them as well as about the subject. Paradoxically, impersonal art is personal.

Since style is a reflection of personality, it follows that when the personality changes, the style changes. An individual does not have the same personality at all times. His personality as a young man is different from his personality as a middle-aged man or an old man. And so it is with style. The style of Beethoven is different from the style of Mozart, and the style of Beethoven as a young man is different from his style in his middle period or his style in his last period. The style of Shakespeare is not the same as that of Marlowe or Beaumont, and Shakespeare's early style is different from his later style.

Often we hear that a young artist is working in someone else's style. For instance, the early symphonies of Beethoven are said to be in the style of Mozart; the early plays of Shakespeare are said to be in the style of Marlowe. It is true that, in these cases, Mozart and Marlowe were the models whom Beethoven and Shakespeare, respectively, followed, as a child

learning to speak follows the tone and the pronunciation of his father and mother. But it is more accurate to note that even when working in the style of older men, Beethoven and Shakespeare still produced works which are recognizable as their own.

The work of "schools" presents a similar situation. An artist creates something that is good; it is recognized as good, and it has an influence over other artists of the time. Soon there arises a "school" of artists who are carrying on the tradition of the master. Especially is this true in the visual arts. We have a school of Botticelli, a school of Scopas, a school of Cézanne. The work of the school has all the obvious characteristics of the master; at first glance it may even be mistaken for his work, and it is only on careful study that one may be able to distinguish the work of the school from that of the master. Because schools pick up the obvious characteristics of the master, the work is simpler, and it is at first glance easier to grasp and more attractive than the original. Many a person immediately likes the winsome Madonnas of Luini (Figure 17-3, page 368) and learns only later to like the greater Madonnas of Luini's master Leonardo (Figure 17-5, page 370).

STYLE AND STYLES

So far we have talked of style as individual, and in the last analysis it is always individual. It is the way a particular person living at a particular time does that thing by which he is known. Just as no person is ever an exact duplicate of any other person, the style of any person is not exactly like that of any other person. Still, people are alike in a great many respects, and we soon begin grouping them together under certain headings to show their likenesses. Similarly, we may find likenesses among the styles of various individuals. We speak of a British style or an American style, a humorous style or a poetic style, a journalistic or a scientific style, a medieval or a Renaissance style. A *style* in this sense is a recognition of certain qualities in which the works of individuals are similar.

The Historical Styles

The historical styles arise because of the similarities among people living in the same place at the same time. These people speak the same language, dress alike, have the same manners and customs, and share the same ideas; and their work reflects this community of interests. Thus we have the style of Elizabethan England, the style of the Italian Renaissance, a Chinese style, an early Greek style, a late Greek style, and so on.

Styles Based on Attitudes and Ideas

Besides the historical styles, there are also styles which arise as a result of similar attitudes and ideas. There are many examples of styles in this category: naturalism, realism, impressionism, expressionism, abstract

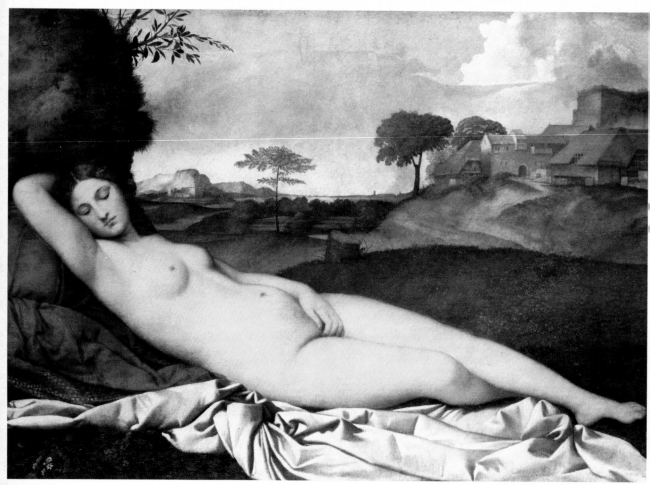

Figure 17-1. Giorgione; landscape by Titian. Sleeping Venus (ca. 1505). (*Oil on canvas. Height: 3 feet, 6¾ inches. Dresden, Museum. Photograph by Alinari.*)

expressionism, surrealism, cubism, the picaresque novel, the problem novel, Puritanism, imagism, and others. Many of these styles have not lasted very long, because the ideas they reflect, or the problems they deal with, have ceased to be of importance. There are, however, two categories of style which have been of importance for centuries. They are: (1) the classic and the romantic, and (2) the tragic and the comic. We will consider the classic and the romantic now; the tragic and the comic will be discussed in Chapter 18.

Classicism and Romanticism

The distinction between classicism and romanticism, though one of the clearest and most basic distinctions in art and one almost unerringly recognizable, does not lend itself easily to exact description or definition. The confusion is made worse by the fact that the words themselves have shifted

in meaning a great deal. *Classic* should mean nothing more than "belonging to a certain class." But by a process analogous to that whereby we say that a person has taste when we mean he has good taste, *classic* came to mean "belonging to the first class of excellence, the best." And the word is still used in that sense when we speak of the *classics* of English literature. Then, since for many years Graeco-Roman culture was considered the best, the word *classic* came to be associated only with Greek and Latin authors, so that even today in the schools the "classics" are Greek and Latin works. When, however, we use the word *classic* or *classicism* as opposed to *romantic* or *romanticism,* we do not mean any of these definitions but a fourth. The word *classic* came to connote the qualities that were supposed to characterize Greek and Latin authors: clarity, simplicity, restraint, objectivity, and balance.

The word *romantic* is also used in various ways. It should mean nothing more than "pertaining to or descended from things Roman or Latin," a usage that survives in the term *Romance languages*—French, Spanish, Italian, Portuguese. The word came into use in the Middle Ages to distinguish the vernacular from the literary Latin. And, by a process of change

Figure 17-2. Edouard Manet (1832–1883), French painter. Olympia (1863). (Oil on canvas. Height: 4 feet, 2 inches. Paris, Louvre. Photograph by Stoedtner.)

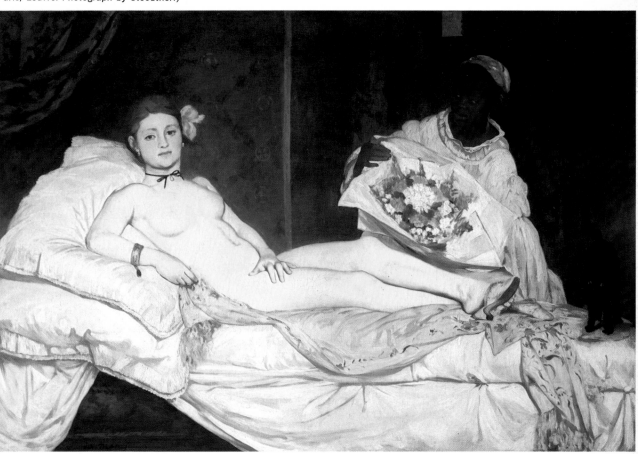

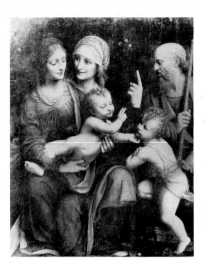

Figure 17-3. Bernardino Luini (ca. 1465–1532), Italian painter. Holy Family (undated). (Oil on wood panel. Size: 27⅝ by 24¾ inches. Milan, Pinacoteca Ambrosiana. Photograph, Biblioteca Ambrosiana.)

very like what happened to the word *classic*, the words *romance* and *romantic* came to mean the literature of France, Spain, Italy, and Portugal at that time. The most outstanding type of literature was the tale of chivalry, which is still known as the "romance," and the word is kept for all narratives with emphasis on plot, as when we speak of Scott's novels as romances. *Romantic,* then, came to describe the qualities found in the medieval romance: love of the remote and indefinite; escape from reality; lack of restraint in form and emotions; and a preference for picturesqueness, grandeur, or passion, rather than finish and proportion.

Classicism and romanticism are thus fundamentally in opposition; what is classic is not romantic, and what is romantic is not in that respect classic. The classic is restrained; the romantic is not restrained. The classic is more real; it is concerned with an idealization of the everyday; the romantic is unreal, concerned with the fantastic, the strange, the unusual. The classic is finished, perfect; it has great beauty of form; the romantic is unfinished, imperfect, and often careless as regards form. The classic is simple; the romantic is complex. The classic is objective; the romantic is subjective. The classic is finite, concerned only with projects that can be realized and accomplished; the romantic is infinite, concerned with plans that can never be realized, affecting "thoughts co-equal with the clouds." The classic is like an arrow shot from the bow that goes straight to the mark; the romantic is like a sailboat that tacks to one side and then to the other, reaching its destination by heading away from the mark.

The difference between the two can be seen most clearly in the great art of each type. The Greek temple, for example, is classic, and the medieval cathedral is romantic. Both are religious edifices, but they show an enormous difference in the attitudes that created them, a difference far deeper than the dissimilarities of construction and mechanics. The Greek temple is hard, bright, exact, calm, and complete; the walls and the columns are low enough to stand of their own strength; the lintels and the roof are simple, sane, and sensible. Nothing more is attempted than can be accomplished, and the result is a perfect building, finished and finite. Anyone can understand its main construction at a glance.

The Gothic cathedral, on the other hand, is not self-contained but is built on the principle of balance. The openings are not made with lintels but are arched. One stone holds in place only by its relation to the other stones. The walls will not stand alone; they must be buttressed. As the walls go higher, the arches become more pointed, the roof becomes more pointed, and the buttresses are strengthened with pinnacles and flying buttresses, the whole so carefully and cleverly balanced that a fault in one stone might cause a side or even the entire building to collapse. And the whole cannot be grasped at a glance; one is conscious only of its great complexity, its enormous variety, its striving upward and beyond.

The Greek temple might be as solid as a statue, for all the feeling we have of its interior; the inside does not matter; it has no more character than the inside of a box. But with the cathedral, on the other hand, the outside sends us inevitably within. And inside we find a mystery in light

and dark, a spiritual experience of unlimited space which is the essence both of the Gothic and of romanticism (Figure 17-4). Compare the Greek temple (Figure 13-33, page 277).

The difference between the two can also be seen clearly in music. Haydn and Mozart are typical composers of the classic school. The emotions are often subordinated to the forms used. Beethoven followed Haydn and Mozart in his early works; his early symphonies, notably the second and the fourth, are classic. But his more characteristic symphonies, such as the fifth and ninth, are romantic. The music is personal and emotional; it is not contained and perfect, but exuberant, exultant, and free.

The difference, again, is clearly demonstrated if we examine two pieces of sculpture: the Greek *Hegeso Stele* (Figure 4-9, page 80) and the American *Adams Memorial* by Saint-Gaudens (Figure 4-10, page 81). Both are tombstones. The Greek stele (an upright slab) shows us Hegeso with her servant; the two are watching intently as Hegeso lifts a jewel from the box. It is a simple scene of everyday life, treated quietly and impersonally. On the other hand, the Adams monument wraps us at once in mystery and questioning. A robed and hooded figure is seated before a severe granite slab. Is it a man or a woman? What does it mean? Is it sup-

Figure 17-4. Chartres Cathedral, *view of ambulatory from south transept.* (*Photograph, Harry H. Hillberry.*)

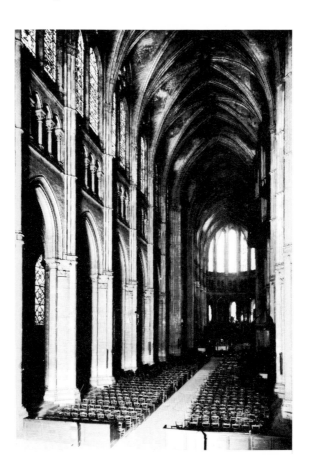

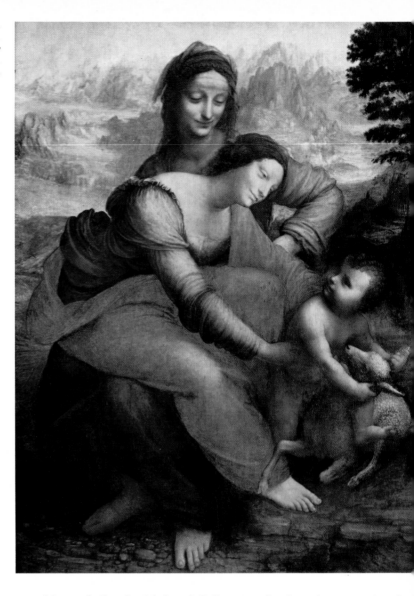

posed to symbolize death? Or grief? Our attention is no longer centered on the object itself, as it was with the stele of Hegeso; the object now serves as a point of departure for our emotions and questionings.

Another demonstration of the difference between the classic and the romantic viewpoint may be seen in a comparison of the *Lance Bearer* of Polyclitus (Figure 13-18, page 267), from the fifth century B.C., with a later work of the Hellenistic age, the Laocoön (Figure 3-8, page 52). The *Lance Bearer* is an idealization of the male figure, and although it draws on "facts" about mankind as a whole, the result is a sort of summing up of what is most desirable in the human body. The figure is serene and

calm, almost godlike in his self-assurance as he proceeds into the arena with his lance. This dignified and glorified person might be considered the artist's ideal of humanity. The *Laocoön,* on the other hand, presents a highly emotional situation. A Trojan priest is punished by the gods for advising his countrymen not to admit the horse of the Greek besiegers into the city of Troy. Not only is he himself to die; he must also watch as his two sons are overwhelmed by serpents. The emotions of these three figures are expressed in their anguished expressions and strained muscles; such emotional elements are not present in the *Lance Bearer.* Since the human figures of the *Laocoön* are seen at the moment of greatest possible strain, they are not idealized in the same sense that the *Lance Bearer* is. Another difference is that the *Lance Bearer* is simple whereas the *Laocoön* is complicated. It can be seen, then, that the classic and romantic approaches to art are not determined by historical period. An artist at any time may use classical or romantic qualities to achieve his purpose.

The difference also appears, of course, in literature. The classic drama, for example, deals with godlike emotions and carries them above the plane of humanity. Euripides' *Medea,* which we have discussed earlier, presents a woman who takes revenge on her husband by an act which has the character of fate: she murders their children. This terrifying act is, however, done off-stage; as a result of this restraint, it is the *meaning* of the act, rather than the emotions causing it or produced by it, which is of utmost importance. This is characteristically classic. Let us compare this with Shakespeare's *Hamlet.* Here, the meaning is uncertain when Hamlet kills the king: the *emotion* is foremost, because the characters have been presented to us in all their humanity and we have become involved with their feelings. This is characteristically romantic.

The difference is fundamentally a difference of attitude, which may be found in all types of art. We may see it illustrated also in two love poems. The first, by Landor, is classic; the second, by Shelley, is romantic.

Ah, what avails the sceptred race,
 Ah, what the form divine!
What every virtue, every grace!
 Rose Aylmer, all were thine.
Rose Aylmer, whom these wakeful eyes
 May weep, but never see,
A night of memories and of sighs
 I consecrate to thee.
 —Walter Savage Landor (1775–1864, British poet), "Rose Aylmer"

I arise from dreams of thee
In the first sweet sleep of night,
When the winds are breathing low,
And the stars are shining bright:
I arise from dreams of thee,

And a spirit in my feet
Hath led me—who knows how?
To thy chamber window, Sweet!

The wandering airs they faint
On the dark, the silent stream—
The Champak odours fail
Like sweet thoughts in a dream;
The nightingale's complaint,
It dies upon her heart;—
As I must on thine,
Oh! beloved as thou art!

Oh lift me from the grass!
I die! I faint! I fail!
Let thy love in kisses rain
On my lips and eyelids pale.
My cheek is cold and white, alas!
My heart beats loud and fast;—
Oh! press it to thine own again,
Where it will break at last.

—Percy Bysshe Shelley (1792–1822, British poet),
"The Indian Serenade"

We find the difference also in acting. Many years ago Sarah Bernhardt was starring in a classic drama, Racine's *Phèdre*. The story tells how Theseus, in his old age, married Phaedra, the sister of Ariadne, the daughter of Minos. She fell in love with his son Hippolytus, who combined all the virtues of his father with youth and beauty that matched her own. Hippolytus, though he returned the love of Phaedra, would have nothing to do with his father's wife. In one scene Phaedra makes passionate love to Hippolytus. In the production by Sarah Bernhardt and her company Hippolytus stood apparently unmoved through the time that Phaedra was wooing him; at last she turned away in desperation, and as she turned Hippolytus took one step forward, with his arms outstretched, showing in this one movement all the love which was in his own heart but which honor had kept him from making known. If this gesture of Hippolytus is compared with what we may call the usual theatrical portrayal of love, with its emphasis on the embrace and passionate words, we see again the difference between the classic and the romantic. Here it is not a difference in the amount of feeling expressed, but in the manner of expression.

Between the two extremities of pure classicism and pure romanticism there are, as always, many gradations. We can almost never say that any work of art is entirely classic or romantic; a work usually tends toward one or the other. The work of any artist is likely to be predominantly classic or romantic, although almost any artist will show both tendencies. Shakespeare is romantic in most of his plays, but quite classic in *Othello*.

Classicism and romanticism are an opposition present in all art of all

ages. Although it is a mistake to say that any period is exclusively classic or romantic, we may discern times when either classicism or romanticism is distinctly ascendant. Classicism predominated in fifth-century Greece, for example, and in eighteenth-century Europe; romanticism predominated in the Gothic period and the nineteenth century.

It may be noted also that, just as some periods lean toward classicism or toward romanticism, so, of the various arts, some are more essentially classic or romantic than others. Figure painting may be either classic or romantic, but landscape painting tends to be romantic. The distant view is naturally vague and mysterious (see Figure 13-13, page 263, for an example); and even when a composition concentrates on a nearby scene, it is not limited and self-contained—landscape, by its nature, leads one on and on; one wants to know what is over the river, beyond the tree, on the other side of the hill. Poussin is known as a classic painter, but his landscapes are classic only in the sense that they are intellectually conceived and planned; in other respects they are romantic. El Greco, in his *View of Toledo,* has heightened the romantic aspects of the scene by his use of light and cloud; the landscape is gloomy and menacing as well as mysterious and romantic (Figure 17-6, page 374).

Sculpture is by nature exact, precise, well defined, and balanced. The effects most natural to it are therefore classic, and a people of marked classic tendencies, like the Greeks, find in sculpture one of their best means of expression. It can, however, be romantic, as we have seen in the *Adams Memorial* and the *Laocoön*. Nevertheless the classic seems the more appropriate style for sculpture, and most sculpture tends to be classic in feeling. Music, on the other hand, is by nature vague, elusive, evocative, emotional. The effects most natural for it are therefore romantic, and music can express in a few bars all the yearning and poignancy that it takes the profoundest efforts of the other arts to express. Today we often hear it said that the truest or best music is the "absolute" music of the eighteenth or twentieth centuries, which is objective and without emotion, devoted to purely formal beauty. While it is true that a classic master such as Bach represents a pinnacle of musical achievement, it must not be forgotten that even his music often has emotional content. Contemporary music like that of Anton Webern is perhaps a more strict example of lack of emotion. But these instances are relatively rare. Most music throughout the ages, even where it is without subject and not deliberately emotional, is always evocative and mood-filled.

Finally, we should perhaps insert a word of warning that classicism and romanticism are not in themselves good or bad; they are merely different points of view and must be judged on their own merits. The good in the classic is poised, serene, and balanced; the bad in the classic is cold, overformal, and lifeless. The good in the romantic is rich and full of emotion; the bad in the romantic is gushing and undisciplined. Either can be a complete approach to art; neither without the other is a complete approach to reality.

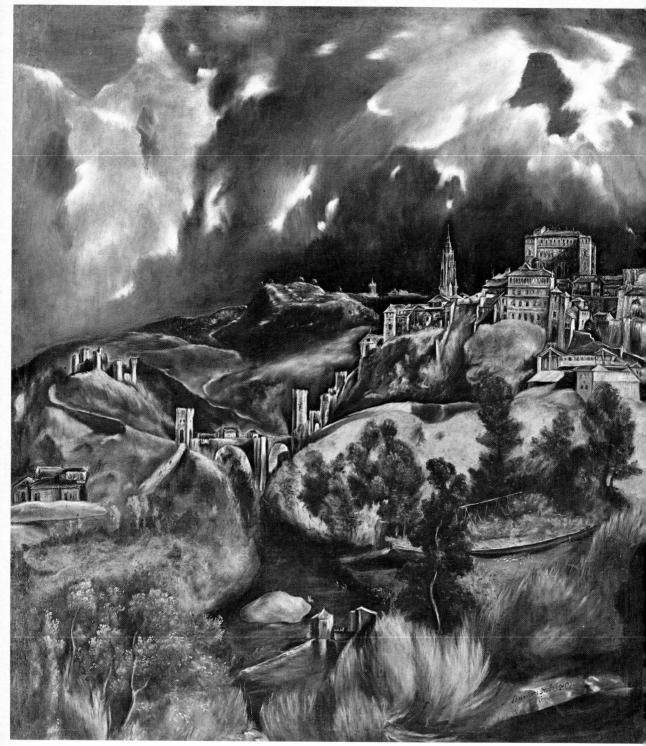

Figure 17-6. El Greco. View of Toledo (ca. 1610). (*Oil on canvas. Size: 48 by 42¾ inches. New York, Metropolitan Museum of Art; bequest of Mrs. H. O. Havemeyer, 1929. H. O. Havemeyer Collection.*)

18. THE TRAGIC AND THE COMIC

THE KINSHIP OF TRAGEDY AND COMEDY

It has been said that tragedy is life viewed close at hand, and comedy is life viewed at a distance. It has also been said that life is comedy to the man who thinks and tragedy to the one who feels. In other words, the same situation may seem tragic to one and comic to another, or tragic at one time and comic at another. Pieter Brueghel painted a picture illustrating one of the parables of Jesus: "Can the blind lead the blind? Shall they not both fall into the ditch?" (Figure 13-14, page 265). The old men in this picture might be inmates of any workhouse or poor farm. Each is trying to keep in touch with the one in front of him by holding onto his shoulder or by touching him with his stick. But the one in front has stumbled and the others are falling. To some the grotesque positions they assume as they try to keep balance are comic; to others, tragic.

The close connection between the comic and the tragic is very well illustrated by the fact that certain characters formerly considered comic are considered tragic. There is no question that Shylock, in *The Merchant of Venice*, was originally considered a comic character; now he is tragic. We feel only sympathy for the old man when we hear him say:

In the Rialto you have rated me
About my moneys and my usances.
Still have I borne it with a patient shrug,
For suff'rance is the badge of all our tribe.
You call me misbeliever, cut-throat dog,
And spit upon my Jewish gaberdine,
And all for use of that which is mine own.

Well then, it now appears you need my help.
Go to, then! You come to me, and you say,
"Shylock, we would have moneys;" you say so—
You, that did void your rheum upon my beard
And foot me as you spurn a stranger cur
Over your threshold; moneys is your suit.
What should I say to you? Should I not say,
"Hath a dog money? Is it possible
A cur can lend three thousand ducats?" Or
Shall I bend low and in a bondsman's key,
With bated breath and whisp'ring humbleness,
Say this:
"Fair sir, you spat on me on Wednesday last;
You spurn'd me such a day; another time
You call'd me dog; and for these courtesies
I'll lend you thus much moneys"?

—William Shakespeare (1564–1616, British poet and dramatist),
The Merchant of Venice, I, iii, 108–130 (ca. 1595)

THE FUNDAMENTAL TYPES OF COMEDY AND TRAGEDY

The fundamental types of comedy and tragedy may be seen in variou
alternative attitudes toward an old joke. If a person about to sit down ha
his chair pulled out from under him, there are, in general, four possibilitie
(1) The person sits on the floor, and we laugh. This is comic, but a comed
of situation only; we are amused because the person on the floor is in
situation in which he did not expect to be. The person himself does n
matter. (2) The person sitting on the floor breaks his back. This is obv
ously tragedy, not comedy; but again it is a tragedy of situation because
does not matter in either of these cases who the person is. The situatio
gives the scene its character. (3) We laugh, but at the man who pulls o
the chair. We are amused that anyone should think such a thing is funn
We are laughing, in this case, not at a situation but at a man; in oth
words, this is comedy of character rather than of situation. (4) Fro
comedy of character to tragedy of character is only a step. Instead
laughing at the person who has such a depraved sense of humor, we fe
it is tragic that anyone who is living in a civilized community should fir
such a trick amusing.

Comedy and tragedy of situation are also called "low comedy" ar
"low tragedy"; comedy and tragedy of character, "high comedy" and "hig
tragedy." Low comedy is the basis for slapstick comedy and farce—th
comedy that results from the throwing of custard pies or from the big fe
of Charlie Chaplin. Low tragedy is the essence of melodrama. One is inte
ested in the events that occur because they are exciting—a train wrec
an explosion, a race, a hunt for a criminal. In low comedy and low trage
the characters are not individuals but types—the hero, the heroine, th
villain, etc. In high comedy and high tragedy the people are individuals.

Shakespeare's *Comedy of Errors* is comedy of situation. This pla
deals with twin masters who have twin servants. To make the confusio

worse, both the masters are named Antipholus and both the servants are named Dromio. The masters, who have been separated since birth, find themselves in Ephesus, and naturally there are many amusing situations as masters and servants are mixed up, until at last their identity is discovered and their relationship established. There is nothing comic in the twin masters or in the twin servants as such. The comedy lies in the situations which arise because they are confused with one another.

The French comedy of Molière and the English comedy of Ben Jonson, on the other hand, present comedy of character almost without comedy of situation. For example, the miser Volpone, in Ben Jonson's play of that name, pretends to be very ill; his greedy friends bring rich gifts, each one hoping to ingratiate himself so as to be the sick man's heir. When Volpone has got all their gifts, he resumes his usual state of health. There is nothing comic in this situation; we are amused only by the characters.

Ordinarily a dramatist uses elements of both high and low drama; the preponderance of one or the other determines the character of the play. In *Hamlet,* for instance, many elements of the plot are frankly melodramatic. To enumerate: the guards are watching at midnight when they see a ghost; the hero kills a man through a curtain; there is a fight in an open grave; drinks are poisoned and the wrong person gets the poison; swords are exchanged and a man is killed with his own poisoned sword. All this is melodrama. The high drama is concerned with what takes place in the minds of the people, and so great is this interest that we are surprised when we realize how much melodrama the play also contains.

Shakespeare's comedies, in general, are not comedies in the strict sense of the word; the plot in a Shakespearean comedy is not itself usually a comic plot but rather a pleasant, gay story which does not take life very seriously. In *Twelfth Night,* for instance, the plot tells how Viola, learning that she is near the estate of a duke (Orsino) of whom she has heard much, decides to assume the guise of a boy, and enter the duke's service in the hope that she may win him and marry him. She does both. It is a pleasant tale, not a comic one. In the development of the story, however, Shakespeare uses both comedy of character and comedy of situation.

THE BASIS OF COMEDY

The chief source of the comic is the incongruous, the unexpected. We expect one thing and we find another. If one man pulls a chair out from under another, the joke lies in the fact that the second sits on the floor when he expected to sit on the chair.

It is unexpectedness that makes for comedy in this speech by the nurse in *Romeo and Juliet:*

Your love says, like an honest gentleman, and a courteous, and a kind, and a handsome, and I warrant, a virtuous,—Where is your Mother?
—Shakespeare, *Romeo and Juliet,* II, v, 56–69

Juliet has sent the nurse to find out from Romeo whether she is to be married that day. The nurse has returned with the news, and Juliet wants to know. But the nurse is hot and tired and out of humor because of the long trip she has had. At last she begins to tell the message from Romeo, but when she comes to the word *virtuous*, she is reminded of the nature of the alliance she is promoting and breaks off with the question "Where is your mother?" It is the contrast between what we expect and what we receive that is comic.

In comedy of character, it is the difference between what a person thinks he is and the person we think him to be that is funny. There is a famous passage in *Much Ado about Nothing* where Dogberry swears in the guard to check their loyalty. There is nothing funny in the situation itself: the comedy comes from Dogberry's pomposity; he thinks he is better than he is.

Dogberry.	Are you good men and true?
Verges.	Yea, or else it were pity but they should suffer salvation, body and soul.
Dogberry.	Nay, that were a punishment too good for them, if they should have any allegiance in them, being chosen for the Prince's watch.
Verges.	Well, give them their charge, neighbour Dogberry.
Dogberry.	First, who think you the most desartless man to be constable?
First Watch.	Hugh Oatcake, sir, or George Seacole; for they can write and read.
Dogberry.	Come hither, neighbour Seacole. God hath bless'd you with a good name. To be a well-favoured man is the gift of fortune, but to write and read comes by nature.

—Shakespeare, *Much Ado about Nothing*, III, iii, 1–22 (ca. 1599)

It is obvious that Dogberry is a pompous fool, and also that he has a very good opinion of himself: therein lies the comedy.

Another type of comedy results from an unexpected twist in a situation: for example, someone may appear in the wrong kind of costume or in no costume, or give a stupid or incoherent account of something—in other words, there may be a departure from what is generally accepted as normal behavior. Of course the unexpected is not, as such, comic; there is nothing comic in having an unexpected attack of ptomaine poisoning, or in getting a letter one has not expected; but if one is expecting to learn whether she is to be married, and hears the question "Where is your mother?" the difference between what one expects and what one hears *is* comic. Sometimes the standard is given; more often it is implied; but in any case we expect a standard, and we find it amusing when the actual deviates from it.

It is this measurement against a standard which has induced us to think of the abnormal as funny. Deformity, insanity, and pain have frequently been considered comic and been regularly used for low comedy

effects. The fool, the hunchback, and the midget were accepted as comic characters of the court; as such they are prominent in Velázquez's paintings of court scenes. In the Elizabethan drama, choruses of madmen were sometimes introduced for comic effects. Drunkenness was widely considered a cause of laughter and is still so considered in many cases. Children laugh if they see a cat having fits. In these cases the abnormal is measured against the standard of the normal and found funny.

CHARACTERISTICS OF THE COMIC

Comedy is primarily intellectual. The perception of the comic depends on the recognition of the difference between the normal and the actual. If one does not know the standard, or if he does not perceive the deviation from the standard, he does not see the comedy in a situation. It is for this reason that jokes are tricky and that there are so many limitations on them. Comedy is highly specialized in its appeal. The people of one country do not like the jokes of another country. There is the American joke, the English joke, the French joke, the German joke. Even the sexes differ in their appreciation of comedy; women do not appreciate all the jokes of men, nor do men appreciate all the jokes appealing to women.

Comedy, moreover, is detached. No one can laugh at anything that is very close to him. Even when one laughs at himself he must, as it were, get away from himself in order to laugh. When one is suffering from puppy love, he cannot laugh at himself; but when he has recovered from the attack, he can. There is thus something impersonal about the comic. It implies a degree of insensibility on the part of the audience; we cannot sympathize too much if we are going to laugh. If we are distressed about the nurse's fatigue or her concern over Romeo's being a virtuous young man, we cannot laugh when she interrupts her tale: "Your love says, . . . Where is your mother?"

Because comedy is detached, we laugh at all sorts of things in the world of comedy that we do not find funny in everyday life: the man who does not pay his bills, the woman who deceives her husband, the young boy suffering from puppy love. In *Arsenic and Old Lace*, a delightful American comedy, two gentle old ladies are in the habit of administering arsenic in elderberry wine to the lonely old men they meet, because they feel sorry for them. The men are then buried in the basement by a brother, who thinks he is Teddy Roosevelt and thinks this digging is part of the work on the Panama Canal. In real life we would demand that something be done; it would be no excuse that the old ladies are insane. Nor would it be possible to keep the whole thing quiet, as is done in the play. In short, there would be consequences. In the play there are none: the plot seems to take place in a vacuum. Evil in comedy is not evil but something to be laughed at.

Because comedy is intellectual and depends on perception, the comic always has in it a feeling of superiority. The person who sees the joke feels

superior to the one who does not, and frequently he is patronizing. There is a bond between people who like the same joke. Sustaining comedy is like walking a tightrope. The artist usually veers to one side or the other; and he takes sides with or against his characters—he is either sympathetic or critical. If he is sympathetic, his writing becomes humorous; if he is critical, it becomes satirical.

HUMOR AND SATIRE

Humor is a matter of spirit rather than of words. It is kindly; it is sympathetic. Usually it has in it something of extravagance. The author, looking at his extravagant characters, smiles with tolerant indulgence. In this way we love Falstaff while we smile at the extravagance of his statements:

Bardolph, am I not fallen away vilely since this last action? do I not bate? do I not dwindle? Why, my skin hangs about me like an old lady's loose gown; I am withered like an old apple-john. Well, I'll repent, and that suddenly, while I am in some liking; I shall be out of heart shortly, and then I shall have no strength to repent. An I have not forgotten what the inside of a church is made of, I am a peppercorn, a brewer's horse. The inside of a church! Company, villainous company, hath been the spoil of me.
—Shakespeare, *Henry IV*, Part I, III, iii, 1–11 (1592)

When Orlando, in *As You Like It*, protests that he will die if he does not win Rosalind, she reminds him of famous lovers, none of whom died of love: the brains of Troilus were beaten out with a club; Leander died of cramp while swimming the Hellespont, and so on. She ends with a summary for all time:

But these are all lies: men have died from time to time, and worms have eaten them, but not for love.
—Shakespeare, *As You Like It*, IV, i, 106–108

Because we know Rosalind, and realize how much she is in love with Orlando, and how gallantly and cleverly she is carrying on her game with him, we find the words humorous, but had they been spoken by another we might have found them cynical.

Satire aims, or at least pretends to aim, at improvement. The satirist sees the vices and faults of the human race, and exposes them in a comic manner in order to call them to attention. To this end, the satirist may use any device. Swift uses allegory in *Gulliver's Travels*, where he is satirizing the littleness of men. On his first voyage Gulliver goes into the land of the Lilliputians, a people who are only a few inches in height. Here he is amazed at the cunning and the foolishness of the little people. The test of the politician's ability to hold office, for example, is his skill in walking a rope. And the Lilliputians are in a great agony of disagreement and even fight a war to decide at which end an egg should be broken. Those who believe in

should be broken at the big end are called the Big-endians; others, who are just as strong in their faith that it should be broken at the little end, are called the Little-endians. The point of all this becomes apparent: it is that human politics and disputes are equally ridiculous.

WIT

Wit is a general name for those forms of the comic which have to do with words. Like all other forms of the comic, wit may be based on incongruity. We may expect one word, for example, and hear another. Under the heading of wit come spoonerisms, malapropisms, puns, epigrams, and parody.

The *spoonerism,* named for one of its most distinguished exponents, the Reverend W. A. Spooner of Oxford, is the accidental transposition of the initial letters of two or more words. One says he has just received a "blushing crow," when he means a "crushing blow"; the English poets Keats and Shelley become Sheets and Kelly.

The *malapropism,* named for Mrs. Malaprop in *The Rivals,* is the ludicrous misuse of a word for one resembling it—for example, "contagious countries" for "contiguous countries."

Observe me, Sir Anthony, I would by no means wish a daughter of mine to be a progeny of learning; I don't think so much learning becomes a young woman. For instance, I would never let her meddle with Greek, or Hebrew, or Algebra, or simony, or fluxions, or paradoxes, or such inflammatory branches of learning—neither would it be necessary for her to handle any of your mathematical, astronomical, diabolical instruments.— But Sir Anthony, I would send her, at nine years old, to a boarding-school in order to learn a little ingenuity and artifice. Then, sir, she should have supercilious knowledge in accounts; and as she grew up, I would have her instructed in geometry, that she might know something of the contagious countries;—but above all, Sir Anthony, she should be mistress of orthodoxy, that she might not misspell and mispronounce words so shamefully as girls usually do; and likewise that she might reprehend the true meaning of what she is saying.—This, Sir Anthony, is what I would have a woman know; and I don't think there is a superstitious article in it.

—Richard Sheridan (1751–1816, Irish-born British playwright),
 The Rivals (1775)

A *pun* is a play on words which have the same sound or similar sounds but different meanings. A serious pun is that on "grave" in Mercutio's speech in *Romeo and Juliet:*

Romeo. Courage, man; the hurt cannot be much.
Mercutio. No, 'tis not so deep as a well, nor so wide as a church-door; but 'tis enough, 'twill serve. Ask for me tomorrow, and you shall find me a grave man. I am pepper'd, I warrant, for this world.
—Shakespeare, *Romeo and Juliet,* III, i, 99–102 (ca. 1593)

James Joyce's "Lawn Tennyson" is a delightful pun (the reference is to lawn tennis).[1]

The *epigram* is a condensed, pithy statement, like that of the young man in Wilde's *Lady Windemere's Fan:* "I can resist everything except temptation." Martial is one of the most famous writers of epigrams; here is an example:

I do not love thee, Doctor Fell,
The reason why I cannot tell;
But this alone I know full well,
I do not love thee, Doctor Fell.
 —Martial (ca. A.D. 40–104, Roman poet),
 "*Non Amo Te,*" trans. Tom Brown (1663–1704)

John Wilmot's epigram on Charles II is famous:

Here lies our Sovereign Lord the King,
Whose word no man relies on,
Who never said a foolish thing,
Nor ever did a wise one.
 —John Wilmot, Earl of Rochester (1648–1680, British courtier and
 poet), *Epitaph on Charles II* (ca. 1675).

A *parody* is an imitation, usually of a very well-known work. The parody imitates the model very closely but turns the serious sense of the original into the ridiculous. Lewis Carroll was a great writer of parodies. He made nonsense of "How Doth the Little Busy Bee Improve Each Shining Hour," a preachy poem, in this version:

How doth the little crocodile
 Improve his shining tail,
And pour the waters of the Nile
 On every golden scale!
 —Lewis Carroll (1832–1898, British mathematician and writer),
 Alice in Wonderland

And "Twinkle, Twinkle, Little Star" becomes:

Twinkle, twinkle, little bat!
How I wonder what you're at!
Up above the world you fly,
Like a tea-tray in the sky.[2]

[1] David Daiches, *A Study of Literature for Readers and Critics,* p. 44.
[2] *Ibid.,* p. 205.

THE NATURE OF THE TRAGIC

Tragedy implies an unhappy or unfortunate ending to a series of events; usually it means death. But it is not just any kind of death; if an old man of eighty dies after an illness of months or years, his death is not called tragic. Tragedy implies a sudden reversal in prospects, a drop from a high estate to a low one. In the great traditional tragedies, the hero is usually of royal, or at least noble, blood, so as to make the change in his position all the more telling. Lear is a king; Hamlet is a prince; Agamemnon is a king and leader of all the Greek armies in the Trojan War. Moreover, the tragic hero is not just any king or prince; he is an exceptionally fine man. Othello comes from "men of royal siege," and he is cherished by all the people of Venice. Macbeth is no average general; he is unusually brave, courageous, and devoted; he is "brave Macbeth," "Valour's minion." The tragic hero is always a person of merit, usually of outstanding merit. We admire and respect him for virtues that are above the ordinary. When, therefore, we see his fall, there is something catastrophic about it. We almost cannot believe that a person so great or fine could come to such an end. Yet at the same time the hero's fall seems inevitable. In high tragedy the ending must follow necessarily from the events and the hero's character.

The necessity for the hero's death is clearly defined and distinguished in the two great types of tragedy, the Greek and Shakespearean. With the Greeks, the necessity was primarily religious in character. The hero does something that is against the law, and so he must suffer. In the play called by her name, Antigone hears the decree of the ruler, Creon, that her brother should not be buried. This is a horrible sentence, since according to the Greek religion the funeral rites determined the position of the dead in the next world. Antigone therefore refuses to obey the decree, and buries her brother; by doing so, she violates the law and incurs death.

With Shakespeare, this necessity is found in character; because the hero is the kind of person he is, he must fall. Othello's personality, his background, his idealism, his ignorance of Venice, and even the secrecy and hurry of his wedding make the murder of Desdemona inevitable. The real cause of the tragedy is in Othello.

But even though the hero fails, tragedy is never fatalistic or pessimistic, nor does it leave one with a sense of frustration. We know that the hero has failed, and we realize that he had to fail; but there is no sense of despair or desolation. We feel even more strongly the essential values of life: love, justice, truth, goodness. In *Othello,* Iago is the only one of the important characters left alive when the play is over, but we do not admire him as a clever schemer; we hate him with all the power we have, and we love and admire even more the goodness we saw in the lives of Othello, Desdemona, and Emilia. When Antigone tells her sister she has planned to bury her brother and asks for her help, Ismene objects: it is against the law, they are but women, it is no use to attempt the impossible. But Antigone goes right on:

I'll neither urge thee, nor, if now thou'dst help
My doing, should I thank thee for thine aid.
Do thou after thy kind; thy choice is made;
I'll bury him; doing this, so let me die. . . .

But leave me, and the folly that is mine,
This worst to suffer—not the worst—since still
A worse remains, no noble death to die.

> —Sophocles (495–406 B.C., Greek dramatist),
> *Antigone*, 74–77, 102–104 (ca. 442 B.C.), trans. Robert Whitelaw

Antigone is killed, as she knew she would be, but there is no question that she has played the nobler part, and that it is better to die for what is right than to live knowing that wrong is being done.

In tragedy we know that the hero will not be saved and cannot be saved. There is no possibility of a happy ending. At the same time, however, we know that the values with which the hero is identified are not lost, and we feel triumphant in that assurance. Tragedy leaves one in a state of grief but also of positive exaltation. It is a strange combination, and if we add the fact that in tragedy these emotions are felt keenly, we have the reason why tragedy is counted the greatest of all literary forms. The pain of tragedy is great, so great it can hardly be endured. And the heroes of tragedy suffer; indeed, Othello, Antigone, Oedipus, and Lear are great because they suffer. "It is by our power to suffer, above all," says Edith Hamilton, "that we are of more value than the sparrows."[3] Because we have the power to suffer, we can feel both the pain of the hero and our own joy and exaltation in the dramatic resolution of his story.

Tragedy is, then, almost the exact opposite of comedy. Comedy is intellectual; tragedy is emotional. Comedy depends on the unexpected, the incongruous; tragedy demands a sense of inevitability. Comedy lives in a world of trivial values where there are no consequences; tragedy, in a world where every deed brings its consequences and values are triumphant.

TRAGEDY IN THE PRESENT DAY

Tragedy as written by the Greeks and by Shakespeare is generally recognized as one of the highest phases of literary art, but it is not common today. To all intents and purposes it has not existed since the eighteenth century. Perhaps the reason for this has to do with the fact that at this time the middle class began to emerge as the dominant group in modern society. Monarchy and nobility became less important, and the noble hero must have seemed less important as well. With the nineteenth century, moreover, there came an interest in men as victims not of their own characters, or of fate, but of social and economic circumstances. John Galsworthy's play *Strife*, for instance, shows a man victimized by capitalism;

[3] Edith Hamilton, *The Greek Way to Western Civilization*, p. 130.

Henrik Ibsen's *Ghosts* shows a woman victimized by convention. Given the circumstances of modern society—the way impersonal forces impinge on our lives—it is perhaps dramatically false to insist on the individual's responsibility for his own fate.

There is, in fact, some debate over whether there is such a thing as a genuine modern tragedy. Arthur Miller's *Death of a Salesman* (1947) gave rise to such an argument. The protagonist, a salesman named Willy Loman, is by no means royal or noble: this is one important departure from traditional tragedy. He is, however, brought down from a happier state (conveyed through a sort of flashback device), and the sense of the inevitability of his downfall is strong. Moreover, it seems that a flaw in his character is responsible for this; but it can be argued that the cause is, rather, the false values of his society.

This issue of the values of society brings up another possible reason for the failure of modern drama to produce much, if any, tragedy. In modern society there is less agreement on values than ever before. No contemporary seeing *Antigone* could doubt that the heroine's action was magnificent and ennobling. A similar situation today would be likely to strike different people in different ways: "Did she do right?" "Was her action worthwhile?" "Perhaps she should have . . ." Indeed, Willy Loman's suicide prompts just such opposed reactions: was it a noble sacrifice or a cowardly retreat? Modern life is—what a tragedy must never be—full of ambiguity.

A third factor may be mentioned, though it is questionable how much emphasis it deserves—the cheap solution, the idea that all will come out right anyway. We associate this attitude with Hollywood, but the film is not the only medium that reflects it. This is, perhaps, less influential today then it was three or four decades ago, when people felt disappointed not to get a "happy ending." Today, seeing a serious drama, we tend to be braced for unhappiness. Whether this ever is, or can be, the stuff of tragedy, remains a vexed question.

COMEDY AND TRAGEDY IN THE OTHER ARTS

Literature can deal with the intellectual more completely and more exactly than the other arts because its medium is the language of the intellect, the language of philosophy; therefore, the comic finds itself at home in literature more than in any of the other arts. This does not mean, however, that there is no comedy in music and the visual arts. In the visual arts, of course, there are paintings of comic situations; but in these, the problem of interpretation is ever present. The scene or the character that is intended as comic may not seem comic once it is painted; the picture intended to be tragic may seem comic, as we saw in Brueghel's *Parable of the Blind*. With pictures or statues of happy people having a good time there is no difficulty of interpretation, but neither is there anything comic about them.

There is a great deal of comedy in program music and in vocal music, but the comedy lives primarily in the story or in the words, not in the music

itself. The music of Haydn is friendly and genial, and we are tempted to call it witty because of the way one theme or one voice repeats and answers another, but it is not really comic. A superb example is the Rondo from the Sonata in E minor. We laugh aloud when listening to it, but it is a laugh of pleasure, of joy and excitement from following the repetitions. Mozart's "Musical Joke," a parody of an inept village band playing a ridiculous composition, is comic music, but such examples are extremely rare.

The tragic, like the comic, exists primarily in the realm of literature, though it, too, is found in the other arts. Music can seem to portray tragic conflict and its resolution. Most of Beethoven's sonatas and symphonies show conflict, and one feels the exaltation of the ending. But music is disembodied unless it is associated with a story (Wagner's music dramas are superb examples of the way music may interpret and resolve the conflict of a story); and then, of course, it is not the music itself which is tragic.

Painting and sculpture are limited by the fact that they can present only a single moment of time. Hence they can show either the struggle or the peace attained after the struggle is ended, but they cannot show both. The so-called *Medusa Ludovisi* (shown in Figure 18-1) from the Terme Museum at Rome shows the struggle but not the peace that follows: even though the figure sleeps, the tension is apparent. *The Resurrection* by Piero della Francesca (shown in Figure 18-2) shows the solution of struggle. It is as nearly tragic as any visual art can be. Many have seen in the face of Piero's Christ the suffering and horror of his time in hell, the sympathy that he had felt for those who he met, and his final victory over death. Painting and sculpture at their greatest show the elements of the conflict after the conflict is ended, when the warring elements are no longer in collision but at peace.

Figure 18-1. Medusa Ludovisi, or Sleeping Fury, copy of a late Hellenistic original. (Pentelic marble. Size: about 14½ inches. Rome, Terme Museum. Photograph, Alinari.)

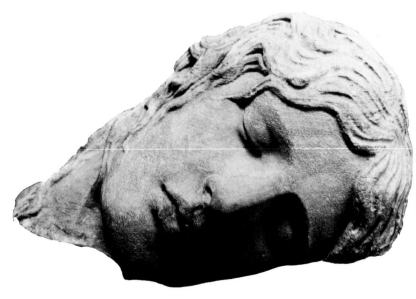

STYLE

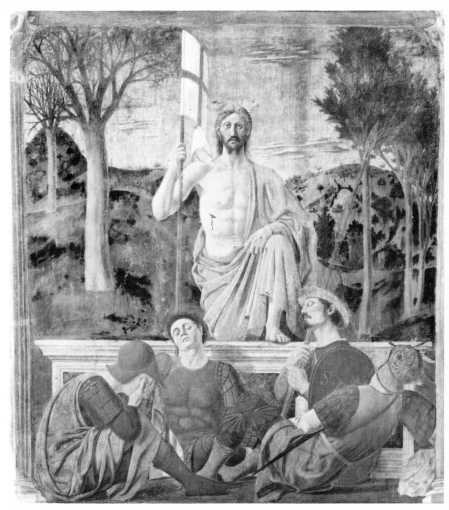

Figure 18-2. Piero della Francesca (ca. 1410–1492), Italian painter. The Resurrection of Christ (1460). (Fresco. Figures life size. Borgo San Sepolcro, Palazzo del Comune.)

19. JUDGMENT

Among the most frequent and perhaps the most justifiable questions the teacher has to face are these: "How do we know that a certain poem or picture is really good? Who is the final judge?" The American poet Marianne Moore has something to say about this problem:

POETRY

I, too, dislike it: there are things that are important beyond all this fiddle.
　　Reading it, however, with a perfect contempt for it, one discovers in
　　　　it after all, a place for the genuine.
　　　　Hands that can grasp, eyes
　　　　that can dilate, hair that can rise
　　　　　　if it must, these things are important not because a

high-sounding interpretation can be put upon them but because they are
　　useful. When they become so derivative as to become unintelligible,
　　the same thing may be said for all of us, that we
　　　　do not admire what
　　　　we cannot understand: the bat
　　　　　　holding on upside down or in quest of something to

eat, elephants pushing, a wild horse taking a roll, a tireless wolf under
　　a tree, the immovable critic twitching his skin like a horse that feels
　　　　　　　　　　　　　　　　　　　　　　　　　　　　a flea, the base-
　　　　ball fan, the statistician--
　　　　　　nor is it valid
　　　　　　　　to discriminate against 'business documents and

school-books'; all these phenomena are important. One must make a
distinction

however: when dragged into prominence by half poets, the result is not
poetry,

nor till the poets among us can be
 'literalists of
 the imagination'--above
 insolence and triviality and can present

for inspection, imaginary gardens with real toads in them, shall we have
 it. In the meantime, if you demand on the one hand,
 the raw material of poetry in
 all its rawness and
 that which is on the other hand
 genuine, then you are interested in poetry.

—Marianne Moore (1887–1972, American poet)[1]

THE PROBLEM OF JUDGMENT

With the study of style we have completed our formal analysis of art; we
turn now to our last topic about art: judgment. We ask of any example:
How good is it? What has the artist tried to do? How far has he succeeded
in accomplishing his purpose?

This does not imply that we can in a short time form opinions of
individual works which will be permanent and lasting. The great scholars
and critics have not succeeded at that game; what is liked in one year or
one decade may be considered worthless in the next. The only real test of
value in art, perhaps, is that of time. The really good, the truly great
artists are those who survive the centuries: Shakespeare, Sophocles, Bach,
Beethoven, Michelangelo, Phidias, Rembrandt.

Still, if we pursue the analysis of art according to the plan of this
book, we consciously or unconsciously make judgments about individual
qualities in specific works of art, and to that extent address ourselves to
these questions about judgment. Not that our analysis has said, "This is
good," or "That is bad," but through the better understanding that comes
from analysis we have learned to know details, and as a result we have
instinctively judged them interesting or dull, superficial or significant. What
remains now is to assemble such partial judgments into a comprehensive
evaluation. To the questions already mentioned, however, we must add
others which deal with judgment alone. They are assembled here under
three headings:

1. Sincerity
2. Breadth or depth of meaning
3. Magnitude or effectiveness

Sincerity

One of the important criteria in making a judgment is the sincerity of the artist, or, as we say more often, the honesty of his work. We want a work of art to be a serious expression of the author's thoughts and ideas. As Marianne Moore says, we want the genuine, and we do not care for those things "so derivative as to become unintelligible," or those other phenomena "dragged into prominence by half poets" or other half artists. We want in a work of art an honest, genuine piece of work.

To put the matter somewhat differently, what we look for is a genuine expression of the artist's own personality rather than a shallow imitation of someone else's. We may ask, To what degree is this work original? To what degree is its type of expression borrowed from some other work or some other artist? Michelangelo's style and achievements, for example, were so overwhelming that it was virtually impossible for anyone working during the sixteenth century not to have shown his influence in one way or another. Today, Picasso is an extremely dominant figure; he has influenced art and artists since he began to work early in this century. We have, accordingly, expressions like "Michelangelesque" and "Picassoid" to describe the work of artists who are followers of such masters.

To the extent that an artist follows someone else *imitatively,* we may judge his work unoriginal and hence inferior. An artist who is to be respected will, even if he starts from a basis of someone else's work, eventually move on to create works expressing his own individuality. Raphael, who worked in the early sixteenth century, was such an artist. He did borrow from Michelangelo at the beginning of his career, but he became one of the most outstanding and individual masters of the High Renaissance period. (To appreciate this, the reader may compare the left foreground figures in Figure 9-21, page 178, with *Isaiah,* Figure 3-25, page 66).

It should be pointed out that originality for its own sake is not a good criterion of quality, or of sincerity. During the latter part of the nineteenth century, from the impressionists onward, there was an expression among artists: *"Epatons les bourgeois!"*—"Let us astonish the middle class"— in other words, let us baffle them as much as we can. Matisse, who gave classes for painters in Paris during the first decade of the twentieth century, once asked a student why she was attending the course. She replied that she wanted "to do something new." This is an understandable feeling, but the urge to do something new does not of itself make for sincere artistic expression. Our reaction to the "Dada" art of the period around the First World War, or the "happenings" of today, may be influenced by a feeling that the artists were motivated too greatly by the desire to shock.

Another criterion that can be applied as regards sincerity is the extent to which a work of art does or does not express the character of the age in which it was produced. This criterion is particularly useful when we approach works of art, such as the great cathedrals of the Middle Ages, which were produced by anonymous artists. We cannot talk of the sincerity of any individual architect or stonemason in connection with, say, the

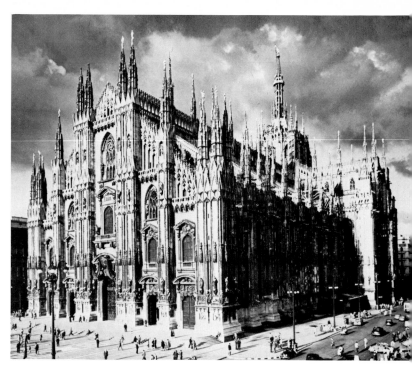

Figure 19-1. Cathedral at Milan (*mostly 1386–1522; West facade seventeenth to nineteenth centuries; most of the pinnacles nineteenth century*). (*White marble. Length: about 490 feet; width: about 200 feet. Milan. Photograph, Italian State Tourist Office.*)

cathedral of Milan (shown in Figure 19-1). We can only speak of its authenticity as a work of Gothic art—that is, the degree to which it embodies the Gothic ideal as we discussed it earlier, in our examination of the history of architecture. We may find that although the size and richness of decoration in the cathedral at Milan are indeed impressive, the building as a whole does not express the Gothic style as it was developed and perfected in northern and central France in the thirteenth century. The cathedral of Milan is, actually, an Italian adaptation of a much earlier French style, a style in which stone (in the cathedral of Milan marble is used instead) was used to produce an organic structure whose dominant feature was an emphasis on functionally related parts. The later French Gothic style, with its emphasis on verticality, symbolized the aspirations of the faith of those who created it. The cathedral at Milan, on the other hand, was produced in a country where the Gothic style had never taken root. In Italy, the style of the simple basilica always remained the norm; the cathedral at Milan represented a bow in the direction of a fashionable but foreign style, a style that the Italians had never understood. This cathedral is, then, a highly ornamented basilica: the pointed arches, tracery, pinnacles, and other Gothic elements are added as a kind of frosting rather than being organically related to the structure. Because of such considera-

tions, one might find such a building out of place, not genuine, inappropriate, or unmoving.

The form in which insincerity is most often found in art is sentimentalty. Sentimentality may be defined as an insincere emotion; it is interest in the effect of an action rather than in the action itself. Sentimentality is not to be confused with sentiment, which is genuine feeling. We are all sentimental when we are young; we love to think how good and noble we are and how we are not appreciated, how sorry our parents will be when we die and they recognize us as the wonderful people we really are. That is essentially the point of view in this little poem by Christina Rossetti:

When I am dead, my dearest,
 Sing no sad songs for me;
Plant thou no roses at my head,
 Nor shady cypress-tree:
Be the green grass above me
 With showers and dewdrops wet;
And if thou wilt, remember,
 And if thou wilt, forget.

I shall not see the shadows,
 I shall not feel the rain;
I shall not hear the nightingale
 Sing on, as if in pain:
And dreaming through the twilight
 That doth not rise nor set,
Haply I may remember,
 And haply may forget.
 —Christina Rossetti (1830–1894, British poet of Italian parentage),
 "Song" (1862)

The speaker seems interested in the effect of her death, and she is enjoying the melancholy prospect of being in the grave. It is essentially a romantic pose.

Similarly, in the "Good Night" from the first canto of Byron's *Childe Harold's Pilgrimage*, we sense not so much loneliness and desertion as enjoyment of the thought of being lonely and deserted.

And now I'm in the world alone,
 Upon the wide, wide sea;
But why should I for others groan,
 When none will sigh for me?
Perchance my dog will whine in vain,
 Till fed by stranger hands;
But long ere I come back again
 He'd tear me where he stands.
 —Lord Byron (1788–1824, British poet),
 Childe Harold's Pilgrimage, Canto I (1812)

For comparison, read the lyric "She Walks in Beauty," where Byron has his mind on the woman, not on himself—where, in other words, he is not sentimental:

She walks in beauty, like the night
 Of cloudless climes and starry skies;
And all that's best of dark and bright
 Meet in her aspect and her eyes:
Thus mellow'd to that tender light
 Which heaven to gaudy day denies.
 —"She Walks in Beauty" (1814)

It is harder to be sincere about oneself than about other people, but not impossible. Byron is sincere even about himself in the following:

And I have loved thee, Ocean! and my joy
Of youthful sports was on thy breast to be
Borne, like thy bubbles, onward. From a boy
I wanton'd with thy breakers—they to me
Were a delight; and if the freshening sea
Made them a terror—'twas a pleasing fear,
For I was as it were a child of thee,
And trusted to thy billows far and near,
And laid my hand upon thy mane—as I do here.
 —*Childe Harold's Pilgrimage*, Canto IV (1818)

The examples of sentimentality given so far have been from literature, but sentimentality is found in all the arts. We are especially conscious of it in music, thought we cannot explain how we recognize it. Beethoven's Sonata in C minor (or Chopin's Prelude No. 6) has in it something of self-pity, something of the spirit that finds itself an abused and sorrowful object —in short, something of sentimentality. The title by which it is usually known, the *Pathétique* ("pathetic") is evidence of this. In comparison, Beethoven's Symphony in C minor is entirely lacking in sentimentality; it is open, frank, direct. It seems to show suffering, but it does not enjoy the suffering.

Painting, like literature and music, is an open field for sentimentality; and sweet, sentimental creatures are almost as common in painting as in life. In the *Virgin of Consolation* by Bouguereau (shown in Figure 19-2) the figures are artificially posed; the Virgin, the mother on her knee, and the child lying at her feet are all designed primarily to produce a certain effect. There is no truth; it is not genuine. If this is compared with any of the great paintings of the Madonna, the difference is clear; in Giotto's *Madonna Enthroned* (shown in Figure 19-3), for example, the artist avoids the melodramatic, and projects calm, dignity, and nobility.

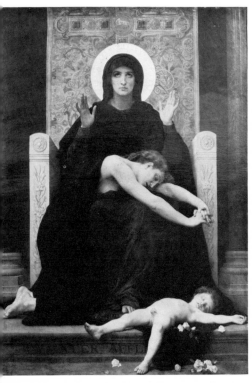

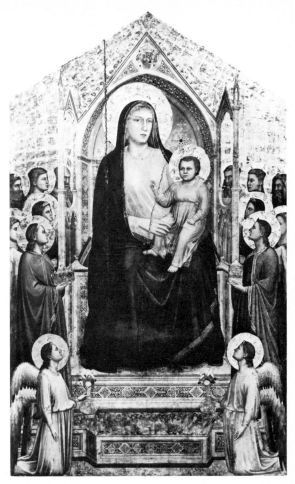

Figure 19-2. Adolphe William Bouguereau (1825–1905), French painter. Virgin of Consolation (1877). Oil on canvas. Size: about 14 feet by 11 feet, 3 inches. Paris, Luxembourg. Photograph, Braun, Inc.)

Figure 19-3. Giotto (1266–1336). Madonna Enthroned (ca. 1304). (Tempera on wood. Height: 10 feet, 8½ inches. Florence, Uffizi Gallery. Photograph, Anderson. See also Figure 3-11.)

Depth of Meaning

Another criterion to apply to a work of art has to do with its depth of meaning. How much is the artist trying to do? What has he attempted?

Consider two works by Brahms. His "Lullaby," which we love to sing ("Hushabye and goodnight, with roses bedight"), is beautiful. But compare it with the magnificent final movement of his Symphony No. 1. The lullaby, although it is true and fine, lacks the breadth and depth of the symphony. Each work is supreme of its kind, but Brahms has attempted more in the symphony.

Let us examine two works of literature on the subject of war. In Hardy's short poem "The Man He Killed," an ordinary man thinks about his own experience of war:

Figure 19-4. Niké Loosening Her Sandal (end of fifth century B.C.), from Temple of Athena Niké. (Pentelic marble. Height: 3 feet, 2 inches. Athens, Acropolis Museum. Photograph, Royal Greek Embassy.)

"Had he and I but met
By some old ancient inn,
We should have sat us down to wet
Right many a nipperkin!

"But ranged as infantry,
And staring face to face,
I shot at him as he at me,
And killed him in his place.

"I shot him dead because—
Because he was my foe,
Just so: my foe of course he was;
That's clear enough; although

"He thought he'd list, perhaps,
Off-hand like—just as I—
Was out of work—had sold his traps—
No other reason why.

"Yes, quaint and curious war is!
You shoot a fellow down
You'd treat if met where any bar is,
Or help to half-a-crown!"

—Thomas Hardy (1840–1928, British novelist, short-story writer, and poet), "The Man He Killed" (1902)[2]

Tolstoi's novel *War and Peace* comes to conclusions that are not radically different from those of Hardy's poem as far as the value and meaning of war are concerned, but its scope is much greater. Tolstoi makes us see the horrors of war year in and year out, the hopes, dreads, uncertainties, and dangers as they are stretched out for years, until it seems that man can take no more.

The question of levels of meaning is another important aspect of appreciating a work of art. Some works we seem to enjoy purely on the surface level. Here are two examples: One of the reliefs from the Temple of Athena Niké in Athens is known by the title *Niké Loosening Her Sandal* (shown in Figure 19-4). The goddess rests her entire weight on her left leg; the right leg is raised as she leans over to loosen the cord of her sandal. Her costume is of a soft material, which falls in soft folds across her body, curve after curve all falling in the same general lines but with no two exactly alike. We have already studied a Greek vase which shows two women putting away their clothes (Figure 13-24, page 271). The figures and their clothes are balanced perfectly; the space is filled but is not crowded; the bodies of the women are graceful and each seems to complement the other, although there is little exact repetition. These are not works to make one think or ponder; one simply rejoices in the grace of the

[2] From *Collected Poems* of Thomas Hardy. Copyright 1925 by The Macmillan Company. Used by permission of The Macmillan Company.

shapes in the design. We do not ask why the sandal is being removed or why the clothes are being put away.

There is the same sense of untroubled enjoyment when one reads a little poem like Yeats's "Fiddler of Dooney":

When I play on my fiddle in Dooney
Folk dance like a wave of the sea;
My cousin is priest in Kilvarnet,
My brother in Mocharabuiee.

I passed my brother and cousin;
They read in their books of prayer;
I read in my book of songs
I bought at the Sligo fair.

When we come at the end of time
To Peter sitting in state,
He will smile on the three old spirits,
But call me first through the gate;

For the good are always the merry,
Save by an evil chance,
And the merry love the fiddle,
And the merry love to dance:

And when the folk there spy me,
They will all come up to me,
With 'Here is the fiddler of Dooney!'
And dance like a wave of the sea.
—W. B. Yeats (1865–1939, Irish poet and playwright),
"The Fiddler of Dooney" (1899)[3]

This is very pleasant, and we enjoy it; we don't stop to ask if the Catholic church puts the work of the fiddler above that of the priest. The poem makes the heart dance "like a wave of the sea"; it does not set the mind to puzzling.

These examples are simple, clear, direct, finished, and perfect. We know them at once, and we feel we know them well. There is no hidden meaning in them.

Often, however, a work of art has more than one level of meaning. To start with an obvious instance, let us look at a poem by Robert Frost. It has only two lines:

The old dog barks backward without getting up,
I can remember when he was a pup.
—Robert Frost (1875–1963, American poet)[4]

[3] From *The Collected Poems* of W. B. Yeats. Copyright 1903 by The Macmillan Company; rev. ed., 1956. Used by permission of The Macmillan Company.
[4] From *A Further Range* by Robert Frost, Copyright 1936, by Robert Frost. By permission of Henry Holt and Company, Inc.

This is short and simple, like the examples we have just discussed, but there is a difference. Change the second line to

He was frisky and lively when he was a pup

and the poem becomes more like the three first examples—pleasant and final. In restoring the line as Frost wrote it, "I can remember when he was a pup," we find that the meaning is changed entirely. There is a sudden realization of the weakness of age, the eagerness of youth, and the shortness of life. In spite of the use of the pronoun "I," the poem seems far away and abstract. It fits the title, "The Span of Life."

From a small, simple, obvious object the poet can draw philosophical conclusions. John Ciardi in his poem "Credibility" looks at an ant and sees in it universal significance.

Who could believe an ant in theory?
a giraffe in blueprint?
Ten thousand doctors of what's possible
could reason half the jungle out of being.
I speak of love, and something more,
to say we are the thing that proves itself
not against reason, but impossibly true,
and therefore to teach reason reason.
—John Ciardi (1916— , American poet), "Credibility"[5]

Muriel Rukeyser interviews a Zen Buddhist and captures the essence of an obscure philosophy in her poem "Fragile."

I think of the image brought into my room
Of the sage and the thin young man who flickers and asks.
He is asking about the moment when the Buddha
Offers the lotus, a flower held out as declaration.
"Isn't that fragile?" he asks. The sage answers:
"I speak to you. You speak to me. Is that fragile?"
—Muriel Rukeyser (1913— , American poet),
"Waterlily Fire," Part IV, "Fragile"[6]

We find the same sort of thing in two short poems by Robert Browning, "Meeting at Night" and "Parting at Morning." The first is a vivid description of the meeting of two lovers, the eagerness hardly to be borne as the lover makes his way to the house where his loved one is awaiting him. The

[5] From *In Fact.* Copyright 1962, Rutgers, the State University. Reprinted by permission of the author.
[6] From *Poems* by Muriel Rukeyser, 1935–1962. Copyright 1962. Reprinted with permission of The Macmillan Company.

images are very clear: gray sea, long black land, yellow half-moon large and low, tap on pane, scratch of match, warm sea-scented beach.

The gray sea and the long black land;
And the yellow half-moon large and low;
And the startled little waves that leap
In fiery ringlets from their sleep,
As I gain the cove with pushing prow,
And quench its speed i' the slushy sand.

Then a mile of warm sea-scented beach;
Three fields to cross till a farm appears;
A tap at the pane, the quick sharp scratch
And blue spurt of a lighted match,
And a voice less loud, through its joys and fears,
Than the two hearts beating each to each!
 —Robert Browning (1812–1889, British poet),
 "Meeting at Night"

Here is the second poem ("him" in the third line refers to the sun):

Round the cape of a sudden came the sea,
And the sun looked over the mountain's rim:
And straight was a path of gold for him,
And the need of a world of men for me.
 —Robert Browning,
 "Parting at Morning"

Each of the two poems has its own meaning, clear and exact when taken by itself. Each describes a situation. But the meaning changes when they are taken together, as Browning put them. Together, they say that the "need of a world of men" is a greater, higher appeal than that of "two hearts beating each to each." This prods us to thought: Why is this conclusion reached? We start to go below the surface of the poem to find what underlies it.

"Ozymandias" is nothing if it is only a description of a ruined monument.

I met a traveller from an antique land
Who said: Two vast and trunkless legs of stone
Stand in the desert . . . Near them, on the sand,
Half sunk, a shattered visage lies, whose frown,
And wrinkled lip, and sneer of cold command,
Tell that its sculptor well those passions read
Which yet survive, stamped on these lifeless things,
The hand that mocked them, and the heart that fed:
And on the pedestal these words appear:

"My name is Ozymandias, king of kings:
Look on my works, ye Mighty, and despair!"
Nothing beside remains. Round the decay
Of that colossal wreck, boundless and bare
The lone and level sands stretch far away.
 —Percy Bysshe Shelley (1792–1822, British poet),
 "Ozymandias" (1817)

What is important is not the surface but the point being made on the second level—that of irony. The theme is presented not explicitly, but in the unstated contrast between the king's proud words and the desolation that makes them ridiculous.

In the visual arts, the existence of levels of meaning may be illustrated by good portraiture. A good portrait shows more than what can be seen at any time and by anyone. It shows the man inside the face, as it were; looking at it, we may seem to know what the man hoped and feared, and to what he was true. In Rembrandt's *Man in the Gold Helmet* (Figure 19-6, page 402) we see first the beauty of the helmet, its rich chasing; then we notice the rich garments. The exterior details show a man who has apparently all that money and power can bring him. The face is a great contrast to the rich garments. It is tired, stern, kind; it seems to be the face of a man who has known hard work, who has had to make hard decisions and take the consequences; a man who has had so much wealth that it means nothing to him; a man who can be trusted to see truth and deal fairly with it.

In *Early Sunday Morning* (shown in Figure 19-5) Hopper has given us more than a painting of a street. A sense of stillness pervades the street; we are conscious of how the delicate light of morning, the quietness of Sunday, can touch a poor, ugly scene with beauty and dignity, and impart a sense of time suspended.

El Greco's *View of Toledo* (Figure 17-6, page 374) is a painting of a city where a storm is about to break. But beyond the natural appearance, the scene is ominous and foreboding; it is one of emotional intensity, mystery, and passion.

Magnitude or Effectiveness

Magnitude is concerned with the impact or effectiveness of a work as a whole, whether it be shallow or deep, important or unimportant, great or trivial—in short, with the quality of greatness felt in it.

For some years, one of the criteria applied was the degree to which a work met the ideal of sublimity. The source of the sublime is always greatness of power. One feels the sublime in the ocean, in a fierce storm, in a mighty waterfall; there is no sense of greatness in a small pond or trickling stream in a pleasant meadow. But even greater than the sublimity of physical power is the sublimity of spiritual power, the power of the Mass in B minor by Bach, or the Book of Job.

The sublime ordinarily demands a great protagonist: a person who is noble or powerful. It seems more natural to think of great emotions in great

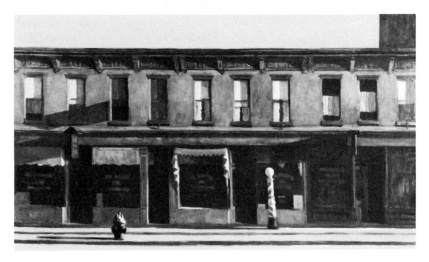

Figure 19-5. Edward Hopper. Early Sunday Morning (ca. 1930). (*Oil on canvas. Size: 35 by 60 inches. New York, Whitney Museum of American Art.*)

persons—kings, queens, and people in authority; hence the tradition was that heroes and heroines must be of noble birth. But greatness of rank is not essential; the highest emotions can be found even in the simplest subjects. A. C. Bradley quotes this passage from Turgenev as an example of sublimity in so little a thing as a sparrow.

I was on my way home from hunting, and was walking up the garden avenue. My dog was running in front of me.

Suddenly he slackened his pace, and began to steal forward as though he scented game ahead.

I looked along the avenue; and I saw on the ground a young sparrow, its beak edged with yellow, and its head covered with soft brown. It had fallen from the nest (a strong wind was blowing, and shaking the birches of the avenue); and there it sat and never stirred, except to stretch out its little half-grown wings in a helpless flutter.

My dog was slowly approaching it, when suddenly, darting from the tree overhead, an old black-throated sparrow dropped like a stone right before his nose, and, all rumpled and flustered, with a plaintive desperate cry flung itself, once, twice, at his open jaws with their great teeth.

It would save its young one; it screened it with its own body; the tiny frame quivered with terror; the little cries grew wild and hoarse; it sank and died. It had sacrificed itself.

What a huge monster the dog must have seemed to it! And yet it could not stay up there on its safe bough. A power stronger than its own will tore it away.

My dog stood still, and then slunk back disconcerted. Plainly he too had to recognize that power. I called him to me; and a feeling of reverence came over me as I passed on.

Yes, do not laugh. It was really reverence I felt before that little heroic bird and the passionate outburst of its love.

Love, I thought, is verily stronger than death and the terror of death. By love, only by love, is life sustained and moved.[7]

[7] A. C. Bradley, ''The Sublime,'' *Oxford Lectures on Poetry*, p. 44. With permission of Macmillan & Co., Ltd., St. Martin's Press, Inc.

Figure 19-6. Rembrandt Harmensz van Rijn *(1606–1669). Man in the Gold Helmet. (Oil on canvas. Height: 2 feet, 2½ inches. Berlin, State Museums. Photograph, Stoedtner.)*

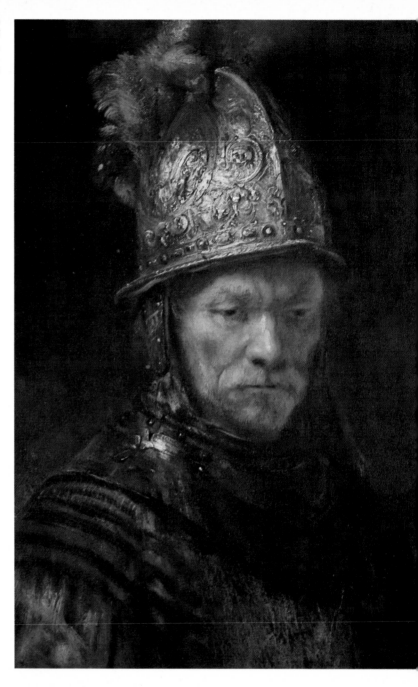

Below the sublime are other degrees of magnitude, such as the grand, the beautiful, the graceful, and the pretty. By common consent, prettiness is the opposite of sublimity; it is pleasant, but it arouses no strong emotions. The grand and the sublime both have the quality of greatness; the pretty and the graceful have not. The beautiful may or may not be great.

These terms will become more meaningful if we try to apply them to definite works. Differences can be seen most easily if we contrast two subjects that are alike or two works by the same artist.

Dvorák's *Humoresque* is pretty or graceful, but his *New World Symphony* is beautiful, perhaps even great. Yeats's poem "The Second Coming" is great or beautiful; his "Fiddler of Dooney" is no more than pretty or graceful.

Turning and turning in the widening gyre
The falcon cannot hear the falconer;
Things fall apart; the center cannot hold;
Mere anarchy is loosed upon the world,
The blood-dimmed tide is loosed, and everywhere
The ceremony of innocence is drowned;
The best lack all conviction, while the worst
Are full of passionate intensity.

Surely some revelation is at hand;
Surely the Second Coming is at hand.
The Second Coming! Hardly are those words out
When a vast image out of *Spiritus Mundi*
Troubles my sight: somewhere in sands of the desert
A shape with lion body and the head of a man,
A gaze blank and pitiless as the sun,
Is moving its slow thighs, while all about it
Reel shadows of the indignant desert birds.
The darkness drops again; but now I know
That twenty centuries of stony sleep
Were vexed to nightmare by a rocking cradle,
And what rough beast, its hour come round at last,
Slouches towards Bethlehem to be born?
　　　　—W. B. Yeats (1865–1939, Irish poet and playwright),
　　　　"The Second Coming." 1921[8]

Compare two great compositions by Michelangelo: the *Pietà* (Figure 19-7, page 404) at S. Peter's in Rome, which was done when he was a young man, and the *Entombment* (Figure 19-8, page 404) in the cathedral at Florence, done some fifty years later. Both are sincere; both are complete. In the *Pietà*, the Madonna is young, her face sweetly serious, her head bent forward as she tries to comprehend what has happened. One hand is holding the body of Jesus, the other is left free in a youthful gesture. In the *Entombment*, youth and sweetness have been left behind. The greatest

[8] From *The Collected Poems* of W. B. Yeats. Copyright 1903 by The Macmillan Company; rev. ed., 1956. Used by permission of The Macmillan Company.

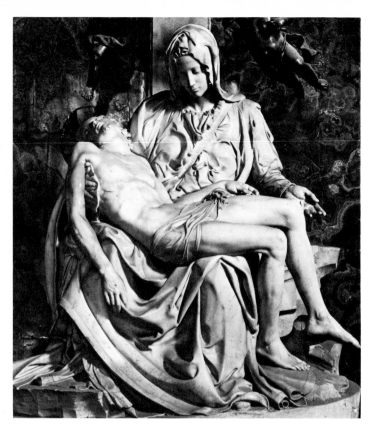

Figure 19-7. Michelangelo. Pietà (1498–1502). (Marble. Height: about 6 feet, 3 inches. Rome, S. Peter's. Photograph, Anderson.)

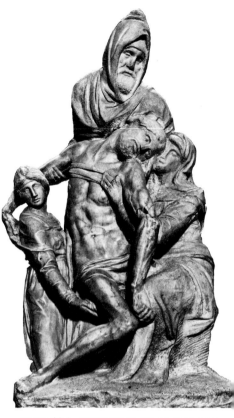

Figure 19-8. Michelangelo. The Entombment (ca. 1550). (Marble. Height: about 7 feet. Florence, Cathedral. Photograph, Anderson.)

change is in the face of Jesus, for he is now the Christ who has died to save the world. This agonized yet triumphant statue has elements of sublimity, whereas the lyrical and gentle *Pietà* lacks them.

The sublime arouses in one a feeling of astonishment, rapture, and awe. In comparison with its greatness one feels his own littleness but, paradoxically, the attempt to share the sublime makes one greater than he was before. Confronted with the greatness of Socrates as we see him in Plato's account, we feel petty, and yet our attempt to understand him makes us greater than we were.

Crito, when he heard this, made a sign to the servant; and the servant went in, and remained for some time, and then returned with the jailer carrying the cup of poison. Socrates said: "You, my good friend, who are experienced in these matters, shall give me directions how I am to proceed." The man answered: "You have only to walk about until your legs are heavy, and then to lie down, and the poison will act." At the same time he handed the cup to Socrates, who in the easiest and gentlest manner, without the least fear or change of color or feature, looking at the man with all his eyes . . . as his manner was, took the cup and

said: "What do you say about making a libation out of this cup to any god? May I, or not?" The man answered: "We only prepare, Socrates, just so much as we deem enough." "I understand," he said: "yet I may and must pray to the gods to prosper my journey from this to that other world—may this then, which is my prayer, be granted to me." Then holding the cup to his lips, quite readily and cheerfully he drank off the poison. And hitherto most of us had been able to control our sorrow; but now when we saw him drinking, and saw too that he had finished the draught, we could no longer forbear, and in spite of myself my own tears were flowing fast; so that I covered my face and wept over myself, for certainly I was not weeping over him, but at the thought of my own calamity in having lost such a companion. Nor was I the first, for Crito, when he found himself unable to restrain his tears, had got up and moved away, and I followed; and at that moment, Apollodorus, who had been weeping all the time, broke out into a loud cry which made cowards of us all. Socrates alone retained his calmness. "What is this strange outcry?" he said. "I sent away the women mainly in order that they might not offend in this way, for I have heard that a man should die in peace. Be quiet then, and have patience." When we heard that, we were ashamed, and refrained our tears; and he walked about until, as he said, his legs began to fail, and then he lay on his back, according to the directions, and the man who gave him the poison now and then looked at his feet and legs; and after a while he pressed his foot hard and asked him if he could feel; and he said, "No"; and then his leg, and so upwards and upwards, and showed us that he was cold and stiff. And he felt then himself, and said: "When the poison reaches the heart, that will be the end." He was beginning to grow cold about the groin, when he uncovered his face, for he had covered himself up, and said (they were his last words)—he said: "Crito, I owe a cock to Asclepius; will you remember to pay the debt?" "The debt shall be paid," said Crito; "is there anything else?" There was no answer to this question; but in a minute or two a movement was heard, and the attendants uncovered him; his eyes were set, and Crito closed his eyes and mouth.

—Plato (427?–347 B.C., Greek philosopher), *The Phaedo*, trans. Benjamin Jowett (1817–1893, British scholar)

An excellent example of sublimity in music is the choral section of Beethoven's Ninth Symphony (1824) based on Friedrich Schiller's "Ode to Joy," a poem about the brotherhood of man. Few listeners can remain unmoved in the presence of this majestic combination of music and verse, with its full orchestra and huge chorus. Other examples are the mighty final movement of Brahms' First Symphony (1876), and the portion of Wagner's *Götterdammerung* ("Twilight of the Gods," 1874) known as "Siegfried's Death," which begins with a spine-chilling roll of the timpani and the unearthly forest music that presages the death of the hero.

Today, sublimity is no longer the supreme criterion applied in discussing the magnitude or effectiveness of works of art. A number of factors, including the development of abstraction, have presented a challenge to traditional values and methods of judging. The term *sublime*, indeed, is not applied to modern and contemporary works, although we do retain the sense that some works are characterized by "greatness," by a magnitude beyond that of other works. The murals of Orozco, the triptychs of Max

Beckmann, and Picasso's *Guernica* are examples of impressive magnitude, but these works cannot properly be described as sublime. Similarly, the concept of sublime heroism no longer seems to apply, as was suggested in our discussion of the absence of traditional tragedy from modern drama.

Does this mean that the criteria we apply to modern works must be different from those applied to traditional works? We are now approaching a very complex subject, which the scope of this book will not allow us to deal with. Aestheticians—that is, scholars who devote themselves to the problem of characteristics of art and value in art—believe that there are universal criteria, that we can make exactly the same demands of all kinds of art produced at all times. Unfortunately for our purposes, the aestheticians differ on what these criteria may be. It is not even entirely clear whether there are basic irreconcilable differences among the various sets of criteria suggested, or whether the criteria might not represent different aspects of roughly similar ideas. For example, we have suggested as criteria sincerity, depth, and magnitude or effectiveness. Monroe Beardsley, a well-known American aesthetician, has suggested unity, complexity, and intensity. Are these two sets entirely incompatible? Perhaps "complexity" and "depth" are essentially the same idea; but perhaps "intensity" and "magnitude" are altogether different concepts. We have not taken up "unity"—that is, the fact that a work of art is complete in itself and totally self-contained—and Beardsley's criteria do not include "sincerity." James Joyce, speaking through the character Stephen Dedalus in *A Portrait of the Artist as a Young Man,* proposed "wholeness," "harmony," and "radiance." To what extent do these criteria agree or disagree with those we have just mentioned? Even if we decide to take it for granted that there are universal criteria, formulating them is an enormous and subtle problem. (It is also a fascinating problem.) For practical purposes, it is well to know that there are, broadly speaking, two main ways of evaluating works of art. One is purely formal. Those who take this approach are interested in the physical or structural characteristics of the work: in visual art, for example, these would include form, space, color, and texture. The work of art is considered to be a combination of these formal elements. Meaning and emotion are not so important. Another approach concentrates on the way a work of art reflects the period in which it was produced, and particularly the standards which existed during that period. Following this second approach, one would try to distill from the works of an era the artistic ideal of that era, and then apply that ideal to the works of the time.

These two approaches do not necessarily produce opposed judgments about a work of art. For example, let us take each approach to Luini's *Holy Family* (Figure 17-3, page 368). First, we can see that it lacks clarity, restraint, and adequate space for the figures in it; that is, it is not pleasing as a formal design. Second, we may compare it with contemporaneous works by Leonardo, Raphael, and Michelangelo. We find in the works of these High Renaissance masters qualities which we may consider as part of the Renaissance ideal: the sculpturesque, the geometric, great control

and restraint over emotional content, careful composition. These qualities do not seem to be present in the Luini. With either approach, then, we are led to the conclusion that this is not a particularly good work.

GROWTH IN JUDGMENT AND EVALUATION

The judgment each person makes of a work of art is individual and personal, just as the experience itself was individual and personal. Since one person is never exactly like any other, his evaluation and appreciation of art will never be exactly like that of another. Moreover, no person's judgment of any work of art will remain exactly the same. With each new experience he tends to like it more or less, to find it more or less rewarding. In short, there is never one evaluation which can be embalmed and put away as final.

Not only does evaluation change with each new experience, but it changes as one comes to know the judgments of others. Both history and criticism can help us to see and hear what we have not seen and heard for ourselves, and so our experience becomes richer and deeper.

This is the greatest contribution history and criticism can make to us, but there is a secondary influence which is also of importance. History and criticism can help us in the selection of works we want to become acquainted with. No one can possibly know all the art in the world; he cannot read all the books that are printed or hear all the music that is composed and played in any one year; he can hardly know all the pictures and statues in any one of the great galleries, much less in all of them. Therefore, we use the opinions of others to help us decide what is worth looking at and listening to, to tell what has been thought good and what poor, what has been reckoned great and what mediocre.

This is especially important in the case of those artists who have become known through the ages as the very great: Dante, Homer, Rembrandt, Shakespeare, Phidias, Bach, Beethoven, Michelangelo. They cannot be known easily or at once. Therefore we do not get the immediate satisfaction we get from lesser works; we are perhaps repulsed, and we put them aside. The very great in art, as in everything else, is difficult; almost anything worth doing is difficult; it cannot be attained easily or without hard work. The prophecies of Isaiah and the Book of Job in the Old Testament are among the supreme examples of literature, but it is doubtful if anyone can get very great pleasure from them without study. No one can ever appreciate the Mass in B minor or the *Divine Comedy* on a casual hearing or a superficial reading; they need concentrated attention. When we know that these are considered among the world's great masterpieces, we can prepare to give them the necessary study. The person who gives them this study will not necessarily like them; in art, as in life, one must count on a certain number of failures. But no one can know if he will like the great works of art until he has given them the necessary attention.

Fortunately, there is little difference of opinion with regard to the very great. About the lesser works there are many and various judgments—one person prefers this and another that—but as we approach those few masterpieces that can be called supremely great, the differences melt away. Hence we may approach them with greater assurance, understanding that though they demand work, they will bring their reward; the work will not be in vain. Fortunately, also, the rewards of art, like the rewards of goodness, are open to everyone. Appreciation of art, like virtue, is not reserved for the learned but is free to the honest and sincere.

20. A FINAL WORD

In the preceding chapters we have attempted to guide you in experiencing some of the great art of the past, our artistic heritage, and in experiencing selected examples of the recent past. What of the art of the present and the future? How does the way of looking at art, of listening to music, and of reading literature which has been presented in these chapters apply to current art and to styles yet to be developed? What of "aleatory music," "electronic music," "musique concrète"? What about "happenings," "the theater of the absurd," "the drama of the imagination"? What of "light sculpture," "op art," "pop art," "found objects"?

The present chapter attempts to provide a context for dealing with these and similar questions, but not by analysis of specific examples, styles, or schools. You have by this time had sufficient exercise in that. It insists, rather, that now that your eyes have been opened and your senses sharpened, you can with some confidence approach unfamiliar art and expand still further your horizons of awareness. We suggest here some broad perspectives which will be helpful.

PERSPECTIVE ONE

All art comes before the theories which explain it, the terminology which enables us to point to various aspects of it, the name which classifies it. This fact is especially important to remember as we consider the newer art forms and styles. Often we tend to approach them with the expectancies built into us from all our previous experiencing of art. When these do not correspond to what we see or hear, we tend to reject the new art completely or to judge it harshly. To give the new a chance, however, we must

go beyond *sensing that it is different* to asking what the "differences" are expressing. Sometimes we may conclude that the "difference" is no more than deliberate perversity. More often we shall discover that it evokes in us new ranges of sensitivity. A good example of this is Thomas B. Hess's *Abstract Painting: Background and American Phase* (1951), which was the first attempt to explain abstract expressionism. This book made clear what the movement stood for and what it was trying to do.

PERSPECTIVE TWO

In looking at any new or unfamiliar work of art, we should interpret in their broadest sense the terms we have been using to point to various aspects of it. *Organization, order*—whatever term one uses should be thought of not as an absolute, exact description but as a continuum running from chaos at one end to geometric, mathematical forms at the other. Art always seeks some reconciliation of these opposites. The reconciliation may be toward one end of the continuum or toward the other. Style is the part of art which comes into play unconsciously. In all periods there are great individualists whose personal stamp is so strong that it becomes recognizable in everything they produce. Sometimes it is so distinctive and powerful that it is copied by lesser artists and creates a "school" or "movement." At other times the style may break so completely with prevailing ones that the works of the artist when seen in the perspective of history do not seem to belong—that is, they do not fit into the academic generalizations about a period. Medium, too, should be broadly interpreted. In contemporary art the traditional compartmentalization of mediums has yielded to experimentation with various "intermediums"—for example, art which is between music and theater, between sculpture and painting, between sculpture and architecture. There is no right or wrong medium nor any known limit to appropriate mediums. Mediums are always being found and artists are always exploiting them to their maximum expressive potential. (Artists like Passmore—Figure 5-7, page 99—illustrate the breakdown between the older categories of painting and sculpture.)

PERSPECTIVE THREE

It is helpful to look at new art from the point of view of the artist as he slowly creates it step by step. From this point of view, from the way in which it came into being, one can consider art on a scale of homogeneity to heterogeneity. "From the moment work starts on a picture, it begins to shift slowly along a scale from extreme homogeneity (blank space) toward ever-increasing heterogeneity. Maximum heterogeneity (a mass of fuzzy detail) is not apparently visually desirable and so somewhere along this homogeneous-heterogeneous scale there is for each picture a point of optimum heterogeneity. This is the point at which the picture is considered

finished."[1] Similarly, into utter silence the musician puts a sound, a succession of sounds, a harmony. He leaves more or less of the homogeneous silence in his composition. By including greater amounts of silence he can focus attention on a single sound which would otherwise be "lost" in the din of maximum heterogeneity. The music of John Cage and the sculpture of Henry Moore would illustrate this phenomenon, the open spaces in the latter representing spatial silence (Figure 2-7, page 25).

PERSPECTIVE FOUR

New art frequently seems shocking. The operas of Richard Wagner, the paintings of the impressionists during the 1870s, the public demonstrations of the Dadaists of 1916, the "happenings" mounted in the 1960s—these are only a few examples of work that was not accepted by the general public of its time. Much of what is now accepted as standard repertoire in music, and many pieces now automatically included in anthologies of literature, were at one time considered odd, strange, or incomprehensible. This will continue to be so, because one of the functions of art is to help us bring again into our perceptual systems things which we have been conditioned to exclude. Each of us has his own personal orientation which "keeps us from seeing reality, locks us into the illusory embrace of given orientations." But "art . . . by breaking up those orientations releases us to see aspects of reality which orientations conceal from us."[2] Thus, while it is correct to think of art as an ordering and extending of relationships, it is also important to remember that it is a disordering of our usual ways of seeing; it omits things commonly emphasized and includes those not commonly emphasized. A function of art, therefore, is to read back into life the complexities which our orientations, our systems and abstractions, have tended to obscure and omit. The simplifications and systems necessary to functioning in our social structure tend to impoverish our full functioning as organisms. By putting back into the consciousness the excluded, art can give back to us some sense of our wholeness. It is, therefore, in the strict sense of the term, consciousness-expanding in its nature.

PERSPECTIVE FIVE

One thing the new art forms say is simple. They are saying that the old forms are too constricting to hold our view of the world, or to hold the personal experience of the artist in our world, or to accommodate our perceptual patterns. They are saying that the same courageous freedom which produced the older art is a continuing right of the artist, that this freedom

[1] Desmond Morris, *The Biology of Art*, Alfred A. Knopf, New York, 1962, p. 165.
[2] Morse Peckham, *Beyond the Tragic Vision*, George Braziller, Inc., New York, 1962, p. 150.

must be exercised, and that it is necessary if art is to fulfill its cultural function. The established conventions, traditions, and forms constrict. And artists who begin to feel trapped often resort to somewhat violent means of escape. Serendipity, the planned accident, chance art, and other ways of achieving random relationships have throughout history been used by artists in their search for immediacy, freshness, and individual expression. It is, however, only in our time that they have gained status as a significant phase of the creative process. The "planned-accident" type of expression is perhaps best seen in the work of Jackson Pollock (Figure 2-23, page 39); the absolute break with the past in the "minimal art" of Tony Smith (Figure 2-5, page 23).

PERSPECTIVE SIX

The arts should be viewed as continuous with other human activities contemporary with them. A new invention, medium, world view, or way of seeing things reflects the changes in science, psychology, and philosophy that have been taking place in ways frequently unnoticed by the public at large. Art is a way of making visible these changes in our thinking and feeling. It is a way of making them a part of our sensory and conscious experience. It explores their echoes and eddies in our psychic life and gives expression to them. Advances in our understanding of how we think, new insights into our ways of perceiving, have in the past influenced the arts. A question always worth asking, therefore, is: How does what is being done in the arts relate to the other human activities in which the culture is engaging? The discoveries of the past twenty years and the consequent revisions of what we know have confirmed the observation that "knowledge does not keep any better than fish." To continue as participants in our culture, therefore, it is imperative that we become competent in fishing; that is, in the attitudes of open inquiry which will continue to add to and replace our present knowledge. Already we have come to see that logic frequently leads us to go wrong with a sense of certainty, that myth is as true as history, that the world is a letter addressed "To Whom It May Concern," and that the answers it gives depend upon the questions we ask of it. If one looks for a single word to characterize the attitude toward knowing in our time, he might well choose "tentativeness," for we have come to entertain the possibility that all knowledge is tentative, partial, and personal.

It is quite possible that these new insights have contributed to an insecurity in our time. In fact, it has been argued that one of the reasons we have clung with such desperateness, persistence, and inflexibility to the vision of an ordered, certain universe is that we cannot tolerate such uncertainty. To the extent that you, however, can entertain this broader view, it should be liberating, for it makes you an authority along with whatever other authorities you know. It should give you confidence and freedom in

your own observing and perceiving. Whose eyes but yours can see the world you see?

While these developments may appear to set us adrift in chaos, they can and do, after the initial shock, function to expand one's sense of his own presence in a cosmos which always seems to be breaking out of our little contrived systems and orderly forms of thought.

ART IS A ROAD BACK

Many people are saying that we have become caught in our own thinking, that in making the machine the model of perfection and measuring our achievements in terms of it we have become automatons dissociated from our feelings and individual responses, that we have relinquished ourselves so completely that we are willing, conspiring victims of authoritarianism. If this is true, then it is time that we asked: Is there no alternative for us? Is there no road back? Art is a road back; and, like all roads back, it is a road forward, for it leads not to a past, accomplished somewhere back there, but to the past within us. It offers a road back to experiencing, to a quickening of the senses, to a fuller realization of our humanity, and to a wholeness which is our real heritage.

TEACHING MATERIALS

I. ILLUSTRATIONS OF ART SUBJECTS

UNESCO WORLD ART SERIES (NEW YORK GRAPHIC SOCIETY)
The following volumes have been issued: Spain, India, Egypt, Australia, Yugoslavia, Norway, Iran, Ceylon, U.S.S.R., Mexico, Japan, Czechoslovakia, Greece, Israel, Ethiopia, Turkey, Bulgaria, Tunisia, Rumania, Cyprus, Poland, Austria, Masaccio (Italy).

MUSEUMS OF THE WORLD (NEWSWEEK, INC.) 1968–1969
A series of fifteen volumes, each devoted to an outstanding museum. All-color, plus a history of the museum in question and short art-historical comments on the important objects in that collection.

SKIRA
Skira Inc., Publishers, New York, have brought out a number of books of art with excellent illustrations in color. Some deal with a single artist, some with a movement or a period.

PRAEGER PUBLISHERS
A variety of series in the history of art and the history of music. Among these such collections as *Ancient Peoples and Places* and the *Praeger World of Art* are outstanding.

PHAIDON PRESS
A relatively older company established in England to produce fine black-and-white art books has subsequently added a series of excellent and modestly priced artist monographs in color.

HARRY N. ABRAMS
Perhaps the most active art book publisher in the United States, this company covers both traditional and modern areas in period books, monographs, original graphic art, etc.

TEACHING PORTFOLIOS (MUSEUM OF MODERN ART, NEW YORK)
Large illustrations suitable for mounting on a wall; one on *Modern Sculpture*, one on *Texture*, etc.

LANDMARKS OF THE WORLD'S ART (MCGRAW-HILL, 1966–1967)
A series of ten color-illustrated period books divided into the broadest historical segments; e.g., *The Age of Baroque, The Classical World.*

II. MUSIC

SKELETON SCORES. A skeleton score shows the melodic line of a composition, with annotations which give indications of form (first theme, development, etc.), timbre, tempo, and dynamics.

The series *Symphonic Skeleton Scores* is edited and annotated by Violet Katzner (Theodore Presser Company, Bryn Mawr, Pa.). The series at present contains these six symphonies:

Beethoven, Symphony No. 5 in C minor
Brahms, Symphony No. 1 in C minor
Brahms, Symphony No. 3 in F major
Franck, Symphony in D minor
Mozart, Symphony in G minor
Schubert, Symphony in B minor (*Unfinished*)
Tchaikowsky, Symphony No. 4 in F minor
Tchaikowsky, Symphony No. 6 in B minor (*Pathétique*)

Scored for Listening, by Bockman and Starr (Harcourt, Brace & World, Inc., New York, 1959), contains skeleton scores for many of the compositions referred to in this volume.

MINIATURE SCORES. As the name implies, the miniature score gives the entire score, but in miniature; collections of miniature scores are published by E. F. Kalmus Orchestra Scores, Inc., New York, and by Penguin Books, Inc., Baltimore, Md.

LIBRETTOS. The complete words of operas, often with one or two musical excerpts, can be obtained from the Metropolitan Opera Association or Fred Rullman, Inc., in New York City, and Oliver Ditson Co., Boston.

III. FILMS

Henry Moore (British contemporary sculptor), British Information Service (1947)
Rodin (French sculptor, 1840–1947), United World (1950)
Steps of the Ballet, Encyclopedia Britannica Films (1949)
Four Films on Design, Young America (1950)
How to Make an Etching. Almanac Films (1951)
Frank Lloyd Wright, Encyclopedia Britannica Films (1960)
Boundary Lines, McGraw-Hill (1947)
What Is a Painting? Metropolitan Museum (n.d.)
The Making of a Mural (Thomas Hart Benton), Encyclopedia Britannica Films (1947)
Orpheus and Eurydice, Stephens College (1960)

IV. COLOR SLIDES

COLOR SLIDE PROGRAM OF ART ENJOYMENT (MCGRAW-HILL, NEW YORK)
A series of nineteen volumes, each with twenty-four slides and a historical text plus commentaries on the individual slides. These books cover individual periods such as the *High Renaissance, Impressionism, Between the Two Wars.*

COLOR SLIDE PROGRAM OF THE GREAT MASTERS (MCGRAW-HILL, NEW YORK)
A series of fourteen volumes with twenty slides each, plus texts as above. These volumes cover individual masters; e.g., Chagall, Picasso, Brueghel, Michelangelo.

COLOR SLIDE COOPERATIVE (NEW YORK)
An extensive catalogue lists thousands of color slides covering the entire history of art. Slides are available in a variety of prepackaged collections covering specific areas.

SANDAK COLOR SLIDES (NEW YORK)
A number of different important historical areas are covered by the offerings of this company; e.g., *Modern Architecture, Modern Painting.* Especially well-known for their collection of 4,000 color slides, *Arts of the United States.*

V. COLOR PRINTS

As an instructional tool very few media can rival the color print, now available in all sizes and prices. Perhaps the leading publisher in this field is the New York Graphic Society in Greenwich, Conn., with its very impressive illustrated catalogue in color. Important general distributors include Konrad Prothmann, Baldwin, L.I., and the F.A.R. Gallery, New York.

BIBLIOGRAPHY

This bibliography is divided into five groups. The first contains the dictionaries and other volumes needed for factual reference or allusion. The second contains those volumes, such as the ones on aesthetics, which are concerned with more than one art. The third, fourth, and fifth groups are the regular classifications of the individual arts—literature, drama, and film; the visual arts; and music and dance. Biographies and collections of illustrations are kept to a minimum.

I. DICTIONARIES AND REFERENCES

Avery, Catherine B., ed.: *The New Century Classical Handbook*, New York, 1962.

Catholic Encyclopedia, New York, 1907–1922.

Cirlot, J. E.: *A Dictionary of Symbols*, trans. from the Spanish by Jack Sage, New York, 1962.

Cruden, Alexander: *Complete Concordance to the Old and New Testament . . . with . . . a Concordance to the Apocrypha*, London, 1769.

Encyclopedia of World Art, New York, 1959.

Ferguson, George: *Signs and Symbols in Christian Art*, New York, 1954.

Frazer, Sir James George: *The Golden Bough: A Study in Magic and Religion*, 3d ed., London, 1907–1915, 12 vols.

Gayley, Charles Mills: *Classic Myths in English Literature and in Art*, rev. ed., New York, 1939.

Gray, L. H., ed.: *Mythology of All Races*, Boston, 1916–1932, 13 vols.

Grove, George: *Grove's Dictionary of Music and Musicians*, 5th ed., New York, 1954, 10 vols.

Guirand, F., ed.: *Larousse Encyclopedia of Mythology*, London, 1959.

Hackin, J.: *Asiatic Mythology: A Detailed Description and Explanation of the Mythologies of All the Great Nations of Asia*, New York, 1963.

Hamilton, Edith: *Mythology*, New York, 1961.

Harmon, N. B., ed.: *The Interpreter's Bible*, New York, 1951–1957, 12 vols.

Hastings, James, ed., *Encyclopedia of Religion and Ethics*, Edinburgh and New York, 1908–1927, 12 vols. and index.

The Interpreter's Dictionary of the Bible, New York, 1962, 4 vols.

Jacobs, Arthur: *A New Dictionary of Music*, rev. ed., Baltimore, 1960.

Lehner, Ernst: *The Picture Book of Symbols*, New York, 1956.

Maillard, Robert: *Dictionary of Modern Sculpture*, New York, 1960.

Myers, B., and S. Myers: *Encyclopedia of Painting*, New York, rev. ed., 1970.

Myers, B., and S. Myers: *Dictionary of Arts*, New York, 1969 (5 vols.).

Myers, B., and T. Copplestone, eds.: *Landmarks of the World's Art*, New York and London, 1966–1967.

Penguin Companion to Classical, Oriental, and African Literature, New York, 1969.

Penguin Companion to European Literature, New York, 1969.

Penguin Companion to American Literature, New York, 1971.

Penguin Companion to English Literature, New York, 1971.

Standard Dictionary of Folklore, Mythology, and Legend, New York, 1949.

Whittick, Arnold: *Symbols, Signs, and Their Meaning*, Newton, Mass., 1961.

II. AESTHETICS

Berenson, Bernard: *Aesthetics and History in the Visual Arts*, New York, 1954.

Bonnard, André: *Greek Civilization—From the Iliad to the Parthenon*, London, 1957, 3 vols.

Bosanquet, Bernard: *Three Lectures on Aesthetics*, New York, 1963.

Coomaraswamy, Ananda K.: *The Transformation of Nature in Art*, New York, 1934.

Fleming, Williams: *Arts and Ideas*, New York, 1963.

Hamilton, Edith: *The Greek Way to Western Civilization*, New York, 1942.

Hauser, Arnold: *The Philosophy of Art History*, Cleveland and New York, 1963.

Langer, Susanne K.: *Feeling and Form*, New York, 1956.

—— *Philosophy in a New Key*, 3d ed., Baltimore, 1957.

—— *Problems of Art: Ten Philosophical Lectures*, New York, 1957.

Larkin, Oliver: *Art and Life in America*, New York, 1960.

Margolis, Joseph Z.: *The Language of Art and Art Criticism: Analytic Questions in Aesthetics*, Detroit, 1965.

Maritain, Jacques: *Creative Intuition in Art and Poetry*, New York, 1955.

Miller, William Hugh: *Introduction to Music Appreciation: An Objective Approach to Listening*, Rahway, N.J., 1961.

Murry, John M.: *The Problem of Style*, London, 1960.

Rader, Melvin: *A Modern Book of Aesthetics: An Anthology*, 3d ed., New York, 1960.

Read, Sir Herbert: *The Meaning of Art*, Baltimore, 1959.

Seldes, Gilbert: *Seven Lively Arts*, New York, 1962.

Sypher, Wylie, ed.: *Rococo to Cubism in Art and Literature*, New York, 1960.

—— *Art History: An Anthology of Modern Criticism*, New York, 1963.

III. LITERATURE, DRAMA AND FILM

Baldry, H. C.: *Ancient Greek Literature in Its Living Context*, New York, 1968.

Barnet, Sylvan, and others: *A Dictionary of Literary Terms*, Boston, 1962.

Baugh, Albert C., ed.: *A Literary History of England*, New York, 1958.

Beardsley, Monroe, Robert Daniel, and Glenn Leggett: *Theme and Form*, 2d ed., Englewood Cliffs, N.J., 1962

Benét, William Rose, ed.: *The Reader's Encyclopedia*, 2d ed., New York, 1965.

Booth, Wayne C.: *The Rhetoric of Fiction*, Chicago, 1961.

Bradley, A. C.: *Shakespearean Tragedy*, London, 1956.

—— *Oxford Lectures on Poetry*, 2d ed., Bloomington, Ind., 1961.

Butcher, S. H.: *Aristotle's Theory of Poetry and Fine Art*, 4th rev. ed., New York, 1955.

Chase, Richard: *The American Novel and Its Tradition*, Garden City, New York, 1964.

Daiches, David: *A Study of Literature for Readers and Critics*, New York, 1964.

—— *The Present Age in British Literature*, Bloomington, Ind., 1958.

—— *English Literature*, Englewood Cliffs, N.J., 1964.

Eisenstein, Sergei M.: *Film Form (and) Film Sense*, New York, 1957. 2 vols. in one.

Eliot, T. S.: *On Poetry and Poets*, New York, 1957.

Forster, E. M.: *Aspects of the Novel*, New York, 1956.

Fowler, H. W.: *A Dictionary of Modern English Usage*, 2d rev. ed. by E. Gowers, New York, 1965.

Harvey, P.: *Oxford Companion to English Literature*, 3d ed., New York, 1946.

—— *Oxford Companion to Classical Literature*, 2d ed., New York, 1937.

Isaacs, J.: *Background of Modern Poetry*, New York, 1952.

Jesperson, Otto: *Growth and Structure of the English Language*, 9th ed., New York, 1955.

Keene, Donald: *Anthology of Japanese Literature*, New York, 1956.

Kernan, Alvin B.: *Character and Conflict: An Introduction to Drama*, New York, 1963.

Kettle, Arnold: *An Introduction to the English Novel*, New York, 1951, 2 vols.

Kronenberger, Louis: *The Thread of Laughter*, New York, 1952.

Lattimore, Richmond: *The Poetry of Greek Tragedy*, Baltimore, 1958.

Lawson, John H.: *Film: The Creative Process: The Search for an Audio-Visual Language and Structure*, New York, 1964.

Leavis, F. R.: *The Great Tradition: A Study of the English Novel*, New York, 1963.

Legouis, E., and L. Cazamian: *A History of English Literature, 630–1914*, trans. by H. D. Irvine and W. D. MacInnes, 2 vols., rev. ed., New York, 1957.

Literature of America, The. 2 vols., New York, 1971.

Mandel, Oscar: *A Definition of Tragedy*, New York, 1961.

Manvell, Roger: *Film*, rev. ed., Baltimore, 1946.

Macgowan, K., and W. Melnitz: *The Living Stage*, New York, 1955.

McCollom, William G.: *Tragedy*, New York, 1957.

Nilsen, Vladimir S.: *The Cinema as a Graphic Art*, New York, 1959.

Norton Anthology of English Literature. 2 vols., New York, 1968.

Penguin Companions to Literature (see above, under Dictionaries and References).

Preminger, Alex: *Encyclopedia of Poetry and Poetics*, Princeton, N.J., 1965.

Quiller-Couch, Sir Arthur: *On the Art of Writing*, New York, 1961.

Reinert, Otto: *Drama: An Introductory Anthology*, alt. ed., Boston, 1964.

Sapir, Edward: *Language: An Introduction to the Study of Speech*, New York, 1949.

Shapiro, Karl, and Robert Beum: *A Prosody Handbook*, New York, 1965.

Spurgeon, Caroline: *Shakespeare's Imagery*, Cambridge, 1952.

Thrall, William Flint, and Addison Hibbard: *A Handbook to Literature*, rev. ed., New York, 1960.

Tyler, Parker: *The Three Faces of the Film*, New York, 1960.

Van Ghent, Dorothy: *The English Novel: Form and Function*, New York, 1961.

Watt, Ian: *The Rise of the Novel*, Berkeley, Calif., 1964.

Wellek, René, and Austin Warren: *Theory of Literature*, 2d ed., New York, 1956.

World Masterpieces (literary anthology), New York, 2 vols., 1966.

IV. THE VISUAL ARTS

Arnheim, Rudolf: *Art and Visual Perception: A Psychology of the Creative Eye*, Berkeley, Calif., 1954.

Barr, Alfred H., Jr., ed.: *Masters of Modern Art*, New York, 1954.

——— *Picasso, Fifty Years of His Art*, New York, 1946.

Berenson, Bernard: *The Italian Painters of the Renaissance*, New York, 1957.

Boardman, John: *Greek Art*, New York, 1964.

Canaday, John: *Keys to Art*, New York, 1963.

Christ-Janer, Albert, and Mary Mix Foley: *Modern Church Architecture*, New York, 1962.

Clark, Kenneth: *The Nude: A Study in Ideal Form*, Garden City, New York, 1956.

——— *Civilization*, New York, 1970.

Constable, W. G., *The Painter's Workshop*, New York, 1954.

Drexler, Arthur: *The Architecture of Japan*, New York, 1955.

Faulkner, Ray, Edwin Ziegfeld, and Gerald Hill: *Art Today*, 4th ed., New York, 1963.

Fletcher, Bannister: *A History of Architecture on the Comparative Method*, 17th ed., New York, 1961.

Frankl, Paul: *Gothic Architecture*, Baltimore, 1962.

Gardner, Ernest A.: *A Handbook of Greek Sculpture*, 2d ed., New York, 1929.

Gardner, Helen: *Art Through the Ages*, 5th ed., New York, 1970.

Giedion, S.: *Architecture, You and Me*, Cambridge, Mass., 1958.

——— *Space, Time and Architecture*, 4th ed., Cambridge, Mass., 1962.

Gombrich, E. H.: *The Story of Art*, 10th ed., Greenwich, Conn., 1960.

Green, Samuel M.: *American Art*, New York, 1966.

Heller, Jules: *Printmaking Today: An Introduction to the Graphic Arts*, New York, 1958.

Hitchcock, Henry-Russell: *In the Nature of Materials: The Buildings of Frank Lloyd Wright*, New York, 1942.

——— and Arthur Drexler: *Built in U.S.A.: Post-War Architecture*, New York, 1953.

——— *Architecture: Nineteenth and Twentieth Centuries*, Baltimore, 1963.

——— *World Architecture*, New York, 1963 (intro. by H. R. H.).

Huyghe, René: *Ideas and Images in World Art (Dialogue with the Visible)*. New York, 1959.

Illinois, University of: *Contemporary American Painting and Sculpture*, 1965.

Janson, H. W., with Dora Jane Janson: *The Picture History of Painting*. New York, 1957.

——— *A History of Art*, New York, 2d ed., 1969.

——— ed.: *Key Monuments of the History of Art (A Visual Survey)*, New York, 1962.

Lavedan, Pierre: *French Architecture*, Baltimore, 1957.

Lawrence, A. W.: *Greek Architecture*, Baltimore, 1957.

Le Corbusier (pseud. of Charles E. Jeanneret-Gris): *Towards a New Architecture*, trans. from the 13th French ed., with an introduction by Frederick Etchells, New York, 1959.

Loran, Erle: *Cézanne's Composition: Analysis of His Form with Diagrams and Photographs of His Motifs*, 3d ed., Berkeley, Calif., 1963.

Mâle, Emile: *Religious Art from the Twelfth to the Eighteenth Century*, New York, 1963.

Mumford, Lewis: *The Culture of Cities*, New York, 1938.

—— *Sticks and Stones*, 2d rev. ed., New York, 1955.

Myers, Bernard S.: *Art and Civilization*, New York, rev. ed., 1967.

—— *Modern Art in the Making*, 2d ed., New York, 1959.

—— *Understanding the Arts*, rev. ed., New York, 1963.

—— *The German Expressionists*, New York, 1967.

—— *Mexican Painting in Our Time*, New York, 1956.

—— *Fifty Great Artists*, New York, 1959.

Newton, Eric: *European Painting and Sculpture*, 4th ed., Baltimore, 1960.

Paine, Robert Treat, and Alexander Soper: *The Art and Architecture of Japan*, Baltimore, 1955.

Panofsky, Erwin: *Meaning in the Visual Arts*, New York, 1955.

Peterdi, Gabor: *Printmaking: Methods Old and New*, New York, 1959.

Pevsner, Nikolaus: *Outline of European Architecture*, 5th ed., Baltimore, 1960.

Pope, Arthur: *The Language of Drawing and Painting*, Cambridge, Mass., 1949.

Read, Sir Herbert: *A Concise History of Modern Painting*, New York, 1959.

Rewald, John: *Post-Impressionism: From Van Gogh to Gauguin*, New York, 1958.

Richards, J. M., and Elizabeth B. Mock: *An Introduction to Modern Architecture*, Baltimore, 1956.

Richter, Gisela M. A.: *The Sculpture and Sculptors of the Ancient Greeks*, rev. ed., New Haven, Conn., 1950.

Robb, David M., and J. J. Garrison: *Art in the Western World*, 4th ed., New York, 1963.

Scott, Geoffrey: *The Architecture of Humanism*, New York, 1954.

Seiberling, Frank: *Looking into Art*, New York, 1959.

Seuphor, Michel: *Dictionary of Abstract Painting*, New York, 1957.

Sewall, John Ives: *A History of Western Art*, rev. ed., New York, 1962.

Tapié, Victor L.: *The Age of Grandeur: Baroque Art and Architecture*, trans. from the French by A. Ross Williamson, New York, 1960.

Upjohn, Everard M., Paul S. Wingert, and Jane Gaston Mahler: *History of World Art*, 2d ed., New York, 1958.

Venturi, Lionello: *Painting and Painters: How to Look at a Picture from Giotto to Chagall*, New York, 1945.

Warner, Langdon: *The Enduring Art of Japan*, New York, 1958.

Watrous, James: *The Craft of Old-Master Drawings*, Madison, Wisc., 1957.

Woelfflin, H.: *Principles of Art History*, trans. from the 7th German ed. by M. D. Hottinger, New York, 1949.

Wright, Frank Lloyd: *The Living City*, New York, 1958.

Zigrosser, Carl: *Prints: Thirteen Illustrated Essays on the Art of the Print*, New York, 1962.

V. MUSIC AND DANCE

Abraham, Gerald: *Design in Music*, New York, 1949.

Apel, Willi: *Harvard Dictionary of Music*, Cambidge, Mass., 1944.

—— *Gregorian Chant*, Bloomington, Ind., 1958.

Barlow, Wayne: *Foundations of Music*, New York, 1953.

Bauman, Alvin, and Charles W. Walton: *Elementary Musicianship*, 2d ed., Englewood Cliffs, N.J., 1959.

Bernstein, Martin: *An Introduction to Music*, 2d ed., Englewood Cliffs, N.J., 1951.

Boyden, David Dodge: *An Introduction to Music*, New York, 1956.

Chujoy, Anatole: *The New York City Ballet*, New York, 1953.

Cooper, Grosvenor: *Learning to Listen: A Handbook for Music*, Chicago, 1957. Prepared with the humanities staff of the College at the University of Chicago.

Copland, Aaron: *Music and Imagination*, Cambridge, Mass., 1953.

—— *What to Listen for in Music*, rev. ed., New York, 1957.

Dallin, Leon: *Listener's Guide to Musical Understanding*, Dubuque, Iowa, 1959.

DeMille, Agnes: *The Book of the Dance*, New York, 1963.

Dent, Edward J.: *Opera*, Baltimore, 1940.

Ewen, David, ed.: *From Bach to Stravinsky: The History of Music by Its Foremost Critics*, New York, 1933.

Finney, Theodore M.: *A History of Music*, rev. ed., New York, 1947.

Forsyth, Cecil: *Orchestration*, 2d ed., New York, 1942.

Geiringer, Karl: *Musical Instruments*, New York, 1945.

Green, Douglass M.: *Form in Tonal Music*, New York, 1965.

Grout, Donald J.: *A History of Western Music*, New York, 1960.

—— *Short History of Opera*, 2 vols., 2d ed., New York, 1965.

Grove, George: *Beethoven and His Nine Symphonies*, London, 1898.

Hadow, Sir W. H., ed.: *The Oxford History of Music*, 6 vols., 2d ed., New York, 1929.

Hansen, Peter S.: *An Introduction to Twentieth Century Music*, Boston, 1961.

Harman, Alec: *Man and his Music: the Story of Musical Experience in the West*, New York, 1962.

Haskell, Arnold, ed.: *Ballet* (annual). nos. 16 and 17, New York, 1962 and 1963.

Hill, Ralph: *The Symphony*, Baltimore, 1949.

Hindemith, Paul: *The Craft of Musical Compostion, Part I*, New York, 1942.

—— *A Composer's World: Horizons and Limitations*, Cambridge, Mass., 1952.

Howard, John Tasker, and James Lyons: *Modern Music: A Popular Guide to Greater Musical Enjoyment*, rev. ed., New York, 1957.

Humphrey, Doris: *The Art of Making Dances*, ed. by Barbara Pollack, New York, 1959.

Hutchinson, Ann: *Labanotation*, New York, 1954.

Lang, Paul Henry: *Music in Western Civilization*, New York, 1941.

Lawson, Joan: *A History of Ballet and Its Makers*, New York, 1964.

Liepmann, Klaus: *The Language of Music*, New York, 1953.

Mann, Alfred: *The Study of Fugue*, New Brunswick, N.J., 1958.

Marek, George R., ed.: *The World Treasury of Grand Opera*, New York, 1957.

Martin, John: *Introduction to the Dance*, New York, 1939.

—— *The Modern Dance*, New York, 1933.

—— *The Dance*, New York, 1946.

Meyer, Leonard B.: *Emotion and Meaning in Music*, Chicago, 1956.

—— and Grosvenor W. Cooper: *The Rhythmic Structure of Music*, Chicago, 1960.

Mitchell, Donald: *The Language of Modern Music*, New York. 1963.

Morris, R. O.: *The Structure of Music: An Outline for Students*, New York, 1935.

Murphy, Howard A.: *Form in Music for the Listener*, Camden, N.J., 1945.

New Oxford History of Music, New York, 1963.

Newman, Ernest: *Wagner Operas*, New York, 1949.

Piston, Walter: *Harmony*, 3d rev. ed., New York, 1962.

Portnoy, Julius: *Music in the Life of Man*, New York, 1963.

Raffe, Walter G.: *Dictionary of the Dance*, New York, 1965.

Ratner, Leonard G.: *Music, The Listener's Art*, New York, 1957.

Rufer, Joseph: *Composition with Twelve Notes*, trans. by Humphrey Searle, New York, 1954.

Sachs, Curt: *The Wellsprings of Music*, ed. by Jaap Kunst, The Hague, Netherlands, 1962.

—— *World History of the Dance*, New York, 1963.

Salazar, Adolfo: *Music in Our Time: Trends in Music since the Romantic Era*, trans. by Isabel Pope, New York, 1946.

Scholes, Percy A.: *Listener's Guide to Music*, with a concertgoer's glossary and an introduction by Sir W. Henry Hadow, 10th ed., New York, 1948.

—— *Oxford Companion to Music*, 9th ed., New York, 1955.

Stearns, Marshall W.: *The Story of Jazz*, New York, 1956.

Stringham, Edwin John: *Listening to Music Creatively*, 2d ed., New York, n.d.

Toch, Ernst: *The Shaping Forces in Music*, New York, 1948.

Tovey, Donald Francis: *Essays in Musical Analysis*, 6 vols. New York, 1935–1939.

—— *Musical Articles from the Encyclopaedia Britannica*, with an editorial preface by Hubert J. Foss, New York, 1944.

—— *Beethoven*, with an editorial preface by Hubert J. Foss, New York, 1945

—— *The Main Stream of Music and Other Essays*, collected with an introduction by Hubert J. Foss, New York, 1949.

Tyndall, Robert E.: *Musical Form*, Rockleigh, N.J., 1964.

Zuckerkandl, Victor: *The Sense of Music*, Princeton, N.J., 1959.

McGRAW-HILL FILMS

Caravaggio and the Baroque
Dürer and the Renaissance
Gothic Art
The Rise of Greek Art
Eskimo Artist Kenojuak
Greek Sculpture
Submerged Glory: A Study in Stone
Space and Perspective in Painting
American Realists, Parts 1 & 2
Ceramics: What? Why? How?
Fernand Léger
Goya
I, Leonardo da Vinci
Marc Chagall
Picasso
Renoir
The Titan, Story of Michelangelo
A Trip with Currier and Ives
Van Gogh: A Self Portrait
The Vision of William Blake
Yankee Painter: The Work of Winslow Homer

INDEX

Page references in **boldface** indicate figures.